NAPOLEON SARONY'S LIVING PICTURES

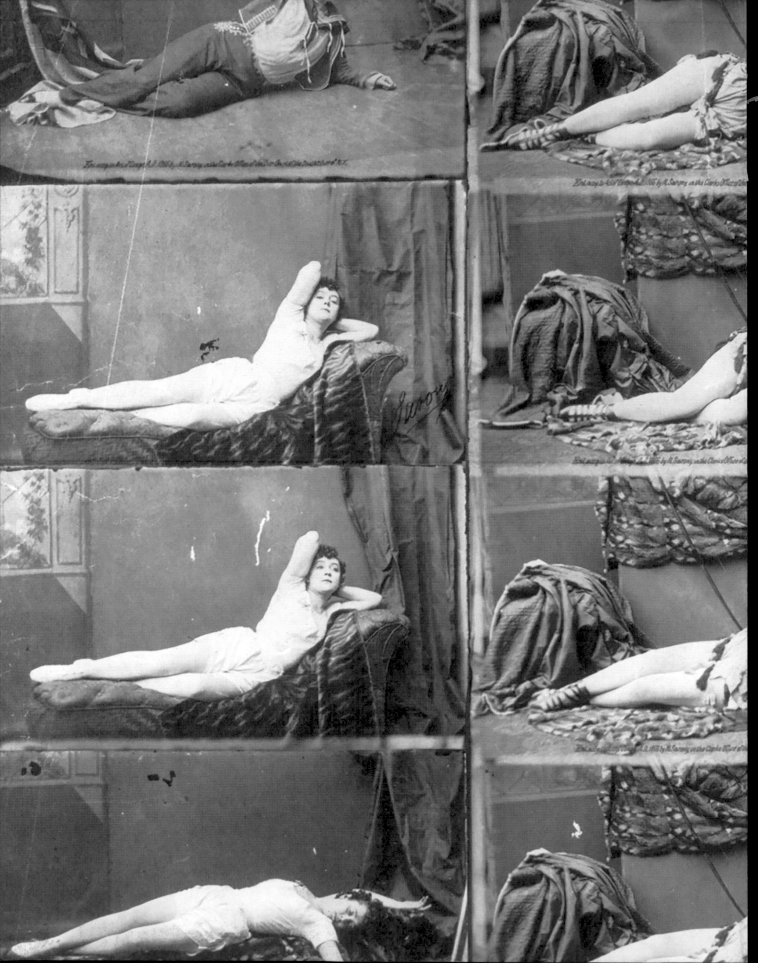

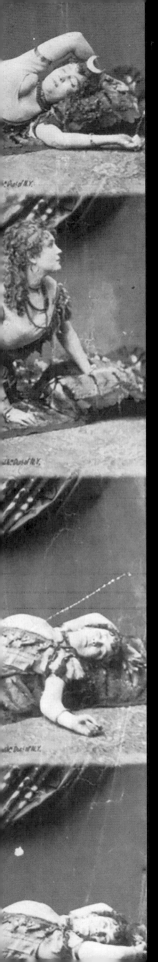

NAPOLEON SARONY'S LIVING PICTURES

The Celebrity Photograph in
Gilded Age New York

ERIN PAUWELS

The Pennsylvania State University Press
UNIVERSITY PARK, PENNSYLVANIA

Library of Congress Cataloging-in-Publication Data

Names: Pauwels, Erin Kristl, author.
Title: Napoleon Sarony's living pictures : the celebrity
 photograph in Gilded Age New York / Erin Pauwels.
Description: University Park, Pennsylvania : The Pennsylvania
 State University Press, [2023] | Includes bibliographical
 references and index.
Summary: "Examines the career of the Gilded Age
 photographer Napoleon Sarony and his role in the rise
 of celebrity culture in the United States"—Provided by
 publisher.
Identifiers: LCCN 2023012984 | ISBN 9780271095066
 (cloth)
Subjects: LCSH: Sarony, Napoleon, 1821–1896. | Portrait
 photographers—New York (State)—New York—Biography.
 | Portrait photography—New York (State)—New York—
 History—19th century. | Staged photography—New
 York (State)—New York—History—19th century. |
 Celebrities—Portraits—History—19th century. | LCGFT:
 Biographies.
Classification: LCC TR140.S37 P38 2023 | DDC
 770.92/274710904—dc23/eng/20230330
LC record available at https://lccn.loc.gov/2023012984

The Pennsylvania State University Press is a member of the
Association of University Presses.

It is the policy of The Pennsylvania State University Press
to use acid-free paper. Publications on uncoated stock satisfy
the minimum requirements of American National Standard
for Information Sciences—Permanence of Paper for Printed
Library Material, ANSI Z39.48–1992.

Additional credits: half title, Napoleon Sarony (1821–
1896), Self-Portrait in a Studio Snowstorm, ca. 1875 (fig.
1); frontispiece, Napoleon Sarony, Portraits of Adah Isaacs
Menken, ca. 1866 (fig. 18); page vi, Frederic Lewis, Sarony
Studio on Union Square at Broadway, 1892–93 (fig. 47).

For my parents

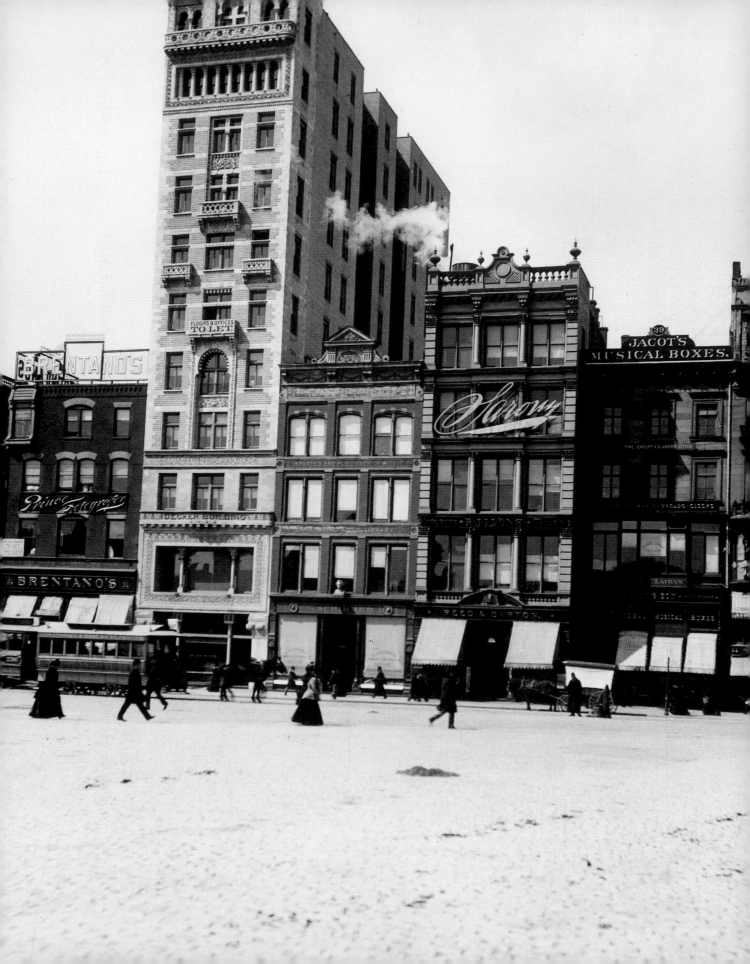

CONTENTS

ILLUSTRATIONS

ACKNOWLEDGMENTS

This book has been years in the making and was only possible through the generosity of the people and institutions I now have the pleasure of acknowledging. My thanks, first of all, to my friend and advisor Sarah Burns for seeing potential in Sarony, and in me, and for supporting this project every step of the way. My work also benefitted immensely from the early guidance of Alan C. Braddock, Frank H. Goodyear III, Bret Rothstein, Giles Knox, Melody Barnett Deusner, Vanessa R. Schwartz, and Andrés Zervigón. My esteemed professor at Carleton College, the late Lauren Soth, deserves special tribute in these pages as well. It was his gruff determination that I should become an art historian, and his kind graduation gift of my first membership in the Association of Historians of American Art set me on my current career path.

Reconstructing Sarony's legacy and body of work has been a monumental undertaking. I am indebted to the archivists, curators, and librarians who provided material assistance in locating surviving images and information about Sarony's career, including staff at the American Antiquarian Society; the Archives of American Art; the Smithsonian National Portrait Gallery and the National Portrait Gallery of London; the New-York Historical Society; the Library of Congress; the George Eastman Museum; Bancroft Library of the University of California, Berkeley; the University of Pennsylvania's Kislak Center for Special Collections, Rare Books and Manuscripts; the Morgan Library and Museum; the Folger Shakespeare Library; Green-Wood Cemetery and Saints Peter and Paul Catholic Church in Brooklyn, New York; the Westchester County Archives; the Free Library of Philadelphia; the Library of Birmingham, UK; the Musée McCord; the Bibliothèque et Archives nationale du Québec, and the Museum of the City of New York. What remains of Sarony's studio photographic collection is preserved at Harvard University, and I extend special thanks to Dale Stinchcomb of the Harvard Theatre Collection at Houghton Library and Joanne Bloom of the Fine Arts Library at Harvard University for their abundant generosity over the

years, and for supplying so many of the beautiful photographs contained within this book. Thanks also to Mazie M. Harris of the J. Paul Getty Museum; Marie-Stéphanie Delamaire at the Winterthur Museum, Garden & Library; Shannon Thomas Perich of the Photographic History Collection at the National Museum of American History; Barbara Orbach Natanson of the Library of Congress; Morgen Stevens-Garmon and Lindsay Turley of the Museum of the City of New York; Angela Kale of the Scarborough Library in England; and Lauren Hewes at the American Antiquarian Society. Thanks as well to Emily Guthrie, Tom Guiler, and Catherine Dann Roeber for supporting my research, and me personally, during the complications of a Covid-era postdoctoral fellowship at the Winterthur Museum, Garden & Library. Finally, lasting gratitude to Martin and Lauretta Dives, Harriet Culver, and Anne-Marie Ehrlich for helping launch this project many years ago.

I have been fortunate to hold grants and fellowships throughout my research that aided my continuing progress. The foundations for my work were laid during a Wyeth Foundation Fellowship with the Smithsonian American Art Museum and National Portrait Gallery, and I am grateful to the remarkable intellectual community at the Smithsonian Institution for their enduring support, especially Wendy Wick Reaves, William H. Truettner, Amelia Goerlitz, Kate Clarke LeMay, Dorothy Moss, Brandon Brame Fortune, Robin Veder, Leslie Ureña, and Ann Shumard. Equally formative were fellowship awards from the Henry Luce Foundation and American Council of Learned Societies, Indiana University, the Harry Ransom Center for Research in the Humanities at the University of Texas–Austin, and a Beatrice, Benjamin and Richard Bader Visiting Fellowship in the Visual Arts of the Theatre from the Houghton Library of Harvard University. A generous travel grant from the Huntington Library allowed me to explore the site and artifacts of Sarony's early photographic practice by funding research in London, Birmingham, and Scarborough, England. Revisions of my manuscript were made possible by postdoctoral fellowships from the Center for the Humanities at Temple University; the Winterthur Museum, Garden & Library, and a Jay and Deborah Last Research Fellowship in American Visual Culture with the American Antiquarian Society. Finally, my sincere gratitude to Dean Susan Cahan of the Tyler School of Art and Architecture and Temple University for generously supporting my research and this book.

Thanks are also due to the organizers and audiences who created opportunities for me to share material from the book during lectures at the Edgar P. Richardson Symposium at the National Portrait Gallery; the Greenberg Steinhauser Forum in American Portraiture at PORTAL; the Smithsonian American Art Museum; the Art Institute of Chicago; the Harry Ransom Center; the American Antiquarian Society; Bryn Mawr College Center for Visual Culture; the Library Company of Philadelphia; the Rochester Institute of Technology; the Newberry Library; the P19 Interdisciplinary Research Group, and the Center for the Humanities at Temple University.

Special thanks to Christian Fleury for inviting me to participate in his documentary *Trois saisons de Sarony*, and to John Rohrbach of the Amon Carter Museum of American Art for involving me in the exhibition *Acting Out: Cabinet Cards and the Making of Modern Photography*, which recognizes Sarony's starring role in this pivotal moment of US photographic history.

Gratitude to my students and colleagues at Temple University and the Tyler School of Art and Architecture, especially Mariola V. Alvarez, Therese Dolan, Jane DeRose Evans, Leah Modigliani, Gerald Silk, Ashley West, and Byron Wolfe. Thanks as well to the inspiring scholars and friends who shaped this book in countless ways by sharing fellowship, offering feedback, and generally cheering me on, among them Jennifer A. Greenhill, Anna Arabindan-Kesson, Sarah Beetham, Emily C. Burns, Jenny Carson, Maggie M. Cao, Liam Considine, Kate Crawford, Seth Feman, Catherine Holochwost, Laura Turner Igoe, Emily Liebert, Emilee Mathews, Bibiana Obler, John Ott, Erika Piola, Marika Plater, Kristin Romberg, Naomi Slipp, Anna Simon, Alex J. Taylor, Adam M. Thomas, Hélène Valance, Jonathan Frederick Walz, ShiPu Wang, and Tatsiana Zhurauliova. I am especially grateful to the network of close colleagues in Philadelphia—Gwendolyn DuBois Shaw, Tiffany Barber, Jason E. Hill, Delia Solomons, and Jessica L. Horton—who read chapter drafts and responded with helpful insights and encouragement. My book is also much better thanks to the two anonymous reviewers who provided thoughtful critical feedback on the first draft of the manuscript. I am also deeply grateful for the expert guidance of my editor, Ellie Goodman, and the supportive efforts of the entire production team at Penn State University Press.

Most of all, I am grateful for my family, which is enriched by chosen members, many of whom are listed above but also including Whitney York, Amy Burton, Shannon Piercy-Alvarez, Alyce Waxman, and Jessica Buskirk. Thanks to my supportive brother, Matt, my constant companion Teddy, and especially to Jim, who has lived as closely with Sarony as I have over the past few years and shared in the struggles and triumphs of my research with kindness and welcome good humor. Finally, I owe most everything I have achieved in life, including this book, to the unconditional love and support of my parents, Gerard and Colleen Pauwels, who together inspired my belief in the magic of the theater and the mysteries of archives. This book is dedicated to their memory, with my eternal gratitude.

INTRODUCTION

The name Napoleon Sarony is easy to remember once you have learned it. After you do, you realize how frequently it appears in connection with photographs and prints made in the United States during the late nineteenth century. I first encountered "Sarony" printed in florid cursive letters on the lower margin of a cabinet card in the archives of Culver Pictures in New York City. It was during a time in my life when I only dimly imagined writing a book or becoming an art historian, so I had no expectation that I would come to spend so much time thinking about the artist behind the name and all the reasons he had become unfamiliar.

Culver Pictures is a family-owned news photo service founded in the 1920s that once housed an exuberant jumble of nearly one million photographs and prints in an unassuming loft in Chelsea.[1] These were working pictures rather than fine art objects and were preserved for the purpose of being licensed as reproductions for publishers and documentary filmmakers. For this reason, materials were organized according to depicted subject matter rather than by artist, date, or medium, as they would be in a museum. It meant that one could find exquisite hand-pulled engravings or velvety platinum prints in filing folders alongside inexpensive picture postcards, newspaper scraps, and glossy press photos that still bore the marks of an editor's grease pencil. Such philosophical disregard for conventional filing systems extended from the cabinet contents to the space of the archive. Drawers labeled only "Coal," "Construction," or "Wigs" left much to the imagination in terms of what might be found

inside, and every vaguely level surface in the place was piled high with unsorted pictures. This state of disarray seemed less a matter of inertia than of the fact that so many of the historic images defied easy categorization, seeming to merit a form of cross-listing that their analogue form made impossible. Perhaps it was just that so many of the old photographs of grinning families, lonely city streets, dancing showgirls, and boatloads of soldiers waving goodbye to their sweethearts were too poignant and indescribably charming to be consigned indefinitely to the darkness of a closed drawer with an inadequate label. I imagined a well-meaning archivist regarding each image in turn and considering how to file it, before setting it back down and thinking, "Maybe not just yet."

My role at Culver was to act as an intermediary between the archive's need to adapt to the demands of the digital era and the recognition that there was something rare and irreplaceable in the unruly inclusivity of a collection of old pictures that took shape over a great many years. I was charged with selecting a few thousand of the best prints to be digitally preserved before their impending sale to a private collector. The thought, which at the time was shared by other great New York City stock photography collections, such as the Bettmann Archive, was that a digital copy could serve the purpose of reproduction as well as the original, and the sale would support the remaining collection while reducing the need to take up expensive city real estate.[2] My only working criterion was to limit my selection to photographs that were either artistically significant because of their creators or culturally significant because they illustrated the practical arcana of a previous generation's everyday life. The problem I quickly encountered, however, was that most photographs did not fit comfortably in either of these practical categories. Often the most compelling pictures were created by anonymous photographers or depicted subjects so unfamiliar that they were unlikely ever to be called out of obscurity by a future licensing request— usually both. During the years since, I have found myself haunted by the memory of images I admired, lingered over, and ultimately passed by because they did not fit my working definition of pictorial usefulness. These included publicity stills of a beautiful tightrope performer named Bird Millman, the horrifying spectacle of show horses high-diving from the steel piers of Atlantic City, interior views of smoking lounges on luxury steamships, and thousands upon thousands of cabinet card portraits. Sometimes there were simply too many images of an obviously significant subject to choose from, such as Sarah Bernhardt or suffrage marches, which left me with the agonizing task of deciding which pictures were the most characteristic and most deserving of long-term preservation. That it pained me, almost physically, to eliminate any photographs as insignificant helped solidify my vague ambition to pursue a career as an art historian. It also led me to consider how the rehearsal of historical narratives and canons built upon narrowly defined visions of artistic success result in lacunae in our understanding of the art and visual culture of the past. These lapses extend from

what archives and museums select for preservation to the questions researchers ask of these materials.

Culver Pictures was not the only archive to stockpile visual artifacts from the decades around the turn of the twentieth century, when a proliferation of new technologies and methods for circulating information caused the engines of mass media to whir into life. Its disorderly expansiveness made it a productive space in which to think about the connection between organization and cultural memory, or, as Carolyn Steedman has succinctly paraphrased Jacques Derrida, about the connection between archives as raw material and the formal academic histories that are "written out of them."[3] At Culver, the didactic categories that conventionally distinguish fine art from illustration, high from low, creative from commercial, were temporarily redrawn, reconfigured, or erased. Enduring narratives surrounding the history of photography and its canonical characters lost focus and familiarity. The work of familiar artists like Mathew Brady, Jacob Riis, Berenice Abbott, Man Ray, and Edward Steichen was scattered throughout the collection, but these well-remembered names were subsumed within a larger chaos of anonymous creative production: unsigned prints and photographs created on assignment or to suit obsolete market purposes. Resembling what James Elkins describes as the bland vastness of a "photographic surround," this mass of everyday *living pictures* preserved the practical conditions of the modern American picture industry like dust in amber—an archival manifestation of what Walter Benjamin calls the detritus or "refuse" of history, or, more appropriately in this case, the detritus of historical visual culture.[4]

The peculiar stylistic imagination of Napoleon Sarony's staged photography was among the most enduring souvenirs of my experience. His unforgettable name made him a conspicuous representative of the scores of anonymous artists populating Culver's files. But the visual qualities of Sarony's work distinguished it as well. I encountered his portraits frequently as I proceeded through the drawers of photographs, coming to recognize his name and his distinctive swirling calligraphic signature only when I realized that the same artist, yet again, was responsible for a picture that caused me to pause my frenetic pace, suspend judgment, and enjoy a second look. Most of his portrait subjects—Gilded Age celebrities such as Lotta Crabtree, Lester Wallack, Frank Bangs, Adelaide Ristori, Fanny Kemble, Kate Claxton, and Clara Morris, among many others—were unknown to me at the time, so it was not personal recognition that caught my attention. Instead, I found (and find) that Sarony's portraits make their long-dead subjects seem personable, animated, and engaged with the viewer in a way that is rare in the photography of the era. More typically, the subjects of nineteenth-century photographs wear a vaguely pained expression that communicates both physical discomfort and unpracticed anxiety in front of a camera—a state of technological insecurity that is difficult for media-savvy citizens of the present day to fathom. Sarony's photographs are different. Though subjects might be dressed

in an outlandish fashion and posed in an artificial environment, they usually appear comfortable, confident, and charismatic before the lens, making them relatable even when their faces are otherwise unfamiliar.

After coming to recognize Sarony's work, I was surprised to find how difficult it was to learn anything more about it. His name is mentioned frequently in histories of Gilded Age New York, especially in accounts of theater and cultural events, where he has a Zelig-like omnipresence, but apart from one short monograph written by Ben L. Bassham in 1978, Sarony has received little scholarly attention, despite the massive volume of his output and clear influence of his portrait style during the cabinet card era.[5] If anything, these two factors—Sarony's commercial success and carefully cultivated celebrity image—have reinforced his obsolescence. When he is mentioned in textbooks on photographic history, his colorful persona and late nineteenth-century market dominance receive more attention than the qualities of his work that helped him attain this position. In essence, Napoleon Sarony and his photographs were filed away long ago under the label of commercial popular art, and that narrow definition has prevented much further attention.

But this is hardly the entire story. In fact, the central argument of this book is that Sarony's success in managing the commercial stakes of public images—as a portrait maker, a businessman, and an artistic personality—is precisely what makes his work a powerful source of insight into the shifting media conditions and altered stakes of artistic authorship that emerged during the latter half of the nineteenth century. In this respect, his career was shaped by a problem of scale that was shared by his contemporaries in all branches of cultural production: how to retain an authoritative claim over intellectual property in the face of mass media's global expansion. To understand Sarony's work solely in commercial terms is to overlook the innovative balance he struck between industrial production and individual creative recognition. Much as Sarony appeared to be at once part of the unknowable masses and a memorable individual in the files at Culver, his ability to assert individual authorship over his creations while simultaneously exploiting the expanded audience of mass culture makes him an ideal historical subject for examining the art-world issues of his time, along with supplying an important precedent for the expansive scale of new media that continues to change how fine art is valued, consumed, and circulated in the global digital era.

At the same time, there is no doubt that Sarony's photography was crafted, unapologetically, to fit the demands of nineteenth-century consumer culture. His career in photography coincided with a period of economic prosperity in the northeastern United States following the Civil War and capitalized on the popular taste for lighthearted entertainment that arose in the wake of its violent divisiveness. This cultural climate boosted the fortunes of the American theater and fostered the expansive publication of periodicals and books focused on fashion, celebrity, and humor. Sarony's efforts as a portraitist dovetailed with these thriving adjacent industries. He was best

known for producing stylish photographs of the stars of contemporary theater, dramatically posed in his studio to emulate the fictional characters they portrayed onstage. Barbara McCandless has argued that Sarony's success rested in part on his introduction of a fundamentally new business model for US photography. Rather than expand into multiple studios or market photomechanical prints as expensive luxury objects, as his predecessor Mathew Brady had done, Sarony produced photographs at industrial scale and sold them at prices consumers could easily afford.[6] His appeal to the masses was facilitated by the introduction of new technologies for producing paper photographic formats, including the carte de visite and cabinet card in the 1850s and '60s. Sarony estimated that during his three-decade career as a photographer, he made a total of two hundred thousand portraits, and that at its peak in the 1880s his studio filled orders for more than one thousand cabinet cards a day.[7] Though he is best remembered for his celebrity portraits, only around forty thousand portraits in his total catalogue depicted famous personalities—actors, authors, artists, athletes, preachers, and politicians—and were available for sale nationwide in photographic galleries and printshops or from street peddlers and mail-order dealers. The majority depicted everyday people who, moved by the celebrity pictures they saw, went to Sarony's grand studio on Union Square in the hope of acquiring a similarly glamorous image of themselves.

Previous scholars have associated the commercial expansion of photographic portraiture with a diminishment of the form's serious purpose. McCandless concludes that Brady's aspiration to make portrait photographs that would "inspire and educate" was undermined by a Gilded Age picture industry that stoked consumer preference for pictures that represented "entertainment and recreation." By courting stars instead of political leaders, Sarony gave the public what they wanted rather than what was good for them, setting up a fundamental distinction between pre- and postwar photography in the United States based on character versus celebrity. "Brady's portraits showed the American public the noble expression to be emulated," says McCandless, while "Sarony's demonstrated that not only actors but anyone could imitate those noble and animated expressions."[8] Though McCandless is hardly alone in taking a dim view of Gilded Age consumer taste, the judgment distracts us from more significant cultural phenomena latent in the emergence of media celebrity.

Napoleon Sarony's Living Pictures proposes instead that the market changes surrounding photography in the late nineteenth century heralded a radical shift in the function of portraiture at the dawn of the mass media era, which introduced new models of photographic authorship and more expressive possibilities for subjects. Rather than make portraits as an accessory to a distinguished biography, Sarony's theatrical approach gleefully embraced the possibility that photography could reshape reality rather than merely reflect it. Antebellum portraits had been created for a visual culture steeped in phrenology and physiognomy, and their visual conventions supported

the belief that external appearances were an accurate register of internal character. By the late nineteenth century, modern notions of personality had begun to emerge, and in Sarony's studio, staged poses and settings were transformed into a set of expressive tools that suggested that it was not the quirks of physical fate and heredity that determined the limits of social renown, but how tastefully those innate characteristics could be displayed. This is not to say that Sarony's studio was significantly more enlightened or inclusive than those of his contemporaries; his clientele was predominantly white and relatively wealthy. Yet expanding the visual language of photographic portraiture allowed the conventional markers of identity to be assigned along a more open set of creative categories than previous portrait practices had permitted. For this reason, the late nineteenth-century studio era represents an important point of transition between the rigid professional formulas of the daguerreotype era and the popular access of the Kodak revolution, along with a growing conviction that natural appearances were not a rigid metric of internal personal character but could be improved upon through the application of artistic taste.[9]

Sarony had a passion and a gift for self-promotion, and he employed the same tactics used in his celebrity portraits to fashion an indelible artistic brand for himself. In the 1860s, he used photographic self-portraiture to reinvent his public and professional image, disguising his small stature and working-class immigrant background by picturing himself costumed as a fur-clad explorer or a Dutch Old Master in a ruff and velvet cap. Even at a time when it was common for artists to cultivate grand personae that appealed to the "media-made theater" of popular attention, as Sarah Burns described it, Sarony was unusually invested in projecting a spectacular public image.[10] He regularly appeared on the streets of New York City wearing a red-tasseled fez or dressed in a military uniform of his own design. Though this cartoonish flamboyance (like Sarony's commercial empire) later distracted attention from his weightier artistic accomplishments, it contributed significantly to growing popular acceptance of photography as an art form during the late nineteenth century. Sarony's larger-than-life persona aligned the social role of the photographer with contemporary notions of the bohemian artistic type. Moreover, it reinforced Sarony's individual creative participation in the photographic process at a time when the medium remained widely perceived as an autonomous form of mechanical reproduction. More than being a simple bid for fame, Sarony's insistence on personal recognition was a crucial strategy for seizing authorial control within a system of early mass visual culture that rendered many producers anonymous. His collaboration with famous subjects furthered this goal and was at times nakedly transactional. He was known to pay his celebrity sitters for the exclusive right to take their portraits, a fact that received considerable press coverage and directed further attention to the studio; he once paid Sarah Bernhardt $1,500 and Lillie Langtry $5,000, astronomical sums at the time.[11] These photographic monopolies were rarely honored for long,

but in addition to garnering publicity and profit, the brokered agreements served the purpose of clarifying copyright control over the portraits—a fact that was of crucial importance to the landmark 1884 US Supreme Court case *Burrow-Giles Lithographic Company v. Sarony*, which established a precedent that gave photography legal recognition as a creative art. Being known, being famous, being visible in the context of mass culture was becoming an increasingly valuable commodity, and Sarony's aptitude for fashioning public images, or creating "living pictures," as he summed up his aesthetic ideal, was simultaneously good for business and a distinctive style of portraiture. This is why Sarony's commercialism and creativity cannot be understood in isolation from each other.

If modern scholars have had trouble reconciling these two poles of Sarony's career, his Gilded Age contemporaries did not. Napoleon Sarony was not only the most famous name in American photography during the last three decades of the nineteenth century; he was also revered for introducing a new level of artistic achievement to the field of photography. Many contemporary accounts of his work are so glowing as to seem hyperbolic. Fellow photographer C. C. Langill acknowledged this fact, admitting that it was "difficult to speak of Sarony without seeming to give way to undue praise," adding that this could scarcely be avoided, in that "he was at once the leading spirit of his profession and the personification of all that is summed up in the words Bohemian and artist." Sarony's unexpected death in 1896 prompted an outpouring of emotional superlatives that made clear that his contemporaries expected a different and more lasting legacy than he was actually to enjoy. He was described as the Victor Hugo of portraiture, the Bonaparte of photography, a giant among men, the life and soul of the photographic profession, and, repeatedly, as "the father of artistic photography in America." Sarony's close colleague Benjamin J. Falk wrote that, considering "the great amount of work he did, and the elevating and far-reaching effect it had on the entire profession all over the world . . . we may rest assured that his fame is secure."[12]

Yet this of course did not turn out to be the case, and among the praise and laments that characterized most obituary tributes, only the photographer's close friend the cartoonist Thomas Nast hinted that the process of forgetting Sarony had already begun. "Thousands of people admired the photographic and other work of Napoleon Sarony, and thought him one of the most artistic men of his time. Thousands had no taste for him at all, and considered his pictures . . . just so much artificiality and 'popular prettiness.' . . . To-day he is more in danger of getting less than his deserts for the reason that photographic portraiture has progressed by leaps and bounds. Where a plate would once have been discarded as too 'vague,' too 'misty,' it is now prized as representing the quintessence of photographic beauty."[13]

When Sarony began his career as a photographer in the 1860s, crisp focus demonstrated mastery of the notoriously finicky collodion processes then in use. By the close

of the nineteenth century, however, the methods of early studio photography were becoming obsolete, and a rising generation of pictorialist photographers increasingly favored platinum prints, soft detail, and atmospheric effects. Considering how rapidly changing tastes had redefined the art of photography, Nast cautioned that the most just approach when regarding his friend's accomplishments was "to steer between those two extremes, and to value Sarony for having done intelligent, clever work when other men were commonplace." My aim in the pages that follow is to adhere to Nast's suggestion, and to reconstruct the legacy of an individual artist not to heroize or condemn but as an interpretive key for understanding what lapses in scholarly memory teach us not only about the evolution of photography in the United States, but also about how we conventionally write and remember the history of art.

SUSPENDING DISBELIEF

Beyond reevaluating the career of a single artist, *Napoleon Sarony's Living Pictures* engages the paradigm of skeptical vision that is often used to characterize the visual culture of the United States during the long nineteenth century. Scholars across academic fields have described American viewers of this period as preoccupied with decoding and deconstructing everyday appearances in the world around them.[14] Many cultural forces encouraged this impulse: rapid population growth and immigration added an unfamiliar cast of characters to urban environments; economic turbulence created intermittent class instability; the expansion of mass media opened new channels of information for describing prominent or notorious individuals; and the introduction of visual technologies such as photography, motion pictures, and X-rays demonstrated that machines were capable of seeing things the unaided human eye could not. In an environment where appearances could not be trusted to reflect facts, Enlightenment-era faith in the reliability of the senses gradually eroded. The resulting cultural anxiety can be linked to an array of historical phenomena, from restrictive rules for fashion and public comportment, to pseudosciences like phrenology and physiognomy, to the graphic design of early advertisements, to enthusiasm for illusions, trompe l'oeil paintings, and all manner of visual humbug. Deceptive images exploited the tense relationship between surface and substance and provided audiences with tools for meeting the challenges of unreliable systems of perception with modern strategies of discernment. No longer satisfied with believing their eyes, nineteenth-century viewers came to regard the world through a mechanism that Neil Harris calls the "operational aesthetic," which associated the ability to decode deceptive representations with access to high-minded and elusive forms of truth.[15]

This visual state of affairs had significant implications for the creation and consumption of art in the United States, where it seemed to map neatly onto evolving notions of national character. Wendy Bellion has described how, during the early

national period, pictorial and optical illusions confronted American viewers in the statehouse, the market, and the street, fueling "a pronounced ideological equation between vision and patriotism." Painted examples of trompe l'oeil were engineered at once to fool the eye and to "undeceive" their viewers by encapsulating the conditions for their own detection. This process was thoroughly bound up with matters of self and subjectivity, since the very possibility of becoming undeceived demonstrated "hope of retaining agency in a world that seemed to be awash with forgers, counterfeiters, plagiarists, conspirators, imposters and demagogues."[16] Examining related visual phenomena in the late nineteenth century, Michael Leja has argued that navigating the treacheries of visual culture prepared American audiences for the formal challenges of modernism by encouraging a mode of art reception rooted in critical detachment. The hoaxes and deceptions that filled everyday experience, in the form of misleading advertisements, amusement park illusions, and even painted constructions of realism, required that audiences look beyond surface appearances and regard their environment with suspicion as the source of misleading (if sometimes entertaining) detail. Leja writes that accepting and internalizing this critical skepticism was "part of the process of becoming a modern subject able to function in the modern world. A modern self, knowing well the perils presented to modern vision, looked askance."[17] The ability to debunk illusion countered the seductions of clever visual effects with rational thought, a form of mastery that appeared fundamental to visual experience in the United States during the long nineteenth century.

At the same time, skeptical vision can be difficult to reconcile with the abundant modes of cultural production that unabashedly embraced the immersive pleasures of fantasy—dramatic spectacles, costume balls, *tableaux vivants*, anthropomorphic paintings, or, most relevant to this study, public role playing and theatrical portraiture, which paradoxically claimed to express truth despite having obvious roots in fiction. These cultural forms permeated the world of legitimate art making in the late nineteenth-century United States and were fundamental to the ways in which artists publicly positioned themselves as sophisticated, cosmopolitan tastemakers. Though these types of entertainment and dramatic play may also have functioned as opportunities for deductive reasoning, they represent a joyful abandonment of reality that is not fully explained by skepticism alone.

Rather than focus on how visual illusions were penetrated and debunked, this book explores the productive ways in which US artists and viewers inhabited and indulged them as *living pictures*, which provided strategic shelter and new ways of making meaning within the shifting proliferation of influences, consumer possibilities, and cultural hierarchies that emerged from global nineteenth-century experience. In the parlance of Sarony's time, living pictures connoted several vivid modes of representation, from dramatic staged portraiture to the performance of *tableaux vivants* and the early display of motion pictures, all of which exploited perceptual uncertainty

between representation and realism. I propose to extend the term further, to describe the mannered mode of self-performance characteristic of late nineteenth-century artists, their enthusiasm for constructing "artistic atmosphere" in studio interiors or on the dramatic stage, role playing in portraiture, and the eager acceptance of representational ambiguity that informed contemporary viewing practices. I argue that Gilded Age audiences, in addition to decoding, disassembling, and digesting unreliable visual experiences, genuinely relished the immersive pleasures that visual illusion made possible, and, moreover, that the higher truths that artists and viewers sought were not exclusively bound up in demystifying art but were also used to transcend or alter lived reality. What Sarony's theatrical portraiture makes clear is that in addition to training viewers to look askance, the artifice and illusion of nineteenth-century visual culture also provided powerful new strategies for self-transformation and personal expression. By embedding dramatic role play in the formal language of everyday public images, these photographic fantasies activated the flip side of visual skepticism, rewarding not only the critical identification of deception but also, and equally, the willing suspension of disbelief.

MEDIATED PERFORMANCE

Celebrity culture was another strategy for self-determination that was born of late nineteenth-century media expansion. As a consumer practice and representational strategy, it represented a point of contact between the individual and the mass, either by allowing virtual connection with a famous individual through a mass-produced image or by suggesting a framework through which to attain similar visibility. In both cases, celebrity culture confirmed the persistence of personal agency within the expansive field of mass culture as a means of communicating with and being known to a global audience. The medium of photography was uniquely suited to support this expanded scope of representation. Capable of industrial reproduction yet anchored by a single point of origin in time and social circumstance—what Derrida has called the "photographic event" and Ariella Azoulay, the "photographic encounter"—its characteristic dimensions are analogous to individual experience in the face of mass culture.[18] This made photography, and particularly photographic portraiture, a prime location for testing the changing boundaries of public visibility at the dawn of the information age, and for formulating new aesthetic strategies to meet the challenges this shift in scale posed for traditional modes of representation. Sarony had a manifold investment in the production of public images. In his work as a printmaker and photographer, he aimed for broad popular appeal and the largest possible audience. His mass-produced portraits fueled the fame of well-known subjects and helped make individuals like Oscar Wilde and Maud Branscombe, who were not well known before he photographed them, into stars. Sarony also deployed his own recognizable public image

as an artistic branding system, using its visibility to reinforce his status as the singular author of mass-reproduced work. For all these reasons, understanding the mechanisms of celebrity in the Gilded Age United States is crucial to appreciating both Sarony's individual creative decisions and the changing stakes of photographic portraiture for the subjects and consumers of his work.

Of course, portraiture and fame have a long shared history that stretches back far before the advent of photography. From the colossal statuary of Egyptian pharaohs to the imperial profiles on Greek and Roman coins, portrait images have served for millennia as powerful tools of personal propaganda and publicity, allowing individuals to reinforce their influence by making themselves "known" to populations unlikely ever to meet them in the flesh. Celebrity, however, though related to fame, is a modern phenomenon that is closely tied to the emergence of mass media and the commercial consumption of images and information. If fame is a system for expressing power, celebrity can be a means of acquiring it through the successful introduction of public images to a consumer marketplace.

The link between celebrity and mechanical reproduction has helped shape an enduring impression of celebrity as an autonomous force generated by commercial and capitalist forces.[19] Daniel Boorstin, for instance, attributes the emergence of celebrity to a revolution in nineteenth-century image reproduction that allowed for the large-scale dissemination of what he calls "pseudo-realities"—affordable printed portraits, books, caricatures, pamphlets, newspapers, and magazines—that created a public taste for news and entertainment by making famous individuals a source of conversation and speculation. Regarding such consumer appetites as frivolous, he has famously quipped that "a celebrity is a person known for his well-knownness," and that unlike the great heroes of the past, who were "self-made" by virtue of great deeds and accomplishments, "celebrities are made by the media."[20] Theodor Adorno and other critics similarly present celebrity as a taste imposed upon hapless consumers by the mechanisms of an autonomous "culture industry."[21]

This view of "the media" as a faceless star-maker is out of step with what digital social media has revealed about the genuine economic and cultural influence that individuals can exercise through public visibility. From a historical perspective, too, it overlooks the agency of media producers and consumers, and also the efforts of celebrities themselves to exert control over their media-made alter egos, sometimes at great professional cost.[22] Without denying the systemic inequalities inherent in the politics of visibility, particularly in the nineteenth-century United States, this book proposes that the consumer market for public images—including celebrity pictures and endorsements, as well as the flood of portraiture that accompanied the introduction of paper photographic formats such as cartes de visite and cabinet cards—created significant opportunities for reinventing the formulas through which identity was visualized, constructed, and consumed. Whereas fame, in its traditional historical

form, functioned as an expression of untouchable power, celebrity's symbiotic connection to the marketplace extended a share of partial ownership to consumers, who might buy into an individual's public image and, in the process, play a role in defining and amplifying its importance. Recent scholarship by Sharon Marcus supports this sense of consumer empowerment, noting that if celebrity were simply a media-made phenomenon, publicity would be all that was required to achieve it. Instead, Marcus reenvisions traditional models of celebrity as a tripartite system of power in which publics, media producers, and stars all compete and cooperate to assign value and meaning to famous subjects. Within this determinative structure, the division of responsibility is fluidly distributed, so that at varying times any one of the three groups might take a turn to "create, spread, and interpret artful representations of famous people and their followers."[23] What is significant about this model for Sarony's history is that it repositions mass media as a communication platform rather than an autonomous technological force, with celebrity being a status achieved through the successful public transmission across that platform of personal qualities perceived as desirable, attention-worthy, or both. Though such platforms might be steered by corporate interests in directions that defy public trust, they can similarly be harnessed as unofficial vehicles for collective cognition through which the meaning of publicly circulated images and information can be collaboratively defined. Rather than alienating consumers from the means of production, globalized communication systems such as online social media, or the products of the nineteenth-century picture industry, amplify the volume of transmission and open access for a wider swath of participants to employ the equipment of mass media as a personal megaphone.

Glimmers of this network dynamic are evident in the earliest descriptions of nineteenth-century viewers interacting with portraits in the galleries of photographic studios, demonstrating that the collective definition of public images may drive celebrity, but it does not function only on this scale. Photographic galleries sprang up in American cities during the 1840s and '50s, and early visitors were quickly enchanted by the possibility of comparative social spectatorship. In 1846, Walt Whitman described the uncanny sensation of confronting the likenesses of hundreds of his fellow Americans displayed in rows on the walls of the daguerreotypist John Plumbe's gallery. Transfixed by the idea that each picture captured a single moment in the unknowable life of a stranger, Whitman became preoccupied with imaginatively restoring these pieces of reality to a longer narrative thread. Spotting a young bride in her wedding gown, he speculated on the moments before and after the photograph was taken, wondering if her new husband had accompanied her to the studio and what had happened next—did the couple love each other still? "What tales might those pictures tell if their mute lips had the power of speech! How romance then, would be infinitely outdone by fact."[24] Seeing the portrait photograph sparked a desire to know more about its depicted subject, and though he recognized the factual incompleteness of the image (a quality Allan

Sekula might have described as the photograph's "contingent" sense of meaning), its inability to speak for itself invited a romantic form of speculative dialogue—a new way for the individual to be known as the subject of imaginative reinvention by an observer like Whitman, or any other visitor to the public realm of the portrait gallery.

The romance of portrait photography made studio galleries popular sources of urban spectacle for many nineteenth-century Americans. Drawn to the type of virtual social encounter Whitman describes, viewers learned how to "read" an individual's role in a larger social drama through pictorial cues like pose and costume. Alan Trachtenberg emphasized the inherent performativity of this experience when he wrote that antebellum photographic galleries functioned less as museums for passive spectatorship than as what he called a "theater of desire," where viewers could evaluate portraits of their contemporaries and imagine themselves assuming the roles they saw depicted. To Trachtenberg, this made the antebellum photographic studio "a new kind of city place devoted to performance: the making of oneself over into a social image."[25] This transformation flattened the complex realities of individual identity into easily legible coded markers based on period-specific perceptions of class, gender, and ethnic type. Andrea Volpe argues that photography reshaped the mechanisms of class formation in the early nineteenth-century United States by supplying a durable template for visualizing bodily propriety and respectability. By performing a photographic role before the camera, antebellum subjects cast themselves in molds of uniform social convention, resulting in self-images that simultaneously supplied "proof" of social position and "evidence of the cultural production of such claims."[26]

Building on the concept of the portrait studio as a "theater of desire," this book argues that photography came to supply individuals not only with strategies for fitting in but also with an increasingly acceptable platform for standing out. While the basic mechanisms of identity formation persisted into the late nineteenth century, the allowable cast of characters expanded radically as viewers gained experience being subjects and consumers of social images (stars and publics, in Marcus's model). Seeing in multiple, as Whitman did, across rows of similar portraits encouraged recognition of the poses, costumes, and settings used to construct conventional representations of identity. It also illustrated how easily these compositional elements could be appropriated and rearranged. They could be used to depict the niceties of middle-class convention, or they could be employed more dramatically to recast individual reality into something more artistic, glamorous, and refined than everyday appearances allowed. This was the animating dynamic of the Sarony studio, where photographic performance and celebrity were founding principles and the photographer's grand public image suggested that he could similarly enhance the mystique of even ordinary clientele.

One source of inspiration for the changing form of American portrait photography was the contemporary dramatic realism movement, which supplied a visual language and conceptual framework for envisioning public-facing social images.

Dramatic realism was a global phenomenon during the late nineteenth century, with diverse manifestations, but in the United States, it assumed a distinctly visual valence. Theater historian Brenda Murphy writes that European theaters pursued sociological or content-driven strategies for enhancing the perceived authenticity of staged productions—incorporating common speech dialogue and increasingly class-diverse characters. In the United States, by contrast, dramatic realism "focused chiefly on the *representation* of that subject matter, the creation of an illusion of reality in the text and on the stage by playwright, actors, director and producer."[27] For the first internationally renowned generation of US theatrical producers—Edward Harrigan, Augustin Daly, David Belasco, and Steele MacKaye—this took the form of technologically innovative stagecraft: constructing working sawmills, full-sized Pullman cars, and Roman amphitheaters onstage as the settings for dramatic spectaculars. These feats of engineering and invention were, in a sense, acts of reproduction that staged the real world inhabited by audiences within the fictive space of performance.[28] The construction of persuasively staged illusion yielded a synthesis of antithetical qualities—performance and truth, fabrication and authenticity—that were adapted into the studio methods and elaborately constructed settings used by Gilded Age portrait photographers.

Principles drawn from dramatic realism also supplied a framework for reading and representing a more idiosyncratic cast of character types, and a significant pre-psychological model for understanding social performance and personality. The question of how and under what conditions the art of acting represented expressive truth was the subject of lively debate in the 1880s. Producers and actors advocated for so-called natural acting techniques that would replace the rote gestures of classical melodrama with more personal, individualized performance styles. The central question was how a realistic mode of performance could be achieved. Denis Diderot had framed this problem as the essential paradox of acting, and in 1883 his *Paradoxe sur la comédien* (1830) was translated into English for the first time, introducing American and British audiences to his theory that an actor must efface his own feelings in order to approach the playwright's fictional characters as an intellectual exercise. Five years later, the British critic William Archer published *Masks or Faces? A Study in the Psychology of Acting* as a rebuttal of Diderot's *Paradoxe*. Drawing upon Charles Darwin's *Expression of the Emotions in Man and Animals* (1872), Archer argued that because emotional expression is not subject to conscious control, a performance is realistic only when an actor erases the distance between himself and his character so that the emotions expressed onstage represent natural feeling—a model of emotion that was cited by William James in his *Principles of Psychology* (1890) and later also contributed to Konstantin Stanislavski's system of method acting.[29]

Popular audiences absorbed ideas about contemporary performance in the theater and also through a series of heated open letters exchanged among actors Constant Coquelin, Sir Henry Irving, and Dion Boucicault that was followed by thousands of

readers in 1881–82 and became a touchstone for understanding expressive acts on and off the stage.[30] Weighing in on whether dynamic performance resided in the head or the heart, Sarah Bernhardt suggested that personal magnetism also had something to do with it. She noted that her aim when performing the roles of Phaedra, Cleopatra, or Camille, or any of the other characters she famously portrayed onstage, was to fuse herself with these fictional identities in such a way that audiences never forgot that it was the great actress Bernhardt playing a part. Describing her approach as the formation of a dramatic "personage," Bernhardt asserted that such exaggerated self-performance was the only appropriate scale for reproducing reality to suit the "theatrical optics" of a public stage, and the best way to ensure that the audience perceived it accurately.[31]

For Sarony and his contemporaries, this logic, and the debates surrounding dramatic realism, supplied significant conceptual models for constructing public images on the photographic stage. The connection between Gilded Age portrait studios and theatrical practice also allowed leniency in social decorum that was not permitted under other circumstances. Within the world of theater, and the contained context of staged performance, the strict codes that normally governed public comportment could be safely relaxed or ignored, and forms of social transgression, eccentric dress, and expressive behavior that were considered unacceptable elsewhere might temporarily be tolerated or even encouraged. Celebrity subjects and elaborate staging practices enhanced the resemblance between photography and the theater so that by the late nineteenth century, portrait studios operated similarly as spaces of exception from everyday behavior. Unlike its antebellum counterpart, the Gilded Age "theater of desire" was not limited to modest acts of social aspiration, nor did it operate precisely like legitimate theater. Mikhail Bakhtin conveys a related distinction in his notion of "footlights," which he considered the most important architectonic difference between drama and carnival, since they were present in spectated theatrical events but absent in participatory modes of performance, where distinctions between actor and audience were elided. In essence, the photographic studio of the late nineteenth century operated as a space for performance "without footlights." It had the effect of temporarily redrawing the boundaries between public and private space and the behaviors typically confined to each, allowing a carnivalesque portrait style that blended fact and fiction into "an ideal and at the same time real type of communication, impossible in ordinary life."[32] Through the pretense of playacting and costumed role-play, photographic subjects could assume unconventional characters and experiment with alternate modes of identity, allowing behaviors that were normally acceptable only in the context of private spaces or dramatic performance to creep into public visibility through the extended reach of the photographic stage.

The problems of negotiating new media that prompted Sarony and his peers to seek novel strategies of self-representation make this chapter of photographic history

a useful prequel to the flourishing of online public images today, and to the practices of performance and staging in the work of contemporary artists such as Samuel Fosso, Yasumasa Morimura, Cindy Sherman, Zanele Muholi, Rodney Graham, and Stephanie Syjuco (to name just a few). If anything, the vast platform of cyberspace makes social photography an even more important tool for testing the limits of representational reality through what Carrie Lambert-Beatty calls "parafictions," constructed visualizations of fantasy that keep one foot planted firmly "in the field of the real."[33] Harnessing photographic realism to picture circumstances and identities not yet realized or given regular visibility in the everyday world strengthens the medium's capacity to serve as a platform for individual expression and cultural critique. By opening this imaginative potential for broader public use, Sarony and his "living pictures" anticipated the use of photography as a tool for public performance, demonstrating that the tension between the medium's dueling capacities for illusion and truth weave a persistent thread through its history.

OVERVIEW OF THE BOOK

This book began with a simple question raised by a chance encounter with a photographer in an archive: Who was Napoleon Sarony? Over time, however, I came to find the processes that contributed to Sarony's present-day obscurity just as interesting as those that made him a celebrity in his lifetime. By singling him out for recovery, I do not mean to assert that his professional experiences were unique, however. In fact, I believe the opposite to be true, and this is to some extent the point. Sarony, with his memorable name, provided me with a point of entry to a realm of nineteenth-century artistic experience that would be difficult to access without an individual guide— the world of early mass visual culture, which was populated by artists working in the "new media" of the day: lithography, photography, and mass-reproduced illustration. Their work comprises the popular and public images that crowd the margins of nineteenth-century art history and, like most of the materials I encountered at Culver Pictures, are often not distinguished by a famous author or timeless subject to give them obvious significance. With that in mind, I conceived of this book as an experimental variation on a traditional monograph, one that explores what the form can do as representative microhistory when divorced from obligatory triumphalism and opened to the reality that most artistic careers fail to achieve canonical status yet still carry genuine weight and meaning.[34] Sarony's individual example illuminates the broader experience of artists who did not make it to the top, either in their own day or posthumously, but instead struggled through the indignity of a career stuck in the middle. Their experiences and failures offer insight into the circumstances that elevated their more fortunate peers and built the foundation for the modern art world of the twentieth century.

Shortly before Sarony's death in 1896, the contents of the grand studio on Union Square that had been his professional home for twenty years were sold at auction, and his life's work of hundreds of thousands of negatives disappeared during the following decades. Much of my research involved recovering the scattered and lost pieces of his archive. This book draws together previously unexamined images, archival materials, and unpublished photographs to reveal a more complete picture of his contributions to photography than has ever previously been published. At the same time, my goal has been not simply to fill a Sarony-shaped hole in art history but rather to build a meaningful case for the broader significance of his experiences. Consequently, each chapter of the book places an aspect of the photographer's career in context, demonstrating the ways in which he engaged in and contributed to the history of American art and photography. My first chapter offers an introduction to Sarony's life and career through a self-portrait he made around 1875 that depicts him standing in a furious snowstorm that was staged inside his studio. Sarony used self-portraiture to reinvent himself personally and professionally during the 1860s, and similar portraits were common during the late nineteenth century, using painted canvas backdrops, courtly poses, and theatrical props. Though described as artistic by original observers, the stagey pretense of this style of portraiture makes it hard to evaluate today. By reinserting these works into the discursive framework of period debate surrounding photographic realism, I demonstrate the strategic importance of staged photography as an artistic gesture at a moment when photographers were breaking free from the legacy of mechanical autonomy that defined the earliest applications of the medium.

This discussion sets the stage for chapter 2, which explores how Sarony drew from contemporary theatrical practice to help his clients invent captivating public images of their own. Beginning with Sarony's first career-making portrait series—of the notorious actress Adah Isaacs Menken—I demonstrate how Sarony's approach to portraiture revolutionized photographic practice in the United States by transforming the studio into a stage for collaborative experimentation in the art of making public images. Rather than adhere to existing frameworks for representing mainstream middle-class identity and normative gender identities, Sarony drew upon staging conventions of period theater—pose, costume, studio settings, and props—to redefine portraiture for a mass consumer market. Through his directorial approach to photographic sessions, he encouraged his subjects, whether actors or not, to perform for the camera—documenting multifaceted public images that contributed to the mounting tide of consumer culture while at the same time modeling a novel form of mediated individuality.

Chapter 3 steps back in time to the early nineteenth century and explores how Sarony's early career as a producer of popular prints sparked his enduring concern with establishing and maintaining his artistic authority. Tracing Sarony's progress through the professional ranks of the US lithographic industry, I establish how this

commercial avenue of production was related to but separate from the fine arts in terms of the legal and honorific mechanisms that allowed artists to take credit for their work. Though few textual records have survived to illuminate the workings of this industry, the prints themselves can provide insight about their reception and perceived cultural use among their original viewers. Pursuing this logic, I propose that acts of copying and pictorial translation, or what I call "adaptive reuse," register the ideas communicated through a visual network, signaling that images created in one place were seen and appreciated in another. In this way, I suggest that the reproducibility of print constructed a discursive network through which like-minded professionals were able to communicate ideas and visual information about art.

Chapter 4 considers how Sarony used his famous signature logo to claim authorship of his photography and mobilize his artistic persona. This flourishing calligraphic logo not only marked the exterior of his Union Square studio in gilded letters one story high but was printed on the cardboard mount of every photograph he produced. In the late 1890s, Joseph Benson Gilder, editor of the magazine the *Critic*, wrote that among the many innovations of Sarony's career, "nothing, perhaps, was more striking than the way in which he wrote his name on his photographs. That signature (his trademark) . . . was imitated by half the photographers in the land."[35] I argue that the appeal of Sarony's signature came not simply from its originality as an artistic logo but also from its assertion of the artist's touch on a mass-produced photographic image, an act of pairing autograph and photograph that Derrida later described as restoring singularity and authenticity to the reproducible photographic event.[36] At once mass-produced and evocative of personal touch, Sarony's printed autograph was emblematic of a type of media celebrity new to the late nineteenth-century United States, and of a mounting association between public identity, personal mark making, and the legal authentication of intellectual property. During the 1870s and '80s, reproductions of handwritten testimonials by famous individuals were common features in printed advertisements. Photographic reproduction of handwriting was introduced as evidence in criminal proceedings, and handwriting analysis and autograph collecting emerged as faddish popular pastimes. In 1883, Samuel Clemens attempted unsuccessfully to trademark the autograph of his alter ego Mark Twain, a request that baffled contemporary legal experts since it was deemed impossible to assign personal rights to a fictional person—however celebrated he might be as an author.[37] For Sarony, the gesture took on lasting significance with the 1884 Supreme Court copyright case *Burrow-Giles Lithographic Company v. Sarony*, which allowed him to assert intellectual property rights over his portraits of Oscar Wilde and created a legal precedent for the recognition of photography as a form of fine art.[38]

Chapter 5 situates these changes in the larger context of the American art world, exploring how the emergence of mass media and consumer culture aligned to reshape the material context for making and selling fine art in the United States during the

last decades of the nineteenth century. Like his close friend and fellow Tile Club member William Merritt Chase, Sarony lavishly ornamented his public studio with objects of fine art and with a proliferation of beautiful things that he collected obsessively from auction sales—arms and armament, statues of Buddha, a Russian sleigh, medieval footwear, Mesoamerican art, an Egyptian mummy, and, famously, a taxidermied crocodile that he suspended from the gallery's ceiling. These objects occasionally found their way into the portraits taken in his studio, where they complicated the representational fiction of his staged images in fascinating ways. A portrait subject might, for example, be photographed examining an oil painting by Eastman Johnson, Paul Marny, or Thomas Moran while posed against a canvas backdrop that was painted to resemble Sarony's studio. These pictures within pictures dramatized the act of art appreciation, demonstrating the mass appeal of cosmopolitanism in the wake of the 1876 Centennial Exhibition and presenting a clever visual argument for elevated consideration of photography. By demonstrating the capacity of his work to contain, consume, and compete with traditional fine art media, Sarony's "fortified" photographic compositions prompted viewers to exercise discernment in separating one scale of representational reality from another.[39] Deconstructing the surrounding spaces of Sarony's portraits also provides valuable historical insight into the adjacent industries that blossomed around the US photographic industry during the 1870s and '80s, including supporting figures such as Lafayette W. Seavey, a specialty scenic painter of immense ambition who described himself as the "power behind the throne" of many prominent US photographers.[40]

The book's final chapter provides a coda to Sarony's story, considering how new types of media literacy emerged alongside motion pictures and new, more sophisticated methods of photomechanical reproduction dramatically altered both the media landscape and his artistic legacy in the decade preceding his death. I begin by analyzing the ambitious but ill-fated art periodical *Sarony's Living Pictures*, which proved to be the final project of Sarony's career. Published in 1894–95, the magazine was a bound portfolio of color photogravures that reproduced heavily retouched tableau photographs. Although these densely layered, hybrid media artworks have conventionally been dismissed as kitsch, their publication was motivated in part by a desire to experiment with the modern, widely accessible new forms of hybrid media art produced by the Photochrome Engraving Company, a printing firm owned and operated by a young Alfred Stieglitz. Like Sarony, Stieglitz explored new methods of producing and circulating visual images through photomechanical technologies and color printing. Though Stieglitz, of course, moved on to more successful strategies for achieving his goals, the brief interaction of these two fathers of American artistic photography demonstrate the medium's messy, intermedial origins and the overlooked figures who contributed to its modern form.

1.

A PORTRAIT OF THE ARTIST

Sometime around 1875, Napoleon Sarony created a curious self-portrait. It depicts him in costume as a fur-clad explorer standing at the center of a snowy winter landscape (fig. 1). Behind him, white hills recede into the distance, and the gnarled branches of bare trees reach up to meet a threatening sky. It appears that a blizzard is beginning. Snowflakes swirl through the air all around him and accumulate in a thick layer on the lapels of his bulky overcoat, atop the crown of his woolly cap, and on the ground surrounding his tall, well-polished cavalry boots. Yet, although there is no sign of nearby shelter, Sarony seems unfazed by this inclement weather. Assuming a courtly position with one hand tucked neatly in a jacket pocket, he gazes into the distance with an air of enigmatic purpose, like an emperor surveying some freshly acquired wilderness.

The fictions of this photographic pose do not hold up for long, however, before a series of peculiar details announce the scene's artifice. Beneath his rustic furs, Sarony is dressed in a formal evening jacket and ribbon bowtie, and he appears to have paused in his wintry hike to lean jauntily upon a long-handled umbrella, an elegant accessory better suited to promenading down Fifth Avenue than to the represented conditions. Most disorienting is the portrait's landscape setting. The distant hills and trees appear strangely detached from the spatial logic of the foreground where Sarony stands, so his crisply focused figure advances forward abruptly from the setting that supposedly contains it. Adding to this disjointed sense of realism is the fact that although the air around the photographer is thick with snow, somehow not a single

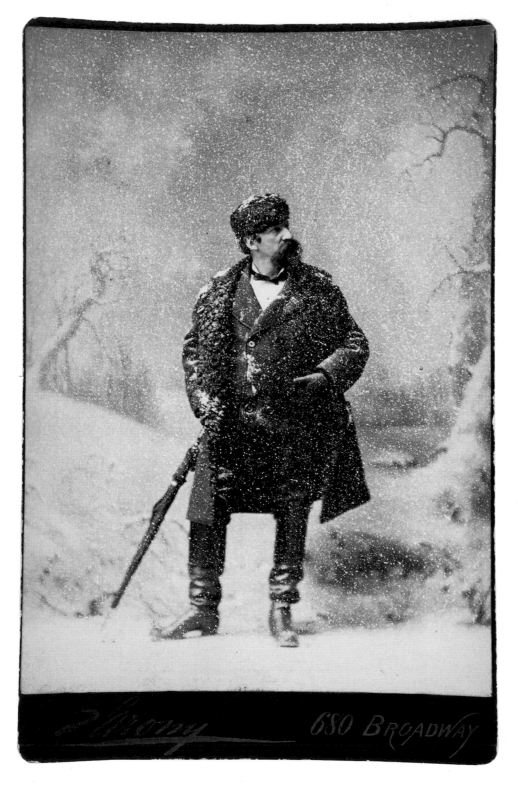

Fig. 1 | Napoleon Sarony (1821–1896), *Self-Portrait in a Snowstorm*, ca. 1875. Albumen silver print on card, 15.9 × 10.8 cm (6 ¼ × 4 ¼ in.). Courtesy of Special Collections, Fine Arts Library, Harvard University.

flake falls in front of his face, leaving his voluminous goatee and distinctive profile improbably unobscured by the weather.

It becomes clear, then, after only preliminary examination, that Sarony's self-portrait is staged. It does not document a real scene in a real snowstorm, but instead was created inside a studio using theatrical props and darkroom manipulations—all finished with a flick of gouache snowflakes across the surface of a glass plate negative. Despite the picture's interpretive stubbornness—indeed, because of it—Sarony's self-portrait in the snow is a good introduction to the photographer and the school of portraiture he brought to prominence in the United States during the last three decades of the nineteenth century. Sarony's photography, like the work of many of his Gilded Age contemporaries, presents a challenge to present-day viewers because it appears to take itself terribly seriously while at the same time assuming a somewhat laughable relationship to reality. Its effects are neither persuasive enough to form a seamless illusion (and thus to be overlooked) nor sufficiently overt to clarify the creative logic that inspired them. Sarony's self-conscious posturing perfectly embodies this stance. His stiff formality signals clear awareness of the camera, but he fails to acknowledge the viewer with a winking glance or to offer a conspiratorial gesture that would invite us in on the fun.

The suspicion that may greet Sarony's work today certainly stands in contrast with how it was received by its original viewers. During the last three decades of the nineteenth century, Sarony was revered as the "father of artistic photography in America," and his elaborately staged tableaux were regarded as the most creative and sophisticated portraits of the era. Around the time his self-portrait in the snow was created, in the mid-1870s, Sarony was at the peak of his career. He was preparing to expand his thriving business into a grand four-story building on Union Square in what was then the heart of the city's theater district, and his studio printed and sold as many as one thousand photographs per day. His self-portrait, then, offers a rich source of insight into his vision for his business and his creative approach to photography—if only it weren't so difficult to understand the meaning of what we see.

This chapter proposes that what makes photographs like the self-portrait in the snow challenging is a question not merely of taste or savvy but also of visual literacy—a habit of mind regarding expectations of photography that was shaped by modernist work made after Sarony's time. The idea is well illustrated by considering Sarony's self-portrait alongside a more familiar photographic blizzard: Alfred Stieglitz's *Winter—Fifth Avenue* of 1893 (fig. 2) (that the comparison feels impertinent only helps to support my point). Though created fewer than twenty years earlier and just a few blocks away, Sarony's picture appears worlds away from Stieglitz's defining vision for modern photography. For one thing, *Winter—Fifth Avenue* appears to deliver immediately on the representational claims that Sarony's photograph deliberately undermines. Here, after all, is a photograph clearly taken outside in real winter conditions.

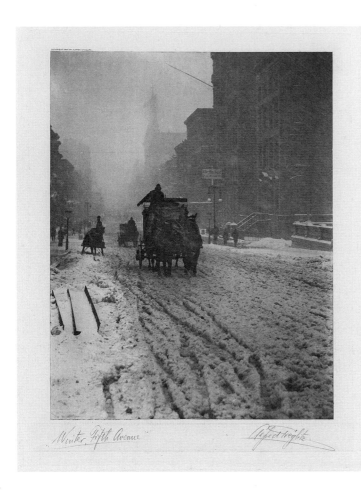

Fig. 2 | Alfred Stieglitz (1864–1946), *Winter—Fifth Avenue*, 1893, printed 1905. Photogravure, 21.8 × 15.4 cm (8 9/16 × 6 1/16 in.). The Metropolitan Museum of Art, New York. Gift of J. B. Newmann (58.577.20). Photo © The Metropolitan Museum of Art, New York. Image source: Art Resource, New York.

Every aspect of the composition emphasizes this fact and invites empathy with the experience of its creator—cuing us to feel the cold along with him. The picture's low perspective positions the viewer in the street, standing ankle deep in ruts of wet snow churned up by passing carriage wheels, intermingling our photographic perspective with what Stieglitz originally witnessed: a stalwart streetcar pushing forward in an urban cityscape softened by the atmospheric haze of falling snow.

The visual evidence the composition provides supports what we know about the circumstances surrounding the photograph's creation. Stieglitz was fastidious about recording and retelling the details behind his process, and *Winter—Fifth Avenue* was a particularly important illustration of his artistic myth of origin, marking an inventive breakthrough in his establishment of a fresh, modern ideal for the medium. In his 1897 essay "The Hand Camera—Its Present Importance," Stieglitz offered this photograph as evidence of what could be achieved when photographers abandoned heavy tripod cameras and old-fashioned tastes in favor of a more direct approach. Rather than wait on clients in a studio, the modern photographic artist took to the streets,

envisioning a composition and then waiting for the world around him to deliver it. As Stieglitz recounted, he was able to capture the image only after standing in a fierce snowstorm on the corner of Fifth Avenue and Thirty-Fifth Street for three hours, clutching a hand-held camera in his freezing fingers, until the shot he had in mind finally presented itself. In contrast with the scene carefully constructed in Sarony's studio, the ideal result, for Stieglitz, "contained an element of chance, as I might have stood there for hours without succeeding in getting the desired picture."[1] Embracing this moment of creative clarity, he later described *Winter—Fifth Avenue* as "the beginning of a new era" for American photography, pointing him away from the Victorian pretensions of his predecessors and toward a school of modern photography that privileged direct representation and self-determined, amateur practice.[2] Though Stieglitz does not appear in the picture, it nonetheless represented a personal and professional milestone. Biographer Richard Whelan notes that the artist considered *Winter—Fifth Avenue* to be a "symbolic self-portrait," as "he felt that the driver struggling up Fifth Avenue against the blasts of a great storm represented his own plight as an artist in a philistine city."[3]

Over time, this creative narrative became inscribed within the visual details of the photograph, shaping Stieglitz's self-definition as a modern artist even as it informed later readings of the photograph—to the point that it is difficult to regard the lone driver guiding his coach through the snow without imagining an equally cold young photographer laboring determinedly to capture a singular vision of his urban reality. By implicit comparison, warm and snug in their studios, Sarony and an earlier generation of photographers appear to have taken the artistic easy road. Stieglitz, of course, played an outsized role in championing the modern art of photography, particularly in the United States, and among his remarkable gifts as an artist was his ability to articulate an enduring rhetorical framework for evaluating and appreciating the fine art of photography. Accordingly, historians have regularly interpreted *Winter—Fifth Avenue* in metaphorical terms of which Stieglitz might have approved, describing the image as "establishing the blizzard as the defining trope of urban experience in the 1890s,"[4] or, more presciently, as forecasting "the coming storm of modernism."[5] With the aim of deflating this artistic mythos, Allan Sekula similarly described Stieglitz's critical influence as an enveloping atmosphere, writing that his multipronged professional endeavors as artist, publisher, and critic generated "an entire discourse situation" around modern photography that defined "the lasting terms under which it could be considered art."[6] This discourse bound specific types of photos to specific cultural roles while powerfully effacing evidence of its existence, so later viewers were unconscious of the baggage they brought to their aesthetic judgments. Consequently, the culturally constructed criteria by which a photograph came to be identified as fine art or document—associated with good taste or bad—became subtly naturalized measures of perception.

This is not to diminish Stieglitz's legacy as a photographer or an artistic force, but rather to underscore that one consequence of the "storm of modernism" and its accompanying discourses was to obscure the mechanisms for finding meaning in the photographic work of the immediately preceding generation. To read Sarony's self-portrait fairly, it is necessary to begin by reconstructing the circumstances that originally surrounded its production. I propose that the creative decisions behind its theatrical staging and representational pretension were artful, and reasonable, negotiations of the technical possibilities, systems of distribution, and historically specific discourse situation that surrounded photography during the second half of the nineteenth century. Recovering the literacies necessary to appreciate this requires expanding the frame of Sarony's self-portrait beyond the visible edges of its snowy fictions, from the top floor of a popular portrait studio where a middle-aged man costumed in furs was photographed before a painted backdrop, to the bustling Manhattan photo district outside his studio doors, and, even further, to the hardscrabble immigrant upbringing and transnational artistic education that shaped his circuitous professional path to a career in photography. Through this framework, we might read Sarony's self-portrait as containing two imagined and interconnected landscapes: one formed of the visible elements framing the subject—the ink-spot snowflakes, the riding boots and furs, the snow-covered hillside painted on a theatrical scrim—and the other, encompassing the first, generated by the aesthetic priorities and peculiarities of the nineteenth-century art world, a network of creators, consumers, cultural gatekeepers, and material limitations that remain invisible in the photograph but were nonetheless crucial in shaping its form.

NATURAL MAGIC

Sarony's most significant contribution to photography in the United States was his decisive break from the myth of autonomous production that dominated understanding of the medium in its first decades. This was also why his contemporaries were inclined to perceive his work as more artistic than what had come before. Photography's early enthusiasts routinely stressed the spontaneity of the new technology, designating the natural forces of sunlight and chemistry, rather than human operators, as the active agents in its production. When Daguerre announced the details of his process in 1839, he wrote, "The Daguerreotype is not merely an instrument which serves to draw Nature; on the contrary, it is a chemical and physical process which gives her the power to reproduce herself."[7] William Henry Fox Talbot, inventor of the calotype, similarly described his image-making technology as a type of "natural magic" with nearly miraculous powers of self-reflexive representation. A related sense of magical possibility was evoked by the title of Talbot's early photographic treatise, which described the medium as "the pencil of nature."[8] Ironically, this rhetoric

downplayed the considerable amount of human labor involved in producing a successful image, particularly at the outset, when imperfect lenses and finicky chemical processes demanded significant investments of time and effort. Mia Fineman notes that popular insistence on "mechanical spontaneity," despite much evidence to the contrary, was not due to excessive modesty on the part of early practitioners, who were in fact eager to claim credit and financial remuneration for their innovations. It was instead a celebratory reaction to what was perceived to be the revolutionary distinction between photography and older forms of making images—namely, the capacity to record and preserve a trace of real-world appearances without the need for artistic handiwork. In this sense, the mythos of photographic autonomy can be attributed to the same widespread cultural desire for objective visual representation that precipitated its invention in the first place.[9]

This idea is supported by the fact that the rhetoric of mechanical spontaneity predated widespread direct experience of photography itself. Months before any physical examples of daguerreotypes had reached the United States, they were praised by American newspapers for their unimpeachable accuracy. In April 1839, the *New-York Observer* published Samuel F. B. Morse's account of a visit to Daguerre's studio, which described his wonder at reading minute letters on shop signs or seeing the image of a spider no larger than the head of a pin, photographically enlarged with the aid of a solar microscope. "No painting or engraving has ever approached it," Morse attested. In an aside, the *Observer*'s editor added with excitement that the new image-making technology would at last make it possible "to procure perfect representations of the human countenance . . . drawn, not with man's feeble, false, and flattering pencil, but with the power and truth of light from heaven!"[10] Such enthusiasm was wildly speculative. Not only had the editor never seen a daguerreotype, but no photographs of human subjects yet existed, and Daguerre himself initially doubted that exposure times would ever be fast enough to make photographic portraiture a practical possibility.

The notion of photography as a form of natural magic persisted, however, and continued to outweigh the role of human operators even at midcentury, when photographic portraiture was an established reality. If anything, the rhetoric of autonomy was amplified in the United States during the 1840s and '50s by the democratic ideals regularly mapped upon portraiture's new economical accessibility. Ralph Waldo Emerson wrote, "Tis certain that the Daguerreotype is the true Republican style of painting. The artist stands aside and lets you paint yourself." In this climate, photographers understandably hesitated to claim significant creative credit for their efforts. Mathew Brady, undoubtedly the most prominent US photographer of the antebellum years, confessed that while he sought to elevate the quality of the daguerreotype in terms of its appearance and chemical processes, he saw his role as distinct from those who worked in the "kindred arts of painting, drawing & engraving." In a letter to Morse in 1855, he mentioned his professional aspirations with cautious

humility: "The fact that [the daguerreotype] has found its way where other phases of artistic beauty would have been disregarded is recognized. During my experience however, I have endeavored to render it as far as possible an auxiliary to the artist."[11] So long as ideas of magical autonomy dominated photographic discourse, there was little room for ambitious photographers to claim more than an "auxiliary" relationship to fine art.

This rhetoric shifted significantly during the 1860s, however, as members of the international photographic community began to question whether the simple goal of objective reproduction was sufficient, as a measure of either the success or the potential of the medium. Scottish optical scientist Sir David Brewster, imagining the possibility of heliographic art in 1862, wondered whether strict attachment to realism had not quashed the pursuit of more artistic outcomes. "Is it not possible to make the *absolute truth* in photographic portraiture, when attained, as *pleasing* also as we could desire?"[12] Writing in 1870, the American critic Richard Grant White similarly observed that the thousands of mediocre likenesses churned out during photography's first three decades had established beyond doubt that something more than a basic grasp of photographic processes was needed to make a successful portrait. What was missing, in his view, was the false and flattering touch of the artist. "Of what value is a portrait," he wrote, that transcribed every line and blemish on an individual's face but "does not produce on the beholder the effect which the face itself produces? It fails in attaining the highest and most essential point of faithfulness."[13] Objective reality, in other words, could be overrated, especially when it came to portraiture, where creative artistry could easily surpass mere mechanical reproduction.

Yet unsettling perceptions of photographic autonomy also required reimagining the intellectual and creative labor portraiture entailed. For this reason, these shifting aesthetic priorities did not immediately translate into radical changes in the visual content or style of portrait images. Instead, they were paralleled by a subtler campaign to reshape popular understanding of the role photographers played in relation to their work. Rather than think of photographers only as camera operators, who facilitated but did not control the pencil of nature, it was necessary to assert that individuals of refined artistic ability might choose the camera as one tool among many and that quality pictures were produced through human skill. Philadelphia photographer Marcus Aurelius Root devoted his influential 1864 treatise *The Camera and the Pencil* to outlining just how this distinction might be drawn. He argued that in every field of art, from painting to photography, there were two classes of practitioner—"the artists and the mere mechanics." Both could execute the basic requirements of their trade adequately, and a "dexterous-handed" mechanic might transcend the artist in terms of chemical and manual processes, but when it came to matters of expression, which Root defined as "something which reveals the soul of the sitter, the individuality which differences [*sic*] him from all beings else," the mere mechanic, however dexterous, could

not hope to compare. "As the mechanic can but put together dead materials, his work must needs be lifeless," Root wrote. "The artist on the contrary, creates, and into his work he 'breathes the breath of life,' and it 'becomes a living soul.' . . . Whether the pencil or the camera be employed, this distinction equally holds."[14] The problem for ambitious photographers of the 1860s was how to develop a style of portraiture that manifested this kind of living picture by signaling a level of creative artistry that surpassed the mere mechanics of a chemical process.

One answer seemed to emerge with the publication, in 1869, of British photographer Henry Peach Robinson's influential treatise *Pictorial Effect in Photography*. Arguing against earlier notions of the camera as an autonomous "pencil of nature," Robinson described the transcription of detail as a beginning point for artistry rather than a sufficient end in itself. In his view, it was only by reshaping natural appearances according to ideals of the picturesque that photographers could elevate their work to the level of fine art. Though he disapproved of using photography to represent purely fantastical subjects—pictures that were doctored to include mermaids, floating cherubs, or other creatures that did not exist in nature—he found unadulterated realism no better. Particularly in the area of portraiture, Robinson advised photographers to aim for creative refinement rather than straightforward appearance. "Although likeness is the quality of first importance, artistic arrangement is scarcely second to it. In some cases indeed art excellence possesses a wider and more permanent value than mere verisimilitude."[15] In fact, going far beyond merely dispelling myths of photographic autonomy, Robinson's text actively encouraged image manipulation as a strategy for communicating creative ambition. With this rhetorical turn, the notion that photographic mechanisms harnessed the "power and truth of light from heaven" was replaced by the idea that human photographers could channel natural magic in service of higher forms of artistic truth. Fineman writes that the global influence of Robinson's book marked a pivot point in photographic history, by locating the medium's artistic possibility "not in the faithful replication of facts but in the creation of a convincing illusion."[16] Putting this idea into practice made identifying how photographs deviated from reality essential to appreciative viewing. Confronted with photographic subjects that appeared real but surpassed the capabilities of existing technologies, consumers of photography gradually learned to regard photographic compositions with the same contemplative discernment they had previously reserved for paintings.[17]

At a time when such viewing practices remained novel, however, some photographers worried that their artistry might be overlooked if applied with too delicate a touch. The heavy-handed embellishments evident in late nineteenth-century photography perhaps betrayed an anxiety among early photographers that their creative work might be mistaken for an autonomous product of natural magic if not staged boldly or visibly enough. As Robinson explained, any sophisticated viewer could appreciate the dexterity of a photographer's hand, provided it was not too subtle to register. "We

must know that it is a deception before we can enjoy it; it must be a gentle surprise, and not a delusion," he said.[18] The idea is significant in explaining the conspicuous manipulation of studio portraits like Sarony's self-portrait in the snow. By fabricating pictorial realities in ways that were plausible but eye-catching, the photograph invited viewers to engage with the work as a "gentle surprise," by focusing critical attentiveness on spotting the seams in its construction.

FAUX SNOW AND ARTISTIC AMBITION

It was no coincidence that both Sarony and Stieglitz chose winter scenes to demonstrate mastery of their respective artistic priorities. Throughout the nineteenth century, snowy conditions, precipitation, and low temperatures posed notorious challenges to the basic functions of photochemical processes, making it difficult to achieve a balanced tonal range and slowing the reactiveness of light-sensitive chemicals. German photochemist Hermann Vogel wrote that photography should be thought of as a seasonal occupation, since the "extraordinarily weak" chemical power of winter light required exposure times to be almost doubled even in clear weather, with snowy or rainy winter days being "for the most part useless for photography."[19] Photographic treatises advised that winter conditions be avoided when possible. Robinson devoted an entire chapter of *Pictorial Effect in Photography* to strategies for countering the artistic hazards of cold and wind. He wrote that the only profession more at the mercy of winter weather was seafaring, though he acknowledged that photographers received less sympathy for their suffering than sailors did. "Everybody knows how the east wind searches, pierces, and cuts the body, but it takes a portrait photographer to perfectly appreciate the wreck that it makes of the appearance of poor humanity." For this reason, though intrepid photographers might explore the picturesque potential of hoarfrost and snow-covered landscapes (if equipped with stout waterproof boots), Robinson strongly advised against snow portraiture and winter genre scenes. "None but the most case-hardened to biting cold should face the camera . . . [in the] horrible, blighting bitterness of the wind," he warned, lest blue noses, shriveled faces, and chattering teeth destroy an image's picturesque potential.[20]

These abundant warnings presented the ambitious contrarian with an exciting opportunity to demonstrate mastery of craft in notoriously challenging circumstances. For this reason, winter subjects were often chosen by photographers who had something to prove, as success gave them special bragging rights. Reflecting on *Winter—Fifth Avenue* in 1897, Stieglitz noted with satisfaction that other members of the Society of Amateur Photographers of New York had scoffed when he went out in a blizzard with his camera, but the quality of his work "proved to them conclusively that there was other photographic work open to them during the 'bad season.'"[21] Four decades earlier, Charles Marville had won praise for his calotype *L'École*

des beaux-arts sous la neige (1852 or 1853, Bibliothèque historique de la Ville de Paris), which offers a tonal study of the academy's open gates, balancing dark architectural elements in the foreground with a view through the misting snow into the school's inner courtyard. Sarah Kennel remarks that Marville probably selected the subject from "a combination of wounded pride and ambition," since his photographic career came about only after the academy rejected him. The display of mastery may have soothed the injury of an earlier dream unfulfilled by allowing him imaginative access through the venerated gates. "Though his painting and draftsmanship had failed to grant him entry into the École des Beaux Arts, with photography . . . [he] finally succeeded."[22] Whether born of wounded pride or a desire to show off, many photographers embraced the challenge of making pictures in the snow as a way of communicating new creative ideas, or to correct the misconception that their craft had little to do with the skill of a human operator. Though all could appreciate their beauty, such pictures carried special cachet in photographic circles due to the inherent challenge of their creation.

In the spring of 1866, the artistic possibility of winter photographs became the topic of animated conversation in American photographic communities when the *Philadelphia Photographer*, the country's leading trade journal, featured a staged tableau titled *Caribou Hunting, The Chance Shot*, by the Canadian photographer William Notman (fig. 3). Each monthly issue of the journal included one real photographic print that was tipped in as a frontispiece in a section titled "Our Picture." This photographic "original" stood apart from the magazine's other illustrations, which were all engraved reproductions, and enjoyed special prominence in the technical discussions that followed. In describing the purpose of the section, chief editor Edward L. Wilson noted that the featured photo was specially chosen each month to demonstrate novel techniques or simply to give photographers "something to think about and aspire to."[23] In the case of Notman's photograph, it was both. Part of a larger series devoted to documenting scenes of caribou hunting in Canada, the photo depicts two hunters crouching at the edge of a clearing. Having already bagged one sizeable caribou, which lies on the snow-covered ground beside them, they gaze with anticipation into the distance beyond the frame of the photograph. Whether the "chance shot" of the title refers to hunting or to the spontaneity of Notman's apparently candid photograph is deliberately ambiguous. Is the older hunter raising his gun to aim at an unlikely catch, or are the two men pictured in the split second before they discover whether his aim is true? Or should the photograph be understood as the chance product of Notman's extraordinarily good luck with his camera as he trailed these hunters in the snow? The open-ended title and the persuasive quality of the image allowed these layered interpretations to intermingle and coexist, even as readers of the *Philadelphia Photographer* would have recognized that the outdoor action scene taken in snowy conditions would have been impossible to capture photographically.

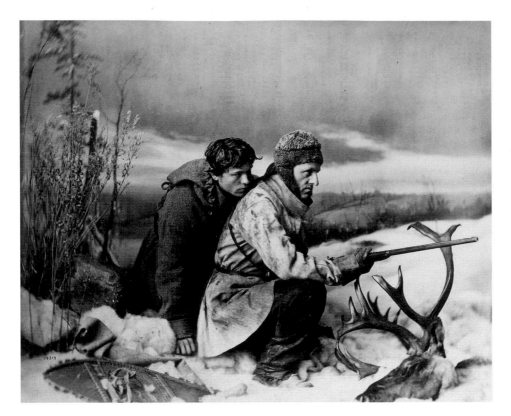

Fig. 3 | William Notman (1826–1891), *Caribou Hunting, The Chance Shot*, Montreal, 1866. Silver salts on paper mounted on paper, albumen process, 12.3 × 8.6 cm (4 4/5 × 3 3/8 in.). Musée McCord, N-0000.57.6.

Wilson's accompanying text cited all these reasons for hailing Notman's photograph as an important advance for the field. "Our expectations were large, but they have been more than realized. . . . This is a picture that could not have been made a year or two ago." He explained that it was not a matter of technological improvement, however, but instead of how effectively Notman rendered the gentle surprise of photographic illusion. "We can only guess how it is done . . . for it must not be forgotten that these pictures are all made indoors." Whereas Stieglitz embraced the element of uncertainty the hand camera introduced to photographic work, what earlier viewers celebrated about Notman's work was that, despite its title, no aspect of his photographic composition had been left to chance. In fact, eliminating inconvenient realities such as weather resulted in a photograph that was as far from an autonomous production of natural magic as it was possible to get. "To make these pictures, trees, rocks, snow, tents, air, light, fire, men, background, *cariboos*! had to be brought in and arranged to suit the chosen subject for the picture; but that the artist has given us a remarkable photograph of a snowstorm without snow, we cannot deny." For Wilson and his contemporaries, awareness that a photograph was entirely staged did not detract from its veracity but enhanced it, because it indicated the care and thoughtfulness the photographer had invested in sidestepping technical limitations. Additionally, with

Notman's series on caribou hunting, it was not merely that every photograph in the series was delicately manipulated, artistically posed, and beautifully lit, but that they documented realities of outdoor sport with a fidelity that nineteenth-century cameras would not otherwise be equipped to capture. Their detailed construction made it readily apparent how much artistic labor was involved in their production of truthful appearances. "Each one shows the expenditure of time, brains, and talent . . . and the whole series combined give a truthful account of the sports, pleasures, and perils, of a Cariboo hunt in snowy Canada."[24] For a generation of photographers seeking to demonstrate artistic control of their medium, Notman's documentary unreality presented an exciting fusion of truth and fiction that successfully demonstrated the triumph of human artistry over photography's mechanical autonomy.

The problem for photographers who admired Notman's style was that there was little market for artistic genre scenes in the United States. The most reliable way to make a living in photography was the portrait business, and the question of how to introduce pictorial effects to portrait images would not be solved by bringing caribous into the studio. This was why Napoleon Sarony made such an impact with his arrival on the American photographic scene. In June 1866, one month after Notman's photograph appeared in the *Philadelphia Photographer*, Sarony circulated his first-ever series of self-portraits in New York City (fig. 4). He had been abroad in Europe since 1858 and spent the previous three years running a studio in Birmingham, England. His photographs were accompanied by an announcement that he intended to return home to New York and establish a new American portrait business.

Though these early self-portraits were far simpler in their composition than the elaborate snow scene he constructed a decade later, they display a similar swagger, along with the unconventional spirit that animated Notman's snowless snowstorm. Each of Sarony's eight self-portraits shows him costumed in a fur-trimmed coat and hat, checkered pants, scuffed riding boots, and a sheepskin vest worn inside out to show its woolly lining. The outfit was highly eccentric by the rigid standards of Victorian fashion and better suited to one of Notman's caribou pictures than to the parlor setting in which the artist appears. Sarony's rakish poses also strayed from the upright, well-mannered posture and direct gaze that was more typical of American portraiture during the period. The most frequently reproduced photo shows him in profile, leaning against the back of a tasseled posing chair with ankles crossed, one hand on his hip. It was not uncommon in the mid-1860s for actors to be photographed in costume for plays, but Sarony's unusual attire defied recognizable type and represented an amplified mode of self-performance that had few contemporary precedents. Perhaps more important, it suggested how the fusion of fact and fiction exhibited in Notman's studio tableau might be successfully applied to portraiture. By embracing theatricality as a tool and treating the photograph as a public stage, it was possible to infuse commercial practice with an expressive unreality. The photographer W. A. Cooper recalled

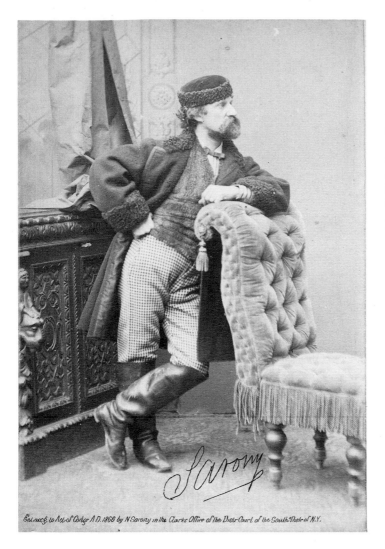

Fig. 4 | Napoleon Sarony, *Self-Portrait*, 1866. Albumen print; carte de visite, 10 × 6 cm (3 15/16 × 2 3/8 in.). Courtesy of Special Collections, Fine Arts Library, Harvard University.

that, for all these reasons, the arrival of Sarony's first self-portraits struck the American photographic community "like a meteor from a clear sky." In addition to their unconventional approach, the photos employed material innovations not previously seen in the United States; they were toned sepia and printed on a "double-albumenized" high-gloss paper invented in Birmingham, where Sarony had been working. Though both soon became industry standards, Cooper thought that the photographer's "audacious individuality" made a bigger impression than these material details. "With top boots, checked pants, fur cap, posed over his own chair, [he was] the personification of ease and gracefulness. How we raved over his work and effects! And wondered what secret processes he had used, forgetting it was the man, not the process," who was responsible for the artistic results.[25] Sarony's self-portrait persona was a revelation to US photographers accustomed to thinking of themselves as businessmen

and of their medium as a kind of mechanical science. Debonair, unconventional, and unabashedly eccentric, Sarony's self-portraits confidently approached photography as a creative mode of personal expression, a platform for promoting a new public image of the photographer as artist.

PHOTOGRAPHIC CHARACTERS

Personal and professional reinvention had been major factors in attracting Sarony to photographic practice. He came to the field in his early forties, after working for decades in the field of popular lithography. Though successful in business, he had difficulty holding onto money, and one friend noted that "he made and spent several fortunes" over the course of his life. Certainly, many of Sarony's major career decisions were shaped by the rise and fall of his personal finances.[26] This was not a matter of opportunism so much as that he was left to support himself from an early age, so that making art could not be separated from the need to earn an income.

Napoleon Sarony was born in Quebec City on 9 March 1821 to a French-Canadian mother and a Prussian-born father. His father, Adolphus, had been a member of the Schwarze Legion in the Napoleonic Wars and fought in the Battles of Leipzig and Waterloo before emigrating to Canada, making it a matter of intriguing irony that he chose to name his second son Napoleon. His parents married in 1818, and during a brief period of stability Adolphus established a store for fancy imported goods called Sarony's Bazaar.[27] In 1831, the business failed, and Marie Lehoullier Sarony died shortly afterward. Following the death of his mother, Sarony and the three youngest of his seven siblings moved with their father to New York City, where they lived in the diverse immigrant community of lower Manhattan's Third Ward. Although Sarony showed an early talent for drawing, his father's continuing financial difficulties precluded the possibility of fine art training. Instead, Napoleon was apprenticed at an early age to the lithographer Charles Risso, a professional fate Sarony always regretted.[28] He was successful enough in lithography to establish his own firm, Sarony & Major, in 1846, but in 1857, after having accumulated "what he considered sufficient funds to retire," he sold his interest in the firm to Joseph F. Knapp and announced that he was leaving lithography to pursue a career as a painter. The professional transition came at a moment of personal upheaval as well. Later accounts noted that Sarony was in poor health at the time, and after leaving the lithographic firm, he traveled to Cuba in the company of friends who were similarly ill, in hopes that the weather would cure him. Though Sarony improved, his traveling companions unfortunately died in Cuba.[29] They may have included his first wife, Ellen Major Sarony (the sister of Henry Major, his partner in the lithographic business), who died in the winter of 1858.[30] On 16 February 1858, Sarony married Louisa Long Thomas, and shortly afterward, the newlyweds set sail for Europe along with his three children from his first marriage.[31]

The extent to which Sarony seriously followed through on his plan to pursue academic training as a painter is unclear. He spent the period between 1858 and 1866 visiting museums and calling upon famous artists and lithographers in France, Germany, and Italy.[32] At the same time, his lithographic firm, now called Sarony, Major & Knapp, publicly entertained hope that he would return to the business following his trip. An advertising leaflet printed in 1860 announced that "Mr. Sarony's European sojourn" had been undertaken to secure new orders and expert printers to bring back to the United States.[33]

Whatever his initial intentions, Sarony's plans were quickly upended by the loss of his personal fortune. Though in later years this was often attributed to mismanagement by trusted agents, it seems equally possible that Sarony simply ran out of money overseas. During the early 1850s, he had invested his earnings from lithography in a series of land purchases along the Hudson River in the Glenwood neighborhood of Yonkers, New York. While he was in Europe, Henry Major, his former brother-in-law and lithographic business partner, sold these at a loss.[34] Whether these sales caused Sarony's financial downturn or were precipitated by it, he reset his ambitions and decided to study photography. By 1861 he was living in the seaside resort town of Scarborough, England, with his older brother Oliver, who had established a successful portrait photography business there in 1857. It was probably with Oliver's encouragement that Napoleon set up his own first photographic portrait studio in 1862 in the industrial center of Birmingham, England, joining the existing firm of Samuel Hill and Robert Thrupp, along with his brother's associate Silvestre Laroche.[35] The Sarony & Co. photographic studio was located at 66 New Street on the city's main commercial thoroughfare. In addition to creating portraits of local society members and the occasional visiting celebrity, Sarony's surviving photographs from the Birmingham years indicate that he invested a significant portion of his studio time in self-portraiture, creating the photographs he would use in 1866 to announce his triumphant return to New York and his professional transformation from a little-known lithographer to a bohemian photographic artist from abroad.

Sarony's early self-portraits are intriguing because they were made at a time when the photographer was entirely unknown in his field. They were not, therefore, created to supply any demand from admirers but rather seem to have represented a hopeful strategy for correcting that lack. There was probably a practical aspect to the studio exercise as well. As a beginning photographer, using himself as a model allowed him to test different poses, costumes, and studio configurations. Yet the fact that these early self-portraits were preserved in what remains of the artist's studio collection at Harvard University's Fine Arts Library suggests that they also had deeper personal significance as the proving ground for the artistic alter ego he would ultimately develop. The early self-portraits certainly have an experimental air. The photographer is arrayed in diverse outfits, using the checkered suit, fur coat, and vest in varying combinations,

Fig. 5 | Napoleon Sarony, *Self-Portrait*, ca. 1866. Albumen silver print; carte de visite, 10 × 6 cm (3 15/16 × 2 3/8 in.). Courtesy of Special Collections, Fine Arts Library, Harvard University.

Fig. 6 | Napoleon Sarony, *Self-Portrait*, ca. 1866. "Photo-crayon" print; cabinet card, 15.9 × 10.8 cm (6 ¼ × 4 ¼ in.). Courtesy of Special Collections, Fine Arts Library, Harvard University.

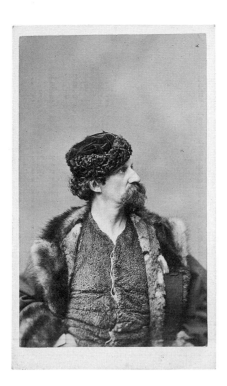

and pairing them with a bewildering assortment of hats, including a busby, slouch cap, bowler, and tam-o'-shanter. Though most ensembles were abandoned after a single photograph, one appeared repeatedly: a fur-lined overcoat with tattered lapels, a shearling vest worn with the buttons facing in, and an astrakhan wool hat (fig. 5)—the same costume used in the self-portrait sent to New York in 1866, and a scruffier, nascent version of the gentleman explorer depicted in the self-portrait in the snow of circa 1875. In one half-length photograph in this costume, Sarony even strikes the same courtly pose he would assume in this later work, gazing out of the frame in three-quarter profile view with his hands on his hips.

Clearly, something about this unconventional character and pose appealed to Sarony. Not only did he revisit the fur-clad alter ego repeatedly in later years, but while still in Birmingham, he translated the photograph into a hand-colored vignette using a lithographic "photo-crayon" process he would later patent to make photographs resemble pastel miniatures (fig. 6). This mediation adds color to the artist's face and applies a decorative motif of fern fronds to the background. It also mitigates a few of the less picturesque physical realities revealed in the original photograph, touching up the patchy fur in the overcoat's lining, lending volume to the artist's goatee, adding a white shirt collar that makes the ill-fitting vest resemble a courtly doublet, and cropping the image just above a slight paunch that pulls the buttons taut across his

belly in the undoctored photo. Disguising the necessary economies of Sarony's early practice, the altered photo-crayon image anticipates the later, grander realization of this character in the self-portrait in the snow.

These photographs also reveal Sarony's adherence, even if coincidental, to later ideals of pictorial photography in that they treat the photographic image as the raw material for a more fully realized artistic vision, and the camera as just one of many image-making tools at the artist's disposal. Sarony articulated this sentiment precisely later in his career, when he told an interviewer that he saw no meaningful distinction between his images and those of artists working in other media: "I think my work proves that photography has aspects personal and individual apart from mechanical considerations. The camera and its appurtenances are, in the hands of an artist, the equivalent of the brush of the painter, the pencil of the draftsman, and the needle of the etcher."[36] In the 1860s, the challenge, which Sarony shared with such similarly ambitious photographers as Nadar (the professional name of Gaspard-Félix Tournachon), Robinson, Notman, Oscar Gustave Rejlander, and André Adolphe-Eugène Disdéri, was convincing a skeptical public that the camera was indeed in the hands of an artist.

Self-portraiture provided a crucial tool for making this case by increasing the visibility of individual photographers and influencing how the public regarded their professional role. This method of publicity had two strategic results: it advertised the products of the photographer's portrait studio, and it asserted the creative direction of an individual artist, helping dispel the notion of photography as a purely mechanical process. Perhaps for reasons similar to Sarony's, Nadar circulated self-portraits in the 1860s depicting himself posing in the basket of his hot air balloon and wearing extravagant baroque wigs and collected items of Native American attire (1862–64, Metropolitan Museum of Art, New York). Disdéri represented himself as a wild caricature of a Left Bank bohemian, dressed in embroidered jackets, blousy oversized tunics, and garishly colored scarves that became the building blocks for reproductions of his image in the popular press (ca. 1853, Getty Museum Collection, Los Angeles).[37] Rejlander portrayed himself varyingly in assumed roles as a classical sculpture, as the Italian revolutionary Giuseppe Garibaldi, and in a double self-portrait where he appeared to be introducing himself as an artist to himself as a volunteer soldier in uniform (ca. 1871, Victoria and Albert Museum, London). As with Sarony's self-portrait in the snow, the objective of such unconventional self-representation was less about the legibility of specific characters than about creating an air of romantic eccentricity around the entire portrait process that helped to align the public image of the photographer with notions of artistic identity.

Using publicity as a tool for gaining artistic renown was not specific to photography, of course. Sarah Burns has described the crucial role of constructed public

personae in the process of inventing the modern artist. Painters like James McNeill Whistler and William Merritt Chase adeptly promoted their artistic talents by conjuring an image of genteel bohemianism, fashionable taste, and colorful eccentricity for the "media-made theater" of public attention.[38] However, for photographers in search of artistic legitimacy, this public performance had different stakes. The relative newness of their profession made the task of inventing the modern, artistic photographer as much about breaking from traditional conservatism as about bringing professional visibility to their cause. Whereas painters presented themselves as fashionable dandies or standard-bearers of cosmopolitan taste, late nineteenth-century photographers magnified these conventional markers of artistic identity into almost cartoonish proportions that were engineered to attract attention and counteract lingering perceptions of photographic autonomy.

As a shrewd observer of contemporary photography, Sarony surely recognized self-portraiture as an ideal vehicle for launching himself into what Burns calls "the realm of spectacle," even before he became famous for doing so. Once back in the United States, Sarony's public image grew alongside his thriving portrait business, fueled by his production of increasingly elaborate self-portraits that depicted him in the role of a Dutch Old Master or as an officer clad in a red tasseled fez and borrowed military uniform (fig. 7). These photographic performances were enhanced and reinforced by the exaggerated social roles that Sarony performed in his day-to-day life. When his New York portrait business was new, he and his wife, Louie, would rent elaborate costumes from theatrical suppliers to draw curious subjects to the studio.[39] After he had become a celebrity, the artist James Edward Kelly described him as "one of the sights of the 'Boulevard de Broadway.' . . . Every day around four o'clock, in company with his tall, handsome wife and little doll of a daughter, he would swagger along with his sailor walk, saluting right and left as everybody seemed to know him."[40]

Sarony's public image mattered, not only in terms of his vanity but because it forged an unforgettable link between his popular portraits and the creative artist who made them. In more practical terms, it helped demonstrate that a photograph was far from an exact transcription of nature but could be used to transform personal appearances dramatically. Though Sarony looked tall and imposing in his self-portraits, he was not quite five feet tall, a fact disguised so effectively in photographs that commentators often expressed shock upon meeting him in person. Far from being sensitive about his short stature, Sarony playfully exploited its comedic potential. The painter and writer William Henry Shelton recalled that when Sarony entered a room, "he delighted to make himself still smaller," by walking in a crouch that "reduced his height to a matter of three feet . . . with his wig pulled down to his eyebrows."[41] Others noted that his fashion choices seemed designed to compensate for his small size by seizing an extra share of attention. He would wear massively oversized fur coats even on warm days, and "loud picture shirts" with the "collar cut low in the throat

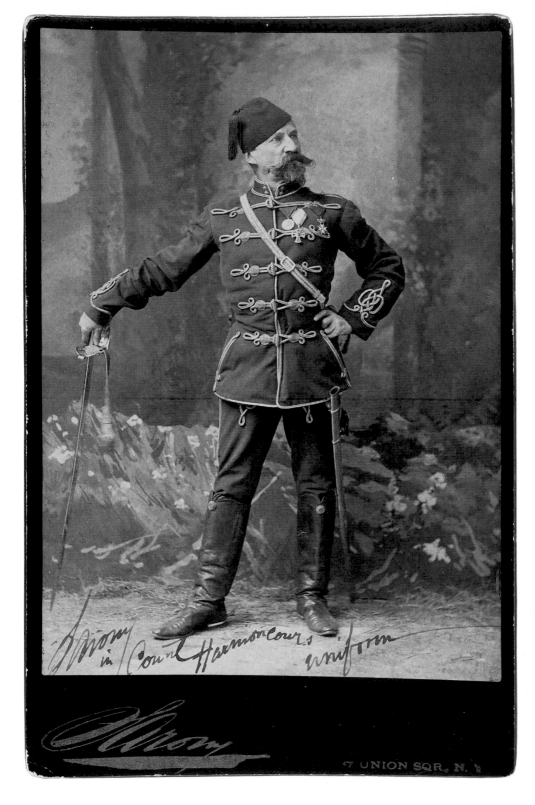

Fig. 7 | Napoleon
Sarony, *Sarony in Count
Harmoncour's Uniform*,
ca. 1880. Albumen
silver print; cabinet
card, 16.4 × 10.6 cm
(6 7/16 × 4 3/16 in.).
Courtesy of the George
Eastman Museum.

and a flamboyant tie."[42] His odd behavior and abrupt passions were reported in the papers as evidence of his artistic temperament and cemented his acceptance within the close-knit artistic community of New York. Shelton recalled that one summer evening at a membership meeting for the Salmagundi Club, a social group for artists, which was taking place in the ground-floor apartment of a Washington Square brownstone, Sarony became so agitated when a candidate he proposed for membership was rejected that he made an "abrupt departure by the window instead of by the door and was not seen again for months."[43]

Jumping out windows, falling off posing platforms, promenading down Broadway—Sarony cultivated a public persona that in many ways seemed custom-built for the "media-made theater" that drove art and cultural activity in the late nineteenth century. Part showmanship and part seemingly genuine, his social and artistic performance allowed him to construct a public image that became part of his recognizable brand, so that one attraction of visiting the Sarony studio was seeing the famous photographer in action and becoming part of the spectacle he generated. Portrait sitters recalled him dancing, posing, and making faces as he raced around his studio to prepare the scene for a portrait, calling him as "active as a squirrel" and as "nimble as a harlequin," as he adjusted their costumes and shifted skylight shutters to modify the lighting. Sarah Bernhardt called him "mon petit Sarony," and Charlotte Cushman referred to him as "that interesting, crazy, little man."[44] Far from viewing his portraits as exact copies of nature, clients understood Sarony's presence in the studio as an essential guarantee of a photograph's quality and artistry. Journalist Cora Linn Daniels wrote in 1881, "people will not be satisfied that they have a 'real Sarony,' unless the little man poses them, attends them, and turns their eyes up or down according to his own particular conception."[45]

Indeed, what made Sarony's impact on American photography "meteoric" is that he defined an image of the artist-photographer that captured the public imagination and came to personify the creative human element in the portrait process—even when it was not directly attached to his name. During the late nineteenth century, caricatures of diminutive men wearing fur hats and vests became a new archetype of the portrait photographer in popular illustrations. An engraving published in *Harper's New Monthly Magazine* in May 1872, alongside a poem titled "In the Studio," depicted a short man in a fur cap and knee boots, clearly inspired by Sarony's self-portraits, posing a fashionable young lady for a portrait (fig. 8). This little photographer embodies Sarony's manic energy as well, practically racing forward to make a final adjustment before the picture was made.

Contemporary images by Frank Bellew and Thomas Nast similarly depicted fur-clad photographers dealing with the day-to-day challenges of portrait clientele. A Bellew cartoon depicts an unnamed "Eminent Photographer," with Sarony's tasseled cap and distinctive goatee, responding in bug-eyed horror when a client with a

IN THE STUDIO.

"YOUR HAPPIEST EXPRESSION, IF YOU PLEASE!"

Fig. 8 | *In the Studio.* Wood engraving from *Harper's New Monthly Magazine*, May 1872, 893. Photo: Internet Archive.

Fig. 9 | Thomas Nast (1840–1902), *Caricature of Napoleon Sarony*, ca. 1866–71. Albumen silver print on card, 15.9 × 10.8 cm (6 ¼ × 4 ¼ in.). Courtesy of Special Collections, Fine Arts Library, Harvard University.

comically large nose asks to be photographed in profile. Nast responded more directly to the exaggerated appearance of Sarony's self-portraits, recasting the photographer's slouching pose in an oil painting in which stagey studio props are subsumed within a natural landscape of blowing grass and creeping ivy, as though growing into real things in response to the artist's touch (fig. 9). While these caricatures poked fun at Sarony's eccentricities, they also bestowed respect by depicting Sarony as a sympathetic straight man who was forced to wrangle young women and appease subjects who thought they knew best how to pose for the camera.

Nast explained the artistic kinship he felt with Sarony, saying of the photographer, "in many ways he was really a caricaturist," who infused the portraits of his customers with his own individual sense of style. "He made everyone he photographed look like Sarony. You know what I mean. The same feeling was in every picture." According to Nast, this was a measure of Sarony's artistic talent and a mastery of photographic portraiture born of hard work. He recalled that Sarony "was so fond of his art that he practiced it for hours simply to entertain himself," dressing up in

Fig. 10 | Napoleon Sarony, *Portrait of Thomas Nast*, ca. 1875. Albumen silver print on card, 15.9 × 10.8 cm (6 ¼ × 4 ¼ in.). Harvard Theatre Collection, Houghton Library, Harvard University.

character, constructing sets and striking poses, and persuading friends and visitors to serve as the subjects of his photographic experiments. "Many a time he has made me dress up in some of his remarkable clothes and sit for him. A big, fur-lined dashing sort of overcoat was a favorite garment in which he arrayed me. I used to object, and tell him that it did not look natural; that I never wore such a thing in my life. But that had no weight against his invariable answer: 'Never mind, it is artistic my dear Nast.'"[46] An undated photograph of Nast, probably made around the same time as Sarony's self-portrait in the snow, shows the likely product of one of these friendly artistic experiments (fig. 10). It depicts the cartoonist in a heavy overcoat, his hands in his pockets and shoulders hunched against the cold, in a snowy winter landscape like the one in which Sarony pictured himself standing heroically. But while the photographer looks beyond the frame, ignoring the camera with fierce bravado, Nast casts

a furtive glance toward the lens with the hint of a good-natured smile. Perhaps he is registering a slight feeling of silliness in the face of this forced performance, or perhaps seeking approval from the scene's invisible director, whom he has once again fondly indulged. By the late nineteenth century, photography's capacity to capture reality had been more than adequately documented. What remained a frontier for active exploration was how photographs could be shaped into art.

ARTISTIC SPIRITS

Sarony's photographic practice in New York City put him at the heart of lower Manhattan's thriving picture industry. His first US studio was located a few blocks south of Brady's famous photographic gallery at Broadway and Tenth Street, and just north of the massive Currier & Ives printing firm at Nassau and Spruce Streets. The area was a center for urban spectatorship as well. It was common during the 1860s and '70s for New Yorkers of diverse social strata to promenade on Broadway between Brady's and Currier & Ives, taking in the goods, prints, and artwork displayed in the shop windows while covertly observing fellow passersby. The stretch of Broadway that Sarony's studio occupied enjoyed a particularly colorful artistic reputation. In addition to photo galleries and shops, the building at 630 Broadway was neighbor to auction houses and print-shops, and was across the street from Pfaff's Beer Hall, where Walt Whitman, Elihu Vedder, and other members of the Greenwich Village bohemian scene held court in a wine cellar beneath the sidewalk. Although not designed specifically for artists, like the nearby Tenth Street Studio Building, 630 Broadway had high ceilings and large windows that made it a popular location for studios, and Sarony shared the hallways with sculptors, painters, engravers, illustrators, and other photographers.

Among Sarony's more notorious neighbors was the spirit photographer William H. Mumler. Although there is nothing to suggest that the two men were acquainted, their physical and professional proximity illustrates the rapidly shifting perceptions of photography and photographers. Mumler gained renown in the late 1860s by claiming to have invented a process of photographic portraiture that captured images of ghosts invisibly interacting with the living. Aided by his wife, who claimed powers as a spiritualist medium, his sessions were part séance and part standard portrait session. Subjects were posed as in any other studio, but once his pictures were developed, it would be revealed that the paying portrait clients had been joined in the studio by translucent spirit "extras," as the photographer described them.[47] Mumler's portrait of William Barker Cushing shows the seated man wearing a guarded expression, seemingly unaware that he is held in the transparent embrace of a woman in a white funeral crown, who wraps both arms protectively around his shoulders (fig. 11).

Though today we recognize the ghostly figures in Mumler's photos as the result of double exposure or composite printing, these manipulations were unfamiliar to

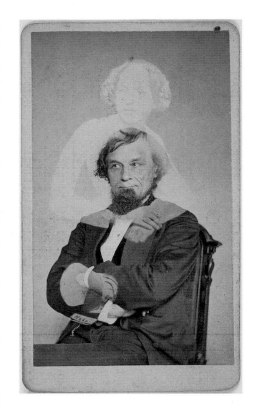

the average viewer of the 1860s. This was less a matter of naïveté than of the rapid changes in technical processes during the medium's first decades of existence.[48] Early photographic images might appear on metal, paper, or ivory, and new chemical formulations and commercial applications were regularly introduced, so even enthusiasts must have found it difficult to keep up with what the latest technologies could and could not do. For those who wished to believe that their deceased loved ones had never really left them, there was even less reason to dismiss the version of reality that Mumler's portraits offered.

In April 1869, shortly after Sarony moved up the street to an expanded studio location at 680 Broadway, Mumler was arrested in a sting operation and charged with defrauding the clients who had paid him huge sums for evidence of ghosts that they believed was genuine. His arrest, and the highly publicized trial that followed, was a watershed moment in the popular understanding of photography. Until then, conversations about techniques and trickery had been largely confined to trade literature, but the Mumler trial made the details of photographic processes the subject of sustained public discourse in the United States and beyond. Concerned that one unethical photographer could damage the entire portrait industry, American photographers mobilized to defend the honest position of their businesses by contributing to the case for the prosecution. Charles Boyle and George Gardner Rockwood offered advance expertise analyzing samples of Mumler's work, and Abraham Bogardus testified at the trial on behalf of the National Photographic Association, which had been formed the previous year, "for the purpose of elevating and advancing the art of photography, and for the protection . . . of those who make their living by it."[49] On the stand, Bogardus detailed the darkroom tricks through which the ghostly effects in Mumler's photos were created, and presented a phony spirit photo made in collaboration with master of humbug Phineas T. Barnum, which was entered into evidence. The prosecutors argued that this obviously fraudulent picture, which depicted Barnum smiling serenely beneath a ghostly shade of Abraham Lincoln (reproduced from a well-known portrait by Mathew Brady), demonstrated that Mumler's spirits could easily be conjured through technical

tricks that were well known within photographic circles, even if not recognized by the defrauded clientele. Their case was made difficult, however, by the fact that many of the clients he had allegedly cheated testified on Mumler's behalf. Even when shown spirit photographs specifically debunked during the trial as the result of improperly cleaned plates or composite printing, they tearfully swore that the spirit images they purchased from Mumler pictured dearly departed family members. Mumler's lawyers argued that just because a bogus photograph *could* be produced did not prove that their client's work was fakery. There was little doubt that the photographer could have defrauded his clients, but whether he deliberately set out to do so was more difficult to prove. At the trial's conclusion, the judge declared that although he was "morally convinced" that Mumler had perpetrated an unconscionable fraud, there was no way to prove that this had been his intention, and so he had little choice but to acquit him.

The ambiguous outcome of Mumler's trial has led to divergent readings of the event: did it signal continuing faith in photographic autonomy or portend its last gasp? Placing spirit photographs at the intersection of science and the Victorian culture of display, Jennifer Tucker sees Mumler's acquittal as evidence of persistent belief "in the power of photography to mechanically reproduce reality." Since Mumler's photographs relied on a framework of dual faith in the spiritual and the mechanical, even those who viewed spiritualism skeptically found photographic authority difficult to question.[50] Michael Leja, by contrast, links the Mumler trial to a larger destabilization of sensorial perception that revealed photography to be yet another means of perpetrating fraud in a cultural climate already saturated with evidence that it was unwise to trust one's eyes.[51] Perhaps it is most accurate, as Mia Fineman has noted, to say that there was no one unified position on the matter; some people continued to believe in photography while others came to view it with suspicion.[52]

There is an additional, overlooked possibility that unifies these divergent perspectives. I propose that, more than being a referendum on the veracity of photographic images themselves, the Mumler trial decisively demonstrated the extent to which photographers bore responsibility for shaping the content and meaning of their work. Those who believed that Mumler conjured spirits in his portraits credited his unique process, not the mechanisms of his camera, since similar results were proved to be false. And those who believed that he defrauded his clients accepted that the medium was fallible and condemned the photographer for deliberately misrepresenting his results. In either case, it was the maker and not the medium that determined how photography was interpreted and the extent to which it should be believed.

By the late nineteenth century, the nuanced truth claims of photography were increasingly recognized as residing outside the framework of an individual image, in the discursive context of circulation and reception, over which photographers had a certain degree of control. The chronophotographic experiments of Eadweard Muybridge, Thomas Eakins, and Étienne-Jules Marey in the 1870s and '80s demonstrate

that photography's capacity for documentary truth was not entirely extinguished by the revelations of the Mumler trial. Instead, as Tucker observes, the scientists who promoted photographs as reliable data in the 1870s became obliged first "to prove their scientific worth in diverse public arenas," before the visual evidence of their photographs was accepted. Nor was representational realism removed from the realms of fine art photography. Instead, as Leja notes, photographers of the early twentieth century "would have to develop stylistic means for laying claim to documentary truth" through the formal rigors of "straight" photography.[53] In other words, photographic technologies remained capable of communicating "truth," under certain circumstances, before and after Mumler. It was only that in the trial's wake photographers assumed and retained a more widely recognized role in how that outcome was defined.

The gentle surprises of early artistic photography, from caribou and snowstorms to staged celebrity portraiture, represent an artifact of this transitional phase in the medium's evolution, a time of reckoning when photographers asserted a new position of prominence in relation to their work. This is evident in a faked spirit photo made by the Sarony studio around 1870, shortly after the conclusion of the Mumler trial, that depicts a popular magician known as the Comte de Cagliostro (fig. 12). Cagliostro was the stage name of an Italian American performer named Lorenzo Gardetti, whose act consisted of sleight of hand and staged séances, a fact that clearly inspired the composition of Sarony's portrait, which shows the magician recoiling in fright from a ghostly apparition draped in a white sheet. In fact, although the portrait's original viewers might not have known it, Cagliostro was an object lesson in the dangers of trusting in appearances, magic, natural, or otherwise. His career was cut short in 1876 when he was arrested for using acts of prestidigitation to steal jewelry from his audience members (unfortunately for the great Cagliostro, the wronged parties in his case were less understanding than Mumler's victims).[54] Though created using the same techniques for which Mumler had been accused of fraud, Sarony's photograph, with its stagey details and studio signature on the lower margin, immediately signaled that it was intended to amuse rather than persuade. It presents the ghostly apparition in the context of the magician's act as an entertaining "gentle surprise" rather than as the product of natural magic or spirit conjuring. The painted backdrop behind Cagliostro has been rolled up along its lower edge to reveal a thick border of bare canvas that emphasizes the artificial platform of the studio performance space. This is not a photographic process like Mumler's, in which the sitter posed normally only to discover later that spirit extras had invisibly surrounded him. Instead, the performing subject has been let in on the photographic act and seems to see and react to the same impossible vision we see in pictures—the sleight of realism that was instrumental to Sarony's art.

Sarony's exaggerated public image helped make clear to the public that he had little interest in representing everyday appearances, a fact that led contemporary observers

Fig. 12 | Napoleon Sarony, *Portrait of "Cagliostro,"* ca. 1870. Albumen silver print; cabinet card, 15.9 × 10.8 cm (6 ¼ × 4 ¼ in.). Harvard Theatre Collection, Houghton Library, Harvard University.

to attribute his flattering portrait results not to natural magic but to an artistic talent for reshaping reality. In 1868, a reporter for *Frank Leslie's Illustrated Newspaper* wrote, "What photographs are usually, any-one who had been vain enough to pose can testify. An ordinary photograph is just such a likeness as one's worst enemy would take if he were the sun . . . but by some legerdemain Sarony has got the upper hand and is master of the situation. Why? Because he is an artist."[55]

This link between studio craft and artistry is ultimately the message that Sarony's self-portrait in the snow aims to communicate. By pairing the naturalism of photography with the magical possibilities of creative invention, Sarony fashioned a vision of the photographer as artist who could captivate audiences and persuade them of his good intentions. There is more common ground between Sarony, Stieglitz, and their

respective snow photographs than may at first be evident. Despite obvious differences in form, approach, and reputation, both men aspired to dignify the craft of photography by making individual creative authority a central feature of their final products. In each case, photography's relationship to realism was an essential artistic tool. For Stieglitz, it positioned the viewer to reexperience the chance impression of a considered moment. For Sarony, it presented a discursive limit to work within and against. And whereas *Winter—Fifth Avenue* locates beauty in the commonplace by inviting its viewer to see the world through the photographer's eyes, Sarony's self-portrait asks us to look differently at the photographer himself, to see him as an artist who inhabits a creative world of his own making—a living picture—that illuminates the power of photography to transform everyday appearances into something fantastical. Modern declarations of independence from staged studio artifice were possible only once this philosophical groundwork had been naturalized. Until then, the photographer remained on view to serve as guide and insistent reminder.

2.

PUBLIC IMAGES

Sarony's larger-than-life public image supported his claim to artistic identity by reminding observers of his creative presence in the photographic process. Yet this alone does not explain the phenomenal success of his portrait business during the last three decades of the nineteenth century. It is equally important that his career coincided with, and to a significant degree helped to fuel, the emergence of modern celebrity in the United States. The image of the photographer as artist that Sarony modeled fed into and was nurtured by this mounting media phenomenon. His public prominence simultaneously advertised his studio and promoted the tantalizing possibility that his stylish photographs could launch ordinary people into the spotlight of notoriety that was generated by his work. As Ben L. Bassham wrote, employing Gilded Age parlance, "Sarony became wealthy and famous because, quite simply, no one else in New York could 'make a position' better."[1]

Though this might seem at first to be a superficial pursuit, it is worth examining what the novel prospect of "mak[ing] a position" implied about photography's changing purpose during the late nineteenth century, in terms of both practical studio mechanics and the medium's expanded function within the emergent field of mass visual culture. In the competitive marketplace of commercial portraitists, Sarony enjoyed a special reputation as the undisputed master of orchestrating creative forms of bodily pose. Nadar himself praised Sarony's "originality of poses and daring effects," and identified him as the only American photographer who significantly

advanced the artistry of the medium during what he referred to as their "primordial" generation of practice.[2] Modern historian Robert Taft noted similarly that Sarony's main contribution to photography in the United States was his successful attempt to dispense with the conventional, staid compositions previously used by the vast majority of the profession.[3] Being recognized as a master poseur is a dubious distinction, however, and even in the late nineteenth century, there were those who questioned the artistic value of depicting portrait subjects twisted into dramatic profile or lunging toward the camera in postures that bore little resemblance to everyday behavior. In 1878, a critic for the *Philadelphia Photographer* wrote dismissively of the portraits on display at Sarony's studio, "Cannot he turn out some fresh ludicrous wiggles?"[4]

Yet the deeper cultural significance behind the art of photographic posing (or of "not posing," as Sarony preferred to describe his studio method) lies in its remarkable contrast to what had come before. Whereas upright posture and uniform appearances represented ideals of dignity and good citizenship during the antebellum period, Gilded Age portrait photographs introduced a fashion for studied nonchalance, which took the form of idiosyncratic and seemingly spontaneous engagement with the camera. More than a simple stylistic shift, the deviation from past conventions signaled a fundamental reconfiguration of the medium's social purpose. Rather than serving as a vehicle for privately emulating others, photography was increasingly a public platform for individual self-expression. Sarony's ludicrous wiggles and theatrically inspired poses were orchestrated to captivate this new imagined audience by seeking and commanding attention.

The expanding reach and function of portrait images helped to fuel changing aesthetic preferences. During the decades following the Civil War, the expanding market for paper photographs and the rise of a national theater system in the United States made celebrity photography a hugely profitable American industry. Scholars have described how the carte-de-visite phenomenon democratized access to portraiture and allowed individuals to see their own images alongside those of celebrated figures they admired—presidents, authors, and actors—so that they might attempt to reshape themselves in emulation of these visual ideals.[5] What is less well explored is how the booming industry effectively redrew the boundaries between public and private imagination. In the expansive context of early mass visual culture, photographic portraits presented a new way for individuals to make themselves known to a vast audience in the form of mediated avatars. Despite their resolutely analogue form, carte-de-visite and cabinet card photographs functioned as an early form of social media in their capacity to connect people in unprecedented ways across vast physical distances. The intersection between photography and theater was fundamental to this transformation, for it supplied late nineteenth-century image makers and consumers with a significant framework for visualizing self-identity or "personality" before modern psychology emerged

as a cohesive system of thought at the turn of the twentieth century. These diverse factors, together with the imaginative break from past conventions for portraiture, helped reshape photography as an expressive modern art form.

PORTRAITURE AND THE DISCONTINUOUS SELF

The concept of "personality" emerged gradually over the course of the nineteenth century along with the dynamic modern conception of individual interiority that the word implies. Today, we use the term to describe characteristic patterns of thinking, feeling, and behavior that shape individual tastes and self-presentation without wholly or inexorably determining them. During the antebellum period, such behaviors were more typically attributed to the idea of *character*, which was presented as a relatively fixed quality. Though it was believed that character could be improved through diligent self-edification, factors of birth, ethnicity, race, and gender were fundamentally accepted as deep-seated determiners that placed hard limitations on an individual's moral and social possibilities. Cultural historians have connected reliance on the idea of character with demographic factors, such as urbanization and population growth, that fueled widespread anxiety about "confidence men" engaging in deceptive forms of social masquerade to disguise their inherent type. Popular fascination with etiquette books, along with pseudosciences like phrenology and physiognomy, were similarly driven by the desire to read external behavior and physical features as reliable registers of interior worth. Such systems of thought were undergirded by pervasive cultural and racial prejudices that used pseudoscientific evidence as justification for continuing bias.[6]

Though reliance on these kinds of fixed social markers had not wholly dissipated by the latter half of the nineteenth century, considerable evidence suggests a gradual shift from "character" to "personality" as an organizing social principle following the Civil War, along with growing acceptance of a more fluidly constructed "discontinuous self."[7] Departing from rigid antebellum ideas of character, the modern subject was conceived as mutable in nature and defined by diverse attributes that would be perceived differently under different circumstances. This more expansive construct of personality was composed of internal as well as external markers, including things like clothing and tasteful possessions, which, unlike the physical features read by phrenology, were within an individual's power to change.

In 1890, with his landmark *Principles of Psychology*, William James offered concrete articulation of this multifaceted model of self. For James, an individual could not be defined in purely physical or familial terms but was a more diverse aggregate of personal attributes and possessions—all an individual might rightly claim: "Not only his body and his psychic powers, but his clothes and his house, his wife and children, his ancestors and friends, his reputation and works, his land and horses."[8] Just as these

properties might fluctuate, so too did the constituent aspects of self wax and wane in relative importance. The Jamesian model outlined four main components of personality. In addition to the pure ego, which James described as the conscious sense of "I" that lent continuity to an individual's past and present, there was a material self, made up of things like belongings; a spiritual self, formed of core values and conscience; and a social self that determined who a person was and how he or she was perceived in any given situation. Of these, the social self was the most readily changeable; someone might be wholly different in the company of family or friends or strangers without being any more or less true to herself. From this perspective, the dimensions of individual identity were virtually limitless, since a person might have "as many social selves as there are individuals who recognize him and carry an image of him in their mind."[9] By establishing a self-image that was recognizable to others, an individual might define or redefine himself in meaningful ways, even as the core, spiritual sense of self remained stable and secure. Having the social freedom to represent and redefine the self remained a privilege that was limited by narrow racial and social categories in the context of the late nineteenth-century United States, but James's ideas nonetheless represented a starting point for modern notions of individual personality and a mutable, evolving sense of self.

The emphasis James placed on the visual definition of a social self provides important insight for understanding the public images that Sarony constructed of himself and others. James's theories acknowledged that individual identity was something to be negotiated across private and public spheres, with the social arena as a forum where limited degrees of personal variability might be acceptably expressed. This differed significantly from fixed notions of character, which was perceived to be constant regardless of circumstances. For the modern social self, personal discontinuity no longer necessarily indicated malfeasance but was positioned as a standard feature of normal social operations—a necessary adaptation to the varied demands private and public life placed upon the individual.

The stylistic evolution of portrait conventions over the course of the nineteenth century maps closely onto this shift between character and personality. Portrait images had appealed to art patrons as a representation of economic and cultural status since the colonial period in the Americas, when finely painted likenesses were embraced by urban gentry and wealthy landowners to project their established position in the social order. In this context, a personal or family portrait demonstrated a level of disposable income that was nearly as important as the aesthetic qualities of the picture itself. David Jaffee argues that the conventional alignment of portraiture and class achievement was further galvanized by the antebellum market economy. In the northeastern United States, itinerant portraitists traveled through the countryside during this period, creating images of the growing number of farmers, craftsmen, and merchants who sought "to consolidate their position in a new bourgeoisie" by purchasing

likenesses that ranged "from stark black-and-white silhouettes to colorful full-length oils," as their budgets allowed.[10]

The advent of photography at first did little to unsettle this traditional relationship between portraits and class symbolism. As Andrea Volpe points out, by the 1840s, many traveling portraitists had simply incorporated new technologies such as daguerreotypes and ambrotypes into their existing offerings to make a cheaper and more accurate portrait option available to the growing ranks of middle-class consumers. With the introduction of mass-reproducible paper photographs in the 1860s, however, portraiture came became affordable to practically every consumer. Cartes de visite, which were invented in Paris in 1854 by A. A. E. Disdéri, had become the preeminent form of portrait photography in the United States by 1861. The introduction of these small-scale, card-mounted photographic prints sparked a consumer frenzy popularly known as "carte-o-mania." Carte photographs could be purchased in American photographic studios for as little as a dime apiece, or $1 per dozen, allowing even working-class consumers to own portraits of family, friends, and celebrities and to display them side by side in specially produced albums. The result was a "deluge" of portraiture, as one trade journal described it, as thousands of consumers took part in an act of image making that historically had been reserved for elite strata of society.[11]

Though expanded access to portraiture had some democratizing effect, it also placed significant strain on the symbolic systems of meaning that governed traditional portrait practice. Whereas painted portraits stood as elite symbols of consumer privilege that connoted a specific sense of family or professional lineage, the ubiquity of paper photography multiplied these signs of distinction to the point of obsolescence—bending the visual language of portraiture to a new social purpose. Volpe has argued that the introduction of carte photography fundamentally altered how portraits participated in the process of class formation by restricting a portrait sitter to a conventional pose and standard form, thus helping produce a collective image of the white middle-class body that was recognizable by normative posture, props, and behaviors. "The carte was both proof and artifact of status and position, naturalized by the cultural authority of photographic realism that located status in the body itself."[12] In this conceptualization, photographic representation had the imagined power to correct and normalize, smoothing down irregularity in the social body by applying a prescribed set of portrait conventions. Alan Trachtenberg describes the social operation of an antebellum photographic studio similarly as a "theater of desire," where viewers might encounter portraits of presidents, generals, and other illustrious individuals and "make oneself over" in their image.[13] In both formulations, the mass-produced portraits of the early photographic industry transformed consumers into products—standardized depictions of middle-class respectability that were scripted according to a limited number of exemplary social roles.

The idea of photography as a system of social order resounds in descriptions of period portrait studios. Visitors to the opening of Mathew Brady's photographic gallery in New York in 1860 praised the portraits on display for depicting accomplished Americans of varying vocations "all in order" and "kept in best behavior." Their similar countenances and upright postures suggested an appearance of unity on the gallery walls even as political disputes and professional rivalries caused conflict in the world outside. One reporter for the *New York Times* wrote wistfully, "If the men themselves whose physiognomies are here displayed, would but meet together for half an hour in as calm a frame of mind as their pictures wear, how vastly all the world's disputes would be simplified."[14] The suggestion that photography presented a simplified view of social realities was supported and symbolized by the minimal compositional formulas that dominated the period. Most studio photographs by Brady and his contemporaries positioned sitters in sparsely furnished settings, using a parlor chair or drapery and architectural column to communicate respectability through the tasteful association with middle-class interiors. This consistent staging reinforced a visual language of respectability that corresponded with the prevailing understanding of personal character as stable, upright, and fixed within easily recognized forms.

These representational formulas were enforced with special stringency when it came to cultural orthodoxies surrounding gender. In his early treatise on photography, Marcus Aurelius Root wrote that it was important to arrange subjects in poses that conformed to ideal attributes of masculine or feminine behavior. He recommended photographing men in standing positions to demonstrate a "propensity to action, vigorous exertion, and power." It was more appropriate, in his view, that women subjects express "softer, milder qualities" by enacting a gesture that "gives the idea of something rather passive than active."[15] With a similar purpose in mind, the *American Journal of Photography* suggested that suitable poses for women included "examining a bouquet, arranging a vase of flowers, buttoning a glove, examining a picture, or reading a letter," quiet domestic activities that conformed to the ideal of feminine modesty and the private sphere of home life.[16]

Although the resulting likenesses were discussed in terms of representational accuracy, this professional rhetoric makes clear that a degree of performance was always expected in posing for a photograph. Sitters did not arrive at the portrait studio needing to button gloves or read letters but were directed to enact these behaviors because they aligned with preconceived scripts for what constituted normative gender roles. Though personalized negotiations may occasionally have been possible, the starting point for decisions about settings and poses remained a matter of preordained cultural convention, so the antebellum photographic studio only functioned as a "theater of desire" for subjects who aspired to conform to a narrow range of mainstream social expectations.

American and European studios used similar compositional formulas during this time. Two photographs, one of Sarony's brother Oliver and the other of Sarony's wife,

Fig. 13 | Camille Silvy (1834–1910), *Oliver François Xavier Sarony (1820–1879)*, 9 June 1861. Albumen print, 8.6 × 5.6 cm (3 3/8 × 2 1/4 in.). National Portrait Gallery, NPG Ax54278. Photo © National Portrait Gallery, London.

Louie, taken by London society portraitist Camille Silvy in 1861, demonstrate how setting, pose, and props were customized for individual sitters according to narrowly conceived frameworks of gender and class identity (figs. 13 and 14). Oliver appears in a space with striped wallpaper that has been staged to resemble an upper middle-class parlor and leans against a carved sideboard topped with a loving cup and flanked by a practical chair. Silvy's meticulous studio daybooks, which are preserved in the National Portrait Gallery of London, indicate that Louie's photograph was taken immediately before her brother-in-law's. Yet her portrait, though staged within the same wallpapered studio setting, deploys an entirely separate group of props and furniture that were presumably perceived to be more appropriate to her gender. The loving cup has been replaced with a potted plant, and an ornately framed mirror takes the place of the parlor chair. These symbolic props appear designed to emphasize the conventional feminine characteristics of fecundity and vanity, and they position Louie in a

bedroom or other private domestic space, instead of the public parlor Oliver imaginatively occupies. Her bodily pose has likewise been orchestrated to invite the viewer's gaze. Posing with her hand beneath her chin, she appears to turn from the mirror toward the camera—as though admiring herself or being admired by others are her chief occupations. Oliver, by contrast, stands with one hand in his pocket and the other marking a place in a book, as though the portrait process has distracted him from important matters to which he is impatient to return. The marked contrast in staging between these two portraits, taken back to back in the same studio space, demonstrates how much effort midcentury photographers invested in fashioning images that conformed to scripted gender narratives by casting male and female subjects in predetermined social roles and spaces.

By the mid-1860s, however, there was increasingly vocal demand for creative variation in the poses and compositions of photographic portraiture. In the United States, this change occurred rapidly and closely corresponded with growing acceptance of a mutable social self and the end of the Civil War. In 1863, *Humphrey's Journal*, a

magazine devoted to photographic arts, recommended that portraitists streamline studio output by having just "two or three different positions in which they submit all their models, whether tall or short, long or small." By 1865, however, the same journal admonished photographers to aim for variation, writing that "the conventional pillar and curtain" that had served as a conventional symbol of stolid respectability in thousands of portrait images had become "intolerable" through their overuse.[17] Suddenly, it seemed, the scripts and settings that had been reliable standards of an earlier era were in urgent need of refreshment.

Sarony's return to the United States, in June 1866, coincided with this desire to infuse stale portrait conventions with a dose of originality, and the excitement that greeted his arrival was generated in part by the perceived artistic novelty he introduced to the field. The photographer W. A. Cooper, writing nearly thirty years later, explained that Sarony's arrival had been momentous, though not because New York City had any shortage of excellent studios (as proof he named C. F. Fredericks, Jeremiah Gurney, Abraham Bogardus, and, "above all others of national reputation, Brady"). But the work of these photographers had been "good but conventional, and the line between photography and art closely drawn and rigid." By breaking all established rules of portrait composition, Sarony's work "battered down the existing worn out ideas of posing and lighting and placed photographers side by side with the painter and the sculptor."[18] Cooper's comments help explain the enthusiasm over photographs like the self-portrait Sarony used to announce his triumphant return to New York in 1866. Despite its conventional setting, the picture eschews the traditional costume and decorous pose used in photographs like Silvy's depiction of his brother, made just five years earlier. As a demonstration of how to break from the formulaic consistency and "worn out ideas of posing," it introduced a strategy for rewriting representational conventions at a time when the modern, discontinuous self was beginning to emerge.

Sarony's career in photography was devoted to depicting this theatrical and dynamically changing sense of self. It was a matter of approach as much as of content and was rooted in treating the portrait process as a form of collaborative play. This is perhaps most evident in a photograph he created of his wife around 1866, the same year that he announced his return to New York (fig. 15). Louie appears dressed in the same checkered suit and riding boots that Sarony himself wore in his self-portraits, and she assumes a similarly cavalier pose, leaning against a carved wooden sideboard with her hands in her coat pockets and legs crossed at the ankle. Louie's costume and pose are obviously at odds with conventional norms for feminine portraiture, and her performance bears little resemblance to the coquettish self-admiration displayed in her photograph by Silvy. In fact, the later Sarony portrait seems to combine elements from Louie's and Oliver's 1861 images, including a loving cup atop a sideboard but casting a woman in the public-facing role and confident posture previously reserved for

men, as if identifying and undermining the conventional symbolic purpose of these compositional elements was part of the intent behind the photograph's creation.

After the couple moved to New York City, Sarony's self-portrait in the checkered suit and fur cap was famously and frequently caricatured, but when Louie's gender-bending portrait was taken, before they had left Birmingham, his public image was not well enough known to merit playful reinterpretation. The circumstances surrounding the photograph's creation and circulation are entirely undocumented, but its existence suggests the intriguing likelihood that Louie was an active participant in shaping her husband's career and public image. It also offers potential insight into a process of portrait making in Sarony's studio that was based on playful improvisation and experiments with costume, setting, and pose, rather than the compositional scripts that dominated photography earlier in the century.

Louie was Sarony's favorite model and muse during the early years of his portrait business, perhaps in part because she was a ready and willing subject when, as Nast described it, the photographer practiced his art for hours on end. Visitors to the New York studio during the 1860s recalled that the walls of his waiting room depicted Mrs. Sarony in an array of different guises, wearing veils ornamented with coins (fig. 16), carrying a lace parasol for a visit to the seaside, and in fashionable attire seated on a café chair. By the 1890s, a newspaper speculated that apart from celebrities such as Sarah Bernhardt and Lillie Langtry, Louie Sarony had perhaps been "photographed more times and in more poses than any other living person."[19]

In addition to demonstrating the close working relationship between husband and wife, the images on display served the practical purpose of illustrating the diverse range of portrait styles on offer at the studio through multifaceted techniques of lighting and staging. Louie's veiled photo employed a lighting technique known as "front shadow" (referred to in early twentieth-century photography textbooks as "Sarony lighting"), while others showcased the studio's stock of painted backdrops and facility for fashionable staging and poses.[20] Most important, and whether or not the average studio visitor recognized the specific techniques deployed, the many photographic faces of Mrs. Sarony proved that an individual subject could inhabit numerous public characters convincingly, even if she was not a professional actress or prominent citizen. In their sheer variety, they illustrated a new and expansive range of possibility for the "theater of desire" by revealing that the expressive wishes a photographic portrait could fulfill need not be limited to basic virtue.

One visitor to the Sarony studio in the early 1870s described seeing a photographic album apparently intended to function in these very terms. It contained "perhaps sixty to seventy pictures of the same person, in various garbs and attitudes, all equally true to life." Turning through the album pages, he remarked that though the same facial features could be recognized in each portrait, they were otherwise so "varied in expression as to be calculated to deceive a careless gazer into believing that they

Fig. 15 | Napoleon Sarony, *Portrait of Louie Sarony*, ca. 1866. Albumen silver print; carte de visite, 10 × 6 cm (3 15/16 × 2 3/8 in.). Library of Birmingham, UK, MS 4256 (2012/096), vol. 8.

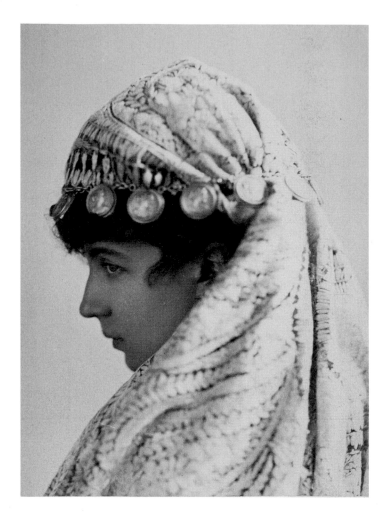

Fig. 16 | Napoleon Sarony, *Portrait of Louie Sarony*, ca. 1870s. Albumen silver print; carte de visite, 10 × 6 cm (3 15/16 × 2 3/8 in.). Harvard Theatre Collection, Houghton Library, Harvard University.

represent different persons," a fact that seemed to testify to the "myriad shades and variations of which one face is capable."[21] For a single subject to be "true to life" and still depicted in assorted guises suggests a reversal of the priorities that had ordered antebellum photography. Like the portraits of Louie on display in the studio reception room, the photographic album showed how an artful public image could be simultaneously individualized and multifaceted, suggesting how the modern social self in all its permutations could work in concert with the medium of photography to assert individuality on an expansive, mass-media scale.

UNCONVENTIONAL SELF-PERFORMANCE

Along with the studio experiments depicting himself and his wife, Sarony's most significant early work in photography was a series of portraits taken in 1866 of the American actress and poet Adah Isaacs Menken. A longtime member of the New York City

bohemian scene, Menken achieved international notoriety in the 1860s for her leading role in a dramatic adaption of Lord Byron's narrative poem *Mazeppa*. Byron's poem tells the story of a Ukrainian prince who is punished for an illicit love affair by being stripped naked and tied to the back of a wild horse, and much of the text relates the prince's inner monologue as he gallops helplessly across the countryside. The work was first adapted for the American stage in 1833 as *The Wild Horse of Tartary*, which presented a dramatic reenactment of the events immediately preceding Prince Mazeppa's punishment. Peppered with romantic melodrama and crowd-pleasing sword-fights, the play was a decades-long popular success that was revived in numerous adaptations.[22] Invariably, its highlight was the final scene, when, in most productions, a live horse topped with a mannequin costumed as Prince Mazeppa was led onstage and then sent careening through the theatrical audience as the curtain fell.

Menken was not the first woman to play the role of Prince Mazeppa, but she ensured that her performance would be the most sensational by leaning into the transgressive sexuality of her gender-bending part. Additionally, instead of using a dummy to enact the dramatic conclusion, Menken was stripped of her costume onstage and personally lashed to the horse before its unpredictable run through the theater. The combination of sex and potential bodily harm proved an irresistible draw. Though in reality the actress remained fully clothed, wearing a light-colored shift, short bloomers, and thick stockings that created the illusion of bare skin, she was shockingly undressed by the public standards of the day, and theater audiences across the United States, England, and France flocked to see her perform this famous "nude scene."[23]

Menken's controversial stage production drew upon the same perceptual ambiguity that animated contemporary debate over the artistic legitimacy of photography. Theater historians observe that the confusion over whether the actress was nude onstage appears to some extent to have been genuine. The play's producer, E. T. Smith, was an acolyte of the Irish-born American playwright Dion Boucicault, whose influential model of dramatic realism employed technically sophisticated special effects to produce a "paradoxical method of representing 'realism' through a distinct reliance on artifice," as Daphne Brooks puts it.[24] Menken's potential nudity was therefore in keeping with the atmosphere of visual uncertainty that characteristically accompanied such productions. When the curtains opened to reveal the actress in a tight white costume strapped to a horse, the audience saw only a blur of bodies before a lightning effect flashed, the music blared, and the horse galloped past. Unsure about what exactly they had seen, many chose to suspend disbelief and accept the illusion, swearing afterward that they had truly seen Menken in the nude. Promotional illustrations for *Mazeppa* deliberately stoked this misapprehension by portraying the actress in a costume similar to the one she wore onstage but with her breasts partially exposed, while at the same time nodding to the gender ambiguity of her performance by showing her with sword raised in the defiant, masculine pose of a military hero (fig. 17). The suggestion

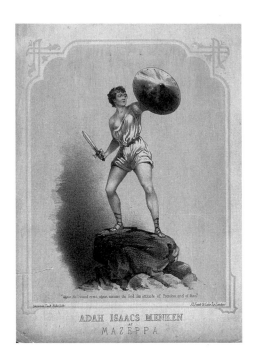

"Again do I stand erect, again assume the God like attitude of Freedom and of Man"

Conversine Park, Robe. lith.

M. J...k & Co...., London

ADAH ISAACS MENKEN
as
MAZEPPA

of androgyny and nudity was no doubt engineered to serve the practical purpose of promoting ticket sales, but it also succeeded in expressing the dynamism and daring that made the risqué performance a popular success.

More than playing with the titillating taboo of public nudity, it was the play's multivalent ambiguities—in terms of gender, morality, and artistic integrity—that drew respectable middle-class audiences to see *Mazeppa* in great numbers. In this regard, the timing of the production's opening—in 1861, at the start of the American Civil War—played a critical part in its acceptance. Not only had cross-dressing become relatively standard theatrical fare by the early 1860s,

with actresses like Charlotte Cushman commonly playing so-called breeches roles, but such defiance of conventional norms represented just a single facet in a flourishing midcentury culture of constructed opposites—North and South, Black and white, humbug and didacticism—and a popular fascination with seeing such seemingly impermeable boundaries transgressed, if only within the safely contained realm of theatrical performance. Menken's gender-bending turn as Prince Mazeppa resonated with contemporary viewers, not simply because it was controversial but also, as Renée Sentilles has written, because its moral and sexual ambiguities "reflected the competing images of the surrounding world."[25] In this cultural atmosphere, Menken was able to avoid alienating public audiences even as she shocked them, since her performance transformed a profound destabilization of conventional gender norms into relatively harmless entertainment.

One of the principal strategies Menken deployed in her negotiations of social propriety was insistently framing her performance in terms of artistic expression. Rachel Shteir notes that although Menken was hardly the only actress to demonstrate "sexual fluidity" by appearing undressed or cross-dressed during the Civil War era, she was among the first to declare her onstage social transgressions to be in the service of her vocation—to announce regularly and prominently, "I am an artist," in defending her work against critics of its alleged indecency.[26] In parallel to Sarony's flamboyant public performance as an artist-photographer, Menken bolstered her own rhetorical claims of artistry by styling her offstage appearance to resemble that of *Mazeppa*'s author, Lord Byron. As the bad boy of British Romanticism, Byron appalled and thrilled readers

in equal measure, with a strident sensuality that was expressed through his androgynous public image as well as his writing. As Menken became increasingly associated with Byron's work, she adopted his characteristic personal style as well, wearing her hair in short curls swept toward the face and favoring ruffled shirts left daringly open at the throat.[27] Playing the role of artist onstage and off, Menken developed a layered set of fictions in which to reside, effectively shielding herself from moral criticism with a camouflaging alter ego, while at the same time embracing artistry to provide cover for otherwise risqué behaviors.

Menken and her defenders similarly sought to repudiate moral criticism through explicit analogy to fine art, and legitimized her onstage "nudity" as Prince Mazeppa by describing her performance as directly inspired by the art of sculpture. Responding to a scathing review of the production's London premiere that condemned the actress as a "corruption from America," Menken wrote that having long been a student of sculpture, her onstage attitudes were "selected from the works of Canova," which, though unappreciated by the British critic, "present a classicality which has been invariably recognized by the foremost of American critics."[28] Though no critics in the United States mentioned Canova as a point of reference, many did align Menken's theatrical nudity in *Mazeppa* with the exhibition of Hiram Powers's *Greek Slave* during the previous decade. This comparison was not always complimentary, however. Samuel Clemens, writing as Mark Twain, observed that the "thin tight white linen" sheath Menken wore onstage was about as revealing as the costume worn by Powers's (nude) neoclassical sculpture, though the actress's "postures are not so modest."[29] Others pointed to the perceived chastity of *The Greek Slave* to support the possibility that Menken's performance could be simultaneously moral and immoral, titillating *and* artistic. Most likely, just as viewers crowded to see the sculpture during its 1847–51 tour of the United States—alternately outraged, moved, scandalized, and appreciative of its artistic qualities—observers had genuinely mixed reactions to Menken's sexually charged performance. Yet, whether they judged her to be artful, indecent, or something in between, most were united in fascination by the actress's ability to maneuver fluidly between the polarized values that structured contemporary culture.

Menken's refusal to be contained by existing cultural norms should have made her an ideal muse for the fledgling art of photography, but many commercial portraitists struggled to reconcile the fluidity of her gender performance onstage with the narrowly defined portrait conventions of the period. Most of them simply attempted to reassign her androgynous posture within recognizable binary categories of male or female, rather than explore, as she did, the generative creative possibility of an identity in between. Consequently, most extant photographs emphasize the perceived naughtiness of a "breeches role," either by posing Menken in a stereotypically masculine attitude of mock physical strength or by making clear that she was a woman playing a male character by falling back on gendered portrait conventions. Photographer

Alphonse Liébert, for example, enhanced Menken's girlish qualities, picturing her as a damsel with her hands clasped beside her chin and her ankle splayed at a coquettish angle—a depiction that had more to do with the actress's offstage attractiveness than with her theatrical role as a romantic warrior prince. The result in either case was to avoid the sexual dynamism that made her performance compelling as well as controversial, by representing her character within the limited visual framework of normative gender categories.

Sarony's photographs of Menken, by contrast, were a phenomenal popular success—in part because they embraced the dynamic complexities of Menken's public performances on- and offstage by deploying the same spirit of play that animated his contemporary portrait of Louie (fig. 18). Sarony probably photographed Menken in January 1866, when the touring company for *Mazeppa* passed through Birmingham.[30] He recalled that when the actress visited his studio, she announced that she would agree to be photographed only if she could choose her own poses. Frustrated by previous photographers' attempts to portray Prince Mazeppa, she was no longer willing to compromise on how the part was enacted before the camera. Sarony accepted her challenge on the condition that after she chose her eight poses, he would be allowed to pose her in eight additional frames. The following day, Sarony visited the theater to present the actress with the results. After seeing the eight frames she had orchestrated, the actress was crestfallen, and said, "They are perfectly horrible! I shall never have another photograph of myself as Mazeppa taken as long as I live!" But when she saw Sarony's poses, she exclaimed, "Oh you dear little man! I am going to kiss you for that"—and then, the photographer reported, "She did!"[31]

What might have pleased Menken about the photos is that instead of relying on conventional studio formulas to emphasize either the femininity or the masculinity of her character, Sarony drew on the uncertain theatrical realism of her "nudity" when conceiving her poses. His portraits reimagine her risqué theatrical costume within the context of traditional depictions of the nude in Western art, showing her stretched out on a divan or wrapped in furs that subtly evoke Mazeppa's harrowing ride through the theater (fig. 19). Though the light-colored costume she is wearing remains clearly discernible, the sensuous pose of her starkly illuminated figure makes it possible to suspend disbelief—as many theatergoers did—and imagine Menken as Mazeppa, nude upon the stage. In this way, the photographs provide a successful visual analogue to the spectacular experience of her performance. At the same time, far from being explicitly sexualized boudoir photographs, Sarony's portraits provided support for Menken's argument about the artistic necessity of her bodily display, with poses that are calculated to invite association between her theatricalized nudity and a reclining Venus by Canova, or the classical form of *The Dying Gaul*. Positioned on the ground beside her scattered weapons, Menken appears in Sarony's photograph to be simultaneously odalisque and warrior, a complex mix of gendered markers and

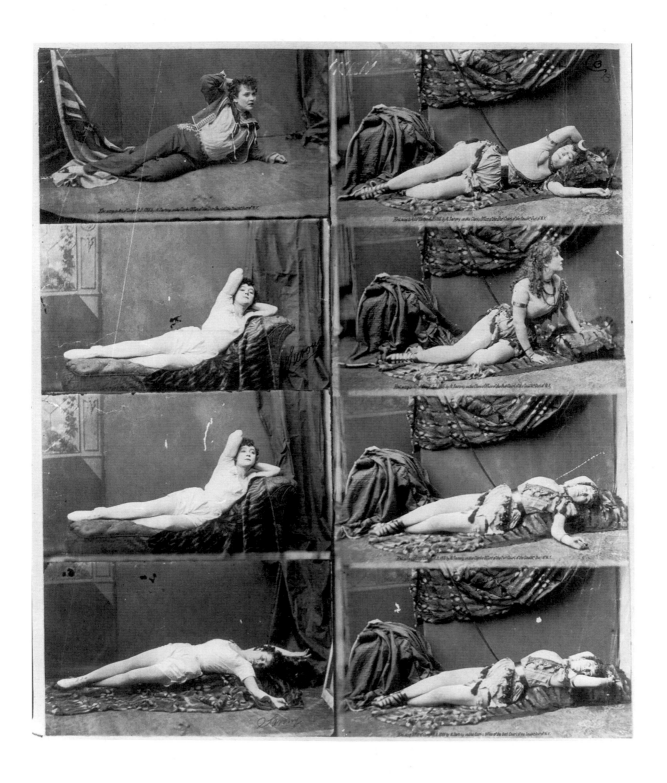

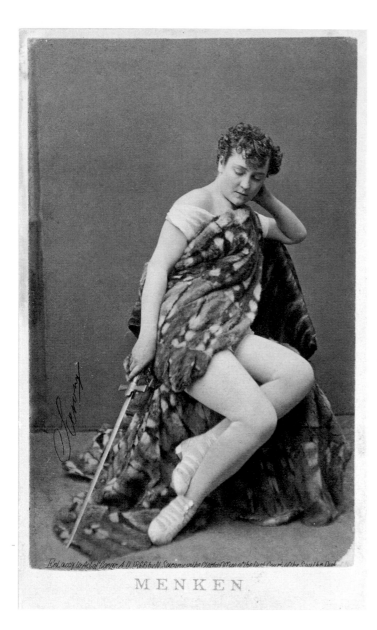

Fig. 19 | Napoleon Sarony, *Portrait of Adah Isaacs Menken*, 1866. Albumen silver print; cabinet card, 10.1 × 6 cm (4 × 2 3/8 in.). National Portrait Gallery, Smithsonian Institution, NPG.80.154. Photo: National Portrait Gallery.

MENKEN

references to high culture within a low cultural form. With cropped boyish hair and a low-cut chemise, she embodies the androgynous magnetism and courageous defiance of period binaries that drew fascinated audiences to see her perform.

The public responded to the photographs with an enthusiasm that rivaled Menken's. Shortly after their creation, Menken began selling the portraits as souvenirs of her tour, and they circulated internationally by the thousands as cartes de visite. Demand for the pictures was so great that for weeks Sarony's staff in Birmingham spent all day printing sheets of photographs and all night mounting and packing images

for shipment. Even so, local observers recalled that the studio was so overwhelmed by orders that the "prints could not be washed properly but were soaked together in solid blocks."[32] For Sarony, who had joined the studio only two years earlier, the portraits were a financial and professional windfall, helping him establish an independent name as the artistic counterpart to his business-minded brother, and probably funding his triumphant return to New York.

Sarony's portraits of Menken were also the first for which he received critical approbation, though reactions were as wildly contradictory as the responses to *Mazeppa*. The *Art Journal* of London recognized the work for its unconventional ambition and grounding in traditional fine art forms, writing that Sarony's portraits of Menken were "of the rarest possible excellence, combining accuracy and force in outline with tone and harmony such as we have seldom seen. . . . His copies from life seem at first sight to be transcripts of paintings."[33] Others regarded the pictures as they did Menken's stage performance: as wantonly lascivious. British theater historian Thomas Edgar Pemberton, who was a teenager in Birmingham at the time of Menken's visit, wrote wistfully in 1890, "I still think regretfully of the very liberal photograph of her which I purchased from Sarony—(a Birmingham institution of those days)—and which was taken from me and destroyed by a still shocked aunt."[34] If public fascination with Menken stemmed from her bold defiance of period norms, the success of Sarony's photographs—and what made them distinct from other contemporary portrayals—straddled a similar line between art and indecency, high- and lowbrow culture. Moreover, the episode provided a foundational example of how celebrity and artistry were yoked together throughout Sarony's career as a photographer; his professional visibility relied on Menken's scandalous notoriety while simultaneously helping to establish the high-minded legitimacy of his work.

Sarony was fond of recounting his encounter with Menken in later years, both as a testament to his professional origins and because it illustrated a central tenet of his practice: that the success of his portraits resulted from his artistic instincts for orchestrating pose and composition. Menken might have approached the camera from the perspective of an actress playing a part—thinking of it as an impartial spectator rather than an idiosyncratic instrument for which some angles and poses worked better than others—while Sarony in turn supplied direction that elevated the composition of portraiture to artistic heights. Sarony's session with Menken included at least thirty distinct poses and an array of costumes, indicating that their shared endeavor far exceeded the sixteen frames they had initially agreed to, as well as any practical need to portray Mazeppa. Although scant information about their studio encounter has survived, the photographs themselves make it appear that they were simply having fun, entertaining each other through the collaborative art of portrait making. After Menken's untimely death in 1879, a Chicago journalist remarked that Sarony's widely circulated photographs offered a multifaceted glimpse of the captivating actress. "She

is dressed, sometimes, in velvet and furs to the throat, and with large black eyes, looking out from under artistically tangled curls. Sometimes she is in black silk, with mantle draped gracefully about her; and once with Sarony's own seal-skin cap on her head."[35] Indeed, a seated portrait of Menken in a dark silk dress and striped shawl shows the photographer's fur cap, familiar from his self-portrait images, perched upon her curls (fig. 20). This artifact of material exchange between subject and artist reveals the playful atmosphere that Sarony cultivated around the art of photographic portraiture. As Nast described it in his hours of studio performance, or in Louie Sarony's mischievous imitation of her husband, the innovation he introduced to late nineteenth-century photographic portraiture lay in this social record of interpersonal improvisation, visibly relaxing the moral uprightness that previously gripped the art of photography.

Fig. 20 | Napoleon Sarony, *Portrait of Adah Isaacs Menken*, 1866. Albumen silver print on card, 10 × 6 cm (3 15/16 × 2 3/8 in.). Harvard Theatre Collection, Houghton Library, Harvard University. Photo: Google Books.

SUGGESTIONS FOR POSING

Embracing performative abandon in photographic portraiture required careful negotiation of a finicky technology. Before cameras operated quickly enough to capture action or candid images, representing human bodies in a way that appeared spontaneous and natural required conscious forethought, skilled orchestration, and sometimes special equipment. Beginning in the late 1860s, as part of the push to improve the industry's creative range, British and American photographic magazines and journals regularly published special sections titled "Suggestions for Posing," which outlined ideals of tonal balance, lighting, and form and included illustrations of gracefully posed figures excerpted from paintings, sculpture, and exceptional photographs (fig. 21). *Anthony's Photographic Bulletin* noted that careful study of these pictures was of the utmost necessity, since aesthetic treatises were of little use without also "educat[ing] the eye to distinguish between superior and inferior modellings by comparison."[36] A similar feature in the *Illustrated Photographer* in February 1868 noted that the accompanying pictures were intended to acquaint commercial portraitists with principles of ideal artistic figural arrangement in hopes of moving the industry beyond "the

common, monotonous range of ordinary photographic posings."[37] Included among the illustrations, alongside fashionable ladies and shepherdesses extracted from contemporary French paintings, was a reproduction of one of Sarony's self-portraits from Birmingham. The *Illustrated Photographer* noted that Sarony's remarkably natural and artistic posture had been made possible using a special "Posing Apparatus" that would allow any photographer to achieve a similar semblance of posed spontaneity regardless of his level of artistic training.[38]

The Sarony "Patented Posing Apparatus" was presented as a secret weapon against the monotony of ordinary photographic poses and as what imbued the artist's self-portraits and his images of Adah Isaacs Menken with grace and seeming spontaneity. Patented by Oliver Sarony in 1866, the device was marketed by the Sarony brothers to photographers in England, France, and the United States from the 1860s through the 1880s.[39] It was designed as an improvement upon the rigid metal posing stands that had been used in portrait studios since the daguerreotype era to steady the body and prevent blurring during long exposure times. In their conventional form, these stands were notoriously uncomfortable and were often referred to as "iron instruments

of torture" by those who experienced a session in their clutches. They held subjects at the back of the neck with a single iron clamp that slid up and down along a vertical pole, and their limited adjustability made them a poor fit for small children or large adults. The Sarony apparatus served a similar practical purpose but had multiple branching arms extending from a rack-and-pinion floor system, which allowed the brace to be easily customized to support bodies of different sizes and a variety of unconventionally animated poses.

It is somewhat ironic that a mechanical shortcut would be suggested as an appropriate solution to the perceived lack of creativity in the portrait industry, but that is not the only puzzling aspect of this fugitive photographic object. Though it was frequently discussed in positive terms in American and European trade literature and was endorsed by prominent photographers, no surviving examples of the "Sarony Patented Posing Apparatus" are known to exist. Moreover, since the device was designed to be invisible in photographs, its actual efficacy as a physical support is harder to perceive and evaluate than what its advertisement signaled about changing cultural desires around photographic portraiture during the late nineteenth century. In this sense, it is useful to consider Sarony's posing apparatus as both a physical artifact of historical photography and a rhetorical framework for describing how the visual templates of an earlier generation were gradually adapted to new creative purposes. Volpe writes that during the antebellum era, traditional posing stands served as "both brace and caliper" for aligning portrait subjects with a socially desirable posture of uniform uprightness. Their rigid uniformity supplied an "exoskeleton for the aspiring middle class: an exterior visible mechanism by which bodies were held and molded."[40] With its branching arms and flexible range of motion, the Sarony posing apparatus signaled an emerging preference for portraits that highlighted the unique characteristics of individual sitters, but that there continued to be a perceived need for a "brace and caliper" to mold subjects' bodies illuminates the delicate balance period photographers struck between embracing creative freedom and maintaining technical control over their businesses and their artwork.

When the Sarony brothers first publicly demonstrated their invention at the Royal Photographic Society in London in February 1866, it was presented as the end of old-fashioned posing stands. Newspapers announced that "the day of deliverance" had arrived for those who feared having their portraits taken thanks to that "marvelously misnamed photographic contrivance the 'head rest.'" J. E. Mayall, favored portraitist of the royal family, testified to the gathered company that he had begun using the Saronys' stand in his studio. To his mind, the device was "what all photographers had been looking for and trying to invent," since it combined mechanical stability, easy adjustment, and, most important, "comfort for photographic sitters."[41] The result freed photographers to choose dynamic and expressive postures for their subjects without fear of blurred limbs or spoiled plates, and without forsaking the

clarity of detail that long exposures made possible.

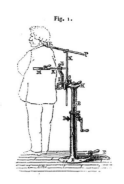

The device was presented later that year to the Société française de photographie in Paris with similar success. The SFP's bulletin published an enthusiastic description shortly afterward of the "appareil de pose de Sarony," along with a pair of illustrations that showed how its adjustable supports could accommodate standing and seated positions (fig. 22). Key to its effectiveness was the fact that the Sarony apparatus supported the body at multiple points. "It must be understood that this is not only a head rest, but also a lumbar support with diverse *barres* and *planchettes* that support the model as well as whatever props might be desired to surround him."[42] Bristling with cranks and jutting metal rods, the contraption hardly looks welcoming or comfortable, but the depicted figure nonetheless appears at ease in the machine's embrace, draping one arm casually over its lowest support as if relaxing at home.

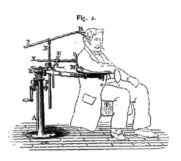

Fig. 22 | Illustrations from *Appareil de pose M. Sarony*, in *Bulletin de la Société française de photographie*, November 1866. Photo: Hathi Trust.

The question of sitters' comfort was more than just a nicety. It was also a potent strategy for improving business and legitimizing the professional standing of photographers. Tanya Sheehan notes that the enforced stillness and use of old-fashioned posing stands led to the common perception that photographic portraiture could be a physically painful experience. At a time when notions of character prevailed, the so-called pain of portraiture and its potentially deleterious effects on the body caused special anxiety, since awkward appearances in a photograph could signify deeper personal flaws. One rhetorical solution was to link the camera to recent medical advances such as surgical anesthesia, which allowed photographers to claim expertise in curing social as well as aesthetic ills. Advertisements for the Sarony posing apparatus employed this very strategy. An 1867 promotion included a testimonial from a satisfied client, who said, "Those of you who have taken laughing gas to ease the pangs of tooth-pulling, know what an improvement it is upon the old plan. . . . With Mr. Sarony's machine you may feel so at ease as to forget you are having your picture taken." Establishing a link between modern medicine and modern photography helped conjure what Sheehan describes as a "fantasy of instantaneous photography," which countered the pain of portraiture by imaginatively rebalancing the material apparatus of photography and its relationship to time.[43] Like the posing apparatus itself, it did not

represent a technical solution to the problem of slow exposure times, but it reframed the pain of portraiture as a burden that could be overcome through the virtue of a photographer's artistic expertise.

In March 1867, Edward L. Wilson, the editor of the *Philadelphia Photographer*, visited Sarony's studio to learn more about the posing apparatus that had been the subject of international discussion. He confessed to feeling "the usual fear" when first confronted with the device, but after seeing it in use he was persuaded that the machine lived up to its reputation for ameliorating painful portrait experiences. "Visions of poor photographers who had pinched their fingers on the old (un)rest, young women with torn waterfalls [pleated bustles] and ruined dresses; little children with bruised heads and full of fright . . . all vanished." Though the innovation held promise for eliminating the pain of portraiture, Wilson expressed more excitement about its creative possibilities. "It suggests positions as profusely as a kaleidoscope does colors and shapes, and the effects that it is possible to achieve with it are extremely beautiful and pleasing."[44]

In illustration of his point, Wilson's article was accompanied by a real photograph selected from a series called "Sarony's Photographic Studies" and tipped into the journal's "Our Picture" section, where Notman's *Caribou Hunting* had been featured the previous spring. Sarony's photographic studies were gridded sheets of portrait images, each depicting a single subject in a range of eight poses (fig. 23). They were marketed by the Sarony brothers alongside their posing apparatus as a way of illustrating its use and capabilities in the studios of commercial photographers. Contemporary advertisements listed thirty subjects in total, each of which was available by mail order for one dollar. Two studies in the series featured Napoleon Sarony himself, detailing the sequence of poses that yielded his famous self-portrait images, and five featured Adah Isaacs Menken in her role as Mazeppa, in costume for a play called *The French Spy*, and dressed in everyday street attire.[45] The remaining studies depicted ordinary men, women, and children—each in an orderly grid of eight distinct poses. Their distribution in the pages of the *Philadelphia Photographer* made them similar to the line engravings typically included in trade journals' "Suggestions for Posing" sections, although their photographic form provided more direct inspiration to contemporary portraitists.

One gridded sheet of these studies shows a young woman identified as "Miss H—" wearing a riding habit and top hat. She appears in the first frame leaning against a handsomely upholstered chair that served to conceal the posing apparatus (and was also available for sale from the Sarony brothers). The following three frames depict Miss H— at three-quarter length, first looking past the camera, then looking down and raising her riding crop, and finally leaning casually against the posing chair and wearing her top hat. The bottom row comprises four full-length standing postures, first wearing her hat and standing in three-quarter profile, then with hat off and turned to face the camera, and, finally, leaning against the posing chair that is pictured in the

Fig. 23 | Sarony advertisement, "Sarony's Photographic Studies, No. 17," 1866. Albumen silver print from glass negative; lithograph, 18.4 × 24.77 cm (7 ¾ × 9 5/16 in.). The Metropolitan Museum of Art, New York. Gilman Collection, Joyce F. Menschel Photography Library Fund, 2005, 2005.100.778. Photo: The Metropolitan Museum of Art.

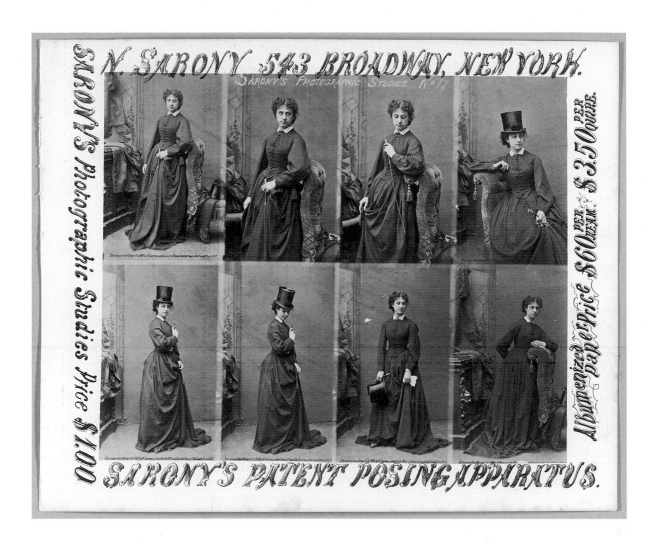

first frame. Though no discernible sequence of narrative or motion links one frame to the next, the juxtaposed images encourage the viewer to seek connections between the poses, imaginatively reconstructing the action that must have occurred between the frames to produce each distinct composition.[46]

For the original viewers of Sarony's studies, the light lines separating each frame provided a vital clue for reading the relationship between images, since they revealed that the gridded photographs had been made with a multilensed carte-de-visite camera, which allowed multiple exposures to be created on a single wet collodion glass plate. One major advantage of Disdéri's multiplying camera had been to maximize the working efficiency of a busy portrait studio, since photographers no longer needed to pause between poses to prepare a new plate and reload their camera. However, time remained a pressing issue. Because collodion plates were light sensitive only when their emulsion was wet, a photographer had just fifteen minutes to make all desired

exposures and develop his plate. Informed by this technical knowledge, Wilson and other contemporary photographers described Sarony's gridded studies in terms of their "intensity of action," a reaction that had less to do with the depicted poses than with what they understood to have occurred between the frames, as Sarony and his assistants raced around the studio preparing each unique exposure during the limited time frame allowed.[47] Wilson noted to readers of the *Philadelphia Photographer* that examining the frames of the photographic studies revealed "the changes in position that can be rapidly made in using Mr. Sarony's machine. With the old arrangement it would be almost impossible to secure eight positions before the film became dry and horny."[48] From this perspective, the additional compositional flourishes Sarony included in his study of Miss H—, such as rearranging furniture and changing the camera position between frames, were probably engineered to impress a canny audience by displaying an extra layer of time-consuming difficulty.

Usually, the sheets of eight exposures produced by the carte-de-visite camera were cut apart to produce small-scale individual photographs, but in the 1860s there was also a market for uncut gridded sheets like Sarony's photographic studies, which were consumed as novelties and templates for artists. Aaron Scharf notes that these so-called progressive series, showing a figure or figures directed through a series of motions, were also sold by the Disdéri studio, and that Degas used them as models for his pastel and oil studies of ballet dancers.[49] The difficulty for producing progressive series was that time did not often allow for eight separate poses upon a single plate. In 1860, Ernest Lacan, editor of the French photo journal *La Lumière*, visited Disdéri in his studio and marveled at the efficient pace of his work: "In my presence he took four portraits in the space of twenty minutes, giving each model two different attitudes." Lacan reported that the eight exposures, which were taken in "good light," required ten to twelve seconds apiece, which meant that they required only a fraction of the plate's total viability.[50] What seems to have been more difficult and time consuming, even for a master of the form like Disdéri, was orchestrating a subject into "different attitudes" and adjusting the lighting and staging of each shot accordingly before the wet plate began to dry. Numerous examples of uncut portrait sheets survive from the Disdéri studio, most showing between four and six distinct poses across eight individual frames. A print made in 1866 illustrates results similar to those Lacan described, showing a model pictured in four poses (two of each), for a total of eight portraits (fig. 24). Another common pattern depicts individual subjects in separate poses on one side of the plate, with duplicated positions in the top and bottom rows one after the other, as if the photographer realized that it was necessary to rush through the final poses as the wet collodion solution began to dry.

Part of the reason, then, for the "monotonous range" of poses that plagued studios in the 1860s was the rushed pace at which photographers had to work, balancing the niceties of customer relations against the speed that the medium required.

Fig. 24 | André Adolphe-Eugène Disdéri (1819–1889), *Esther David*, 1866. Albumen silver print from glass negative, 18.4 × 24.8 cm (7 ¼ × 9 ¾ in.). The Metropolitan Museum of Art, New York. Gilman Collection, Gift of The Howard Gilman Foundation, 2005.100.588.2.142. Photo: The Metropolitan Museum of Art.

Many observers regarded this rapid pace of production as detrimental to advancing the art of photography. Nadar's gridded *Autoportrait tournant*, which was created around 1865, appears to lampoon the lack of personal expressiveness in most carte photography (fig. 25). This self-portrait in the round was created using a multiplying camera that allowed twelve individual exposures, which may suggest that the images were intended as the basis for a photosculpture, a half-manual, half-mechanical process that transposed silhouetted outlines onto clay.[51] In its photographic form, each frame shows the photographer in a slightly rotated position, wearing the same vapid expression, beginning and ending with views of the back of his head. Though this effectively documented the photographer's appearance from every possible angle with industrial efficiency, Nadar's serial images provided no sense of idiosyncrasy or personal insight, revealing that quantity was a poor substitute for quality when it came to personal representation.

Sarony's photographic studies and posing apparatus were designed to help photographers achieve a greater range of creative artistic effects without sacrificing the efficiency that had made the carte era profitable. The praise Nadar and Wilson offered Sarony for his "originality of pose" and "intensity of action" suggests how perceptions of aesthetic success were measured against historically specific technical knowledge and

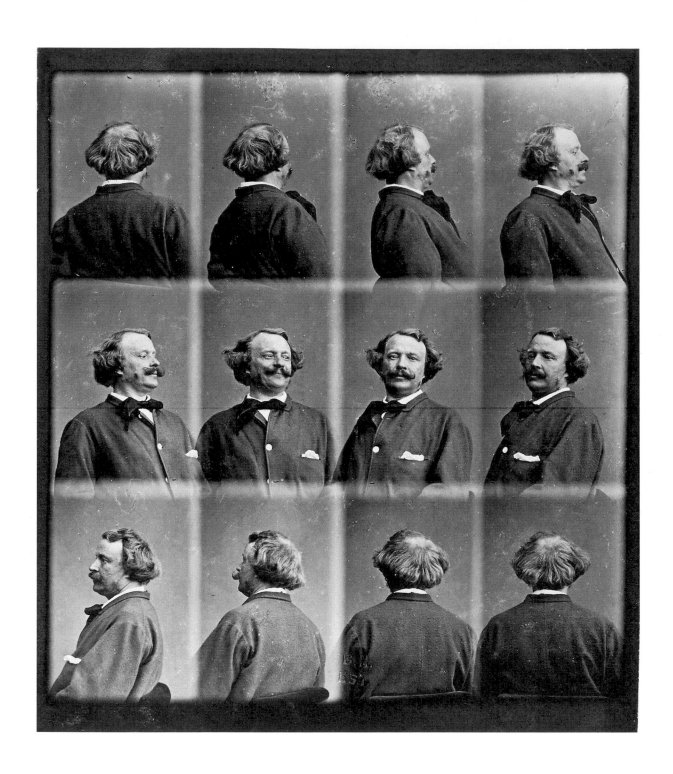

period rhetoric surrounding the "fantasy of instantaneous photography." This helps explain why displays of photographic speed and artistry that dazzled nineteenth-century viewers are often incomprehensible today. For example, in 1873 an author for *Albion* magazine described his amazement at a photograph from Sarony's studio that appeared to depict a woman walking in full stride. Muybridge's stop-motion experiments in California earlier that year produced only faint and poorly focused results, so the prospect of photographing a detailed figure in motion remained a technically impossible feat. Yet even knowing this, the author was startled by the persuasiveness of the image. "She looked just as though her action was caught by a flash of lightning. The lady almost *walked*—so natural and easy and graceful withal did she come from the camera of Sarony."[52]

Although the subject of this remarkable photograph is identified only as "Sarony's Walking Lady," the picture probably resembled a portrait of the actress Lida Cannon that was taken around the same time and artfully posed to give an appearance of motion (fig. 26). Cannon is portrayed leaning forward in a long stride with her skirts gathered to one side to facilitate a rapid pace of movement. She looks toward the viewer with an air of surprise, as though caught unaware by the camera while passing through her parlor. Yet neither Cannon nor the so-called walking lady could have been photographed in motion. As the *Albion* author marveled over the image, Sarony peered over his shoulder to confirm that the illusion had been made possible by his posing apparatus. "Look at that lady. Would you think she had an iron brace to her back and an iron brace to her head?"

The action that appeared caught by a "flash of lightning" did not result from a photographic process that was either speedier or more spontaneous than that of other photographers of the period, but rather from a creative solution to mitigating the medium's technical limitations. Philip Prodger and André Gunthert have noted that during much of the nineteenth century, references to "instantaneous photography" and "lightning-fast" processes did not necessarily refer to exposure times but instead described a photographer's ability to create an illusion of liveliness and animation in his subjects. Gunthert notes that trade literature similarly applied terms like "instantaneous" and "snapshot" to studio portraiture even when the subject did not appear to be engaged in activity that would require quick exposure, since "a portrait was considered instantaneous if the subject looked natural and unaffected."[53] From this perspective, the "flash of lightning" used to describe the motion of Sarony's walking lady or the "kaleidoscope" of lively positions facilitated by the posing stand registered appreciation of the photographer's artfully staged illusions of reality, yielding portraits that were simultaneously persuasive and impossible to believe. As the *Albion*'s reporter concluded, "Sarony's is crowded; the reason is, we fancy, because one would never suspect that his figures have iron frames to their backs, and iron ditto to their heads."[54]

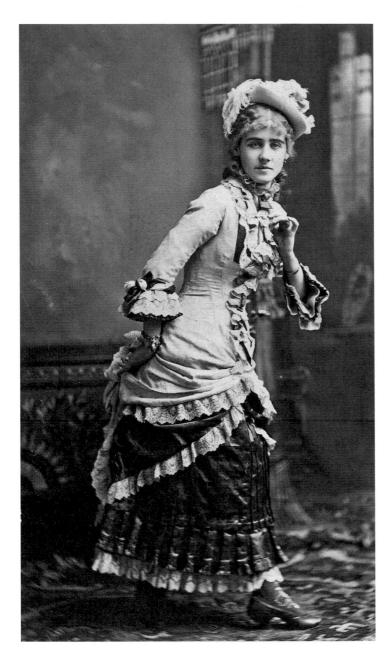

Fig. 26 | Napoleon
Sarony, *Lida Cannon*,
ca. 1870s. Albumen
silver print on card.
Harvard Theatre
Collection, Houghton
Library, Harvard
University.

THE PORTRAIT STUDIO AS STAGE

Sarony's return to the United States corresponded with two intersecting develop-
ments that altered the professional landscapes of photography and theater. The first
was that in the fall of 1866, only a few months after his return, the American photo-
graphic industry undertook a deliberate shift from cartes de visite to larger-scale cabi-
net cards.[55] With the end of the Civil War, the market for photography had started to

cool, prompting Edward Wilson and other industry leaders to propose that a coordinated effort to introduce a new format might help reinvigorate business. "Something must be done to create a new and greater demand for photographs," he wrote. "The carte-de-visite, once so popular and in so great demand seems to have grown out of fashion. . . . All the albums are full of them and every body has exchanged them with every body."[56] The hope was that "the new size," as it was called, could reignite the fire of carte-o-mania by bringing customers back to studios to update their portrait collections. What industry leaders did not anticipate, however, was how this change in format would revolutionize the medium's aesthetic possibilities. At only 2½ × 4 inches, cartes de visite were best suited to straightforward poses and relatively simple compositions. Cabinet cards, with nearly twice the surface area, offered portrait photographers far greater opportunity to experiment with fancy lighting, backgrounds, and creative poses, simply by making these features more visible. As a result, the period between 1866 and the 1890s, which overlapped precisely with Sarony's activity as a photographer in the United States, represented a golden age of studio portraiture characterized by an increasingly theatrical approach, as rival studios sought to outdo one another with progressively more elaborate settings—using balustrades of imitation stone covered in paper ivy, papier-mâché rocks, artificial trees, and a profusion of painted backdrops.[57]

This performance-driven strain of studio photography has often been misunderstood as an attempt to elevate artistic consideration of the medium by aping elements of painting. The more appropriate reference point, however, is contemporary theatrical practice, which underwent a vast expansion during the decades following the Civil War. By 1870, earlier held moral trepidations about the stage had all but disappeared, and the theater attracted an ever-increasing number of people from all walks of life, as both performers and audience members. Additionally, during the postwar period, the first significant generation of American playwrights, actors, and theatrical producers began to find success at home and abroad, supplanting the European plays and acting techniques that had dominated the US theatrical scene earlier in the century. Dramatists such as Dion Boucicault, Augustin Daly, and David Belasco supplied a newly organized conglomeration of Broadway theaters in Manhattan with a range of popular melodramas and comedies. With the increasing ease of rail travel, touring ensembles trekked across the country through networks of playhouses, making theater in the United States a truly nationwide phenomenon and establishing the stars of these productions as the first nationally known celebrities.[58] Photographic studios developed a symbiotic relationship with American theater. They produced cabinet cards of major stars in costume to coincide with the opening of new productions and created glamorous promotional portraits that were displayed and sold in theater lobbies. Fueled by the simultaneous expansion of the illustrated press, portrait photography emerged in the late nineteenth century as a major American industry, and

by 1882 sales of celebrity photographs totaled roughly $1 million in New York City alone.[59]

Calls for idiosyncratic poses and expressions in portraiture coincided with an international dramatic realism movement, which explored new methods for representing multifaceted characters through the introduction of naturalistic staging and performance techniques that gradually replaced older systems of classical gesture and declamation.[60] By the late 1860s, these previously accepted formulas for representing character, like the pillar and curtain of the photographic studio, were perceived to have lost their expressive power. Instead of relying exclusively on traditional academic training, prominent actors such as Sarah Bernhardt, Fanny Davenport, Adelaide Ristori, and Constant Coquelin experimented with individualized approaches to performance that were intended to lend authenticity to their parts. Bernhardt in particular is associated with a performance method that historians describe as the "personality school" of acting, which simultaneously stoked and fed upon her phenomenal celebrity.[61] The actress herself noted that while performing, she did not allow the framework of a scripted role to define her but instead presented herself to audiences as an ephemeral "stage personage," which merged her personality into the fictional character. This allowed her to feel what the character felt and speak with the character's voice, without letting the audience forget that they were watching the great actress on the stage.[62] She similarly declared it a waste of talent to rely on the rote gestures of classical dramatic training as the basis for an expressive vocabulary. Like overreliance on script, these brittle frameworks hampered the power of wilder, freer forms of performance. "The actor's world must be an exact imitation of nature, and his feeling must be real feeling or it cannot affect others," she said. At the same time, it was necessary to adjust the tone of this reproduction of reality to suit the conditions of spectatorship in the theater, a phenomenon critics described as "theatrical optics." For actors in the expansive space of the theater, this meant accommodating audience perceptions by exaggerating normal facial expressions and projecting their voices so that they would be visible and audible from a distance.[63] Though these amplifications would appear outlandish in other contexts, the distortion of reality was a necessary condition for reproducing authentic appearances in the theater.

The optics of photographic pose operate in a roughly similar way. With the aim of replicating natural appearances, a portrait subject temporarily abandons standard behavior and performs exaggerated gestures for the benefit of the camera in hopeful expectation that the resulting image will seem relatively true to life. What poses are considered appropriate and "lifelike" depends largely on the specific cultural and historical context in which they are meant to circulate. In Gilded Age portrait studios, contemporary acting techniques shaped how individuals performed before the camera to a significant degree, and public images that were scaled to suit perceptions in the realm of mass media might be part fiction and part amplification of real-life

appearances—"photographic personages" that functioned as shield and avatar for otherwise private facets of social identity. Thinking of photographic portraiture in this way clarifies how it can be simultaneously perceived as a medium of personal transformation and an accurate depiction of likeness. It also repositions the work of a portrait photographer as the individual responsible for balancing the technical peculiarities of photographic optics against contemporary perceptions of ideal social appearances.

Given Sarony's penchant for dramatic self-presentation, it is not surprising that he excelled at making photographs of actors for the expanded stage of mass media. He admitted that theatrical subjects offered a welcome respite from the mundane demands of the portrait business since, as he put it, "a genuine artist can revel in making negatives of actors in character."[64] Sarony's posing apparatus provided material aid when it came to making portraits of performers in action, creating a semblance of spontaneity and an illusion of motion that aligned photography with the dramatic realism of theater. The device allowed actors to perform for the camera, holding dynamic positions and extended limbs for as long as natural lighting conditions required. A portrait of Edwin Booth as Iago made around 1876 depicts the actor advancing toward an unseen foe with malice in his eyes and a sword in his hand (fig. 27). Though fixed in place by the posing apparatus hidden behind his cloak, Booth affects a crouching lean that appears active, lifelike, and spontaneous—an appropriate physical embodiment of his character's twisted nature. Similarly, most contemporary portraits of ballerinas only showed them standing in position, which offered a detailed souvenir of stage costumes but failed to capture the physical feats they were capable of during live performance. The adjustable arms of the posing apparatus allowed ballet dancers such as Rita Sangalli to be photographed *en pointe*, creating a convincing representation of a skilled dancer in motion (fig. 28). By freezing active poses in place, Sarony sculpted the subject's body into a semblance of physical activity that took on persuasive naturalism only after being photographed. The effect was an adaptation of the laws of "theatrical optics" for the nineteenth-century photographic studio.

The photographer's studio method during portrait sessions was also to some extent inspired by dramatic practice. Like many nineteenth-century photographers, Sarony did not personally operate his camera but rather worked beside it, employing assistants and darkroom technicians to manage the hands-on work of developing negatives and making prints while he reserved his energies for the visionary aspects of the job. In this way, his role in the portrait studio resembled what A. D. Coleman would later term the "directorial mode of photography." Rather than capturing the raw material of real-world occurrences, Sarony orchestrated photographic events that were specially performed for the eye of the camera.[65] After choosing an appropriate backdrop and props for his subject, he adjusted the screens and curtains that controlled the light levels in his sunlit studio and then focused his full attention on

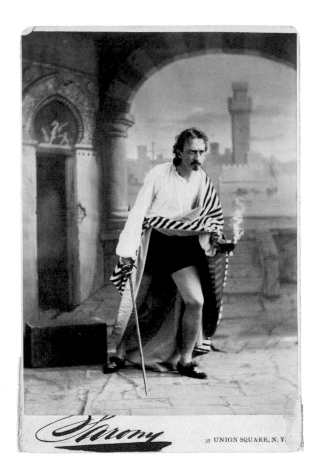

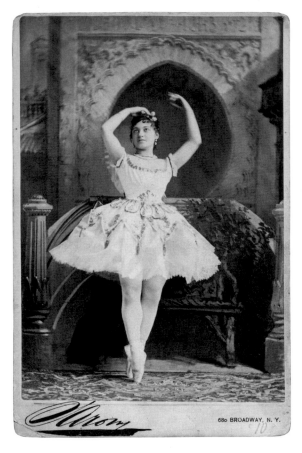

the person before the camera, coaxing him or her into the desired expression and
suggesting changes in pose, while cuing his trusted camera operator, Ben Richard-
son, to open and close the shutter using subtle hand signals. Richardson recalled that
it was no easy task to keep up with Sarony in the studio: "When I knew him he was
the man to make things hum. Sometimes when things were quiet under the skylight,
suddenly his step would be heard on the stairs followed by half a dozen sitters. 'Put
in a plate my boy.' Answer would go back, 'Hi, hi, your honor,' and then things were
quite lively for a time."[66] Sarony's directorial method transformed the portrait stu-
dio into a performance space for the creation of public images, and he applied his
techniques not only when working with professional performers courting fame but
also for everyday subjects. In fact, he took pride in his ability to elevate the aesthetic
results of commercial portraiture through his unique creative direction. "You show
me a pose of a figure by the average photographer that has no special sentiment or
grace," he said in an 1895 interview, "and I'll give you the same figure and the same
pose that will be a work of art."[67]

Fig. 27 | Napoleon
Sarony, *Edwin Booth
(1833–1893) as Iago in
Shakespeare's "Othello,"*
ca. 1876. Albumen
silver print; cabinet
card, 14.9 × 10.5 cm (5
7/8 × 4 1/8 in.). Folger
Shakespeare Library.

Fig. 28 | Napoleon
Sarony, *Rita Sangalli
(1849–1909)*, 1868.
Albumen silver print;
cabinet card. Jerome
Robbins Dance
Division, The New
York Public Library for
the Performing Arts.

Sarony's emotional investment in his work was a frequently reported aspect of his studio lore. One widely published story involved a series of photographs taken in 1868 of the Italian actress Adelaide Ristori in the role of Marie Antoinette. The session reportedly began like any other, with the actress in costume enacting scenes from her play atop an elevated posing platform that allowed maximum illumination from the skylights above. Once the posing session was underway, however, Sarony and Ristori seemed to enter a kind of shared trance. While the actress performed and the photographer encouraged—suggesting poses and signaling Richardson to make exposures—they became increasingly absorbed in the reenactment of Marie Antoinette's final moments. Observers reported that at the climax of Ristori's performance, the veins in her forehead "stood out like whip cords," and she tore the costume wig and bonnet she was wearing from her head and cast them aside, where they remain visible in the foreground of several of Sarony's photographs. Sarony was electrified by the intensity of this gesture and, forgetting that he was standing on the elevated posing platform beside the actress, he took a staggering step backward and fell headfirst onto the floor with a crash, shattering the spell that had gripped the studio. Ristori convulsed with laughter, and exclaimed, "Sarony, you have mistaken your vocation: you should have been an actor."[68] When asked about the incident later, Sarony claimed to have little recollection of what had happened, remembering only that for a fleeting moment, "Why I actually saw Marie Antoinette before me and not her mimic. . . . I have a negative to prove [it]."[69]

Like many anecdotes that emerged from the Sarony studio, the account probably represents a real event filtered through a narrative of strategic self-promotion. In this case, it allowed Sarony to link his directorial studio methods to the emotional spontaneity that fueled international acclaim for Ristori's acting talent. In terms that echoed Bernhardt's notion of the "stage personage," Ristori rejected the prescribed systems of academic gesture, claiming instead that she channeled natural "Italian ardor and vivacity" into the characters she portrayed.[70] Elizabeth Anne McCauley has noted that the actress's uninhibited emotional expression onstage was a source of fascination for the painters Eugène Delacroix and Edgar Degas, who associated her idiosyncratic style of performance with the modern "overthrow of all that was traditional, restrained, and controlled within the social system." In this way, Ristori's dramatic realism supplied a model for the members of this nineteenth-century avant-garde to locate *juste-milieu* between the perceived inexpressiveness of classicism and the realization of artistic truth, so that, according to McCauley, authentic creative expression became "synonymous with spontaneity or rather with the semblance of spontaneity."[71] Similarly, photographers of artistic ambition like Sarony used representational strategies of dramatic realism and personal alignment with renowned performers like Ristori to demonstrate a commitment to rethinking the formal conventions of portraiture and expanding the creative possibilities of the photographic stage.

Fig. 29 | Napoleon
Sarony, *Portrait of
Wilkie Collins*, 1873.
Albumen silver print;
cabinet card, 15.9 ×
10.8 cm (6 ¼ × 4 ¼ in.).
TCS 1.5561, Harvard
Theatre Collection,
Houghton Library,
Harvard University.

Along with his self-portraits, the portraits of Louie on display in his studio, and his photographic studies, the publicity Sarony sought for his studio activities played a crucial part in his campaign to elevate the artistic consideration of photography by educating the public about the creative labor involved in his process—even in images that appeared to show subjects not posing at all. In fact, as Sarony explained in an 1896 interview, the seeming nonchalance of his portrait subjects was the best possible demonstration of his skill. Despite appearances, he noted that it took tremendous thought and preparation—indeed, "all of the art the photographer commands"—to make a subject appear effortless and casual. The worst mistake a photographer could make was simply to tell a subject to "look natural" without offering proper guidance on how to do so. After all, he said, there was nothing natural about posing for a camera,

so if a sitter was left to his own devices, "he will look just as he feels—perfectly idiotic." Instead, Sarony argued that "the art of posing is in not posing. The true pose is not a pose, but a natural position."[72] The photographer's job was to assist the subject in determining how to best present his or her social self in a portrait, by constructing a public image that would read as true to life even when it involved a hidden armature of posing stands and careful negotiation of photography's technical limitations.

As an illustration of his method for "not posing," Sarony offered a portrait of his friend Wilkie Collins, which shows the author contentedly examining a stack of cabinet cards (fig. 29). Sarony explained that before the portrait session began, he had noted "a peculiarity of facial expression when [Collins] talked about his own books so, while he kindly answered a question or two for me about his 'Woman in White,' I made a quick exposure, feeling that I had taken the great novelist at his best."[73] Sarony's penchant for self-promotion occasionally makes it difficult to judge the accuracy of his statements to newspaper reporters. In this case, however, Collins agreed. Reflecting years later on his experience, he wrote Sarony expressing thanks for a photographic experience that was different from, and less painful than, those he had previously experienced. "You have taken just the sort of photograph I like. Those taken of me over here are perfect libels, but I feel like giving your pictures to all my friends. . . . If they prove nothing else, they do plainly show that photography is not a mechanical art—but does depend like other arts on the man who exercises it."[74] Sarony devoted much of his photographic career to persuading the public to see the personal and artistic elements in his portraiture. That Collins regarded his portrait as a representation of the social self he felt proud to share with his friends reflects how changing circumstances have altered what it meant to "make a position" through photography.

3.

CONSUMING COPIES

It is impossible to understand Sarony's photographic career without exploring his professional origins as a commercial lithographer in the 1830s, '40s, and '50s. This international industry reshaped the visual landscape of the United States during its antebellum boom years with a flood of decorative prints and colorful commercial imagery that stimulated a robust consumer culture around the production and circulation of pictures. For Sarony, whose family struggled financially when they emigrated to the United States in 1833, working in lithography provided his only significant education in terms of both artistic training and the practicalities of managing a large-scale image-reproduction business. He got his start in the field around 1835, when he was fourteen years old and was apprenticed to the French-born lithographer Charles Risso in New York City. From there, he quickly climbed the hierarchical ranks that structured the industry, rising from apprentice to draftsman to journeyman artist, and drawing pictures on commission for firms that owned the presses and equipment required to produce and distribute prints. During the 1830s and '40s, Sarony built a name for himself as one of New York's most accomplished lithographic artists through his work with two publishers, H. R. Robinson and Nathaniel Currier. As noted in chapter 1, his success allowed him to launch his own firm, Sarony & Major, in 1846.[1] With each move upward on this professional ladder, he gained a greater level of recognition for his artistic skill and increased control over the circulation of his work.

Though Sarony's shift to photography in the 1860s may appear at first to be a radical departure from his experience as a printmaker, it represented a relatively minor repositioning within the media ecologies of the nineteenth-century picture industry. Like photography, lithography was a modern image-making technology. The first lithographic printing houses in the United States were established in the 1820s, only a decade before the introduction of the first daguerreotype studios, and both media facilitated large-scale commercial reproduction. The lithographic trade thus established a crucial precedent for its slightly younger "new media" sibling and supplied an important model for the American photographic industry in terms of practical business concerns and strategies for balancing artistic tradition with the possibilities of industrial reproduction. For these reasons, lithography and photography operated as intimately intertwined networks throughout the nineteenth century, with common commercial applications, consumer markets, and a large pool of shared practitioners.

The two fields differed significantly, however, in their division of labor and methods for communicating creative authorship to the public. Whereas the lithographic industry adhered to the collaborative labor practices and professional hierarchies that structured traditional printmaking workshops, photography was largely free of such operational conventions. The social interaction at the heart of photographic portraiture allowed a greater measure of individual visibility and authorial control than other kinds of nineteenth-century commercial art. These factors were crucial in motivating Sarony's move from one medium to the other. One resilient thread of consistency throughout his career was his professional ambition. As a commercial artist eager for mainstream acceptance, Sarony found that the photographic frontier promised something that approximated conventional creative recognition, while also taking him one step further up the ladder of recognized authorship.

Sarony's preoccupation with gaining artistic recognition as a photographer was in many ways a response to the failure of the lithographic industry to protect the creative rights of individual artists, as well as a strategic negotiation of the mounting pressures that early mass visual culture placed on conventional systems of creative authorship. Tracing his career trajectory across the commercial arts is meaningful not only for what it reveals about his individual professional activities, but also because it provides valuable insight into the experience of his colleagues—working artists in the US antebellum printmaking industry who labored largely in anonymity without achieving authoritative control over the circulation and production of their work. The expansive media networks that took shape during the nineteenth century allowed artists to reach unprecedented audiences, but they also let the products of their creation travel in massive volumes far beyond their individual physical control. The factors of scale that modern industrial media introduced to nineteenth-century visual culture stretched traditional bonds of artistic authorship to the breaking point. This

development affected cultural producers of all kinds, and, as a result, artists, authors, publishers, and printers were forced to develop new strategies for maintaining commercial and creative claim over their freely circulating intellectual property.[2] Only during the latter decades of the nineteenth century, between 1860 and 1890, did modern copyright laws in the United States and Europe bring relief to producers of reproducible art, as the next chapter discusses in detail. The period prior to that point was a golden age for plagiarism. Before legal protections caught up with the global scale of modern publishing, pictures and texts could be freely appropriated with little potential for individual recourse, and ideas of originality became largely theoretical in the face of emergent technologies that enabled fast and easy reproduction. These issues are all too familiar in our present-day digital information age, and their analogue origin in the early days of mass visual culture makes them easier to map and explore. Sarony's career in lithography offers an ideal vantage point from which to examine how early mass media platforms challenged conventional thinking about authorship and appropriation, both in the specific context of nineteenth-century art and culture and as a subject of lasting concern for artists and authors today.

AUTHORSHIP AND ANONYMITY

Sarony was not alone among American artists in beginning his career as a printmaker. Printmaking workshops and systems of apprenticeship played a crucial role in cultivating artists in the United States, providing a pathway to professionalization at a time when few other formal options for local training existed. Early nineteenth-century lithographic workshops were especially important as a means of artistic education. Because producing lithographs involves drawing on stone with an oil crayon rather than carving metal or wood plates like older intaglio methods, shop owners had to teach their apprentices basic draftsmanship in addition to the practical tasks of preparing plates and running presses. Apprentice printers thus learned principles of composition, draftsmanship, and visual communication within a model of collaborative production and competitive advancement that hewed closely to the conventions of European academic drawing instruction. According to David Tatham, workshop training not only prepared a young artist for a career as journeyman lithographer but also provided "a foundation in art roughly equivalent to that offered by academies of fine art as the first stage of preparation for a career as a painter."[3] For young men from working-class backgrounds like Sarony, a career in lithography offered a practical alternative to an elite form of education that would otherwise have been financially and geographically out of reach.

Being apprenticed to a master lithographer often had the added advantage of supplying room and board, which was of vital importance for Sarony in 1835. He had demonstrated an early talent for drawing, but his apprenticeship to Charles Risso

was motivated by financial necessity as much as artistic interest. Sarony emigrated from Quebec to New York City with his father, Adolphus, and his three youngest siblings after his mother's death in 1831, when he was around ten years old. His father's dry goods store had failed the previous year, which compounded the family's difficulties by leaving significant debt.[4] Adolphus apparently hoped to find a fresh start in the United States, along with a fresh line of credit, in order to resume his work as an importer of fine goods from France. Unfortunately, the move brought no better luck, and by 1835, facing imprisonment for insolvency, Adolphus was abruptly forced to leave New York and entrusted his fourteen-year-old son to Risso's care.[5] Perhaps for obvious reasons, Sarony never mentioned his father's financial difficulty when describing his career origins, but his lithographic apprenticeship might not otherwise have occurred. Sarony later claimed that Risso provided little technical instruction but simply allowed him, according to a piece in the *Photographer's Friend*, "to pursue his own course and work out his own ideas," which had been far more advantageous to his artistic development. Even so, it would have been in Risso's shop that the boy learned the basics of preparing stones, operating a press, and circulating prints. When the Risso and Browne firm closed abruptly in 1836, Sarony was forced to scramble for new employment. He decided to make a new start in life by "donning the style of business man," and went door to door inquiring with local shop owners until he found a billiard table manufacturer willing to pay him ten dollars to make a show card for his shop.[6] The commission launched his career as a journeyman lithographer and also marked his first association with the publisher Henry R. Robinson. Sarony realized only after securing the job that he lacked the means to make a print, and Robinson kindly allowed the young artist free use of his presses and printing supplies to fulfill his first commission. Though Sarony's story speaks to genuine childhood hardship, he proudly recalled that being left to his own devices from an early age taught him that it was necessary "to build a name for himself" rather than rely on "the cold charities of the world" or family fortune.[7]

Even so, building a name for oneself in the nineteenth-century American picture industry was not an easy matter. Far from rewarding creative individuality, the large-scale production of prints required a complex division of labor that was incompatible with conventional artistic recognition. Even the professional title "lithographer" was notoriously fluid in the antebellum period, so that even when prints were signed or captioned, the designation could refer just as easily to a publisher or printer as to the draftsman who prepared the lithographic stone. Workshop production diminished markers of individuality in commercial printmaking as well. Joshua Brown describes how the illustrators employed by nineteenth-century newspapers were assigned responsibility for one specialized facet of a wood engraving, rendering machinery, background landscapes, or portrait likenesses, depending on strict hierarchies of seniority. The lowest-level engravers worked from compositions created by

other artists and contributed a single gridded portion of a larger composite woodblock that would only be assembled into its final form immediately before printing. This arrangement allowed production to move swiftly from one set of hands to another, reserving time-consuming acts of originality for those at the top of the labor chain. In the end, one engraved illustration might involve the labor of ten to forty individuals, so working artists must have found it difficult to gain a "big picture" sense of their contribution to a published print.[8]

The structural anonymity of commercial printmaking is in part why much remains unknown about this major section of the antebellum artistic economy. Much of our understanding of how prints were produced, circulated, and consumed comes from the experiences of exceptional individuals who succeeded in building names for themselves, either by going on to achieve more traditional measures of artistic success (William Rimmer, Fitz Henry Lane, James McNeill Whistler, Winslow Homer); being at the head of major firms (Currier & Ives, Louis Prang); or, in the case of exceptionally successful printmakers (John Sartain, Francis D'Avignon, Grafton Tyler Brown, Fanny Palmer), because their accomplishments have been painstakingly recovered by modern researchers.[9] The majority of those who worked in "the domain of the mechanical arts," as one article described Sarony's lithographic origins, left few surviving records apart from prints themselves.[10]

PRINTING MONEY, MAKING ART

Sarony seems to have recognized early on that there was power in putting his name to his work. Even as a teenage journeyman, he regularly applied his distinctive signature to the lithographic stones he prepared. This precocious affectation may have come from his apprenticeship to a French-born lithographer. Georgia Barnhill writes that the custom of signing lithographic work was imported to the United States in the 1830s along with a wave of French lithographers who emigrated in order to escape severe restrictions on publishers' licenses in France.[11] A native French speaker and born Quebecois, Sarony was deeply involved with the French immigrant community in Manhattan and may have been inclined to embrace this tradition as a mark of his personal and professional heritage. His father, after recovering from his financial difficulties, purchased a half interest in a coffeehouse on Warren Street called the Café Français. Part tavern, part billiard hall, and part entertainment venue (the conjoined twins Chang and Eng Bunker made their New York City debut there), the café hung the French tricolor flag over the bar and was the unofficial headquarters of the city's wits and bohemians, including poets Fitz-Greene Halleck and Charles Fenno Hoffman.[12] Sarony spent considerable time in the café as a young man, taking his first and only formal drawing lessons there from a French artist described in later accounts as the Baron de Belfort, who claimed to have arrived in the United States with Louis

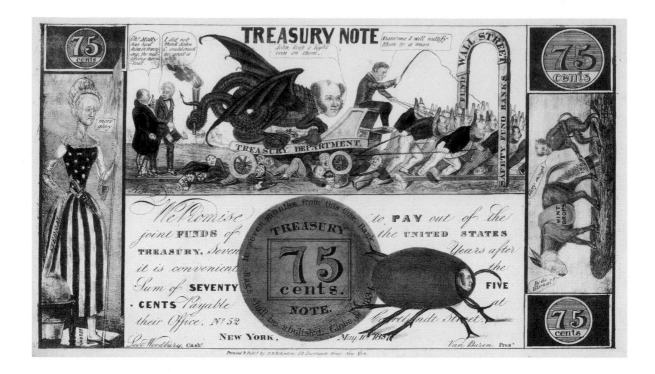

Napoleon in 1836 and stayed on to do what he described as artistic "missionary work" by teaching academic methods of painting and drawing to young Americans.[13]

It is easy to imagine Sarony's formative years shaped by such an environment, where business, entertainment, and pretensions of high culture coexisted fluidly. From an early age, Sarony demonstrated a keen awareness of how the competing elements of artistry and opportunism shaped the currents of commercial illustration, especially during his teenage years as an independent journeyman lithographer. His 1837 print *Treasury Note* probed the disparity between the economic and creative value assigned to his labor (fig. 30). Published by H. R. Robinson, whose printing firm was known for its Whiggish politics, the lithograph pillories the disastrous policies of Democratic presidents Andrew Jackson and his successor, Martin Van Buren, which contributed to the financial Panic of 1837.

Just before leaving office, Jackson issued an executive order known as the Specie Circular, which required that payment for the purchase of Western federal lands be made exclusively using gold or silver rather than paper banknotes. Though it was superficially intended to limit land speculation and curtail the enormous growth of paper currency in circulation, the policy was highly deflationary and quickly drained the hard currency reserves of banks in the Northeast, which caused shortages of the small-denomination coins that were needed for everyday trade. In a misguided attempt to address the shortfall, the Van Buren administration authorized small banks, businesses, and municipalities to act as federal "sub-treasuries" with the power to print and

Fig. 30 | Napoleon Sarony, *Treasury Note*, 1837. Hand-colored lithograph, 25.4 × 44.3 cm (10 × 17 2/5 in.). Published by H. R. Robinson. Courtesy of the American Antiquarian Society.

trade their own legal tender. The result was an unregulated stream of currency flooding already overextended financial markets, which caused the value of paper money to plummet. In May 1837, around the time Sarony drew his lithograph, New York City banks had entirely suspended the exchange of banknotes for hard currency and instead were issuing so-called interim notes to their customers. Popularly known as "shinplasters," a reference to the worthless paper they were printed on, these interim notes functioned essentially as promissory IOUs. They were meant to be cashed once markets stabilized, but since they were accompanied by no guarantee of retaining lasting value, they provided cold comfort to those who had trusted banks with their money.[14]

Sarony's *Treasury Note* parodies the visual form of early nineteenth-century shinplasters, which commonly paired engraved imagery with official signatures as protection against counterfeiting.[15] Most paper bills depicted mythological subjects, decorative scrollwork, or pictures of bank buildings, but Sarony's illustrated panels caricatured Jackson, Van Buren, and their Democratic colleagues. Jackson appears on the left as a decrepit Lady Liberty in an American flag gown, and again on the right with the body of a "jackass," a play on his last name used regularly in the opposition press. Jackson in donkey form expels a stream of gold coins from his hindquarters that Van Buren, who trails behind in the form of a trained monkey, eagerly collects in a top hat. Van Buren appears again in the upper panel as a monstrous dragon on a cart that rolls over the bodies of working citizens, crushing them beneath its wheels. In the center of the design, Missouri senator Thomas Hart Benton, a champion of hard-money policies and one of the architects of westward expansion, is pictured as a tumblebug, or dung beetle, pushing a massive lump of dung labeled with the banknote's supposed value across the face of the bill.[16]

Beyond this comic imagery, the deeper joke of Sarony's cartoon lay in the similarly spurious systems of promise that lent value to printed banknotes and reproducible artwork. As a working artist and printmaker, Sarony earned a living by making money out of paper, yet what he produced had no inherent material value, like a piece of gold, or the significant value assigned to original works of art like oil paintings. The text of his print assured the holder that the promised sum of seventy-five cents would be paid from the joint funds of the US Treasury and collected at the address of Robinson's lithographic firm "seven years after it is convenient." Along with the forged signatures of President Van Buren and Treasury Secretary Levi Woodbury, the artist added his own name—a flourishing "N. Sarony" that appears along the edge of the central panel—to guarantee the print's value. His cheeky self-certification significantly inflated the market value of his work. Early nineteenth-century lithographers typically charged between five and twenty-five cents for an uncolored print, so at seventy-five cents Sarony's banknote promised at least to triple a buyer's return on investment (albeit at some future, inconvenient time).[17] As a political barb, the gesture

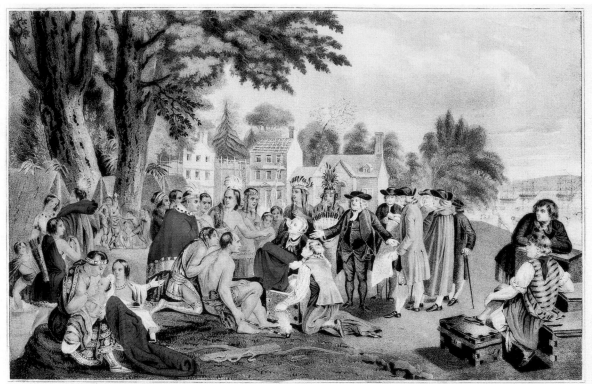

WM PENN'S TREATY with the INDIANS when he Founded the PROVINCE of PENNS? 1681.
THE ONLY TREATY THAT NEVER WAS BROKEN

implies that interim banknotes were no more valuable or reliable than comic lithographs. Both were printed slips of paper worth no more than the good faith behind them, and in this regard the signatures of corrupt government officials carried no more weight than that of an unknown teenage artist.

At the same time, an artist's signature contains a different kind of promise—it is a claim of creative ownership and a demand for recognition. Considering the importance of Sarony's signature in his later photographic career, its appearance in his youthful lithography suggests a note of aspiration. Banks could fail and economic futures decline, but the owner of a signed work by a great artist could expect to reap an exponential return on investment. In a system of commercial printmaking where lithographs circulated widely and counterfeits were commonplace, signing a work was among the few ways that artists could retain association with their creative products. Making a name for oneself and burnishing it with fame represented added value that an artist might one day collect upon. In this sense, Sarony's career-long investment in visible signs of authorship represented a reasonable strategy for managing the shifting value systems that governed mass-produced art by acknowledging its creative and commercial entanglements.

At the same time, Sarony's early experiences as a freelance journeyman demonstrated that professional renown in lithography did not necessarily translate into recognition within the world of fine art he aspired to join. In 1837, the same year in which he drew *Treasury Note*, he also created a reproduction of the 1771–72 oil painting *Penn's Treaty with the Indians* by Benjamin West, for the publisher Nathaniel Currier (fig. 31). In addition to illustrating more traditional artistic skills than his phony banknote, Sarony's print apparently represented a significant rite of passage in his career as a lithographer. Writing for the Quebecois newspaper *Le Populaire*, Hyacinthe-Poirier Leblanc de Marconnay described the reproduction of West's painting as the masterwork that marked the successful end of Sarony's apprenticeship with Charles Risso. He noted that local newspapers had been discussing this young Canadian artist who had "built a reputation for himself in New York" for some time. Leblanc de Marconnay, who had met Sarony the previous year and owned several of his works, wrote that praise for his talent and distinctive style of drawing was not mere flattery. "It is to be hoped that Napoleon will continue his work, and that his celebrity, which already stretches as far as Europe, will come to prove that Canadians are not lacking good guides for achieving ranks of distinction in science and the arts."[18]

The statement makes clear that Sarony was succeeding at an early age in building a name for himself, yet it is fortunate Leblanc de Marconnay noted that he was the artist responsible for reproducing West's painting, because otherwise this professional milestone would have been easy to overlook. Though it does not include an artist's signature, the print does credit Sarony by name along its edge, albeit in letters so tiny that they are scarcely legible (fig. 32). This was not intended as a deliberate slight. Currier rarely identified the artists behind the lithographs he published, and it was by no means standard practice at the time to do so. If anything, that Sarony's authorship was acknowledged even in a small way suggests recognition that the print represented a momentous accomplishment—and perhaps also that the young artist had negotiated the largest share of public recognition the publisher was willing to extend.

Even so, the wildly varying scale of acknowledgment attached to Sarony's early lithographs helps demonstrate that conventional measures of authorship do not comfortably apply to commercially produced art. That Sarony could make his signature integral to a work of comic satire while barely seeing his labor register in the masterwork that marked his professional maturity speaks eloquently to the practical

complications of claiming and crediting authorship within the context of early mass visual culture. When printed images were reproductions of other artists' compositions, collaboratively produced, or both, it was understandably difficult to apportion credit for creative labor, and in a production system where publishers, rather than image makers, controlled profits and circulation, there was little incentive to correct the situation. This left an ambitious young artist like Sarony to maneuver along the margins of professional legitimacy, and it suggests that historians must develop new frameworks for understanding how the creative labor involved in the production of nineteenth-century popular prints was conceived, valued, and recorded.

One significant obstacle to this pursuit is the attachment to originality as an artistic virtue. Works of reproduction, even those that factored significantly in an artist's career, tend to be regarded as lesser acts of art making than those that advance wholly new compositional ideas. In the case of West's painting and Sarony's lithograph, questions of authorship are further complicated by the fact that the relationship between the two artworks is even less straightforward than it appears. Though Sarony effectively reproduced West's composition, his lithograph was not based on firsthand observation, since West's painting remained in a private collection in England until the early 1850s.[19] Instead, Sarony probably used a widely circulated mezzotint reproduction created in 1775 by the British artist John Hall as his source material. In addition to duplicating Hall's mirrored composition, Sarony's print copies the engraving's textual caption almost verbatim. His lithographic masterwork, then, did not result from direct communion with a canonical artwork but was based on an engraver's reproduction of the original painting.

Rather than regard this as one further degree of removal in a linear chain of reproduction, it is productive to consider the painting, engraving, and lithograph as individual nodes within a larger network of mass visual media. Michael Leja describes such clusters of related imagery as a "cascade of re-representation," and proposes that in the context of mass culture, these groupings are more appropriate units of analysis than individual artifacts, since their multiplicity resonates with the scale of their circulation and consumption.[20] Regarding Sarony's lithograph within this kind of cascading chain of copies allows it to be appreciated as a linked response rather than dismissed as merely derivative of West's work. This view also accommodates the diverse forms of transmedial copying involved in West's "original" painting, which, in his quest for historical accuracy, is drawn from a mélange of sources that contain additional linked responses of their own. West's portrait of William Penn, for instance, was based on a cameo by the self-taught sculptor Silvanus Bevan. West relied upon the image as the only known likeness of the Quaker leader to be created by an eyewitness, even though it represents Penn as an old man, when he was actually only thirty-eight at the time of his legendary meeting with the Turtle Clan of the Lenni Lenape tribe. West also did not see the carving directly, but he based his painted image on a hand-drawn

reproduction of it preserved at the British Museum. The Lenape people West depicted were similarly not based on life study. Instead, their images were inspired by artifacts from diverse Indigenous American cultures, including a soapstone pipe bowl carved in the shape of a man's head by an unrecorded Algonquian maker that served as the inspiration for the seated man seen in profile at the painting's center.[21] Viewed within a larger cascade of re-representation, all of these material components and their makers are networked contributors to West's painting, and they accordingly spawn related nodal clusters of their own.

My purpose in unpacking West's pictorial content is not to devalue his creative process so much as to emphasize that any artist's work is necessarily drawn from diverse sources and points of reference, regardless of the media in which it is produced. Moreover, the degree to which an artwork is perceived as original often is tacitly shaped by expectations that are culturally constructed and historically specific. Relaxing these strictures allows re-representation to be read as an unofficial form of critical reception, evincing patterns in public consumption and circulation, or demonstrating how artists responded to one another's work. Patricia Mainardi has pointed out that "copying" only took on a negative association in the twentieth century within the context of modernist discourses that privilege individualism and originality. Within nineteenth-century studio workshop practice, the artistic labor of reproduction was an essential aspect of academic education, and in Sarony's time an entire nuanced vocabulary existed to describe the phenomenon currently identified with the single word "copy." Based on contemporary examples and official definitions offered by the Académie des Beaux-Arts, Mainardi identifies five distinct ways in which this term was understood by nineteenth-century art audiences. Autograph *repetitions* were similar works based on the same subject that were conceived by a master artist though not necessarily produced by his hand; studio assistants might perform the labor of producing a repetition, which was then signed and sold by the master. The second form of copy, a *replica*, was more exacting in its adherence to the master's design and was typically produced by an assistant or apprentice with the idea of developing his craft in the image of his teacher. A third form was the *copie*, which was created by an unrelated master as a form of homage, and could comprise either a study of the entire composition or a specific motif to be incorporated into a distinct new composition or design. The final two modes of copying amounted to changes of form: *reductions* reproduced an artwork on a smaller scale, either as a souvenir of the original to be sold away from the studio or as a platform for experimentation on a theme. Finally, *translations* were reproductions of a work in another medium, such as engraving or lithography. Mainardi notes that translations were usually ranked lowest among the forms of copying, since it was assumed that they were studiously faithful to the original and resembled the replicas made by art students and studio assistants. But this assumption overlooks numerous instances of artists who worked with printmakers to

make reproductions that enhanced or altered aspects of their work. In other words, ranking the originality of an artist's productions according to "chronological priority," as Mainardi terms it, provides a false measure of artistic creativity and privileges the modernist ideal of individuality above the practical and aesthetic forces that framed their initial reception and creation.[22]

This perspective is useful for reconsidering the stakes of creative authorship within the nineteenth-century commercial print world's freewheeling approach to the circulation and piracy of pictorial information. Though printmakers drew liberally from existing sources, the perceived value of their work did not rest wholly on creative originality, but instead was registered in lower frequencies of relative innovation and collaborative invention, an improvisational conversation rendered in visual language. By these terms, Sarony's lithographic rendering of *Penn's Treaty* is part translation, but it is also an homage and replica, a visual statement that engages the work of other artists even as it mobilizes and transmits visual information about West's painting to new audiences. Though its content does not address the question of how artistic value is assigned as explicitly as Sarony's *Treasury Note*, both prints rely on a combination of pictorial information and recognizable names to claim value beyond the sum of their material components. With his reproduction of *Penn's Treaty*, however, Sarony's bid for recognition does not rest solely on his own artistic authority (or pretended authority), but rather uses the act of reproduction, or "re-representation," to yoke his name to that of a considerably better known artist, albeit in tiny letters that are at first not easy to see.

ADAPTIVE REUSE

Imagining reproduction as a mode of discourse draws early mass visual culture into productive dialogue with fine art as well as with other publicly circulated pictures. This is in part because the intermedial translations that fueled the public life of images necessarily signaled their adaptability to appropriation and creative reuse. Bruno Latour writes that published diagrams advanced a global scientific discourse by making scientific data "mobile and immutable." Through translation into pictorial form, theoretical results could be communicated across national and linguistic barriers in a way that fueled new and continued experimentation by allowing an international community of researchers to share their data and results.[23] I propose that in a similar way, the visual and artistic information that was circulated through mass-produced pictures helped establish a discursive network for modern art. Unlike schematized empirical data, however, artistic reproductions could not remain immutable once mobilized as illustrations. So, whereas scientific diagrams fueled innovation by making hard data accessible to a broad audience, the media shifts and image translation inherent in artistic reproduction fostered continuing aesthetic experimentation by loosing fine art objects from their conventional physical forms and demonstrating their malleability.

Oil paintings became lithographic drawings, marble became plaster casts, and, in the process, formerly stable categorical distinctions for art making were revealed to be fluid and became fodder for a global artistic discourse. These acts of pictorial translation, or what I call "adaptive reuse," register how ideas and visual information travel through a creative network and signal that images created in one place were seen and appreciated in another. The mobilization of pictorial information through mechanisms of mass visual culture allowed artists working in diverse locations and at varying strata of cultural hierarchy, like the scientists in Latour's study, to participate in an increasingly global creative discourse.

Another important distinction is that while scientific diagrams mobilized data to fuel experiments in the world outside the page, artistic illustrations were often sites of creative experimentation themselves, preserving traces of their source ingredients alongside fresh pictorial results. The necessarily composite nature of published images might correct, modify, or fundamentally rework the visual information derived from another source, preserving a feedback loop of appreciative and/or critical appropriation. This suggests in visual culture a phenomenon analogous to the idea of "network authorship," which literary scholar Ryan Cordell has described in nineteenth-century periodicals. As demand for printed media expanded, editors scoured rival newspapers and magazines for content that could be reprinted in their own publications, often without crediting original sources. This process of appropriation regularly involved stripping away contextual information so that the bond between a text and its initial author was lost, but the act of reprinting and recirculating a text ultimately magnified its visibility and cultural importance by introducing it to a new host of readers. Though the editors responsible for this outcome cannot be called authors in the traditional sense, the notion of network authorship acknowledges their role in extending the reach and readership of the initial creator's ideas by accounting for the "authority accrued to acts of circulation and aggregation."[24] Moreover, as published ideas, texts, and pictures travel through unofficial channels, their meaning and purpose can shift, with cultural importance taking on new forms and dimensions through collective creative productivity.

We see this in the context of visual culture in the way popular lithographs provide a system for mapping the circulation of pictures. During Jenny Lind's tour of the United States between 1850 and 1852, sheet music covers and portraits depicting the singer, popularly known as the Swedish Nightingale, abounded in the American consumer market. Such public images fanned the flames of "Lind Mania," which promoter P. T. Barnum used to boost ticket sales. Yet because the scale of Lind's celebrity was sudden and unprecedented, few likenesses of the performer existed at the outset of her tour, leaving the mass picture industry with little raw visual material to fuel its engines of re-representation. For this reason, many depictions of Lind relied on a single "parent" image, an 1846 oil portrait by the German artist Eduard Magnus, which was readily

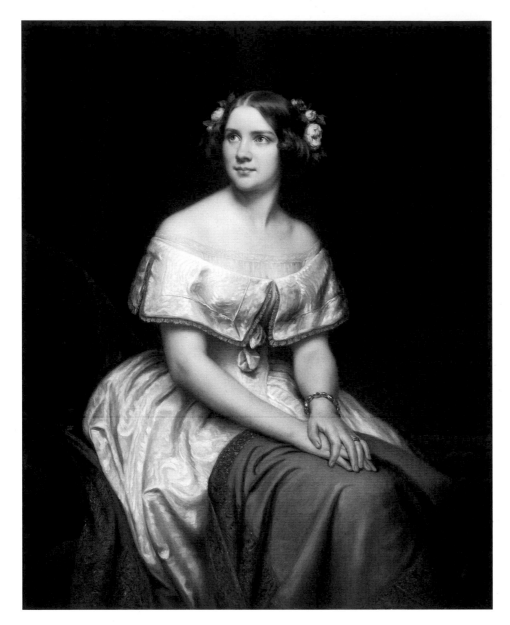

Fig. 33 | Eduard Magnus
(1799–1872), *Jenny
Lind*, ca. 1861, based
on a work of 1846.
Oil on canvas, 118.1 ×
94.6 cm (46 ½ × 37 ¼
in.). National Portrait
Gallery, NPG 3801.
Photo © National
Portrait Gallery,
London.

available as a mezzotint reproduction by Hermann Dröhmer (1849, Henry Graves &
Co. of London) (fig. 33). A traditional model of artistic authorship might credit Mag-
nus alone, as the originator of the painted portrait, but according to an artistic con-
struct of network authorship, Dröhmer would also be recognized for his crucial role
in facilitating its international mobility and transmission to North America.

Once the portrait of Lind entered this visual information stream, its fresh muta-
bility fed numerous adapted reuses. Sheet music covers produced by Sarony & Major
around the start of Lind's tour demonstrate how small, experimental extrapolations

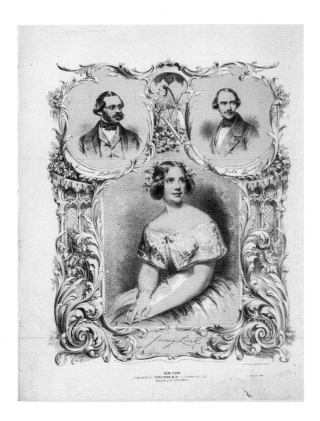

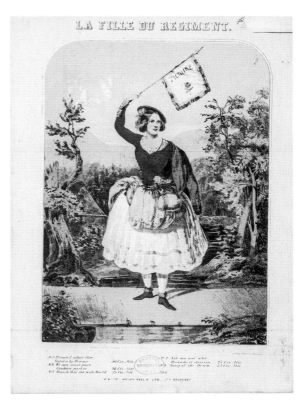

Fig. 34 | Napoleon Sarony, sheet music cover with Jenny Lind, "By the Sad Sea Waves," 1850. Tinted lithograph. Published by Firth, Pond & Co. Courtesy of the American Antiquarian Society.

Fig. 35 | Sarony & Major, Lithographers, sheet music cover with Jenny Lind, "La fille du regiment," 1850. Hand-colored lithograph. Published by William Hall & Son. Courtesy of the American Antiquarian Society.

from the translated portrait gradually reshaped the appearance of the visual information it provided. These ranged from relatively direct reproductions of Magnus's composition to images that extracted Lind's likeness from the portrait mezzotint and inserted it into wholly new compositions—making her a part of a multipaned vignette along with the composers of her songs, or picturing her onstage during a performance (fig. 34). For instance, a Sarony & Major sheet music cover for Lind's song "La fille du regiment" reproduces the head from Magnus's parent image atop a wholly invented body to picture the Swedish Nightingale onstage waving a flag and wearing a costume that befits the song's title character (fig. 35). Designating lithographers as "network artists" dignifies such nuanced changes as creative variations on a theme that contributed to cultural knowledge and magnified the visibility of another artist's work even if their own lacked creative and chronological precedence.

ASSESSING NETWORK ARTISTRY

Reading images in terms of networked, collective, or collaborative authorship opens the additional interpretive possibility of looking across related clusters of pictures in a way that is "close but not deep," to use Heather Love's evocative phrase.[25] By exercising a level of descriptive attention that registers relations of detail without pursuing

traditional hermeneutics of experience, consciousness, and motivation, visual analysis can address how reproduced pictures register traces of their industrial pace of production as well as static compositional outcomes. This method can be particularly useful when considering areas of early mass visual culture for which few records of critical reception or standard business practices exist, such as the inner workings of popular lithography, or workshop production methods that disguised individual contributions to an image's production. Since a completed print passed through numerous hands on its way to the viewer, it can be impossible to ascertain who contributed to the labor of making a print and what part each person played. This information often circulated anecdotally within the commercial art world, but it has been poorly or incompletely recorded, in part because it failed to align with conventional understandings of artistic roles.

One example is the well-known print *Awful Conflagration of the Steam Boat Lexington* (fig. 36). Published in 1840, shortly before the widespread emergence of illustrated newspapers, the *Awful Conflagration* was among the first news pictures to be created in response to a real-world event.[26] The print depicts a horrific fire aboard a luxury steamer in Long Island Sound that killed 140 passengers, leaving only four survivors, who clung to floating wreckage in the freezing water for hours before they could be rescued. It first circulated as an illustrated extra in the *New York Sun* only three days after the tragedy, and demand for reprints ultimately drove production of the picture to approximately thirteen thousand copies—an astronomical print run that signaled an emergent audience desire to see as well as read about what was reported in the press.

At a time before images were regularly included in newspapers, the *Steam Boat* lithograph was a rare collaborative effort between the newspaper and the print publisher Nathaniel Currier. According to Harry T. Peters, Currier's position as the leading figure in antebellum lithography was due in large part to this early success. In addition to bolstering his fledgling company's sales, it suggested a new and profitable line of production that Currier was quick to exploit. Known as "rush stock," these lithographs depicted fires, marine accidents, presidential elections, and other newsworthy events, and they became a major source of revenue for the firm, returning far more upon investment in a single stone than the usual "stock print" illustrations of sporting or sentimental scenes. As the name implies, the success of a rush print depended entirely on how quickly it could be dispatched to the public. If a lithograph could be available for sale in Currier's street carts while it was still a topic of discussion in the pages of the newspapers, profitable sales were almost guaranteed. For this reason, when a promising rush stock print was in the works, the already fluid distinctions between the print workshop's professional roles blurred further, so that, according to Peters, "the entire force, including artists, 'turned to,'" and all members of the firm, from the boys who sold prints in the street to Currier himself, pitched in to ensure that "the presses were kept going night and day."[27]

The unexpected demand generated by the *Awful Conflagration*, the firm's first "rush stock" print, understandably resulted in an extraordinary level of behind-the-scenes chaos and role swapping. Bryan LeBeau writes that even the idea to make the print came about spontaneously, and a hastily formed plan evolved from there. Currier happened to be in the office of the *Sun* when news of the accident arrived by telegraph. He quickly dispatched an artist to the scene in Long Island to make a drawing and then raced the eyewitness sketch back to the printing house.[28] The disorganized rush was the likely source of what has been lasting confusion surrounding the true authorship of the picture. It has been variously attributed to Nathaniel Currier, an independent lithographer named W. K. Hewitt, Sarony and Hewitt working in partnership, and Sarony alone. Peters asserted that based on his interviews with individuals employed by Currier at the time or shortly thereafter, there could be no question that Sarony drew the print. Yet continued uncertainty stems from the fact that while Currier and Hewitt are credited in textual captions, Sarony is not directly named in any of the various states of the lithograph.[29] Though identifying the artist or artists responsible for making this lithographic drawing does not alter the established cultural significance of the print, teasing out its complicated network of authorship demonstrates how printmakers dealt with the unprecedented challenges of mass circulation, and confounds retrospective expectations that the industry hewed to traditionally recognized patterns of artistic organization.

In fact, the *Awful Conflagration* does not even refer to a single lithograph but is rather a series of at least three similar prints that were issued by Currier over a short period of time in 1840. This makes the work a cascade of re-representation all on its own and has also contributed significantly to the confusion surrounding its authorship. James Brust and Wendy Shadwell have established that the hand-colored print most frequently reproduced today was actually its third version. The print that newspaper readers initially saw was a relatively simple black-and-white illustration that did not credit any artist by name and listed only the *New York Sun* as publisher (fig. 37).[30] The print's more familiar hand-colored version was later marketed separately by Currier in response to continued demand as an improved and more accurate revision of the picture that originally circulated as a newspaper supplement. In addition to the coloring, it was supplemented with a line drawing of Long Island Sound to show the distance between the accident site and the print's point of production in New York City. Comparison of the early and late states also makes it clear that the two underlying lithographic illustrations were done by different hands. Since this process involves reproducing a crayon drawing from a stone, it preserves the manuscript quality of an artist's line even in reproduction, and though the compositional elements remain roughly the same in each, the later print greatly romanticizes the scene's dynamism and disastrous details. The first version shows tiny drowning figures bobbing helplessly in the icy water, while in the later print, they enact heartbreaking levels of human pathos—reaching out desperately to one another and clinging to flaming bits of detritus.

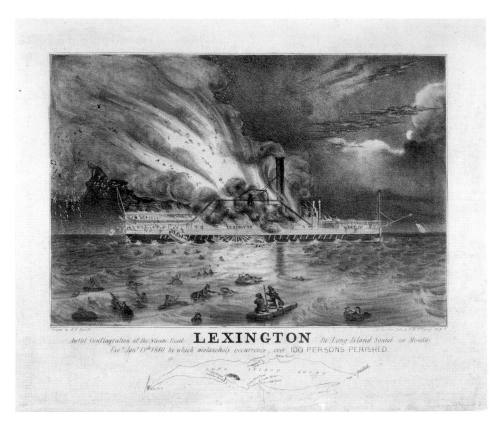

Awful Conflagration of the Steam Boat LEXINGTON In Long Island Sound on Monday Eve.ᵍ Jan.ʸ 13ᵗʰ 1840. by which melancholy occurrence, over 100 PERSONS PERISHED.

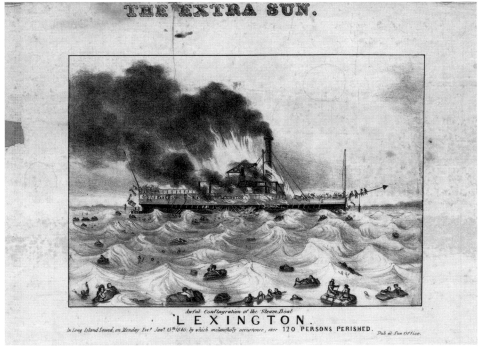

THE EXTRA SUN.

Awful Conflagration of the Steam Boat LEXINGTON. In Long Island Sound, on Monday Eve.ᵍ Jan.ʸ 13ᵗʰ 1840: by which melancholy occurrence, over 120 PERSONS PERISHED. Pub. at Sun Office.

Fig. 36 | Attributed to W. K. Hewitt and Napoleon Sarony, *Awful Conflagration of the Steam Boat Lexington*, 1840. Hand-colored lithograph, 32 × 38 cm (12 ½ × 15 in.). Published by Nathaniel Currier. Courtesy of the American Antiquarian Society.

Fig. 37 | Attributed to W. K. Hewitt, *Awful Conflagration of the Steam Boat Lexington*, 1840. Lithograph, black and white, 36 × 47 cm (14 ¼ × 22 7/16 in.). Published by the *New York Sun*. Courtesy of the American Antiquarian Society.

The waves crashing around these human victims convey a more striking stylistic difference. In the first state of the print, the water is formed into individual peaks, making the raging sea resemble the points in a meringue—while in the later version they are rendered as linear troughs running perpendicular to the doomed steamboat. According to Alfred Maurer, a contemporary of Sarony's at the lithographic firm, Sarony was Currier's marine scene specialist in the 1840s, having developed a reputation for his skill with shipping portraits such as *The Steamer Great Western of Bristol* (1837, Royal Museums Greenwich, UK) during his time working with Robinson. Other marine scenes credited to Sarony before and after the *Awful Conflagration* illustrate that his method of rendering waves more closely resembles the print's later state—which is to say, they were more trough than meringue.

What emerges through careful analysis of this cluster of reproductions is a picture of how antebellum lithographic firms balanced twin priorities of art and industry. Though talent and creative innovation were certainly valued, they were fundamentally regarded as necessary forms of labor, so traditional measures of individual artistic attribution do not always readily apply. Considering the rushed circumstances of the print's production, it stands to reason that Currier at first commissioned any available artist to make an initial eyewitness sketch—presumably Hewitt—and then only later, after sales unexpectedly took off, asked Sarony, the marine specialist on his staff, to improve the initial rushed drawing in a way that would further capitalize on public interest. Given the unprecedented pressures that mass production placed on normal workshop processes, lithographic captions must be read skeptically as sources of attribution and carefully weighed alongside other factors, including the visual evidence of the print itself. In this case, the proposed model of collaborative production is also useful in explaining why Hewitt's name is credited in the later print state while employees of the firm consistently reported that Sarony was the artist. The caption notes the print was "drawn by W. K. Hewitt," though not "drawn on stone," which may suggest that the design was his even though what was finally reproduced was not necessarily his direct handiwork. Whatever the truth may be, there is undoubtedly a richer cast of characters involved in making the image than can be deduced from existing evidence or registered in a conventional caption. That the suggestion of Sarony's authorship persistently traveled along with the print for more than a century despite a lack of supporting documentation indicates that these details of individual accomplishment were preserved within the niche professional networks of people to whom they mattered most, even when not deemed worthy of official record.

PICTURE PIRATES AND NETWORK LIMITS

The merits of collaborative production and insider appreciation had limits for an artist like Sarony, who hungered for individual recognition. The captions on lithographic

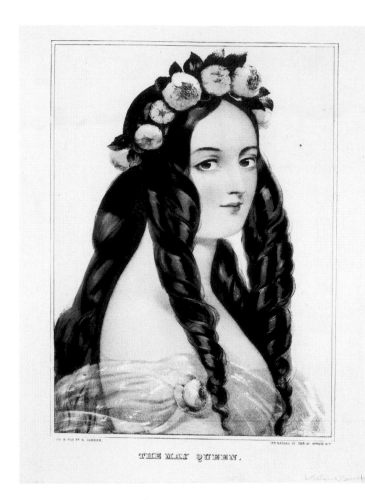

Fig. 38 | Napoleon Sarony, *The May Queen*, ca. 1845. Hand-tinted lithograph, 36 × 28 cm (14 ¼ × 11 in.). Published by N. Currier. Courtesy of the American Antiquarian Society.

prints typically prioritized a publisher's right to copy over the creative labor of his employees, and even artists who signed their work could not ensure that they would get credit over the course of a print's run. For all of lithography's democratic potential in terms of increased access to artistic training and picture consumption, the industry was tethered to the fundamental material reality that whoever controlled a printing stone ultimately dictated the terms of its use and reuse. This made it difficult for an independent lithographer to build a name as an artist, much less a recognizable body of work, since signatures and other identifying details left behind to mark a stone might be removed in later editions.

Even at the pinnacle of Sarony's career as a lithographer, when his skill as a drafts-man was widely recognized and recorded, his prints show frequent evidence of misat-tribution and appropriation by publishers, demonstrating how fragile the bond between an artist and his work could be in the era of early mass visual culture. Several prints published by the Currier firm in the mid-1840s, including *The May Queen* (ca. 1845)

and *Noah's Ark* (1846, Museum of the City of New York), exist in states with and without Sarony's signature (fig. 38). Both were created around the time that Sarony launched his own firm, so it is possible that they were drawings he completed while on Currier's staff that were modified so as not to advertise a rival's skills.[31] It took only small adjustments in inking, hand-painting, or the design on stone to obscure an identifying detail, and simply reducing visibility appears to have been part of the goal. In later versions of *The*

152 NASSAU ST. COR. OF SPRUCE N.Y.

May Queen, Sarony's signature remains partially visible despite a half-hearted attempt to scrape it from the printing stone—an act that apparently relied on the assumption that viewers would be more interested in the central image than in scrutinizing its margins (fig. 39).

In other instances, entire lithographic compositions were copied or significantly changed to justify reproducing a design without the original artist's name attached. The 1843 lithograph *U.S. Ship North Carolina: 102 Guns* (Metropolitan Museum of Art, New York), also published by Currier, exists in two nearly identical, compositionally mirrored states. While Sarony's signature appears prominently on the right-facing version of the print, it is altogether absent from the other. Whether the original stone was damaged or simply redrawn, the copy would technically be perceived as a new "original," even if the image content was the same. Though the *Awful Conflagration* provided an exceptional example, copying and adapting more often appear to have obviated the perceived need to credit the first artist—who had himself probably borrowed details, or indeed entire passages, of a lithographic composition from another source.

In the most egregious instances of picture piracy, virtually nothing about a stone was changed before the image it bore was claimed by a new artist or publisher. Copyright registration appeared to offer little deterrent to this kind of theft, perhaps because damages awarded in a lawsuit often amounted to less than the expense of bringing a case. This may be why Currier had little cause for concern when he appropriated an entire print depicting the Boston Tea Party that had originated with Sarony & Major. Library of Congress records suggest that the two images, which are distinguished in appearance only by their captions and details of hand-coloring, were added to the catalogues of the two firms around the same time, when both independently registered for copyright protection with the Southern District of New York in October 1846.[32] That Currier was the appropriating party seems likely, since the only alteration made

to the print he registered was the replacement of the name of Sarony's lithographic firm with his own, using a slightly different typeface. As with the circumstances surrounding the *Awful Conflagration*, it is likely that no surviving records or lawsuits contest these stolen images because such practices were so widespread that they did not seem to merit special mention.

Harry T. Peters described Sarony's professional renown in antebellum American lithography in similar terms, as a fact so familiar that it almost completely escaped official record. He wrote that although "it is quite clear what a very important part Napoleon Sarony had in lithography, it is indeed very difficult in any way to appraise his work." Despite abundant anecdotal evidence suggesting that Sarony was highly regarded by his peers as an expert craftsmen and enterprising publisher, his individual accomplishments were subsumed within what Peters characterized as a general "carelessness" about proper attribution. In addition to the known lithographs that Sarony completed under Risso, Robinson, Currier, and the various permutations of his own firm, Peters notes that he "undoubtedly produced other work, signed and unsigned, for these and other houses" that can no longer be identified, making it "impossible to untangle Sarony's own work on stone and survey it separately."[33] The relationship between Sarony and Currier was particularly knotty. Both Sarony and his business partner Henry Major had worked for Currier before launching their independent practice, and the two firms freely shared artists, prints, and materials, operating alternately as rivals and collaborators, or, as Peters put it, "When not definitely competing, the two firms worked in very close harmony."[34] Certainly, Sarony's relationship with Currier remained close enough that he asked his former employer to sponsor his application for US citizenship in 1856.[35] According to a "rumor" reported by Alfred Maurer, Currier & Ives purchased all of Sarony & Major's printing stones when the latter firm went out of business in the 1860s, and continued to put them to use for decades afterward—a possibility that further complicates any hope of establishing the two firms' independent histories or Sarony's role as a creative force within them.[36]

An additional impediment to Sarony's ambitions seems to have been that the close-knit world of antebellum lithography provided little opportunity to expand his sphere of influence. No matter how much his skill advanced, there was no reliable bridge from "the domain of the mechanical arts," where he got his start, to the world of fine art he aspired to join, though by the late 1850s it appears that he had become increasingly preoccupied with trying to build one. His brother-in-law Henry Atwell Thomas worked for Sarony & Major during the firm's boom years and recalled that although Sarony managed the entire art department and oversaw every print produced, he remained eager to prove himself publicly as an artist: "If any circus or theatrical orders came in he would himself do the drawings in preference to other work, as it gave him better opportunities for showing his ability." Thomas noted too that when a beautiful portrait of the actress Laura Keene was spoiled during the etching

process, Sarony disappeared from the offices for a week "to brood over the loss of what he, as well as others, considered his masterpiece."[37] Such anecdotes paint a vivid picture not only of increasingly frustrated ambitions but also of how individual successes and failures were registered within the network of an intimate community of commercial artists.

The difficulty Sarony faced in earning legitimate artistic recognition as a lithographer appears to have been the factor that ultimately prompted his departure from the field. Sarony & Major published prints by Francis D'Avignon and F. O. C. Darley for the American Art-Union beginning in 1847. Sarony and his younger brother Hector, also a lithographer, both joined the organization in 1849. From that point forward, Sarony's lithographic work pushed increasingly in the direction of fine art. He reproduced paintings by Thomas Cole, John Trumbull, and Rembrandt Peale, perhaps with the idea of returning to the strategy he employed at the start of his career with the reproduction of *Penn's Treaty*: yoking his name to more conventionally accepted artists in the hope of garnering a new level of professional esteem.[38]

As a mature artist, however, Sarony gained less traction from this professional maneuver than he had earlier in life, thanks in part to the unequal power dynamics of working in reproduction at a lower position in the media hierarchy. Producing artistic "translations" necessarily linked Sarony's fortunes to those of other artists, and his talents either went unnoticed, when the others' work was more successful, or unavoidably tied him to their fate, when it was not. Frequently, the most appreciative audiences for his work were fellow members of the lithographic community, who were in a unique position to recognize his independent contributions to a collaborative effort. As a result, time and again, his most polished displays of craftsmanship were consigned to a feedback loop of print, while the paintings on which they were based circulated in more elevated spheres. In 1849, Sarony created one of the finest lithographic drawings of his career, a reproduction of the oil painting *Susannah and the Elders* by the Philadelphia-based artist Louis Blanc (fig. 40). The original painting was shown at the Pennsylvania Academy of the Fine Arts annual exhibition in 1847, and shortly thereafter, a local businessman named H. H. Doty purchased it as an investment. Doty commissioned Sarony's lithograph, and between 1849 and 1851 he sold copies of the print along with chances to win the original painting.

Doty based his scheme on the promotional model of American Art-Union. For five dollars a year, members of the AAU received at least one printed reproduction of a work by an American artist, along with a lottery ticket that offered them a chance to win an original oil painting from the AAU collection.[39] Criticism had been mounting around the same time, however, that the art lottery practice at the AAU amounted to illegal gambling, and this objection was raised against Doty's scheme as well. One of the few critics who noticed and praised the quality of Sarony's print remarked that it was a pity he had devoted such exquisite craftsmanship to depicting a salacious female

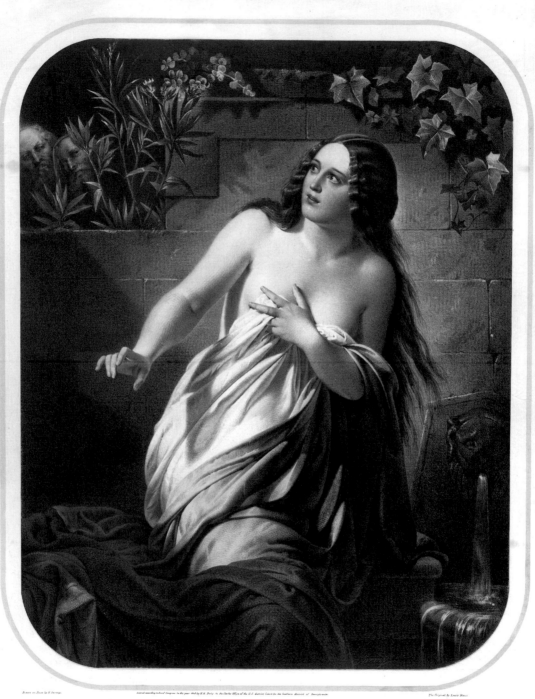

Drawn on Stone by H. Overney.

Entered according to Act of Congress in the year 1843 by H.H. Doty, in the Clerks Office of the U.S. district Court for the Southern district of Pennsylvania.

The Original by Lewis Blanc.

SUSANNAH, AND THE ELDERS.

To the Pennsylvania Academy of Fine Arts this Print is most respectfully dedicated by their most obt. Sert. H. H. Doty

Published by H. H. Doty, Philadelphia.

Lith. of Sarony & Major 117 Fulton St. N.York.

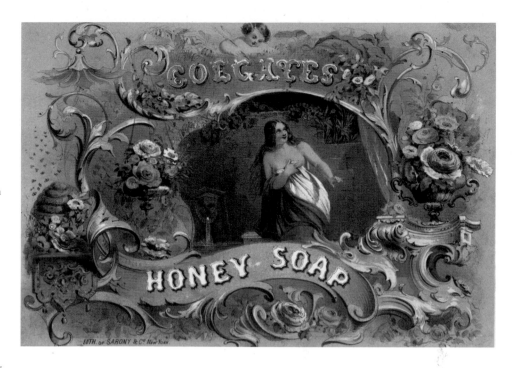

Fig. 40 | Napoleon
Sarony, after an
original painting by
Louis Blanc, *Susannah
and the Elders*, 1849.
Lithograph, 65 × 50 cm
(23 5/8 × 19 2/3 in.).
Published by Sarony
& Co. Courtesy of the
American Antiquarian
Society.

Fig. 41 | Sarony &
Co., Lithographers,
Colgate's honey soap
label, 1854–57. Color
lithograph, 16 × 23 cm
(6 1/3 × 9 in.). Courtesy
of the American
Antiquarian Society.

nude and in support of Doty's disreputable endeavor. "This is one of the finest American lithographs which we have ever seen. We regret that we cannot also commend the subject."[40] Snared in an implicit web of networked authorship, Sarony's artistic accomplishment in printmaking could not rise above the perceived moral failings of the painting it reproduced or the publisher who circulated it. Nonetheless, the print must have sold reasonably well. Today, it is preserved in several public locations, while the whereabouts of Blanc's painting are unknown. During Sarony's lifetime, however, the most prominent exhibition of his mature lithographic masterwork was on a packaging label for Colgate's honey soap (fig. 41). The advertising image, which was produced by Sarony's firm between 1854 and 1857, reworked the original composition, freeing Susannah from the menacing attention of the elders and enclosing her within the secluded bower of a floral vignette. Instead of looking over her shoulder in fright, she looks up toward the brand name and smiles contentedly—her spirits apparently buoyed by a private bath with a high-quality soap. Blanc's painting was not well enough known to have made this a meaningful mainstream reference, so the adaptive reuse of the original print probably represented either an act of appreciation by a fellow lithographer or Sarony's own attempt to give his ill-fated masterpiece a second chance at public life.

Even when Sarony devoted his skills to reproducing a widely celebrated contemporary artwork, he could not seem to escape the circulation networks of lithography. In 1859, he produced a grand reproduction of Rosa Bonheur's *The Horse Fair*

(1852–55, Metropolitan Museum of Art, New York). Drawn directly from the original painting, which was exhibited in New York City in 1858, Sarony's color print was produced and signed with considerable pride and, at nearly two by three feet in size, represented a significant feat in terms of technical printmaking as well as draftsmanship (fig. 42). In this case, however, Sarony's creative accomplishment was eclipsed by the fame of the original, and his lithograph circulated primarily as a "reduction" or souvenir of the painting. Though early printed notices praised the lithograph as "a

Fig. 42 | Napoleon Sarony, after Rosa Bonheur's *The Horse Fair* (1852–55), 1859. Colored lithograph, 41 × 66 cm (16.14 × 26 in). Published by Sarony, Major & Knapp, New York. Courtesy of the American Antiquarian Society.

parlor ornament of unsurpassed interest," this was attributed primarily to Bonheur's genius and the "majestic beauty of the horse" rather than to Sarony's skill as a lithographer. Eventually, the remaining print stock was given away in the form of incentive gifts to new subscribers to the *United States Journal*.[41]

Once again, as it had with *Susannah and the Elders*, the world of lithography provided a more appreciative circuit of reception and exhibition. While *The Horse Fair* jockeyed between elite collections before being donated to the Metropolitan Museum

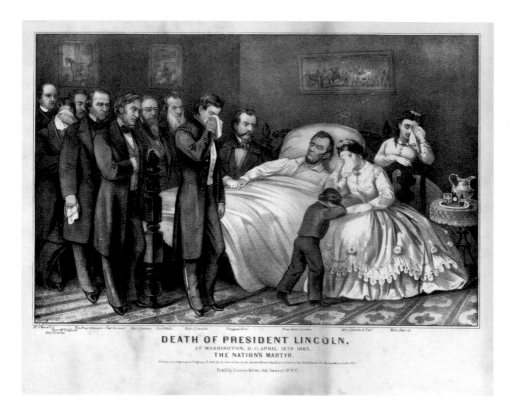

of Art by Cornelius Vanderbilt in 1887, Sarony's print enjoyed an afterlife of more dubious distinction. In 1865, it was included as background decoration in a Currier & Ives print depicting the death of President Abraham Lincoln (fig. 43). The recognizable composition, presented at reduced scale, clearly evokes Sarony's lithographic "parlor ornament" rather than the original monumental painting. Although the work achieved a place of permanent exhibition adjacent to a significant moment in US history, it was probably not the measure of artistic value and renown to which Sarony aspired when he drafted *Treasury Note* at the start of his career.

PHOTOGRAPHIC FORTIFICATIONS

The close-knit social and professional ties within the American picture industry ensured that photography began creeping into lithographic and other printmaking practices almost immediately following its inception. In the 1830s and '40s, the two image-making technologies often functioned in concert, since daguerreotypes were perceived as a means of "fortifying" traditional hand-drawn processes with an added dose of realistic detail.[42] Sarony first learned the details of the daguerreotype process alongside his brother Oliver in 1842 from a colleague who supplied portrait images

Fig. 44 | Sarony & Major, Lithographers, sheet music cover with the Alleghanians, "Roll On Silver Moon," 1847. Two-color lithograph. Published by Firth & Hall. Courtesy of the American Antiquarian Society.

to the Currier firm.[43] Beginning in the mid-1840s, photographs appeared regularly as fortifying elements in Sarony's lithographic work, where they served as source material for the likenesses of prominent individuals that featured in printed political posters, theatrical trade cards, and sheet music covers.

His 1847 sheet music cover for the popular close-harmony singing group the Alleghanians demonstrates the representational advantages of this hybrid media approach, and how it was communicated to viewers (fig. 44). The illustration includes four vignette portraits of the singers that were clearly based on photographs. The detailed likenesses allow idiosyncrasies of individual appearance, hairstyle, and dress to be easily recognized—a potential selling point for consumers who purchased the music after attending a performance.[44] The decorative roundels between the portraits confirm the synthesis of diverse media. Departing from a more serious representational register, they consist of fancifully imagined line drawings of maidens cavorting in woodland settings with musical instruments—a reference to the rustic mountain

life evoked by the song titles. The generalized similarity of the maidens contrasts strongly with the appearance of the four Alleghanians, who possess a homely specificity that makes their real-world singularity and photographic fortification clear. Even in the absence of additional textual information, this marked shift in visual language established a distinction between illustrative elements drawn from the lithographer's imagination, which might have multiple sources of inspiration, and the photographic elements of the print, which were tethered to actual people and their real-world appearances.

Photography's relative immutability in hybrid media creations may have appealed to Sarony after years spent absorbing the hard lessons the American lithographic industry taught aspiring artists about adaptive reuse, network authorship, and the challenge of winning recognition for creative labor. Even when translated into other modes of reproduction, the distinct character of photography cut through muddled issues of appropriation and attributions of authorship that characterized the lithographic industry's typical practices. A series of lithographic illustrations that Sarony was commissioned to make for the official Senate report on Commodore Matthew Perry's journey to Japan in 1853 appear to have had a decisive impact on his career trajectory. Perry's expedition for the US Navy marked a new chapter in US imperial expansion, forcing the island nation into trade relations with the Americas and Europe after nearly 250 years of self-imposed isolation from the West. In addition to its military goals, Perry's journey was conceived as a fact-finding mission about the cultural and mineral resources of the locations in Africa and Asia where Perry's four ships stopped. To this end, in addition to nearly two thousand enlisted men, Perry's crew included oceanographers, geologists, naturalists, and mapmakers, along with two artists: a painter named Wilhelm Heine and a daguerreotypist named Eliphalet Brown. Upon Perry's return to the United States in January 1856, Congress mandated that he submit a complete report of his journey within the year and that this document be released to the public following congressional review. The resulting four volumes, titled *Narrative of the Expedition of an American Squadron to the China Seas and Japan*, were published the following winter and served for decades as a definitive compendium of US and European perspectives on Asian culture.

Constructing this publication was a monumental undertaking, and because data collection factored significantly in the mission, publishing the interdisciplinary findings necessarily showcased prevailing strategies for processing and reproducing diverse forms of visual information. Over the course of their three-year journey, Perry and his crew generated thousands of pages of reports and collected innumerable artifacts. Refashioning this raw material into consumable form essentially required the assembly of a new, land-based publication crew. The historian and author Francis Lister Hawks served officially as "coauthor" of the text, though in reality he assumed full responsibility for crafting a coherent narrative from the crew's diverse collected materials,

including Perry's journal; the correspondence of his secretary and other officers; the logs of the fleet captain and flag lieutenants; and all charts, diagrams, maps, drawings, and photographs produced by the company's scientists and artists. Despite the daunting scale of this task, Hawks insisted that his title of coauthor was deserved. In fact, his introduction explained that although his name appeared with Perry's on the title page, their roles as coauthors did not imply equal creative work. While Perry and his crew supplied the diverse reference materials placed at his disposal, Hawks's work was "that of a compiler merely," whose mission was simply to "present a true picture" of what Perry and his crew experienced as eyewitnesses.[45] In other words, Hawks saw his function as that of a network author, responsible for shaping and disseminating information rather than inventing it outright.

Such concern for proper attribution was hardly the norm in mid-nineteenth-century publishing, whether in text or illustration, but Hawks's unusual attentiveness to assigning individual credit carried over into the work of the printmakers associated with the project. Sarony was one of four independent lithographers charged with preparing ninety tinted illustrations based on Heine's paintings and Brown's photographs, and he and other illustrators followed Hawks's lead in providing unusual transparency about their work as "compilers" of visual information. Each print bore a caption that told viewers how lithographic plates drew upon the hand-drawn or photographic ingredients provided by the crew's eyewitness artists. The caption for Sarony's depiction of the port of Jamestown at the South Atlantic island of Saint Helena reads, "From nature by Heine (*the painter*), Shipping by Brown (*the daguerreotypist*)," and "Lithograph of Sarony & Co." Although the published print effectively blended the source images into a seamless new whole, the text provided the viewer with a key for reading intermediality back into the picture, identifying the visual components each artist contributed to the collective work. Moreover, it emphasized that certain types of visual information were best communicated through different media. While the painter supplied observations "from nature" that related to scenic atmosphere, the precise technical details of shipping schematics were the domain of the daguerreotypist, highlighting the different level of reliability and immutability each form of image-making technology was believed capable of supplying.

Lithographers approached the raw material supplied by Brown's daguerreotypes differently from an aesthetic perspective as well, honoring representational details and even compositional flaws in a way that left photographic source material recognizable within these hybrid media creations. A lithograph by James Ackerman that reproduced a group portrait of delegates from the Matsumae clan emphasized its photographic origins by including the chance detail of a spear blocking the face of a background figure and allowing the illustration to fade into blank space around the margins rather than creating visual detail beyond the narrow focal range of Brown's camera (fig. 45). From a pictorial perspective, these visual quirks reinforced the autonomy of the source

image by preserving the type of spontaneous mishap that might ordinarily have been corrected by a painter or sketch artist. Rather than use the photograph as a point of inspiration for his own imaginative wanderings, Ackerman deferred to its representational authority, honoring the fortifying elements of Brown's camera despite translation by another hand.

Considering the lessons that Sarony absorbed as a lithographer about the problems of credit and recognition, this visual object lesson made an impression, even as he searched for pathways to more independent recognition. The prospect of working in a medium that retained a perceptible link to the circumstances of its creation may well have seemed appealing.

Fig. 45 | Ackerman & Co., Lithographers, *Deputy of the Prince of Matsmay*, 1856. Lithotint based on a daguerreotype by Eliphalet Brown. NYPL Picture Collection. Photo: Wikimedia Commons.

Fig. 46 | Napoleon Sarony, *"Railway Porter" by Mr. Sam Cowell*, ca. 1859. Tinted lithograph, 39 × 31 cm (15 1/3 × 12 1/5 in.). Published by Sarony, Major & Knapp. Courtesy of the American Antiquarian Society.

It is perhaps not surprising, then, that his first serious experiments with photography coincided with his work on the Perry publication. His brother-in-law reported that by the mid-1850s, Sarony "was often found with a camera taking ambrotypes, and good they were in effect."[46] An 1857 city directory for Yonkers, New York, where Sarony lived with his family, listed him as the proprietor of a local daguerreotype and ambrotype portrait studio.[47] Though none of this early work appears to have survived, the decisions that led to the reinvention of his media practice and to his first major studio in Birmingham, England, seem to have resulted from incremental movement through the media ecology of the nineteenth-century picture industry rather than a dramatic leap from one form of practice to another. In this respect, Sarony's career followed contemporary trends, as photography gradually ascended in prominence and range of practical applications within existing hierarchies of popular reproducible media. Some of Sarony's final works in lithography, including a portrait of the actor Sam Cowell completed around 1859, are so nearly tied to their photographic originals as to make the added labor of manual transcription appear unnecessary (fig. 46). After two decades of working to build a name in lithography, Sarony was perhaps showing off his impressive skills as a draftsman. At the same time, having found a medium capable of resisting the pressures that mass visual culture placed on authorship, he was only one small step away from generating this immutable raw material for himself.

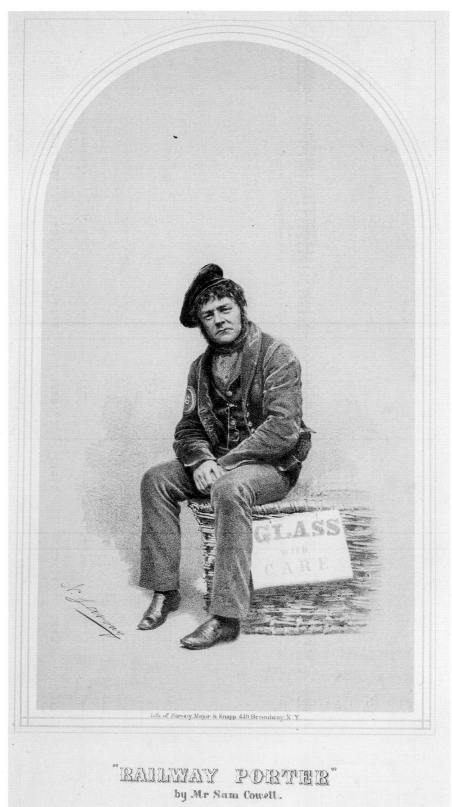

Lith of Sarony, Major & Knapp 449 Broadway. N.Y.

"RAILWAY PORTER"
by Mr Sam Cowell.

4.

A SIGNATURE LOOK

Becoming a photographer allowed Sarony greater control over his artistic fortunes by giving him direct control over the production and circulation of his work. After making this professional transition, he took pains to ensure that his name would remain permanently connected to the pictures he created—both physically and in the public imagination. Sarony's studio logo, a stylized reproduction of his personal signature, became the most visible marker of this conscious claim to artistic authorship. Following his professional frustrations as a lithographic artist, where the right to sign one's artwork came with no guarantee of lasting acknowledgment, Sarony made a point of emblazoning his signature on everything related to his business: trade cards, letterhead, advertisements, and even the façade of his studio. Between 1876 and 1895, a massive version of Sarony's signature greeted visitors to New York City's Union Square in the form of a one-story-high marquee that reproduced his name in gilded calligraphic letters across the face of an otherwise unassuming studio building (fig. 47). Its florid swoops and flourishes rendered the giant reproduction nearly illegible as a written word, but its meaning was immediately understood by contemporary viewers. *New York Times* journalist Cora Linn Daniels wrote in 1881 that spotting the Sarony signature shining like a beacon over the heart of the Manhattan theater district gave her the uncanny sensation that accompanied a massive shift in scale. Peeping out of the peaceful green park at Union Square's center at the busy scene opposite, she described how "the eyes must inevitably take in that great, characteristic scrawl,

Fig. 47 | Frederic Lewis,
*Sarony Studio on Union
Square at Broadway,*
1892–93. Gelatin silver
print. Museum of the
City of New York,
X2010.11.3472.

stretching entirely across a building, and which gives to the mind a pleasant little start, in the well-known signature of Sarony."[1]

Whereas Sarony's grand marquee maintained an unchanging countenance above the whirring city streets, the same signature, with its curling S and inky underline, appeared on the cardboard mount of every photograph that left the studio. In its smaller form, reproduced in gold, black, or chocolatey brown, the Sarony signature became a ubiquitous presence in late nineteenth-century visual culture. While the signed cabinet cards circulated across borders and oceans and were displayed in theater lobbies,

sold in stationery stores, or tucked away in family albums and vest pockets, Sarony's studio sign marked the point of origin for all these miniature replicas—and the professional home of their celebrated maker.

Sarony's signature was so well known at the time of his death in 1896 that Joseph Benson Gilder, editor of the *Critic* magazine, counted it among the many innovations that distinguished the photographer's career: "nothing, perhaps, was more striking than the way in which he wrote his name on his photographs. That signature (his trademark) . . . was imitated by half the photographers in the land."[2] Even a cursory survey of contemporary cabinet cards bears this statement out. Hundreds of photographers across the United States, including Sarony's associates B. J. Falk and José María Mora in New York City, J. C. Strauss of St. Louis, William McKenzie Morrison of Chicago, Louis Thors of San Francisco, and legions in between, adopted similar calligraphic signatures as the identifying marks of their studios, printing them, as Sarony did, on the cardboard mounts of their portraits. Many no doubt hoped that this method of marking their pictures would allow them to emulate Sarony's professional success. Yet the Sarony signature should not be understood merely as a business tactic or empty symbol. Instead, it served to reinforce a more significant public argument about the artistic potential of photography that Sarony devoted his career to building. By replicating the touch of the artist's hand on a monumental scale, the logo emblematized the aesthetic conundrum of the artist-photographer: it balanced the original and the easily duplicated to demonstrate how an essential mark of creative authorship could survive in reproduction.

Signatures carry special weight as acts of writing. Though it is expected that each performance of signing is unique and specific to the situation, the authenticity of the gesture depends on its resemblance to preexisting models. As Jacques Derrida has noted, it would do no good to sign a document in a different way every time, since the efficacy of this mark relies on its being recognizable and consistent. Signatures, therefore, retain a trace of authoritative singularity that is heightened through the necessary intentionality of their reproduction.[3] The Sarony signature presented a neat analogue to an idea that remained novel to photography in the nineteenth century: that the originality of an artistic act need not be invalidated by its subsequent reproduction. While Sarony's audience may not have understood his signature in precisely these terms, its persistent use supported his career-long campaign to achieve creative recognition for his reproducible artwork. As a stamp of authorship, a marker of location, and a certification of artistry, Sarony's signature over time informed a larger understanding of the artistic intention that lay behind his use of photography as medium.

The point is well illustrated by considering a different kind of photographic landmark. In 1884, a photograph known as *Oscar Wilde No. 18*, which Sarony created under the signature of his Union Square studio, became the centerpiece of the

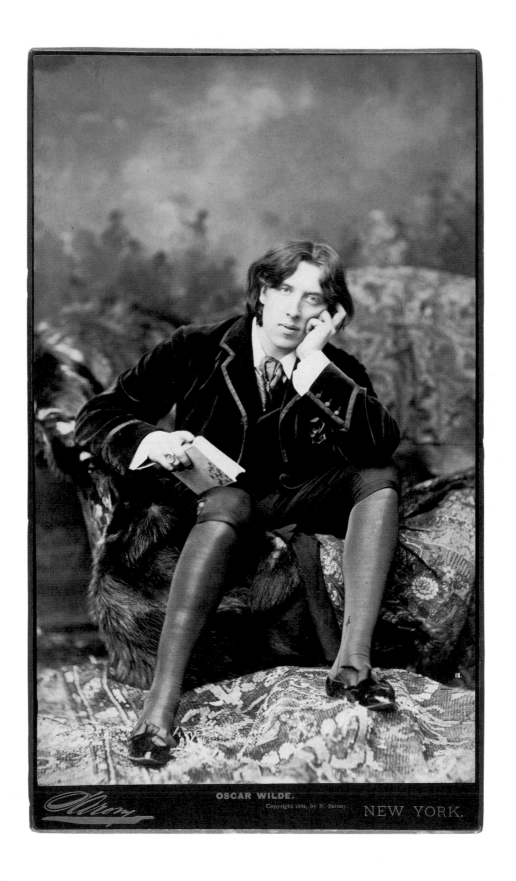

OSCAR WILDE.

Copyright 1882, by N. Sarony.

NEW YORK.

Supreme Court copyright case *Burrow-Giles Lithographic Company v. Sarony* (fig. 48). Although the case has been much discussed from the perspective of copyright law, it established an equally significant art-historical precedent by marking the first legal recognition of photography as a creative art form in the United States. Prior to Sarony's court victory, photographs had been officially categorized as printed reproductions, like the maps, charts, popular engravings, and lithographs among which they were classed under the Copyright Act of 1865. This status corresponded with the conceptual rhetoric, discussed in chapter 1, that dominated photography's first fifty years: the idea that the medium was primarily a factual recording device—a so-called pencil of nature through which the natural world might be reproduced without the corrupting influence of a human operator. The outcome of the 1884 Sarony case confirmed that these opinions had given way to a more nuanced understanding of photography's potential to operate simultaneously as an infinitely reproducible mechanical printing process *and* a vehicle for subjective creative vision. The Supreme Court was not, of course, responsible for driving this larger shift in public thinking, but the ruling reflected a marked change that Sarony and his heroically scaled signature helped usher into popular acceptance.

Fig. 48 | Napoleon Sarony, *Oscar Wilde No. 18*, 1882. Albumen silver print, 30.5 × 18.4 cm (12 × 7 ¼ in). The Metropolitan Museum of Art, New York. Gilman Collection, Purchase, Ann Tenenbaum and Thomas H. Lee Gift, 2005, 2005.100.120. Photo: The Metropolitan Museum of Art.

THE RIGHT TO COPY

Sarony was not alone among photographers of this period in exploring visible public strategies for claiming authorship of his work. The technological advances that fueled the commercial expansion of the international picture industry also introduced new problems in establishing rights of intellectual property. For example, the introduction of the wet-plate collodion process in the 1850s was a boon for business because it made creating and selling copies of photographic images more profitable than ever before. At the same time, however, it allowed publicly circulated pictures to be rephotographed with little loss of quality, bringing the plague of image piracy that was familiar to popular printmakers into the realm of photographic practice. Additionally, since reproducing photographs involved relatively little handiwork, there was little residual visual evidence of copying—through printing complications such as lithographic mirroring, for example—which made it even harder to prove and protest abuses.

Moreover, until the 1860s, when the first photographic copyright laws were enacted in England, France, and the United States, there was no specific legal framework in place through which photographers might defend their intellectual property. The Berne Convention, which went into effect in 1887, established the first international standards for protecting literary and artistic works, requiring participating nations to enact strong minimum copyright protections, and ensuring that those laws protected creative work performed or consumed within that country's borders regardless of where it was created. Prior to that point, copyright was administered

and upheld according to a patchwork of national laws, each of which operated differently and maintained revealingly different working definitions of the types of creative work that merited protection.

In the absence of consistent legal protection, many photographers found that marking their portraits provided some practical deterrent, even as this remained largely a symbolic gesture—a photographer's muted expression of how he wished his work to be viewed. British photographer John Jabez Edwin Mayall, for example, inscribed images with his name and the date as early as the 1850s. As the royally commissioned photographer of the 1851 Crystal Palace Exhibition and a favorite portraitist of Queen Victoria and Prince Albert, he had good reason to be concerned with protecting his exclusive right to profit from the circulation of his work. Photo historian John Plunkett notes that his inscription served as a kind of "unofficial trademark." It carried no real legal weight but expressed Mayall's earnest desire for recognition.[4] Unlike Sarony's extravagant signature, Mayall's name appears on his photographs in neat, businesslike letters and maintains a discreet distance from the portrait's subject. In an 1861 portrait of Queen Victoria, for example, the inscription appears in the lower left corner, on the base of a column just below Her Majesty's royal seal (fig. 49). Although it was added to the negative after the image was taken, the placement gives architectural weight to Mayall's photographic authorship, positioning his contribution as foundational to the portrait's creation. Further, his addition of the postscript *fecit* ("he made it"), which traditionally marked the labor of a sculptor or etcher, underscored a desire to see his work as a photographer valued similarly within traditional frameworks of skilled artistic labor.

The first British laws extending copyright protection to photography followed a similar spirit. They recognized the labor and capital investment made by photographic publishers alongside those of more traditional graphic arts, upholding the "right to copy" of image owners and producers. The United Kingdom's Fine Arts Copyright Act of 1862 introduced copyright protection for three kinds of original artistic work: paintings, drawings, and photographs. While this act technically aligned photography with traditional modes of printmaking, it did so primarily to protect the financial interests of successful painters. The law estimated that working artists had only

Fig. 49 | John Jabez Edwin Mayall (1813–1901), *Portrait of Queen Victoria*, 1861. Albumen silver print; carte de visite, 8.9 mm × 5.8 cm (3 ½ × 2 ¼ in.). National Portrait Gallery, NPG Ax39784. Photo © National Portrait Gallery, London.

three principal avenues for earning a living—sales and commissions (which, it was acknowledged, were difficult to come by except in the field of portraiture), exhibiting ambitious larger-scale works depicting historical or allegorical subjects, and selling reproductions and replicas of such images. Without legal protections in place, painters were denied this third important avenue of livelihood, as they could not claim reproduction fees from engravers or protect their original designs from unauthorized reproduction. The law was significant in that it introduced a "moral right" to creative property within the British legal system and recognized the value of artistic originality, even if principally in financial terms.

This logic of protected profit and reproduction supported photography's inclusion among the media the Fine Arts Copyright Act would cover. Like drawings and paintings, photographs such as Mayall's that were created through royal commission and sold publicly in large volumes were recognized to have commodity value that merited legal protection. Still, the implied possibility that these protections established photography as a form of art sparked considerable parliamentary debate. Photography ultimately gained acceptance only in a later amendment to the original bill at the urging of Solicitor General Roundell Palmer. Addressing his peers, Palmer acknowledged the validity of the objection that "photography was not a fine art, but a mechanical process," and that, for this reason, it "strictly and technically" should not be treated as a work of fine art. Nonetheless, given the public market for pictures, he argued that the act should protect the royal sanction of photographic producers such as Mayall, and the considerable expenses incurred by travel photographers such as Francis Frith. Making these photographs for a public market required an investment of capital and time that approximated a type of innovative creation. Speaking specifically of Frith's large enterprise, Palmer said, "Persons had gone to foreign countries—to the Crimea, Syria and Egypt—for the purpose of obtaining a valuable series of photographs, and had thus entailed upon themselves a large expenditure of time, labour and money. Was it just that the moment they returned home other persons should be allowed, by obtaining negatives from their positive, to enrich themselves at their expense?"[5] In other words, while the Fine Arts Copyright Act of 1862 legally classified photographs alongside paintings and drawings, it did so not because of their creative originality but owing to the commercial enterprise they represented. For photographic entrepreneurs like Frith and Mayall, the law nonetheless offered welcome protection of their right to profit from the fruits of their labor. Perhaps secure in this knowledge, Mayall marked few of his photographs by hand after 1863, relying instead on a simple type-engraved inscription of his last name on the images' mount to communicate his exclusive position as their original creator, with sole rights to reproduce their photographic content.

The first copyright protections for photography in the United States were shaped in this British legal mold and designed to safeguard a publisher's "right to copy" rather

than an individual creator's right of artistic authorship. In fact, US image copyright law was perhaps even more pragmatic in origin. Whereas British law developed out of an initiative to support artists' livelihoods, the earliest significant changes to US law were inspired by the growing market for photographic illustrations to accompany Civil War reportage. Between 1861 and 1865, consumers on the northeastern home front feverishly consumed printed battle maps, charts of troop movements, and photographs—of battlefields, army camps, and soldiers—as a means of visualizing the tragic immensity of the conflict dividing the nation. The fledgling American photographic industry took shape in response to this demand. Its quick evolution is visible in the notations inscribed on photographic images, which in the early 1860s prioritized documenting information surrounding the war rather than clear notations of authorship. Alan Trachtenberg has noted that for Mathew Brady, Alexander Gardner, and other Civil War field photographers, the problem of making sense of the battles raging in forests and fields all around them was compounded by "the clumsy array of equipment" that contemporary photographic technology required.[6] Brady traveled with two mobile darkroom wagons filled with cameras and chemicals, so that his wet-plate collodion negatives could be developed on-site before their light-sensitive coating dried. A Brady photograph from around 1863 bears clear physical evidence of the conditions in which it was created. It depicts General Robert B. Potter and his staff of seven officers gathered in a wooded clearing (along with the photographer, leaning against a tree to the right, and another soldier in the background) (fig. 50). The emulsion coating the glass plate has flaked and lifted around the image's edges, and beneath the central figures, the numerical notes B-44, 9428, and "New No. 224" appear to have been hastily scratched in the foreground and then subsequently amended or effaced. Restricted to the image's margins, where they could easily be cropped out of the final print, the markings represent coded internal references, shorthand notations of location and subject intended for translation into final captions once the plates were returned to the relative safety of the studio. Their ad hoc nature demonstrates how contemporary market demands, and the legal and cultural philosophies surrounding the medium, shaped both the information that traveled with photographic images and the creative behavior of their producers. Such practical sensibilities also shaped the original legal designation of US Civil War photographs as visual data, alongside maps and charts, rather than as visual art. Though later generations of viewers have recognized the beauty and lasting value in these historical documents, this was not necessarily the original impetus behind their creation.

It is, of course, understandable that credit for authorship was not the highest priority for photographers working on the front lines. The pictures they produced were valued for informational content rather than creative ingenuity and often were destined for translation into other visual media. But similar textual markings appear on Brady portraits produced in studio settings, suggesting a more philosophical connection

Fig. 50 | Mathew Brady Studio, *Portrait of General Robert B. Potter & His Staff*, ca. 1863. Digital image from original glass negative. National Archives, Washington, DC, LOT 4186-P, no. 11.

between this system of annotation and contemporary thinking about the cultural function of photographs. A portrait of US Representative Clarkson Nott Potter made around 1863 depicts the politician seated beneath a swarm of numbers and letters scratched haphazardly into the plain gray background of the plate (fig. 51). Written in a variety of hands, these notes name the subject but, again, not the specific creator of the photograph, along with numbered codes that may have corresponded to business records or daybooks. This consistency suggests that in the studio as well as the field, textual inscriptions on early 1860s photographs were devised as an assurance of representational authenticity—a means of pairing an image with accurate caption information—rather than as an expression of creative claim.

The system of mark making further reveals the collaborative workshop structure through which Brady Studio photographs were produced and circulated, one that drew upon the precedent of printers' workshops like Nathaniel Currier's. Indeed, as Trachtenberg and other scholars have noted, photos bearing a Brady mark were often not made by Brady himself, so rather than denoting authorship, his mark indicated his "right to copy" the plates and to publish and profit from the work produced under his imprimatur. Brady's occasional appearance in images like the group portrait of General Potter and his troops reinscribed his position in the pictorial margin between viewer and the events depicted. His efforts to capture images from the front lines

Fig. 51 | Mathew Brady
Studio, *Representative
Clarkson N. Potter*,
ca. 1863. Digital image
from original glass
negative. Library of
Congress, Prints and
Photographs Division,
LC-BH83- 3570.

of battle made him not merely a passive bystander but an intermediary between the
events of war and the private citizens who remained safely at home. Whether or not
Brady was behind the camera, this position of publicly recognized authority strength-
ened his brand and added value to the photographs published under his name.

The US Copyright Act of 1865 was created toward the end of the Civil War to
protect the institutional investment of photographic publishers like Brady. Although
intellectual property protection is enshrined in the US Constitution, the division
between patent and copyright protections created lasting ambiguities in the Ameri-
can system of law with respect to authorship and invention. The basic tenets of these
protections are laid out in Article 1, Section 8, Clause 8, which empowers Congress
"to promote the progress of science and useful arts, by securing for limited times to
authors and inventors the exclusive right to their respective writings and discover-
ies." From this language it developed that authors could be awarded copyrights for
their writings, and inventors, patent rights for their discoveries. Yet the narrowness of
the constitutional language meant that over the years the definition of "writings" had
to be repeatedly expanded to encompass new media. Originally understood to refer
only to printed texts, the legal umbrella of "writings" protected under copyright was

expanded in 1790 and again in 1802 to accommodate additional reproducible texts, ultimately including "maps, charts, designs, musical compositions, engravings, etchings, cuts and other prints."[7] The Copyright Act of 1865 extended to "photographs and negatives thereof" the same exclusive rights of reproduction already in place for these other media forms, with the added stipulation that authors or proprietors register their work by sending one printed copy to the Library of Congress and visibly documenting that this condition had been met by inscribing their prints, photographs, and publications with the full name of the author and the date of copyright submission.[8]

Although the law was not uniformly adhered to in the years immediately following its passage, it did become more common after 1865 for US photographers to display their names either on their image mounts or on the images themselves, if not both. Numerous photographs made by the Mathew Brady Studio around the close of the Civil War display a visible indication of authorship within the frame of the portrait image. Since Brady by that point had expanded operations and had branches in New York and Washington, DC, the notations "Brady NY" or "Brady DC," handwritten in plain letters on the photographic surface, functioned as proprietary stamp and studio advertisement. The varied hands in which these identifications were written make clear that these production marks, like the field notes scrawled on earlier battlefield photographs, credited Brady as publisher rather than as artist. Even so, just as Mayall's privileged access to the members of the royal family in Britain made the publication value of their images worthy of legal protection, Brady's authority as an eyewitness gave weight and legal meaning to the proprietary seal of image ownership.

The earliest photographic signatures to appear in Sarony's work date to 1866, when he produced his career-making portraits of Adah Isaacs Menken, and were probably motivated by a similar sense of creative propriety. Yet even from the start, Sarony's signature deployed an expressive manuscript quality that set it apart from the matter-of-fact notations used by other British and US photographers and suggested an interest in personal artistic recognition that parallel Sarony's professional claims. Perhaps unsure whether the stroke of luck that brought the famous actress to his studio would come again, Sarony took pains with his portraits of Menken to ensure that his authorship would not be easily overlooked. So that his name would be carried along with each carte de visite in circulation, he inscribed his signature in flourishing cursive script within the photographic images themselves by scratching through the emulsion on the exposed glass plate negative. Unlike the marks used by Brady, which identified the studio in plain letters or recorded marginal references to be cropped out of the final print, Sarony's flourishing imprimatur is large and idiosyncratic—a true signature rather than a proprietary stamp.

Further, it functions in his portraits of Menken as an integral element in the overall composition, intruding upon the space of the subject and at times interacting with

Fig. 52 | Napoleon Sarony, *Portrait of Adah Isaacs Menken*, ca. 1866. Albumen silver print; carte de visite, 10 × 6 cm (3 15/16 × 2 3/8 in.). Harvard Theatre Collection, Houghton Library, Harvard University.

the pose of her body—echoing the angle of her crossed legs, perching coquettishly on her hip, or creeping slyly up the back of her skirt (fig. 52). This makes it virtually impossible to view the portraits (or to rephotograph them successfully) without this persistent reminder of their original creator's role in composing the scene, or his physical presence in the photographic studio when the pictures were produced. Elizabeth Anne McCauley has noted that cursive signatures carried legal authority in Europe beginning in the sixteenth century, since the trace of the individual hand denoted "a more personal, chirographic type of authorship in which the body of the maker was invested in the product." In the context of artistic authorship, the uniqueness and

authenticity of the handwritten gesture functioned as a distinctive expression of an "equally unique and coherent personality" behind the act of mark making.[9] Whereas Brady's name guaranteed an authoritative vision of events, serving as a photographic intercessor for the picture's intended viewer, Sarony's expressive cursive signature suggested the artist's lingering presence within the frame of Menken's portrait, registering an indexical trace of the artist's hand and his creative embodiment in his work.

Sarony reinforced this association with the self-portraits he circulated alongside the Menken cartes de visite that pictured him in the same studio space. His signature appears prominently in these photographs as well, though they were far less likely to have required the same protection against piracy. In his own self-portraits he gave his signature an even grander share of compositional territory, underlining his name with a decisive flourish just as it in turn underlined the jaunty cant of his body against the back of a studio chair. In this way, the photographer's likeness, his eccentric self-presentation, and the cursive script of his signature all became deliberately and indelibly embedded in the material framework of the photographic image.

MORAL RIGHTS OF THE AUTHOR

Although Sarony began his photographic career in England, his method of marking his photographs and his style of professional self-fashioning most closely resembled those of his contemporaries in France. Photographers such as Nadar made studio showmanship and grand declarations of personality essential parts of their portrait business, and Nadar's example indisputably shaped Sarony's career. Although there is no direct evidence to suggest that the two men ever met, they certainly knew each other's photographic work. Nadar expressed appreciation in his memoirs for Sarony's bold use of pose, and Sarony's emulation of Nadar's dramatic signature logo clearly indicates that the professional admiration was mutual. Sarony was living in Europe in 1861 when Nadar opened his famous palace of photography on the Boulevard des Capucines. Painted bright red inside and out and emblazoned across the front with the photographer's name illuminated in gaslights, the studio building was designed to attract attention. For Sarony, whose travels abroad marked a moment of career transition, seeing Nadar celebrated as a photographer after beginning his career in lithography would certainly have resonated deeply.

One small irony underlying Nadar's triumphant signature is that the name it prominently displayed was a pseudonym—an artistic disguise left over from Gaspard-Félix Tournachon's early career as a political caricaturist. Originally, the Nadar signature had been a means of covertly asserting artistic agency under the oppressive censorship laws of the July Monarchy. In his later transition to photography, however, the alter ego became a useful marketing tool, carrying with it a chain of associations relating to Tournachon's artistic past, political activism, and daring feats as an aeronaut. At first,

the suggestive power of this pseudonymous brand allowed multiple photographers to operate beneath the umbrella of its artistic claims. For many years, Félix shared the Nadar signature with his son, Paul, and his brother, Adrien—both of whom used the mark on their photographs. In the late 1850s, though, concerned with what he considered the inferior aesthetic quality of his brother's work, he mounted a multitiered campaign to become "the only, the true Nadar," defining that entity through art, journalism, advertising, and a legal suit against his brother for exclusive rights to the name and signature. Though Adrien mounted an appeal, the matter was finally settled in Félix's favor in June 1859, just before construction began on his grand palace of photography. Consequently, the decision to mount the Nadar signature prominently on the front of his building was an announcement of this legal victory—a certain gloating insolence, as he himself admitted—declaring his singular right to its use.[10]

Beyond considerations of personal pride and profit, the principle of authorship carried moral weight in the French legal system, denoting a point of distinction from Anglo-American law that is crucial to understanding the later outcome of *Burrow-Giles Lithographic Company v. Sarony*. As noted above, in England and the United States, laws of "copyright" protected a publisher's right to profit from copies of an original work but did little to acknowledge the individual rights of that original's creator. In France, however, a series of laws established in 1793 protected the *droit d'auteur*, or author's right, which extended legal recognition to the author of a creative concept regardless of the form in which it was executed. This legal protection traversed media, so that a playwright, for example, was recognized as the author of his work whether it was printed as a script or performed on the stage, and a painter was the legal author of compositions both on canvas and in reproduction. It also meant that rather than being defined in terms of its material form, art was legally understood to be the realization of "l'ésprit ou du génie," an individual's creative mind, spirit, or genius, instead of the medium in which that creativity was expressed.[11]

Although this principle of *droit d'auteur* represented an enlightened attitude toward artistic production in many ways, it was twisted under French censorship laws during the 1830s into a means by which the authors of antigovernment propaganda could be held fully accountable for the content of their work. Since a playwright was legally and morally responsible for his creations once they entered the public sphere, he could be prosecuted if his antigovernment work was circulated or performed, even if he had done nothing to sanction it. Thus, according to legal historian Anne Latournerie, the first revolutionary attempt to provide authors with practical recognition was "not the search of creative freedom for authors, but rather the exigency of a responsibility."[12] Pseudonyms allowed political caricaturists like Nadar to claim authorship within this system while avoiding negative consequences. A printer or publisher could not be liable for antigovernment work if that work was signed by an artist, and an artist could not be prosecuted if he could not be identified.[13] Therefore, in France, the act

of signing one's artwork with one's own name, using a pseudonym, or not signing it at all carried political and moral significance, and was related closely to the legal and cultural understanding of art as something that was imbued with an author's *ésprit*—a product of the mind, creative soul, and individual character.

Despite the otherwise fluid understanding of media encapsulated within the concept of *droit d'auteur*, the question of *ésprit* prevented photography from being legally recognized as a vehicle for creative expression in France until 1862. In England and the United States, the greatest legal impediment to photography's recognition as intellectual property had been the question of originality—meaning whether a reproductive medium could generate a product sufficiently new and valuable to merit protection as a financial asset. For French law, however, the crucial question was whether a mechanically produced image could be said to contain anything of human *ésprit*, the individual and creative soul of an author. In all three countries, legal systems of copyright developed in response to growing commercial markets for photographs and the rights of photographic publishers to recoup the personal and financial costs involved in their production.

The legal question was decided in the French Court of Cassation in November 1862 with the case *Betbéder et Schwalbé v. Mayer et Pierson*. The plaintiffs were the photographic partnership Mayer et Pierson, which included Pierre-Louis Pierson and brothers Léopold-Ernest and Louis-Frédéric Mayer. Best known for their work as the court photographers for Napoleon III and as the creators of the series of portraits of the emperor's mistress, the Countess de Castiglione, Mayer et Pierson had, like Mayall, Brady, and Nadar, built a large and successful business based on the sale and circulation of photographic carte portraiture. Their lawsuit accused their rivals—photographers Pierre Eugène Thiébault and Pierre Alexis Marcelin Betbéder and the art dealer Schwalbé—of copying and selling carte photographs they had produced of La Castiglione's cousin, Count Camillo di Cavour. During the court proceedings, the factual determination of this specific act of photographic plagiarism quickly led to a larger philosophical debate over the possibility of photographic authorship. Counsel for Betbéder and Schwalbé argued that because a photograph was produced by a camera rather than by hand, it could not contain the element of human *ésprit* that the concept of *droit d'auteur* sought to protect. In an argument that anticipated Sarony's similar statement years later (and perhaps indicated his familiarity with this legal argument), Mayer et Pierson's lawyers persuasively countered that the tool an author used to realize his work had absolutely no relevance in considerations of creative rights. "What strikes our opponents in this argument is that, in photography, the camera plays an important role, and even the leading role. What does that prove? What if the painter, after having envisioned his painting, found the means to reproduce it on canvas in one go, just as he conceived it, would anyone deny that his work was created as *a production of the mind*? What difference does it make if the execution

is faster or slower, easier or harder? Is it not the concept rather than the fashion in which it is carried out that makes a work artistic?" (emphasis added). They continued that whether an artist of intelligence works with a brush, a burin, or a camera, he faces similar material difficulties in realizing his creation. A photographer envisions his image; he arranges the accessories and the play of light and positions the camera. After this process of imagination and preparation is complete, "of what importance is the speed, perfection, the fidelity of the instrument with which he executes what he has designed, arranged, created. We have said many times before that *droit de l'auteur* derives from the act of creation, which invests a work with the imprint of personality. How is that individuality lacking here?"[14] If a work of art's defining principle was that it was an "act of creation," then no artist's work could be dismissed on the basis of how it was manufactured. Mayer et Pierson's ultimate victory in the case not only legally established rights of authorship for photographers in France, but also, as Bernard Edelman and Jane Gaines have shown, effectively translated the legal understanding of *droit d'auteur* from the vague notion of *ésprit* into the more serviceable concept of "imprint of personality," a legal means by which "a work of art could be seen as something indelibly etched with this sign of its author."[15] One consequence of this ruling for contemporary French photographers such as Mayer et Pierson, as well as for Nadar, is that it endowed the cultivation of recognizable artistic personality with fresh significance. In addition to functioning as an essential creative tool and proof of merit, it rewarded dramatic gestures of professional visibility, such as a gigantic signature scrawled across the face of a bright red studio building, which quite literally made the sign of the author impossible to overlook.

PICTURES SPREAD AROUND THE WORLD

When Sarony returned to New York in 1866, his photographic practice occupied uncharted territory in terms of how the relationship between art and photography had been conventionally constructed. Governed by an Anglo-American legal system but aligned philosophically with French artistic models, his business relied equally on his shrewd management of large-scale picture production and the artistic personality he constructed to publicize his creative *esprit*. One additional complicating factor was that with the close of the Civil War, the primary focus of the US photographic industry shifted from war reportage to celebrity portraiture. This mode of image making was necessarily invested in how the "imprint of personality" was made visible through photography, but it also placed the photographer and his subject at odds in terms of whose personality would be featured more prominently in the resulting public image.

Sarony's manifold investment in celebrity perhaps made it inevitable that his photography business would become a proving ground for the expansion of copyright protections. While legal questions related to reproducing images and texts persisted

during the second half of the nineteenth century, these creative issues aligned more neatly with conventional definitions of authorship and invention than with the more nebulous area of personality rights, which today allows individuals commercial control over their names, likenesses, and any other unequivocal form of self-expression, but which remained largely undefined in the Gilded Age. In this sense, Sarony's mass-produced portraiture represented a point of convergence in the mounting associations between celebrity image, artistic authorship, and the legal authentication of intellectual property. Within this context, Sarony's signature functioned as a marker of artistic identity, a publisher's copyright claim, and a celebrity autograph—a reproducible device that gestured to the ways in which mass media was shattering existing social and cultural relations.

A peculiar conflict between Sarony and Samuel Clemens demonstrates how complex problems surrounding legal language and celebrity culture unfolded in practice. In 1908, Clemens penned a grumbling inscription beneath his portrait in a volume published to commemorate his sixty-seventh birthday: "Of course they would frontispiece it with this damned old libel, which <u>began</u> as a libel when Sarony made it . . . it has been used all over the world in preference to any later & better picture."[16] The inscription, strangely, was not addressed to any specific reader but rather annotated Clemens's personal copy of the book, where it resided quietly for decades as an expression of profound distaste for a picture frequently used to represent him and his writing. Clemens's objection to the photograph appears not only to have been that he found it unflattering but also that it was reproduced with alarming regularity during the fifteen years between its creation in 1893 and the time when he declared it a "libel" (fig. 53).

Sarony, who died in 1896, never registered any awareness of these hard feelings. In fact, he regularly claimed that the photo of Clemens was among the best examples of his work. In an 1894 interview, he proudly recounted the circumstances of its creation. One day, while out walking on Fifth Avenue, Sarony had encountered the author in the street and was struck immediately by the appearance of Clemens's iron-gray hair tumbling over his coat collar and sticking out from under his hat. The effect, the photographer recalled, "gave his head the massive appearance of the old type of patriarch." Running over and catching hold of his arm, Sarony said, "Mark Twain, I want you to let me take your head, just as it is. Don't go to the barber until you see me." Several days later, Clemens appeared in the studio as requested, and Sarony felt satisfied that he had created a portrait of the writer that was true to his vision that day on the street. To his mind, the photograph lent the American humorist gravitas while still retaining a sense of his lively, modern animation. It was, Sarony concluded, "a photograph of which I am justly proud."[17]

Clemens's assessment was quite different, but it was not until 1905, nearly ten years after Sarony's death, that he first expressed his dissatisfaction publicly. In a widely published letter to an admirer who had requested an autographed copy of the photograph

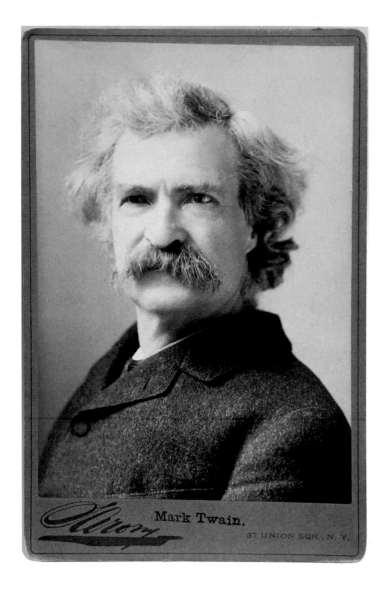

Fig. 53 | Napoleon
Sarony, *Portrait of Mark
Twain*, 1893. Albumen
silver print; cabinet
card. Photo: Wikimedia
Commons.

(the request was denied), the author went so far as to claim he was not the portrait's
true subject, but that the photographer had for years been circulating a picture of a
costumed gorilla in his place. In Clemens's account of how the photograph was made,
Sarony had come to him to announce excitedly that he had located the author's long-
lost great-grandfather in an exhibit of lowland gorillas then touring the United States.
"I was deeply hurt but did not reveal this," the author confided, "because I knew that
Sarony was not a man who would say an unkind thing about a gorilla wantonly." Eager
to facilitate a reunion, the photographer invited both author and gorilla to his portrait
studio, and to demonstrate their shared likeness, he borrowed Clemens's overcoat and
put it on the gorilla. At first, the author had seen only "passing resemblance" between
himself and the ape, but once the animal was in costume, he was forced to admit that

Fig. 54 | Wolf Brothers & Company, Mark Twain cigar box label. Collection of the author.

the similarity was uncanny. "I saw that the gorilla, while not looking distinctly like me, *was* exactly what my great grandfather would have looked like if I had had one." It was then that the seeds for the charge of libel were sown. According to Clemens, "Sarony photographed the creature dressed in that overcoat, and spread the picture around the world. It has remained spread around the world ever since. . . . It is not my favorite but to my exasperation it is everybody else's."[18] Though the story was clearly meant to amuse, it makes clear that Clemens's objection had as much to do with the picture's independent mobility as with how it portrayed him. Once the photo had been "spread around the world" without his permission, it robbed him of the opportunity to participate in shaping a public image he might have found more favorable.

Even so, Clemens would have had no expectation of privacy when he sat for his portrait with Sarony. The nature of the photographer's business as celebrity image maker was well known, and Clemens had posed for him on at least two previous occasions when promoting books as his alter ego Mark Twain. What made the 1893 portrait different is that the image seemed to take on a life of its own once loosed within the realm of mass media. In addition to its official reproduction in the form of cabinet cards produced by the Sarony studio, it had a long commercial afterlife in newspapers, magazines, and books, and it served as the basis for a chromolithographic advertising label pasted inside every box of "Mark Twain" brand cigars—a product that, like the photograph's many other iterations, circulated without either Clemens's or Sarony's consent (fig. 54).

Clemens may have been especially sensitive about safeguarding his public image because it represented the fictional character who was among his most celebrated creations: his pseudonymous alter ego Mark Twain. Clemens's true identity was no secret, and in fact his name and Twain's were often discussed interchangeably, but there was a definite distinction between them that mapped along private and public lines. Clemens was the private citizen and Twain was the public image. Both were authors, but Twain was the celebrity persona that Clemens invented and performed as a way of shielding elements of his identity from general view.

The problem of protecting Twain's intellectual property as a fictional author was one Clemens encountered repeatedly over the course of his career. In 1883, Clemens attempted unsuccessfully to trademark Twain's autograph and persona, in order to prevent its easy piracy by companies like the Wolf Brothers cigar company and the many publishers who reprinted Twain's novels without enforceable consequence. Despite its obvious merits, the case baffled contemporary legal reason, as it was deemed impossible to assign personality rights to a person of fiction—however celebrated he might be as an author.[19] At the same time, the question of who might claim authority over Mark Twain's popular public image placed the writer and photographer naturally at odds, since each had a distinct artistic stake in making sure that his "imprint of personality" remained visible in the portrait. The fluid understanding of media allowed under the construct of *droit d'auteur* was equally alive in the *genie* that animated a literary character and in the photographic artistry that captured his visage.

Twain scholar R. Kent Rasmussen similarly attributes Clemens's compulsive annotation of his personal archive to his frustrated obsession with managing public appearances. The author regularly scrawled handwritten corrections and objections on press clippings, published reviews, and fan letters, because he regarded all such printed mentions as important extensions of his carefully crafted public self, "mirrors reflecting the images Clemens cast on the world," as Rasmussen puts it.[20] By compiling, scrutinizing, and editing his private collection of correspondence and photos, he exerted authority over an aspect of his professional identity that remained otherwise exasperatingly out of his control.

Clemens's attentiveness to his mediated public image makes his joking charge of "libel" a particularly pointed word choice. For a written statement to be libelous it must be demonstrably false and publicly defame its subject. Applying this language to photography necessarily contradicts the truth claims with which the medium is conventionally associated, by suggesting the portrait has no basis in reality. Wilkie Collins referred to a series of portraits taken by London photographers as "perfect libels" in an 1887 letter to Sarony, as a way of describing the absence of similarity to what he believed was his "true" self-image. "If you can see any resemblance between them— and, accepting the profile, any vague point of likeness to me—it is more than I can do."[21] Collins's problem was limited to finding photographs he liked well enough to

circulate to friends and fans. For Clemens, the complaint of photographic libel alluded to the difficulties of fashioning a public image that might simultaneously represent and shield one's private sense of self within the untested grounds of late nineteenth-century celebrity. From this perspective, the "libelous" quality of Sarony's portrait photograph was amplified by its existence on the unruly frontier of mass media, where the layered fictions of authored self and authored image assumed a powerful public life of their own.

AUTOGRAPHS AND PHOTOGRAPHS

In the United States, the popularity of photographic portraiture and the growth of celebrity culture in the late nineteenth century were fueled by a blossoming consumer culture and new modes of social connection formed by expanding networks of mass markets and mass media. Aware of Clemens's frustrations with managing the demands of public life, George Washington Cable arranged in 1884 for 150 famous friends, including Sarony, Ellen Terry, Henry Irving, and Henry Ward Beecher, to participate in an April Fools' Day joke at the writer's expense. Each celebrity fan was instructed to write Mark Twain requesting his autograph, so that on the first of April he would receive "a stupefying mass of letters." Cable specified that correspondents should mimic the lack of consideration many fans displayed when making similar requests; no stamps or envelopes were to be provided for a reply. In his letter, Sarony also deliberately misspelled Clemens's last name as "Clements" while claiming to be a sincere admirer (fig. 55).[22] For the celebrities who were in on the joke, such requests would have been all too familiar. Sarony's note, which bears his dramatic signature at the bottom and is written on studio letterhead that includes his printed signature at the top, emphasizes the photographer's dual role as a maker of public images and a celebrity in his own right, an individual whose autograph acquired its cachet for his role in manufacturing fame as well as portraiture.

Collecting autographs, like collecting portrait photographs, was about forging mediated connections, aspiring to possess something of a distinguished person with whom one would never otherwise cross paths. It was no coincidence, then, that the growth of celebrity and photography were accompanied during the 1860s and '70s by a craze for autograph collecting and handwriting analysis. As evocations of individual touch and idiosyncrasy, handwriting, signatures, and autographs offered an antidote to the anonymity and industrial volume of early mass visual culture, signaling the persistence of individuality within a proliferation of mass-produced information, images, and texts. Tamara Thornton traces the origin of these two pastimes to the era of Lavater in the late eighteenth century and the popular pseudosciences of phrenology and physiognomy, which supported the belief that an individual's inner character could be seen in outward appearance and behavior. The analysis of handwriting and

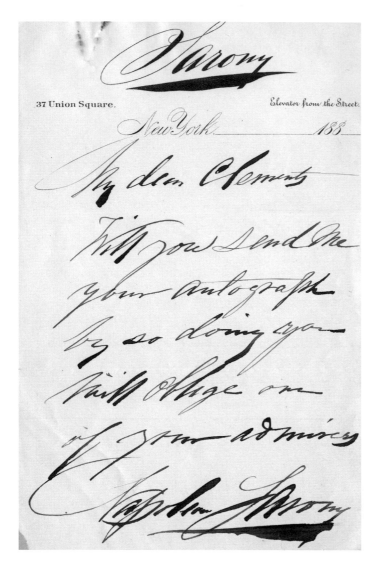

37 Union Square.

Elevator from the Street.

New York _____ 188_

My dear Clemens _____

Will you send me
your autograph
by so doing you
will oblige one
of your admirers

Napoleon Sarony

Fig. 55 | Sarony letter to Samuel Clemens on studio letterhead, 1883. Courtesy of the Mark Twain Project, Bancroft Library, University of California, Berkeley.

signatures, known popularly as "graphology," was another iteration of this Romantic-era belief in a "science of individuality," and it progressed gradually over the course of the nineteenth century from an elite preoccupation to a widespread popular fad.[23]

Just as photographs were cherished for their capacity to capture an individual's appearance in uncompromising detail, the autograph's capacity to communicate individuality was the source of its appeal for nineteenth-century collectors. Edgar Allan Poe, an early enthusiast of both graphology and autograph collecting, wrote in his 1841 "Chapter on Autography" that "the feeling which prompts to the collection of autographs is a natural and rational one. . . . Next to the person of a distinguished man of letters, we desire to see his portrait; next to his portrait, his autograph. In the latter especially, there is something which seems to bring him before us in his true idiosyncrasy."[24] Early in the century, the most sought-after autographs were those

of politicians and authors. Zachary Taylor, during the election of 1848, was the first American president to comment on the mounting burden of responding to letters from autograph seekers. By 1861, Abraham Lincoln reportedly employed the assistance of multiple secretaries to keep up with such requests. Similarly besieged, the writer Washington Irving described autograph collectors as the "musquitoes [sic] of literature," swarming around the heads of creative individuals in hopes of sapping some measure of their personal genius. Unwittingly attesting to the accuracy of this description, one late nineteenth-century autograph collector described his ambitions in distinctly mosquito-like terms. He wrote that by gathering the signatures of great men and women of letters, he and his fellow collectors hoped "to drink inspiration from original fountains, from the streams of thought in the channel through which it first flowed from the author's pen."[25]

Sarony's photographs were often themselves the vehicles for these autographs, with famous subjects like Ada Rehan adding their signatures alongside the photographer's as testament to the dual presence of artist and subject embedded in each reproducible print (fig. 56). Through these evidentiary traces, the distinct realms of private and public life were collapsed into one accessible, consumable field of operation. Perhaps for this reason, while autographs could be requested via correspondence or purchased anonymously through photographic dealers, most earnest autograph collectors savored the experience of requesting a signature in person from a celebrated subject. For autograph collectors, as Thornton puts it, "physical contact with the actual stuff of individuality seemed alive with magical possibilities."[26] So each degree of remove between the consumer/collector and author/creator that could be eliminated enhanced the tantalizing evidence of personal touch that a handwritten signature seemed to symbolize.

In many ways, photographs and autographs are natural analogues. Where a photographic portrait records a subject's visible appearance in exacting detail, an autograph registers evidence of its author's physical touch. Indeed, far from being the simple transcription of a name, the signature permanently retains what Derrida describes as the author's existential "presentness." A signature's inherent tension between reproducibility and originality is essential to this temporal permanence. Every consistently performed autograph encompasses not simply the one-time act of signing but also every previous iteration of that signature and its potential for future repetition. This formal persistence, "the always evident and singular form of the signature," is what lends it authority as the maker's mark by registering the "imprint of personality" across time and space. Whereas handwriting might be seen as the intersection of standard text and individual voice, varying in form and formality, the signature is a necessarily deliberate act that must be repeated in much the same way each time in order to be recognized as authentic.[27] In this way, the signature carries with it a dual implication of both reproducibility and singularity, a temporal and existential complexity that binds it conceptually to the photograph. For just as an individual act of signing is necessarily tied to an

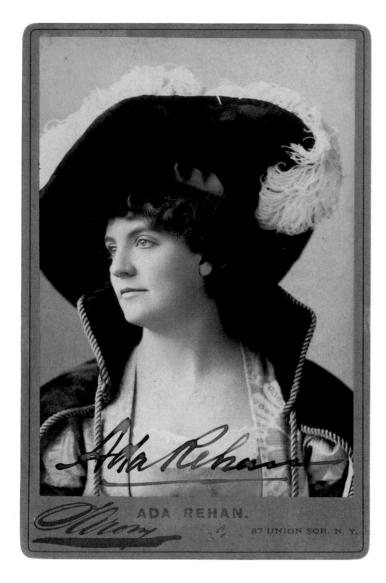

Fig. 56 | Napoleon
Sarony, *Portrait of Ada
Rehan (1857–1916)*,
ca. 1890. Albumen
silver print; cabinet
card, 14.1 × 9.6 cm (5
½ × 3 5/8 in.). Folger
Shakespeare Library.

originating "signature event," a reproducible photograph has a "photographic event"
that is its source—an evidentiary index that Roland Barthes, in a point of conceptual
commonality with Derrida, called the essential "that-has-been" of every photographic
image.[28] Acknowledging this overlap, Derrida reflects that when autograph and pho-
tograph are combined, they certify the unique act of individual creation, a means of
reclaiming "the nonreproducibility at the heart of the reproducible."[29] In their contin-
gency as signs, both the signature and the signed photograph refer insistently to their
original source, even in the face of potentially infinite reproduction.

For nineteenth-century consumers, the symbolic power of written text to signify
individual nonreproducibility seems to have been capable of surviving the additional

mediation of mechanical reproduction. During the decades around the turn of the twentieth century, reproductions of celebrity autographs and handwritten testimonials were common features of printed advertisements, often used to supplement or even substitute for photographic images as representations of celebrity presence. In 1901, Clemens (as Mark Twain) used a reproduced handwritten statement and signature to certify the "authorized" Riverdale edition of his collected works.[30] For celebrities like Sarah Bernhardt, commercial endorsements provided a significant financial sideline, and Bernhardt lent her name,

image, and written testimonials to a variety of products, from cold cream to malt whiskey (fig. 57). Because the actress's actual handwriting was difficult to read, these impassioned personal recommendations were occasionally written by someone else to ensure their legibility and only included Bernhardt's autograph appended at the end. Clearly, the authenticity of handwriting was less important to viewers, consumers, and advertisers than its symbolic connection to personal and idiosyncratic qualities within a print culture increasingly dominated by mechanical type.

Sarony's reproduced signature communicated a similar sense of intimate personal connection linking image subject, producer, and consumer. Like other manifestations of his public image, this trademark of his brand was an assertion of artistic personality engineered for the inflated scale of mass visual culture, intended to rebalance the traditional intimacy of creative presence with the industrial scope of photography's mechanical reproduction. That the indivisibility of these commercial and artistic claims was not unique to Sarony underscores the pressures of mass media on cultural producers of all kinds, from writers to actors and politicians. As public images increasingly became the avatars through which individuals promoted their work and represented themselves in the realms of mass media, they gained currency as the visual language through which celebrities communicated with new and expansive audiences.

INVENTING OSCAR WILDE

More than just certifying a point of manufacture, Sarony's signature communicated the singular event and artistic viewpoint that was at the heart of his photographic process, as well as the promise of an encounter with the artist himself. As a *New York*

Times reporter wrote in 1881, "that stupendous name, written in gold across the front [of his studio], is but the gigantic duplicate of that slashing 'Sarony' which gives a picture a peculiar value, both intrinsically and artistically. . . . For people will not be satisfied that they have a 'real Sarony,' unless the little man poses them, attends them, and turns their eyes up or down according to his own particular conception."[31] The underlying connotation of the giant gold signature in Union Square was the experience of seeing the celebrated photographer in the flesh, walking through his famous studio, and collaborating in his artistic process, and it was the photographer's creative investment in this singular "photographic event" that was authenticated by the same signature printed on each of his portraits.

This promise may have been what brought Oscar Wilde to Sarony's Union Square studio in January 1882 to sit for *Oscar Wilde No. 18* (fig. 48). The image shows the poet in a relaxed seated position on a couch draped with carpets and fur. With one hand, he balances his recently published book of poetry on his knee, and with the other he cradles his head in a gesture of thoughtful melancholy—a pose that serves the dual purpose of establishing Wilde's poetic character and foregrounding his shapely, stocking-clad legs, thereby highlighting the aesthetic costume of velvet jacket and knee breeches with which he is enduringly associated.

Sarony created the portrait, along with twenty-eight others, to serve as souvenirs and press images at the start of Wilde's yearlong lecture tour of the United States.[32] The widely circulated photographs were the basis for most nineteenth-century media images of Wilde, and even today they remain Sarony's best-known and most reproduced works. Their endurance might be attributed to the fact that they read true to what we know of Wilde's public identity as a poet, a leading figure in the aesthetic movement, and a fashionable, convention-challenging dandy. Yet, like Sarony's other work, the photographs are the product of artful invention and creative, collaborative performance. Only twenty-eight years old and a newly published author, Wilde was scarcely known in the United States when he visited Sarony's studio. His US tour had been organized by British theatrical producer Richard D'Oyly Carte to promote Gilbert and Sullivan's comic operetta *Patience*. The play was a parody of the British aesthetic movement and the creative philosophy of "art for art's sake" that dominated art practice in England at the time. Concerned that the play's humor would fall flat with Americans unless audiences were familiar with the movement's principles, Carte hired Wilde to act as a kind of ambassador of aestheticism. The author toured the United States from New York to California and lectured on beauty, fashion, and art before the play opened in each town he visited. Ultimately, Wilde's popularity eclipsed that of the play, and demand for Sarony's photographs quickly outstripped supply. The portraits served as the basis for caricatures, sheet music covers, and trade cards; in addition to the photos printed by Sarony's studio, tens of thousands of unauthorized copies were snapped up by eager fans.[33]

Fig. 58 | Robert White Thrupp (1821–1907), *Portrait of Oscar Wilde*, ca. 1884. Albumen silver print on card. Photo: OscarWilde inAmerica.org.

Though Sarony usually courted celebrity subjects and paid them for their likenesses, it was probably Wilde and his managers who approached the famous photographer to ask Sarony's assistance in creating a public image of the poet in the role of aesthete. The value of this contribution is demonstrated by comparing Sarony's photographs with portraits of Wilde taken two years later by the British photographer Robert White Thrupp (fig. 58). Thrupp worked alongside Sarony in Birmingham and took over their New Street studio when Sarony departed for New York.[34] Yet his photographs of Wilde exhibit little of the ease and grace that define the work of his former partner, suggesting that the portrait gained immeasurably from the unseen collaboration that took place between photographer and subject during the session. Certainly, the difference seems to support Sarony's assertion

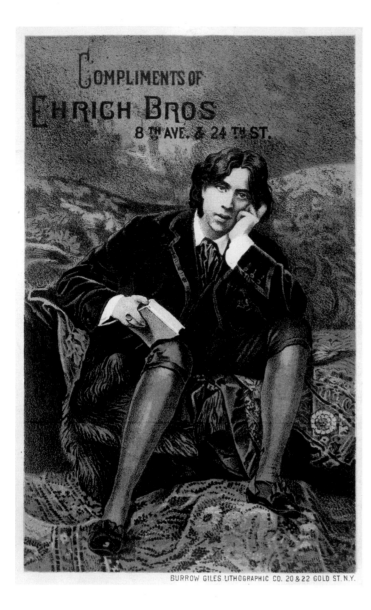

Fig. 59 | Burrow-Giles Lithographic Company, trade card for Ehrich Bros. Department Store, 1883. Chromolithograph. Library of Congress, Prints and Photographs Division, LC-USZ62-138240.

that his photography had "aspects personal and individual apart from mechanical considerations."[35]

The lawsuit that brought Sarony's photographs to the Supreme Court began with a particularly egregious instance of image piracy. The Burrow-Giles Lithographic Company had reproduced eighty-five thousand copies of *Oscar Wilde No. 18* without permission, making Sarony's image the basis of a trade card advertising the Ehrich Brothers Department Store in New York (fig. 59). When Sarony sued for breach of copyright, the lithographic company did not bother to deny that it had used his photograph, since it was entirely evident that it had. Instead, the company challenged the photographer's claim to copyright on more fundamental terms. First, they argued

that Sarony had not properly indicated his authorship of the image since he identified himself most prominently with a signature rather than with his full name, as the law required, and second, reverting to early definitions of a photograph as a machine-made reproduction, they argued that since a photograph was made by a camera rather than a human artist, it contained no original or creative content. After all, Burrow-Giles pointed out, Sarony had not invented Oscar Wilde; he had only reproduced his likeness. In this way, making light of Sarony's suit, the defense argued that if the photographer wished to claim he had invented Oscar Wilde, he had been mistaken in filing for copyright rather than patent protection.[36]

This second point presented the case's most important wrinkle—for as purveyors of printed multiples, the lithographic company had no interest in undermining copyright simply on the basis of reproduction. Instead, Burrow-Giles proposed that artistic originality could best be measured in terms of human touch and mark making, two qualities, the company argued, that photographic processes lacked. Citing the copyright clause of the US Constitution, which specifically protected only the "writings and discoveries" of "authors and inventors," the company's lawyers claimed that a photograph could not be copyrighted because it was not an act of writing—it was an image drawn by the pencil of nature, not by the physical touch of a creative human author.

The press eagerly latched on to the comedic potential of the legal conflict. The *New York Times* reported the case's details under the headline "Did Sarony Invent Oscar Wilde?" A journalist writing for the *St. Louis Globe-Democrat* quipped that the circumstances of the case placed the famous photographer in an embarrassing position: "To secure copyright protection on his picture he must either show that he projected and evolved Oscar Wilde, as one does a poem or a novel or a cookbook; or failing that, he must get a patent on the distinguished aesthete in the manner of a new rat-trap or can-opener."[37] But Sarony saw the case as an opportunity to legally establish the claims to artistry he had made for years. He countered that he had no wish to claim that he had created Oscar Wilde himself, but he did insist on being recognized as the inventor of the author's well-known public image. The legal brief filed with the Court argued that the defining aspects of Wilde's portrait—his dreamy melancholic pose, the artfully draped furs and carpets, and everything else about the picture's composition—had been produced "entirely from Sarony's own original mental conception to which he gave visible form by posing the said Oscar Wilde in front of the camera, selecting and arranging the costume . . . suggesting and evoking the desired expression."[38]

In the end, the Supreme Court ruled in Sarony's favor, agreeing that his creative intervention in posing, arranging, and staging his subject elevated the portrait above "mere mechanical reproduction" and represented instead "ideas in the mind of the author given visible expression."[39] It was not the subject matter alone that constituted

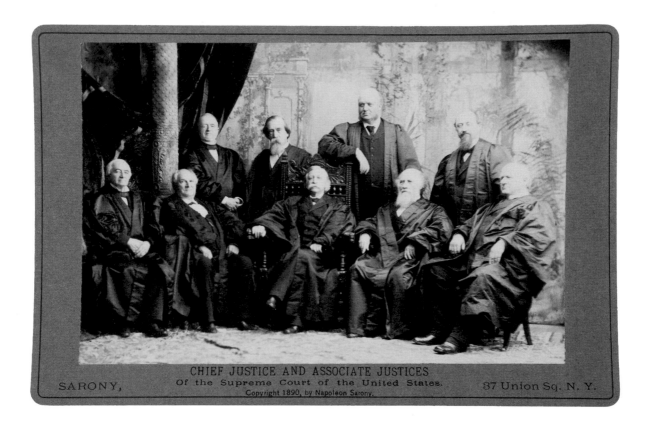

CHIEF JUSTICE AND ASSOCIATE JUSTICES
Of the Supreme Court of the United States.
Copyright 1890, by Napoleon Sarony.

SARONY, 37 Union Sq. N. Y.

a photograph's original content but how that subject matter's natural appearance was composed and transformed according to the creative vision of a photographic artist. By focusing on creative process rather than creative product, the Sarony ruling echoed the moral rights of authorship laid out in the Mayer et Pierson case that went before the French Court of Cassation in 1862. Yet ultimately its legal precedent represented a middle point between the conventional Anglo-American system of copyright and the French legal principle of *droit d'auteur*. Crucially, the 1884 ruling did not protect all photographs, only those that demonstrated a photographer's visible alteration of natural appearances through the act of posing, arranging, and staging a subject. Photographs that did not meet these criteria were not entitled to the same legal protections. In other words, it was only by applying a signature style to a well-known sitter such as Oscar Wilde that Sarony's singular rights as a photographic author could be publicly and legally authenticated.

Six years later, all nine members of the US Supreme Court traveled to New York City to pose for a group portrait in Sarony's Union Square studio (fig. 60). Wearing the ornate costumes of their profession and seated against a backdrop staged to resemble an Italianate garden, the justices performed their roles for the camera with somber dignity. Sarony's signature presence as the scene's artistic director can easily

Fig. 60 | Napoleon Sarony, *Chief Justice and Associate Justices of the Supreme Court of the United States*, 1890. Albumen silver print; cabinet card, 10.8 × 15.9 cm (4 ¼ × 6 ¼ in.). Courtesy of Special Collections, Fine Arts Library, Harvard University.

be observed in the graceful nuance of their individual poses and the carefully composed arc of their chairs, which lends a subtle intimacy to the staged gathering. Yet, perhaps in light of recent experiences, this time Sarony followed the exact letter of the law, and when registering his copyright with the Library of Congress, he took the unusual step of marking the image not with his signature but with his full printed name—twice. By now, however, the campaign he began early in his career to assert his artistic presence in his photography had gained sufficient support to be legally validated. Sarony's signature and the imprint of personality it symbolized had made their mark on American photography.

5.

OBJECTS OF ART

Photography's capacity to translate diverse materials into a single uniform media package made it a convenient repository for the untidy sprawl of Gilded Age consumer culture. Just as a flood of commercial pictures reshaped the visual landscape of the antebellum United States, a wave of manufactured and imported goods during the second half of the nineteenth century eroded the hierarchies of value that had previously ordered diverse classes of objects. The emergence of the department store, the rise of the aesthetic movement, and an economic market that increasingly catered to the demands of an American "citizen-consumer" made the discerning accumulation of material possessions a national pastime and introduced the idea that artfully displayed objects in a home, shop window, or artist's studio were a marker of taste and an expression of refinement.[1]

Photographic portraiture served as an important arena for visualizing and navigating the changing relationship between people and things. Portrait subjects dressed in their finest clothes and posed with favorite belongings in studio environments decorated with fancy furniture and props. Whether owned or borrowed, these material trappings provided a symbolic framework for staging social identity as well as aspiration. Even so, the intersection of late nineteenth-century photography and commercial consumer culture was not as straightforward as conventionally described. The early historian of US photography Robert Taft, for instance, characterized what he termed the "elaborate style" portraiture of Sarony and his contemporaries William

Kurtz and José María Mora as a direct outgrowth of period fashion, comparing studio settings decorated with painted backdrops, artificial trees, and rocks to the accessories of a "well dressed lady's toilet," or other "grotesque" manifestations of Gilded Age taste like bustles and exaggerated side-whiskers. By indulging in such affectations, Taft concluded, photographers like Sarony were simply "reflecting the day in which [they] lived" by documenting the material abundance of the economic boom years that followed the US Civil War.[2]

Though Taft deployed the term "elaborate style" derisively, its evocation of multimedia clutter is useful for focusing critical attention on the pictorial operations of things in Gilded Age portrait photography and developing a methodology for seeking deeper meaning in them. While cabinet cards showcased fashion trends and circulated as collectible consumer objects themselves, they by no means operated as reliable documents of material culture. Their compositions staged human subjects within indiscriminate mixtures of authentic objects and fictive props, positioning a real armchair beside a ten-pound mock piano, or a genuine oil painting before an illusionistic backdrop. I propose that these material assemblages, which were nonsensical in terms of real-world functionality, served to dramatize acts of visual discernment by showing human subjects interacting with objects of disparate value. Thus, rather than simply stoking consumer desire, or reflecting it, the hybrid media and eclectic décor common to Gilded Age photographic studios promoted new ways of seeing and arranging things as a productive response to the seismic destabilization that industrial-scale mass production introduced to the world of modern material culture. In this sense, portrait photographs functioned as symbolic points of transfer between material and cultural capital, disrupting standard terms of ownership through their own mass reproduction. Phrasing this in terms of photographic aesthetics, if a core tenet of modern photography was contemplative focus on "the *Thing Itself*," as photographer Edward Weston described it,[3] the strategy pursued by Gilded Age photographers like Sarony would be better characterized as thing upon thing upon thing, representing aesthetic delight in decorative abundance—furniture festooned with scrollwork, shelves packed with gewgaws, patterned wallpaper on the ceilings—precisely the type of superfluous embellishment that would be anathema to austere modernist sensibilities.

Indeed, Taft's objections to the so-called elaborate style of photography stem from the fact that Gilded Age consumer culture has not often been credited with advancing the cause of good taste. To the contrary, the exuberant excess of high Victorian style was presented in many twentieth-century accounts of US cultural history as a crucible of kitsch from which the purer forms of modernism would eventually emerge. For cultural critics Van Wyck Brooks and Lewis Mumford, writing in the 1910s and 1930s, the "usable past" for modern American culture was conditioned upon rejection of the imitative, mechanical reproductions of late nineteenth-century mass culture.[4] More recently, scholars have described the relationship between nineteenth- and

twentieth-century style in terms of binary division—modernism and antimodernism, highbrow and lowbrow, or imitation and authenticity—positioning these categories as central dialectics of American cultural experience, with modernism representing a shift away from machine-made simulacra and imitative illusion toward material practices that more meaningfully reconstituted "the real thing."[5]

While such conceptual models are useful for underscoring the ways in which modernist aesthetics deviated from tradition, they have been less helpful in identifying threads of historical continuity between nineteenth- and twentieth-century art, or in developing nuanced scholarly approaches that address the messy media hybridizations that abound in Gilded Age mass visual culture. More important, they fail to divorce histories of material circulation from the distraction of changing taste. What is not captured within evaluative binaries like high and low or imitation and authenticity is the significant cultural work that can occur in the spaces between things—through their juxtaposition, display, and hybridization. In this sense, the eclectic excess or "elaborate style" of the Gilded Age United States might be productively regarded as a moment of profound reordering—when a world of industrially produced material objects were accumulated en masse for the purpose of ascertaining new and more modern ways in which they might be reconfigured, or, in the words of Bruno Latour, reassembled into new "associative relationships."[6] Rethinking the "thing-upon-thing" of Gilded Age studio photography in terms of assemblage and associative relationship allows us to consider late nineteenth-century visual culture dispassionately as a problem of scale and translation rather than of taste. Additionally, by demonstrating photography's capacity for omnivorous material consumption, late nineteenth-century studio practices illustrate the evolution of an antebellum media phenomenon that Michael Leja describes as "transmedial fortification." Early photographic technologies required translation into print to allow unique metal daguerreotypes to take on the expansive distribution possibilities of mezzotints. By the late nineteenth century, however, advances in photographic technologies brought about a new position within media ecology. Instead of supplying raw material to bolster the representational realism of prints and paintings, photography itself became the "principal consumer of works in all media"—an apex predator, in visual culture terms.[7] The predatory glee that accompanied this changing position is evident in the characteristic "thing-upon-thing" compositions of Gilded Age studio tableaux and represented a transitional process of growth upon which later, modernist photographic forms depended.

EXHIBITING CONSUMER CULTURE

The Centennial International Exhibition of 1876 in Philadelphia marked a major turning point in the history of US art and visual culture, as well as in the American public's relationship to consumer culture. This first official World's Fair to take place

on American soil was attended by nearly a third of the US population over its four-month duration, and in addition to delivering what Kimberly Orcutt has described as "the nation's first blockbuster exhibition" of fine art, it provided millions of viewers with an opportunity to exercise comparative judgment upon a global expanse of consumer objects.[8] For the mass audience in attendance, the Centennial was a feast for the eyes that emphasized visual consumption as an alternative to physical ownership.[9] Visitors to the Machinery Hall witnessed the latest advances in steam power, mechanical refrigeration, hoisting, manufacturing, and firefighting in the form of elevators, circular saws, hydraulic pumps, and the celebrated Corliss steam engine. In the Horticulture Hall they saw seeds and plants from around the world, including orchids, cacti, orange trees, banana trees, and date palms, along with greenhouse boilers, garden settees, fruits made of wax, and hanging baskets of pressed tin. There were guns and armaments, musical instruments, dental implements, time-keeping devices, corsets, furniture, and sewing machines, along with examples of painting, sculpture, print-making, photography, stained glass, calligraphy, and ceramics from around the world. More than any one specific class of objects, the medium of display was the message at the Centennial Exhibition. The sheer volume of material comparisons could not help but upset preexisting expectations about the way objects behaved in relation to one another. National borders disappeared, as an international assembly of fruits and vegetables greeted visitors to the Agriculture Building; hierarchies of commercial goods collapsed as soap, ladies' hats, farm equipment, and temple bells became neighbors in the Manufacturing Hall; perceptions of normal size and scale were upended by the giant arm of the Statue of Liberty, the world's largest knife and fork, and a mammoth wheel of Canadian cheese. This shifting climate of material abundance made the Centennial a prime opportunity for American photographers, not only to display their wares but to demonstrate the capacity of their medium to reorganize and contain an unruly new world of things.

Among the estimated ten million visitors to the exhibition was a twenty-two-year-old George Eastman. It would be more than a decade before he revolutionized access to photography with the invention of the Kodak camera, but visual and commercial matters were nonetheless on his mind. He reported in a letter to his mother that during his first day touring the sights, he had been able to take in only the Machinery Hall and half of the Main Building, but the unexpected pleasure he found at every turn made him determined to tour every building fully before returning home. "The ingenuity that exhibitors have displayed in arranging such things as tacks, candles, soap, hardware, needles, thread, pipe & all such apparently uninteresting articles is something marvelous—and they command the attention of the observer even against his will."[10] No doubt many visitors to the fair shared Eastman's sense of surprised revelation upon discovering the commanding charm of candles, thread, and thumbtacks within a vast field of consumer options. Crediting the powerful appeal of

buttons and soda crackers to the ingenuity of exhibitors sustained the hopeful possibility that these humble manufactured objects might return to their normal state of useful invisibility once released from this imposed order.

In fact, manufactured objects already exerted considerable power in American public life. The period between 1870 and 1920 marked an epochal transformation of productive capacities and new organizational forms that economic historians have called a "Second Industrial Revolution," during which the United States emerged as the world's preeminent manufacturing nation.[11] Though US businesses continued to follow Europeans in terms of technological innovation, they excelled in adapting mechanized means of productivity, pioneering continuous-process mass-production methods and employing steam power far earlier than their international counterparts.[12] In 1870, the United States accounted for 23 percent of global industrial production, surpassed only by Great Britain. Roughly a decade later, this number had grown to 29 percent, with American factories and businesses manufacturing more goods than any other nation in the world.[13] The Centennial Exhibition marked this economic ascent, occasioning a profound reckoning with the material realities of global industrial production.

Perhaps for this reason, one tacit goal of the exhibition's organization was to invent an ordering framework capable of containing this rising tide of objects. The official catalogue of the Centennial Fair contained forty-five pages of taxonomical classifications that outlined the diverse material and national contributions to the fair and separated them into 739 categories that ranged from minerals to mosaics and from moral instruction to garden management.[14] Art was represented by one independent heading of this organizational system and comprised fifty-four classes of objects spread across six categories: sculpture, painting, engraving and lithography, photography, industrial and architectural design, and the curiously specific catch-all "Decoration with Ceramic and Vitreous Materials, Mosaic and Inlaid Work."[15] Beneath each subheading was a material breakdown that revealed frequent concessions to formal hybridity and organizational compromise, as rebellious art objects refused to fit into a single category. There were paintings on porcelain, photolithographs, engravings on metal, prints made from photo relief plates. Woodworking products were divided among sculpture, industrial design, and the wholly separate Department of Manufacturing, which was home to ceramic art and tiles as well as practical goods such as carriages and surgical prostheses.[16] Clearly, no taxonomy of objects could contain the overwhelming quantity of material treasures that exerted their power (like Eastman's thumbtacks) over observers' attention. Though numerous guidebooks and gallery maps attempted to choreograph visitors' progress through the buildings, the experience was, for many, one of sensory overload. As one personal account put it, "to remain more than an hour or two . . . only served to dazzle and confuse."[17]

Paradoxically, given the diversity of this grand display, the Centennial proved a significant moment in consolidating a modern identity for photography. Since its

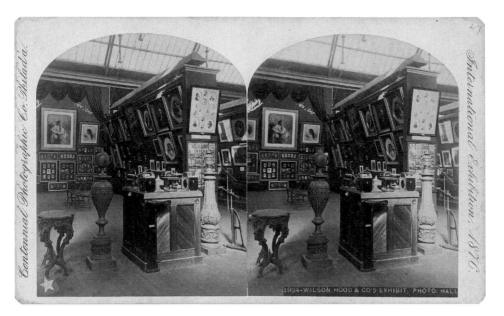

Fig. 61 | Centennial Photographic Co., Napoleon Sarony's display in the Centennial Exposition Photographic Hall (end wall), "No. 1934, Wilson, Hood & Co.'s Exhibit, Photo: Hall," 1876. Albumen silver print stereograph, 11 × 18 cm (4 1/3 × 7 in.). Courtesy of the Free Library of Philadelphia, Print and Picture Collection.

inception in 1839, the medium had existed rhetorically between the established categories of art and science, imagination and machine. This taxonomical confusion was reflected in its location at the fair. Though it was included under the larger heading of art in the exhibition catalogue, photography was displayed in a building adjacent to the main galleries in Memorial Hall. This placement replicated the medium's status as an image-making technology that resembled, but remained materially distant from, fine art as traditionally conceived—at least according to prevailing opinions of the 1870s. Nonetheless, the focused display offered American photographers an opportunity to invite unified attention. At the 1873 Vienna World's Fair, US photographers made a strong showing, garnering fourteen medals among them. Since host countries generally had the largest representation at World's Fairs, the national industry eagerly anticipated that the Centennial Exhibition in Philadelphia would be an opportunity to build upon this success by demonstrating the progress of American photography to an international audience. In the end, more than three-fifths of the Photographic Hall, or 13,482 of its 21,339 square feet, were occupied by 144 exhibitors from the United States, all of whom sought to demonstrate not only how photography could operate as a pictorial form but also how it could participate materially in a visual culture increasingly crowded with things.[18]

Sarony, like many US photographers, took advantage of the Centennial Exhibition to showcase his abilities and his thriving business by contributing a selection of his portrait work to the Photographic Hall. His display, which was captured in a stereograph by Frederick Gutekunst's Centennial Photographic Company, adhered to the fair's spirit of multimedia spectacle by organizing an array of small objects into a

Fig. 62 | Napoleon Sarony, *Centennial Tableaux: The Banner, 1776*, 1876. Mounted albumen print, 45.72 × 55.88 cm (18 × 22 in.). Library of Congress, Prints and Photographs Division, LOT 13714, no. 126.

dramatic form that captured the eye and commanded observers' attention (fig. 61).[19] The large, curtained display wall, which is crowned by a gilded replica of the Sarony signature, was filled out to hold numerous frames within frames—things upon things—that ranged from monumental enlargements colored with pastel to the cabinet card portraits the studio more typically produced.

The theme of variety and containment carried over into the individual photos on display as well. Though invisible in the photographed display, among the cabinet cards and enlargements in the booth was a series of large-format photographic prints grandly titled *Sarony's Centennial Tableaux*. Each of the series' three staged *tableaux vivants* depicted an episode in the mythic creation of the American flag, relying on material changes in fashion and technology to mark one hundred years of national history. The first image depicted the actress Fanny Davenport playing the part of a "colonial dame of 1776" and dressed, as one contemporary observer described it, in the "fashion of Martha Washington" (fig. 62). The actress is engaged in hand-sewing the American flag in a staged domestic setting decorated with a spinning wheel, grandfather clock, and eighteenth-century furniture.[20] On the left side of the composition is a carved armoire that appeared regularly in Sarony's studio photographs, but for the purposes of the tableaux, it has been refaced with two painted panels (probably

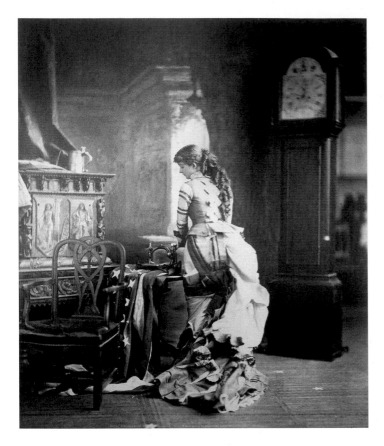

Fig. 63 | Napoleon Sarony, *Centennial Tableaux: The Banner, 1876*, 1876. Mounted albumen print, 45.72 × 55.88 cm (18 × 22 in.). Library of Congress, Prints and Photographs Division, LOT 13714, no. 126.

created by the photographer) depicting a bare-chested female allegory of Liberty and a Native American man that were adapted from the state seals of Virginia and Massachusetts, respectively.

The second *Centennial Tableau* depicts Kate Claxton, another famous actress of the day, as the woman of 1876 wearing a fashionable bustle (fig. 63). The setting is much the same, except that in this image, the colonial dame's spinning wheel has been replaced by a Willcox & Gibbs New Automatic sewing machine, a domestic convenience on display in the nearby Machinery Hall.

This subtle product placement seems at first to align Sarony's tableaux with contemporary advertising trade cards that used the "before-and-after" motif of 1776 and 1876 to demonstrate the superiority of industrial innovations in agriculture, baking, and transportation. Willcox & Gibbs even used this type of diametric image pairing to market the sewing machine pictured in Sarony's photo, presenting the domestic troubles of a harried housewife burdened with crying children and a grouchy husband eliminated by the introduction of a time- and labor-saving automatic sewing machine to her household. Drawing a clear material break between past and present, these before-and-after advertising images encouraged the modern viewers of the

Centennial Exhibition era to take satisfaction in industrial innovations as a source of unambiguous improvement over traditional ways of doing things.

Sarony's third and final tableau breaks from this pattern, however, by presenting a more ambiguous relationship between past and present (fig. 64). It shows the woman of 1776 side by side with her modern counterpart, as the two women work together using the spinning wheel and sewing machine to complete the sewing of the flag. As an allegorical cycle, then, Sarony's tableaux embody the span of US history, showing the objects surrounding human activity as a framework for establishing continuity with the past—a beneficial form of inheritance. In his photographs, the woman of 1776 is no less able to complete her task than the modern woman with her sewing machine, but the job progresses more harmoniously when these embodiments of tradition and technology work hand in hand.

For Sarony, a photographer who longed for conventional artistic recognition, the three tableaux were not simply a sentimental allegory or an opportunistic gambit for selling pictures but a material strategy through which the photographer of 1876 might imbue his modern industrial medium with a trace of established artistry. On one level, this involved promoting photographs in commercial applications previously dominated by lithography, a field that Sarony of course knew well. At eighteen by twenty-two inches, his *Centennial Tableaux* were far larger than a standard cabinet card and better suited for framed wall display than enclosure in an album. The *Boston Daily Globe* responded to Sarony's modern take on history by remarking upon the images' potential appeal as drawing room decorations "of perennial freshness and fascination," its reporter writing that the tableaux "combine the vividness and reality of a photograph with more than the richness of a steel engraving . . . nothing that we have seen better illustrates art and patriotism."[21]

The scene of peaceful unity was underscored by four lines from Joseph Rodman Drake's "The American Flag," which were included as a printed caption on the lower margins of each photograph in the sequence.

> *Flag of the free heart's hope and home!*
> *By angel hands to valor given,—*
> *Thy stars have lit the welkin dome,*
> *And all thy hues were born in heaven!*

Written in the early nineteenth century, the poem had been set to music at the start of the American Civil War and became a popular Union anthem. In the postwar period, many still preferred Drake's poem to Francis Scott Key's "Star-Spangled Banner," which, with its bursting bombs and glaring rockets, was considered too aggressive in tone to promote a spirit of national reunification.[22] Viewers in 1876 might likewise have been predisposed to see the depicted collaboration between America's past and

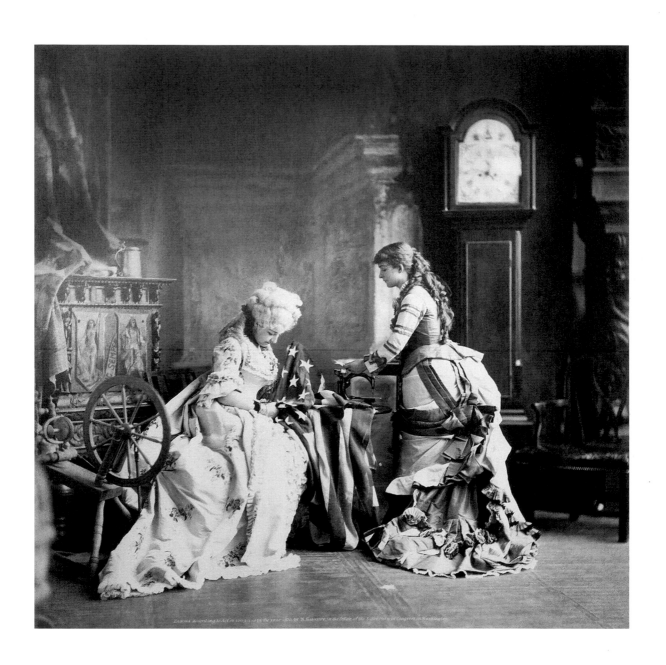

Entered according to Act of Congress in the year 1876 by N. Sarony in the Office of the Librarian of Congress at Washington.

Fig. 64 | Napoleon Sarony, *Centennial Tableaux: The Banner, 1776 and 1876*, 1876. Mounted albumen print, 45.72 × 55.88 cm (18 × 22 in.). Library of Congress, Prints and Photographs Division, LOT 13714, no. 126.

present as a reflection on the postwar project of mending the pieces of the recently divided country, just as it demonstrated on a material level how photography might be stitched together with the decorative qualities of print.

Sarony further blended past and present by embedding unique historical objects within the reproducible framework of the photographic print. An explanatory key exhibited alongside the photographs identified the furniture and artifacts that decorated the curated settings of Saxony's photographs as authentic relics of the revolutionary era, including several objects that had once belonged to George Washington. The low wooden chair was the one in which Washington had been seated during his inauguration, and the pedestal table had been used in his New Jersey camp during the Revolutionary War. The grandfather clock and spinning wheel had also survived since Washington's time.

The fortification of photography with historical artifacts carried special weight within the vexed categories of material distinction that characterized the Centennial displays. Relics of the first American president were prominently featured elsewhere at the exhibition. The federal government organized a scene of camp life at Valley Forge, to which the US Patent Office lent its collection of Washington's belongings, including his dress uniform and pistols, along with mundane objects such as camp cooking pots and trivets. Karal Ann Marling has noted that the distinct domestic flavor of the artifacts that represented Washington at the fair gestured "toward the special material intimacy with the past that the Centennial generation craved."[23] Also significant is how this material pageantry grounded US cultural history in operations of objecthood and ownership, transactions with special pertinence in the commercial atmosphere of the fair. What made camp pots or a wooden chair worthy of exhibition was not their maker or their medium but their provenance and position as witnesses to history. If such humble objects could ascend in value through their adjacency to greatness, it stood to reason that some residue of that distinction might be transferred to subsequent owners. Like celebrity portraits and autographs, historical relics gained fresh significance as objects that retained a sense of singularity in an era of mass reproduction. In this regard it is significant that although Davenport and Claxton both were nationally famous performers, newspapers noted their presence only in passing, as models whose "artistic postures" were well suited to represent each time period. Far more attention was lavished upon the nonhuman stars of the photographs. Published accounts were careful to identify the origins of each object pictured; the chair had come from the library of Charles Carroll of Carrollton, a signatory of the Declaration of Independence, and the "ancient" grandfather clock and spinning wheel had been lent to Sarony by "some of New York's oldest and most distinguished families" to embellish the historical reality of the depicted scene.[24]

Though it was incidental to the narrative represented, the object described with the greatest enthusiasm was the silver drinking cup pictured atop the armoire in the

background of the three tableaux. Known as the De Peyster tankard, this cup was a celebrity object of sorts. It had been commissioned from New York silversmith Cornelius Kierstede around 1700 by Abraham De Peyster, patriarch of a distinguished Knickerbocker family who were among the first Dutch settlers of Manhattan Island. The tankard was frequently mentioned in Gilded Age descriptions of colonial life in New York as an emblem of the former rarity of objects of luxury in the Americas and the lasting value of investing in fine craftsmanship.[25] Embedded in the background of Sarony's photograph, it bestows distinction as a symbol of authenticity. By virtue of its unique, traceable history, it anchors the pictorial fiction enacted by human actors against a solid point of material fact and fortifies the modern medium of photography by aligning it with a longer legacy of American creative production.

In *Sarony's Centennial Tableaux*, the process of transmedial fortification operates on two levels: first, the scenes construct a realist aesthetic similar to the one used by contemporary wax dioramas to bolster the verisimilitude of photography, rather than relying solely on the medium's innate capacity for exacting reproduction. By assembling artifacts with differing claims upon history, the tableaux create "the illusion of reality at the same time that they turned reality into an aesthetic," as Vanessa Schwartz describes the dioramas in the "living newspaper" displays at Musée Grévin in Paris.[26] Second, Sarony's tableaux present an exercise in visual discernment that demonstrates the modern power of photographic form. The pictures' celebration of detail and clear identification of all the elements in the pictures—human and non-human—invited viewers to recognize and discriminate between different modes of reproducing historical reality and their varying claims of authenticity. This transmedial play embodied the confused representational categories that defined visual experience at the Centennial Exhibition, melding commerce and contemplation, past and present, while at the same time demonstrating photography's power to absorb subordinate materials in a single, easily consumable package. The resulting sense of containment recalls Roland Barthes's description of photography as a "transparent envelope," which might hold a subject without disrupting its indexical autonomy.[27] For Barthes, the phrase expressed the medium's essential contingency—its "weightless" relationship to a referent that allowed viewers to forget the distinction between "the *Thing Itself*" and photography as a modern mode of representation. Years earlier, however, late nineteenth-century image makers like Sarony, who were still deeply invested in proving the artistic legitimacy of their craft, had a genuine interest in forcing photography to carry observable weight. Instead of letting its subject matter shine through, their mode of photographic envelopment deliberately pushed the medium into tension with what it pictured. Emphasizing the distinctions between things— human actress, Washington's chair, grandfather clock, flag, tankard—made photography visible as a veil of modernity that might be drawn over a diverse assortment of

objects, regardless of their historical origins. In this way, *Sarony's Centennial Tableaux*, like other, similarly constructed Gilded Age studio photographs, deploy an aesthetic strategy shaped by photography's hybrid identity in late nineteenth-century visual culture, as a modern tool for maneuvering traditional hierarchies that were strained and failing beneath the pressures of mass production. They function as a mode of display within display—thing upon thing—that appealed to contemporary appetites for abundance while anticipating more profound aesthetic changes for the medium of photography in the decades to come.

AT SARONY'S

In June 1876, one month after the opening of the Centennial Exhibition, Sarony moved his portrait studio to a lavish new space on the northwest corner of Union Square. His former location at 680 Broadway had been at the center of operations of the antebellum picture industry, in the neighborhood of lithographic firms and other leading portrait galleries. By the late nineteenth century, Union Square had become the city's theater district, and Sarony was among the first photographers to push northward and join what had become a new sister industry. His business occupied the entire five-story studio building at 37 Union Square, which cost $8,000 in rent per year and housed every aspect of his photographic production, from staging and developing to printing and mounting, employing a team of nearly sixty men and women.[28] There was retail space with display windows at street level, where passing theatergoers could see the latest celebrity portraits or occasionally spot a distinguished customer stopping by for a sitting.[29] Sarony's grand reception room on the building's second floor was the heart of the business, however. Visitors would wait in this long gallery for their turn to pose beneath the skylights in the top-floor portrait studios. It also served as a showroom for Sarony's eclectic collection of paintings, photographs, and objets d'art.

Photographic galleries had been spectator attractions in Manhattan since the 1840s, when John Plumbe, followed by Mathew Brady and others, opened their reception rooms to the public as a way of drumming up business, combining the appeal of social exhibition with subtle commercial promotion. By luring curious viewers into waiting rooms outfitted with attractive examples of their work, photographers entertained the public while planting the notion that all potential consumers needed portraits of their own. In the early nineteenth century, when photography was still something of a novelty, displaying examples of this new image-making technology was sufficiently enticing to draw curious viewers. By the 1860s, as the field grew more competitive in major urban centers, additional attractions were added, and the material trappings that surrounded the act of looking at and making photographic likenesses became an important supplement to the portrait experience.

Photographs of the interior of Sarony's Union Square reception room reveal that it more closely resembled the Centennial Exhibition's decorative abundance than it did the uniform simplicity that characterized earlier generations of portrait studios (fig. 65). Visitors noted that the long walls of the reception room were hung with photographs in every style and size the studio offered, from massive two-by-three-foot enlargements finished in pastel or oil, which were framed like paintings, to unembellished carte photographs displayed in glass cases on tables covered with green baize.[30] These photographs competed for attention with a jumble of furniture, fire screens, parasols, and urns. A life-sized marble sculptural group by the Italian artist Benedetto d'Amore that Sarony purchased at the Centennial Exhibition stood at one end of a long upholstered bench, while at the other was a massive bronze temple bell.[31] Sarony's collection was assembled with an eye to aesthetic appeal rather than cultural or historical context, bringing together an array of objects ranging widely in time and place of origin, from painting and sculpture by contemporary American and European artists to Mesoamerican artifacts, medieval tapestries, Buddhist and Hindu statues, an ostrich egg (a gift from the actress Sarah Bernhardt), and a swan-shaped sleigh that had belonged to Peter the Great. Famously, a stuffed crocodile was suspended from the ceiling near the entrance in a nod to the early modern *Wunderkammers* that provided inspiration for the reception room's general sensibility.[32] Viewed as a chaotic whole, Sarony's gallery was a cabinet of curiosities for a newly hatched consumer culture—a capsule installation of the Centennial Exhibition's confusing splendor, showcasing the best, most beautiful, most artfully arranged goods money could buy.[33]

By constructing a highly decorated studio to serve as backdrop to his commercial and creative activities, Sarony merged the professional traditions of the antebellum photographic industry with the type of stylized ateliers common to contemporary painters. Lavish studios became an entrenched part of US artistic culture during the 1850s and 1860s. The purpose-built art spaces of the Tenth Street Studio Building served as crucial institutional stopgaps for exhibition and socializing at a time when few galleries dedicated to marketing the work of American artists existed. This practice was partly inspired by the richly decorated studios of European masters such as Karl von Piloty, Hans Makart, and Franz von Lenbach, which American painters encountered during their education abroad, but it was also a self-reinforcing demonstration of the powerful relationship between culture and capital—a material philosophy that surely appealed to artists in the United States for whom consumer goods were easier to come by than were the institutional stability and enthusiastic audiences many European artists enjoyed. By the late nineteenth century, numerous artists working in New York City, including John White Alexander, Worthington Whittredge, J. Ferguson Weir, and, perhaps most famously, Sarony's close friend William Merritt Chase, feathered their workspaces with carefully curated collections of beautiful things intended to demonstrate their impeccable taste and cultivated bohemian

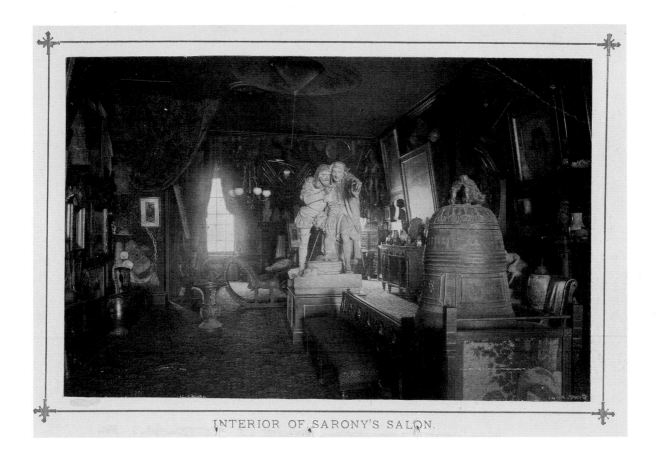

INTERIOR OF SARONY'S SALON.

Fig. 65 | Unidentified photographer, *Interior of Sarony's Salon*, ca. 1880. Indotint, photomechanical calotype-like process, 14.9 × 22.6 cm (5 7/8 × 8 7/8 in.). National Portrait Gallery, Smithsonian Institution. Gift of Larry J. West, AD/NPG.2007.29. Photo: National Portrait Gallery.

eccentricity.³⁴ Annette Blaugrund notes that Chase's decision to decorate his studio lavishly even predated his renting it. When he made the decision to return home to the United States from Munich in 1877, he announced to the commission merchant William S. Macy, "I intend to have the finest studio in New York," and then feverishly set about buying antiques to bring back with him.³⁵

Sarony's collecting habits appear similarly to have bordered on the compulsive. William Henry Shelton wrote that the photographer made and spent several fortunes over the course of his lifetime, and that when he was "flush he bought bric-a-brac and pictures furiously."³⁶ In 1878, the *Los Angeles Herald* reported a heated bidding war between Sarony and the lawyer and writer Colonel Robert Ingersoll for a "heterogeneous stock of rubbish and rarities from all parts of the globe" that was sold during a three-day auction at a Manhattan antiques dealer called the Old Curiosity Shop. The story made the papers primarily because no one could imagine what Ingersoll had planned for the forty or fifty statues of East Asian and African deities he had purchased (as the article's subtitle pointedly asked, "What Is He Going to Do with Them?"). That Sarony, an artist, would purchase statuary in

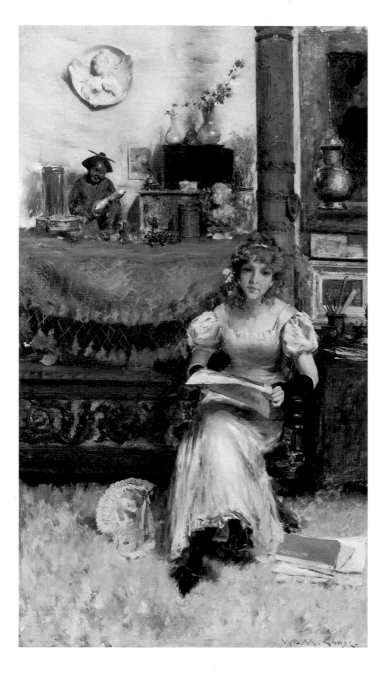

Fig. 66 | William Merritt
Chase (1849–1916),
In the Studio, ca. 1884.
Oil on canvas, 39 ¼ ×
22 ¾ in. Reynolda
House Museum of
American Art. Original
Purchase Fund from
the Mary Reynolds
Babcock Foundation,
Z. Smith Reynolds
Foundation, ARCA, and
Anne Cannon Forsyth,
1967.2.4. Photo:
Wikimedia Commons.

similar quantities appears to have been taken for granted as an occupational necessity. Newspapers presented the distinction as a matter of good taste and professional discipline. While Ingersoll's appetite for carved idols was so "omnivorous" that he bid with equal enthusiasm on every object, Sarony made selections based "on aesthetic principles and for artistic purposes." As evidence, the reporter noted that Sarony bid "for only symmetrical gods."[37] By this standard, consumer gluttony had less

to do with the volume of purchases than with the inability to assess quality from amid a vast field of options.

Indeed, the social role of the American artist in the late nineteenth century was evolving to include the responsibility not only of making beautiful things but also of modeling how best to consume them. This meant, by extension, that artists' studios might be a source of instruction for those seeking to navigate consumer culture with similar success. Sarah Burns writes that the bohemian assemblages in Gilded Age studios allowed artists to "trace a fine and precarious line between the blunt materialism" of the marketplace and the cultivated refinement that established the artist as a "professional seer" who was able to discern quality in a world of tempting objects.[38]

This made the skillful arrangement of treasures a professional imperative for American artists. Yet the aesthetic studio was not simply a backdrop for making art; it also functioned, for painters like Chase, as active subject matter in a modern, bohemian approach to art. Chase's series of paintings depicting scenes in his studio, completed during the 1880s, completed the cycle of aesthetic consumption by rendering these artistic assemblages in paint (fig. 66). Though individual artifacts like a Japanese fan or a model ship might momentarily command attention, these items ultimately recede into larger, ravishing displays of color, pattern, and texture that showcase the pleasure of beholding beautiful objects artistically arranged by the painter. With this emphasis on the whole rather than the part, Chase's painting asserts its place as the paradigm of the aesthetic commodity—in Sarah Burns's words, "the precious object celebrating the joys of seeing a material world full of delectably lovely things."[39] By taking the act of looking as his subject, Chase the professional seer set up a self-reflexive act of observation for his audience. Inviting the viewer to indulge similarly in the joys of seeing, these works depict young women in costume, or occasionally the artist himself, as avatars for the viewer outside the frame, enjoying the artist's sumptuously assembled treasures.

Sarony constructed his lavish studio on Union Square with similar aspirations of public outreach and professional self-promotion, but his aim was less to establish photography as a paradigm of aesthetic experience than to assert its parity with more traditional forms of art. Borrowing strategies from contemporary painters and presenting his photographs as beautiful objects in pleasing aesthetic assemblages allowed Sarony to concoct a potent visual argument that his work belonged within their ranks. One announcement of his move uptown, titled "An Artistic Resort," proclaimed that by opening the doors of his "*salon d'art* in Union Square" to the public, Sarony's studio building served not only as a place for photography but also as an essential free gallery of art in the city. "Since the days of the Old Art Union there has been no artistic lounging place in the city that so exactly met the needs of the public."[40] Visitors could escape to the retreat of an aesthetically curated studio and contemplate paintings in Sarony's collection, such as Eastman Johnson's *Corn Husking at Nantucket* (ca. 1875,

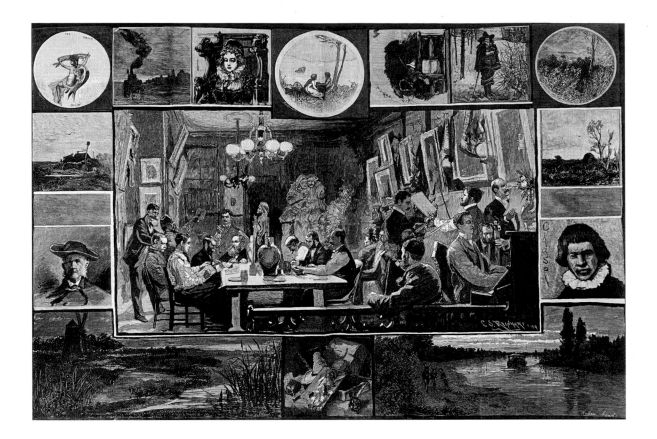

Metropolitan Museum of Art, New York) and Edward Moran's *Moonlight Bay* (1877, location unknown), while letting their "feet sink deep into the heavy soft Turkey carpets," breathing in the carefully curated art atmosphere like some exotic perfume.[41]

Sarony's aesthetic furnishings gained further visibility as a backdrop for the weekly meetings of the Tile Club, an elite fellowship of American artists that included Chase, Winslow Homer, J. Alden Weir, Edwin Austin Abbey, and Augustus Saint-Gaudens, among others. Formed in the fall of 1877 in the wake of the Centennial Exhibition, the Tile Club's stated mission was to nurture a "decorative age" by producing painted tiles.[42] In reality, as Ronald Pisano has written, members remained invested in their careers as oil painters, sculptors, and architects, which they promoted through a popular publicity campaign that highlighted their creative passions and boozy hijinks in a series of comic articles published in *Scribner's Monthly* and *Harper's Weekly*.[43] An illustration by Charles S. Reinhart, which accompanied the article "The Tile Club at Work," pictures one of these gatherings in Sarony's studio, showing the photographer at center in his characteristic fez, holding up a painted tile for admiration as his brother artists sketch, paint, and play music in the bohemian surroundings of his reception room (fig. 67).

Fig. 67 | Charles S. Reinhart (1844–1896), *The Tile Club at Work*, 1880. Wood engraving, illustration for *Harper's Weekly*, 21 January 1880, 72–73. Collection of the author.

For US artists of the Gilded Age, the Tile Club and similar artists' societies, such as the Kit-Kat Club and Salmagundi Club (to which Sarony also belonged), provided organized forums for promoting shared aesthetic sensibilities and furthering cosmopolitan reputations. Sarony's position as the sole photographer in these groups, and the frequent host of their meetings, reinforced his reputation as the most aesthetically refined photographer of the era and established his studio as a must-see destination for American art lovers. Describing an evening meeting of the Salmagundi Club, William Henry Shelton placed Sarony at the center of the studio's artistic atmosphere. "Chinese gods of many colors and grinning crocodiles looked down from wall and ceiling through wreaths of blue smoke on the revelers, among whom the little photographer himself was chief mountebank as well as hospitable host." Engaging in the same antics that endeared him to his portrait clients, Sarony led the dancing, drinking, and joking at these meetings. Shelton recalled that the photographer appeared custom-built for the decorative age these artists inhabited and so integral a part of his aesthetic environment that he sometimes resembled a piece of exotic décor come to life. At gatherings of the Salmagundi Club, Shelton wrote, "It was not an uncommon ceremony to pick [Sarony] up and pass him around as if he were a piece of animated bric-a-brac."[44] This sense of transference between the photographer and the assembled objects that contributed to the cosmopolitan mystique of his studio was the point of Sarony's efforts in collecting and decorating. Reframing the space of commercial portraiture in terms of aesthetic grandeur elevated the position of both the maker and his work.

Though advertisements and the Tile Club's published exploits promoted Sarony's as "an artistic lounging place," its atmosphere of bohemian cultivation also supported the business of the photographic studio and occasionally crept into the frames of his portraits. In the late 1870s, a favorite portrait setting was one staged to replicate the sights in the reception room outside. These photographs gave individuals an opportunity to play the role of aesthete and preserve a souvenir self-image that pictured them immersed in a vision of fine art and good taste. A portrait of Wilkie Collins in this setting depicts a scene that could have been plucked from an illustration of the Tile Club's weekly gatherings (fig. 68). Standing with one foot on a low stool, the novelist thoughtfully contemplates a nocturne landscape painting from Sarony's collection that appears to be by Edward Moran. In the background, a drapery of richly patterned fabric and a carved armoire (the same one that appears in *Sarony's Centennial Tableaux*) help disguise the painted backdrop that creates the illusionistic gallery space. Recalling Chase's paintings of women, a portrait of the actress Clara Morris in the same setting similarly takes the act of looking as its principal subject (fig. 69). Photographic portraits conventionally place emphasis on individual likeness or costume, but Morris is seated on the ground so that her setting takes up much of the composition, and she looks down in rapt admiration of a print she appears to have discovered in the lower cabinet of the armoire.

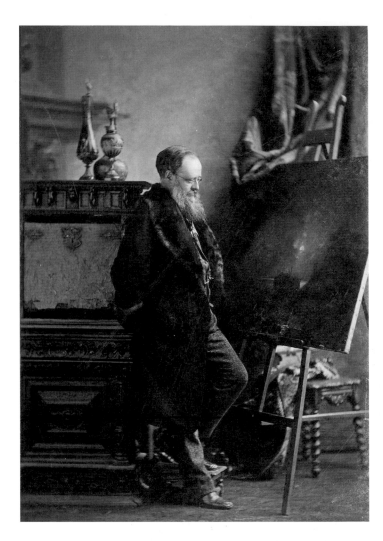

Fig. 68 | Napoleon Sarony, *Wilkie Collins*, ca. 1873–76. Albumen silver print on card, 15.9 × 10.8 cm (6 ¼ × 4 ¼ in.). Harvard Theatre Collection, Houghton Library, Harvard University.

Fig. 69 | Napoleon Sarony, *Clara Morris*, ca. 1876. Albumen silver print; cabinet card, 15.9 × 10.8 cm (6 ¼ × 4 ¼ in.). Harvard Theatre Collection, Houghton Library, Harvard University.

Whereas Chase's paintings invite admiration of a picturesque whole—a translation of diverse materials into paint—Sarony's photographs of scenes "in the studio" court discerning attention to material detail. As with his *Centennial Tableaux*, the staged reception room demonstrates photography's capacity to retain the unique properties of the objects pictured, so that the pleasure of looking comes from recognizing and reestablishing the distinctions between different material objects and modes of representation. To make sense of a photograph depicting Collins admiring an oil painting, the viewer is required to understand the framed picture on an easel on a separate register of reality from the painted canvas backdrop that establishes the pictorial space. Similarly, Sarony's portrait of Morris juxtaposes the elaborate sculptural mantelpiece of the scene's backdrop with the carved wooden figure on the armoire's corner, which mirrors its form in miniature. The beveled edges—one wood, one painted—reach

toward each other across an unbridgeable material gulf that is logically crossed only within the context of their photographic representation. Like the actress, viewers of the portrait are positioned in between and presented with a choice. They must either accept the photographic illusion despite these visible seams in its rendering or take the flaws as an opportunity to pick apart the material distinctions piece by piece. Either possibility demanded a measure of contemplative attention that was not routinely afforded to photographers and their work before the late nineteenth century. Viewers willing to indulge in the exercise might absorb a photographic object lesson from the questions it necessarily raised: what meaningful distinction existed between painted furniture and real wood once both were translated into photography? If none existed, were the painted canvases and paper prints more worthy of attention than the cabinet card portraits that contained them?

These types of material translations were standard expectations in painting, but even in this context, they raised suspicions when it was believed they were too easily achieved. Chase's seemingly magical ability to conjure persuasive reproductions of slippery, iridescent fish and glowing copper kettles was met with criticism that his work was technically too successful—too photographic in its rendering of reality. Disparaging the lack of imagination he perceived in the shallow surfaces of these still lifes, the painter Kenyon Cox in 1889 called Chase a "wonderful human camera" and "seeing machine" who cared for little but cunning verisimilitude and easily emulated technique. John Davis has noted more recently that the notion of Chase as "an emotionless photographic automaton" persisted for more than a century.[45] On the opposite end of this spectrum, Sarony aimed to complicate perceptions of photography through material assemblages that heightened the visibility of his medium and raised meaningful questions about its changing position in nineteenth-century visual hierarchies. Within an expansive frontier of consumer goods and things upon things, photography was uniquely positioned to address the material proliferation of mass culture and picture human subjects in the act of managing it.

PHOTOGRAPHY FORTIFIED

From his early days in lithography to the magazine that would be his last significant professional endeavor, Sarony's artistic career was devoted to multimedia practices, and while this aided his artistic ambitions by giving him a broad array of creative tools to work with, it also had practical applications in the day-to-day management of his portrait business. Mixed-media approaches had in fact always been an aspect of commercial photography. Daguerreotypists enlivened their wares with hand-coloring, and later studios offered pastel or oil enlargements to upsell portrait clients to more expensive, labor-intensive options. Painted retouching became a matter of broad practical necessity with the introduction of cabinet cards in 1866. While

the large-size prints presented new creative opportunities, they also made it difficult to overlook mistakes in printing, shoddy studio equipment, and blemishes or asymmetries in a sitter's features. As a corrective, most Gilded Age photographers relied extensively on retouching their glass plate negatives using paint or ink prior to printing. Before long, the practice extended to the regular use of special effects like composite printing and overpainting, which could be used not simply to correct but also to reinvent a subject's physical appearance, making her appear decades younger or relocating him to a fantastic environment—atop a crescent moon or in the middle of a blizzard.[46]

Sarony's lithographic training made him well suited to this aspect of photographic practice, and his studio set new industry standards in both retouching and the use of painted canvas backdrops. In 1867 Sarony patented a specialized "retouching frame" that was used to hold negatives close to a light source to allow for precise painted corrections. An advertisement in *Anthony's Photographic Bulletin* offered the frames for $5 apiece, exhorting photographers to "send for one, if you want to dispose of freckles, &c., &c."[47] Far from the early days of seeing the camera as the pencil of nature, by the 1870s portrait sitters expected photographers to make artistic corrections to their appearances. Richard Grant White described an incident at Sarony's studio in 1870 in which a man he described as "a hard-featured, money-making, Western pork-packer" returned his recent cabinet cards to the studio because he felt they made him look too old. White thought that Sarony's flattering images "already dealt kindly with the man," who, he reported, was forty-five years old and "looked every hour of it." But Sarony listened patiently to his client's complaints, and, as White looked on, the photographer used conte crayon to adjust the appearance of the portrait, smoothing the sitter's rough complexion and softening his harsh expression. When these and other efforts failed to satisfy, Sarony grew annoyed and, smiling sweetly at the sitter, said, "How young would you like to be made, sir? I could make you twenty-five, but my reputation could not bear that. Thirty-five is as low as I can go." Gripped by sudden humility, the subject replied there was no need to go that far, but he would be happy if the photographer could make him look forty-three.[48] The widely published anecdote, though no doubt partly apocryphal, demonstrates that mediations of photographic portraiture were a widely understood corrective to undesirable appearances. Rather than simply accept an unflattering portrait, a dissatisfied customer could negotiate an artistic solution to achieve a preferable result. Sarony was known not only to correct photographic prints and negatives but also to apply pigments directly to his subjects as a way of counteracting the color sensitivities of photographic chemicals or eliminating the need for retouching after the fact. When a balding man mentioned that he felt sensitive about his thinning hair, the photographer responded, "Ah, we shall alter that," and powdered his head with soot.[49] When asked in an interview about his methods for addressing the capriciousness of natural light, Sarony said that when an

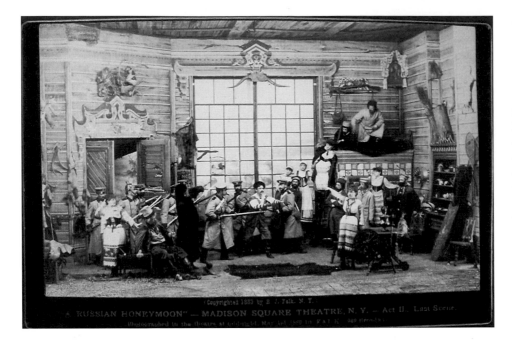

errant ray of light fell across a subject's face after he had arranged a portrait, he would simply "use my charcoal on his cheek, and vamoose the high light."[50]

Although heavy retouching acquired negative connotations in the twentieth century, these hybrid media measures did not function solely as technological stopgaps but often represented an aesthetic preference and deliberate stylistic choice. Even when technological advances made it possible to produce documentary-style images, nineteenth-century photographers continued to fortify their work with traditional artistic media to correct compositional flaws or expand images beyond the proportional limitations of the standard dimensions of the cabinet card format.

This was especially evident in the realm of theatrical photography, where artistic manipulations were perceived to align with the visual spectacle and expressive freedom of the theater. Although the portraits of actors in costume that were produced by Sarony and his contemporaries often appear to be scenes directly extracted from dramatic productions, this was not technically possible before the widespread electrification of American cities in the early 1880s, since gaslight and limelight were insufficient for making clear exposures. It was only in 1883, after setting up a fleet of electric arc lamps in the Madison Square Theatre, that Sarony's associate Benjamin Falk captured the first photograph of a full theatrical production in situ (fig. 70). Falk's cabinet card image depicts the final scene of a play called *A Russian Honeymoon* from the vantage point of the fifteenth row.[51] The photograph depicts a cast of thirty in what is meant to be a scenic replica of a Siberian saloon and offers a rare glimpse of the elaborate dramatic realism characteristic of period stage productions. The

walls of the twenty-foot-high set are painted in a faux wood grain to resemble a log cabin interior, complete with beamed ceiling and decorated with a profusion of antlers, snowshoes, and hanging pelts that make the cast of human actors appear small and inconsequential.

Indeed, though Falk's photographic feat was celebrated as a technical novelty, particularly since it was accomplished only months after the Edison Company began its electrification of Manhattan, it had no impact on the popular market, and Falk was the only photographer who continued with the complicated exercise of producing staged cast photos in theaters. According to Daniel Frohman, the producer who funded Falk's experiments, the problem was that the unembellished photograph counteracted the experience of watching a live play. Though details of setting could be more accurately documented, he explained, electric "flash-lights" were "not successful, so far as faithful reproduction of the actors' faces and expressions go."[52] The glaring light and blurred motion of in situ theatrical photography eradicated the possibility of roaming attention and the spirit of suspended disbelief that enabled the magic of live performance.

Photographic tableaux and studio reenactments corresponded more harmoniously with the immersive *Gesamtkunstwerk* that shaped period ideals in theater, casting a veil of multimedia artistry over aspects of staged reality that a viewer was meant to ignore. Though created four years after Falk's breakthrough with *Russian Honeymoon*, an 1887 cabinet card from the Sarony studio largely dispenses with the possibility of photorealism in its depiction of the grand final scene in Augustin Daly's lavish production of *The Taming of the Shrew* (fig. 71). This closing set piece was considered a spectacular dramatic triumph. For one frozen moment before the curtain fell, actors and setting were carefully orchestrated in a dazzling *tableau vivant* inspired by Paolo Veronese's *The Wedding at Cana* (1563, Musée du Louvre).

By 1919, Daly's tableau was cited as the ultimate example of Gilded Age taste for glittering, costly "ultra-realism" in dramatic scenery.[53] Paradoxically, however, the uncanny effect of the living picture could be neither documented in situ nor restaged within the small space of a portrait studio. As a remedy, Sarony photographed the cast in small posed groups that were reassembled via composite printing, using painted retouching to supply the ephemeral elements of setting and atmosphere. The resulting image includes more painted effects than photographic detail, as the entire architectural setting and most of the furniture in the foreground are represented through hand-rendered additions by Sarony. At the same time, the picture preserves compositional flaws that unmistakably demonstrate its photographic basis. The cakes and candelabra standing in tight formation on the tables threaten to block the faces of any human actors who fail to accommodate their presence. Seemingly conscious of this possibility, the central players lean awkwardly in their chairs to avoid obstruction, while a figure on the left, less attentive to theatrical optics, allows himself to be partially eclipsed by

a vase. Considering the soot and charcoal that Sarony regularly employed in his studio practice to "vamoose" unflattering realities, the choice to embrace these lapses in formal perfection can only be deliberate—a defiant act of photography that demonstrates its unique characteristics within a bigger multimedia picture.

A far more common synthesis of painting and photography, however, were the backdrops that "set the stage" in late nineteenth-century portrait studios. Use of these scenic accessories was widespread and began with itinerant photographers during the daguerreotype era as a means of constructing ersatz spaces for portraiture on the road. During the cabinet card era, the phenomenon expanded radically, driven by the possibilities of this larger form and the popularity of theater. Although materially similar to more venerated forms of fine artwork on canvas, painted backdrops represent a reversal of traditional media hierarchies. Where daguerreotypists aspired for their work to serve as "an auxiliary to the artist," the photographic background made painting a supporting player, by positioning it beyond and behind the viewer's central focus.

Most US photographers turned to specialty scene painter Lafayette W. Seavey to supply the needs of their studios. Born in Victor, New York, in 1841, Seavey began his career as a carriage painter before a chance viewing of a traveling panorama depicting a journey down the Mississippi River inspired him to apprentice himself to a scene

Fig. 71 | Napoleon Sarony, *Augustin Daly Company in "The Taming of the Shrew"* (stage tableau based on Paolo Veronese's *The Wedding at Cana*), 1887. Albumen cabinet card, 10.8 × 15.9 cm (4 ¼ × 6 ¼ in.). Harvard Theatre Collection, Houghton Library, Harvard University.

painter in a Rochester theater.[54] By 1865 he had relocated to New York City and established his own business, supplying scenery, panoramas, sets, and banners not only to theaters but also, as an early catalogue attests, for church pageants, exhibition halls, parlors, traveling shows, and lectures. As the demand for celebrity photographs grew during the 1870s and 1880s, Seavey was able to make outfitting portrait studios his profitable niche specialty, supplying Brady, Kurtz, Gurney, Fredericks, Mora, Falk, and, of course, Sarony. An 1873 advertisement boasted a catalogue of more than five hundred available designs, ranging from forest glens and prison dungeons to parlor settings, all of which could be outfitted with appropriate props like faux gates and rocks or varying classes of furniture, which Seavey's company also supplied.[55]

Despite having this diverse array of options to choose from, most studios kept only two or three canvases in rotation and favored backdrops that could be styled to suit a variety of purposes. In fact, adaptability was perceived as an asset, for it allowed photographers to demonstrate their artistic ingenuity by pairing backdrops with a variety of other studio objects in order to give painted scenes new meaning. Seavey's advertisements listed popular photographs featuring his backdrops to illustrate the success and persuasiveness of his work. This included Sarony's celebrated portraits of Joseph Jefferson as Rip Van Winkle in a popular stage dramatization of Washington Irving's story (fig. 72).[56] The backdrop depicts sunlight streaming through a leaded-glass window into a picturesque interior and appears an ideal fit for Jefferson's character, who is pictured seated on a drop-leaf table in a setting staged to resemble a rustic New York tavern. Yet the same scenic setting was used repeatedly in Sarony's studio in the late 1860s to represent a diverse array of dramatic contexts, from servants' quarters to ship cabins. It appears equally convincing, for instance, as the regal sitting room in a portrait of Mary Frances Scott-Siddons in costume for her role as Princess Elizabeth in an 1870 production of *Twixt Axe and Crown* (fig. 73).

The repeated use of this single domestic interior in portraits representing diverse theatrical productions underscores the complex pictorial operations of these painted objects in cabinet card photographs. In the theater, oversized scenic paintings create illusionistic spatial environments, which, along with an elevated stage and footlights, designate a recognizable area for the performance of fiction that is separate from the space of the audience. Once these backdrops are removed to a photographic studio, however, and translated into two dimensions as the pictorial grounding for a portrait image, they are meant to be understood as part of a compositional whole where real and fictive elements intermingle, and the clear separation between theatrical and social performance is diminished. This use of painting within photographs complicated designations of authorship as well, since painted backgrounds were not simply potential ingredients of transmedial fortification but were designed to serve this specific purpose. This representational contingency effectively allowed Sarony to make Seavey's painting his own, absorbing it into his photographic work by altering the

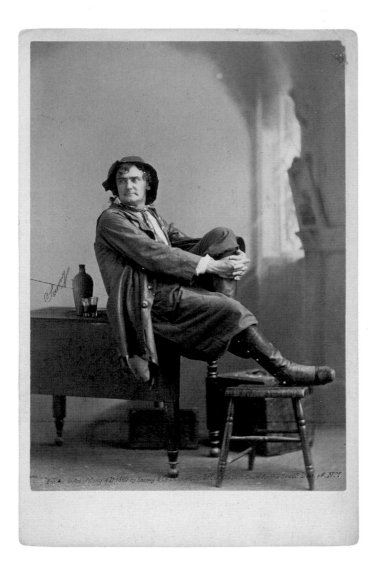

Fig. 72 | Napoleon
Sarony, *Joseph Jefferson
as Rip Van Winkle*, 1869.
Albumen silver print;
cabinet card, 15.9 ×
10.8 cm (6 ¼ × 4 ¼
in.). Harvard Theatre
Collection, Houghton
Library, Harvard
University.

props surrounding the performer to redefine the backdrop's meaning as he saw fit.
For Seavey, however, this arrangement created an uncomfortable professional conun-
drum. Since his oversized, subjectless paintings appeared incomplete except in the
context of photographs, he was forced to rely on other artists to circulate his work
and make it visible to the public. Moreover, the niche function of background paint-
ings meant that they were most successful when they could go virtually unnoticed in
a photograph as the believably natural environment for a portrait subject. This pro-
fessional precarity placed Seavey in a position similar to that of contemporary pho-
tographers seeking public recognition: the more understated his contribution, the less
likely it was to be recognized and valued. This may explain why Seavey occasionally
signed his name in bold dark letters across the painted skies and forest glens of his

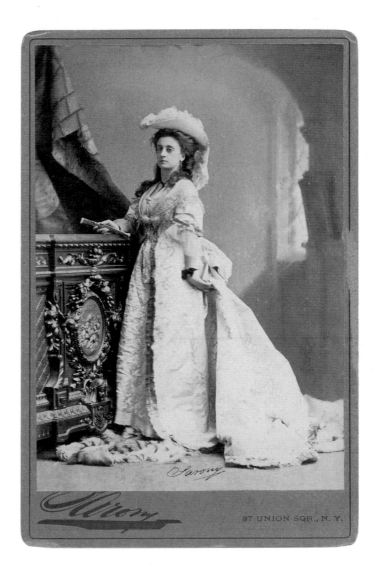

Fig. 73 | Napoleon Sarony, *Mary Frances Scott-Siddons as Princess Elizabeth in "Twixt Axe and Crown,"* ca. 1870. Albumen print; cabinet card, 16.6 × 10.8 cm (6 ½ × 4 ¼ in.). National Portrait Gallery, London, NPG x196959. Given by Terence Pepper, 2014. Photo © National Portrait Gallery, London.

canvas backdrops beginning in the 1880s. His assertive gesture spoiled the illusion of his work but, as Sarony discovered with his photographs of Adah Isaacs Menken, it ensured that his name stayed in the picture.

Sarony relied on Seavey for many of his backdrops, but he also occasionally created his own, and he similarly took the opportunity to sign these fortifying elements as an assertion of creative authorship. Unlike Seavey, however, Sarony added his name in places where it could be easily overlooked, as an illusionistic addition to the trompe l'oeil effects of a photograph's painted environment. For example, a portrait of the Irish minstrel performer Dan Bryant shows the actor sitting on a table in a setting that is staged to resemble a ramshackle cabin (fig. 74). Roughly painted on the wall behind him are a string of onions, a shelf of bottles, a picture of a boxer, and, below

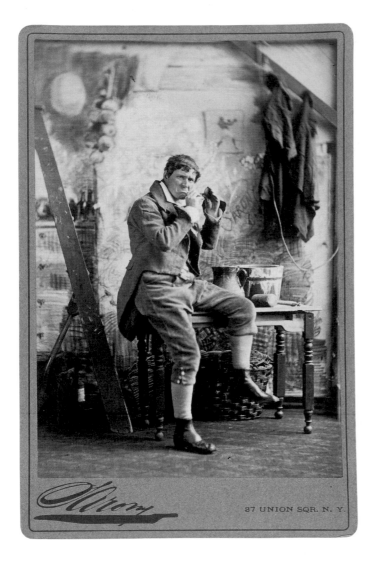

Fig. 74 | Napoleon Sarony, *Dan Bryant*, 1887. Albumen silver print; cabinet card, 15.9 × 10.8 cm (6 ¼ × 4 ¼ in.). Harvard Theatre Collection, Houghton Library, Harvard University.

the boxer, the name "Sarony" written in large block letters, as if scratched into the plaster of the wall.

The photographer's signature appeared again in more familiar cursive form within a backdrop painted to resemble a city street, where it blended in among the theater posters and draft notices on a wall papered with advertisements. The backdrop was used frequently at the studio to set the scene in portraits of actors playing orphans or men and women about town, but it made a particularly apt setting for an 1876 photograph of George S. Knight, who played the role of "the Bill Poster" in a popular comedy called *Over the Garden Wall* (fig. 75). Knight is posed with a ladder, bucket, and brush, as though fresh from the task of hanging signs on the wall. The bristles of his brush are covered with dark paint, however, rather than light-colored paste, in an apparent joking reference to the true makeup of the materials behind him. Sarony's

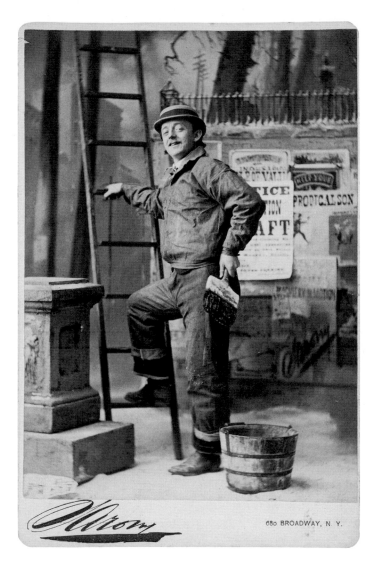

Fig. 75 | Napoleon Sarony, *George S. Knight as the Bill Poster in "Over the Garden Wall,"* ca. 1886. Albumen silver print; cabinet card, 12.7 × 10.8 cm (5 × 4 ¼ in.). Museum of the City of New York, 38.79.7.

680 BROADWAY, N. Y.

name was not included as a disruptive gesture here, designed to steal attention from the subject. Partially disguised within the internal logic of the picture, as it was in the cottage scene, it represents a playful addition to the layers of media translation extended to a discerning viewer. The position of the Sarony signature as advertising in a world of dramatic imagination nods to its dual purpose as a mark of ownership and authorship.[57] Echoed by its larger iteration on the margin of the cabinet card mount, it embedded this creative claim deep within the fabric of his work.

More often than not, however, the painted backdrops used in photographic studios went unsigned, in part because these ubiquitous accessories of the nineteenth-century picture industry were not treated as precious art objects or ranked highly as creations in their own right. Out of necessity they functioned as fortifying tools—living

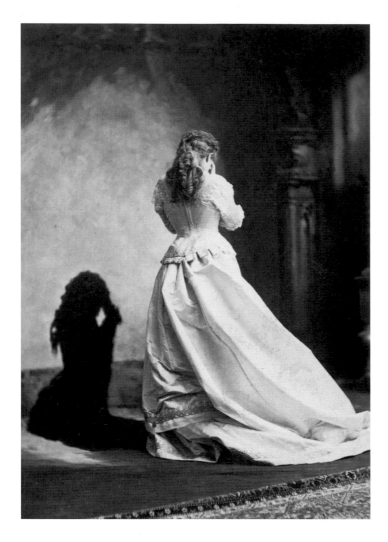

Fig. 76 | Napoleon
Sarony, *Clara Morris in
"Evadne; or, The Statue,"*
ca. 1875. Albumen
silver print on card,
14.2 × 10.3 cm (5
5/8 × 4 in.). Victoria
and Albert Museum,
Bequeathed by Guy
Little. Photo © Victoria
and Albert Museum,
S.140:464-2007.

pictures—whose representational contingency allowed them to play dynamic support-
ing roles in the context of the portrait studio. As paintings alone, they were incom-
plete, requiring the addition of a subject and the activation of photography to be fully
realized. Sarony's circa 1875 portraits of the actress Clara Morris in *Evadne; or, The
Statue* demonstrate how studio backdrops were freely altered to meet the immediate
needs of an ephemeral portrait-making process (figs. 76 and 77). The photographs
evoke the play's dramatic climax, when the title character appeals to the spirit of her
father for protection after being imprisoned in a castle by an evil king. The theatri-
cal scene was conventionally staged at the foot of a giant statue in a grand architec-
tural setting—no doubt as resplendent with material detail as *A Russian Honeymoon*.[58]
For the studio adaptation, however, Sarony posed the actress in a nearly empty space
and amplified the emotional anguish of her performance by doubling her figure with
a dark shadow cast crisply upon the plain background wall.

Fig. 77 | Napoleon Sarony, *Clara Morris in "Evadne; or, The Statue,"* ca. 1875. Albumen silver print on card, 14.7 × 10.4 cm (5 4/5 × 4 in.). Victoria and Albert Museum, Bequeathed by Guy Little. Photo © Victoria and Albert Museum, S.140:463-2007.

This spotlight effect is persuasive in the portrait but would have been impossible to achieve in an unelectrified studio using the photographic technologies of the 1870s. A comparison of multiple photographs from the session reveals that the shadow remains fixed in place even as Morris's position changes, suggesting that it was painted on the spot to resemble an evocative pose rather than cast by light on the canvas backdrop—an indication of how much effort and ingenuity were invested in creating the photograph. Though the unruly mixed-media practices of Gilded Age photographers were misunderstood in later years as a denial of their medium's true, inherent qualities, close attentiveness to the technical problem solving behind the period's "elaborate style" reframes its characteristic thing upon thing as a crucial creative strategy for stretching photography's expansive potential into recognizable modern proportions.

6.

LIVING PICTURES / MODERN ART

In October 1894, the inaugural issue of *Sarony's Living Pictures* arrived in the shops of American news dealers. It was an unusual magazine for the time in terms of its form and content. Though large-scale like *Harper's Weekly* and other illustrated newspapers, it had a colored lithographic cover like *Munsey's*, *Ladies' Home Journal*, and other fashionable monthlies, and the pages inside contained little text. Instead, *Sarony's Living Pictures* most closely resembled a bound portfolio of prints. Each issue of the magazine included ten to twelve full-page illustrations printed on heavyweight paper using a novel, two-color "photochrome" printing process. Launching a publication with an entirely novel format would seem a risky venture at any age, but it was a particularly curious choice for Sarony at the close of his career. By the 1890s, the seventy-two-year-old photographer had built a comfortable and reliable income. Though his magazine could have been motivated by a desire for even greater wealth, this is not a sufficient explanation, particularly since the venture was financially ruinous almost from the start. This chapter explores the possibility that despite appearances and regardless of its long-term success, *Sarony's Living Pictures* represented the culmination of a career-long desire to develop a strategy for making fine art out of reproductive mass media. After a career pursuing emergent trends in image making, Sarony may have foreseen a future for the color photomechanical print as a form of modern art.

An atmosphere of grand ambition certainly surrounded the promotion of the first issue of *Sarony's Living Pictures*. Trade journals reported in 1894 that in addition to keeping up with the demands of his "ordinary" portrait business, "Sarony is constantly engaged in the production of marvellous creations in color."[1] Promotional notices promised that the "High-Class Monthly Magazine of Reproductive Art" would make fine art accessible and affordable to all through vividly colored prints that reproduced either "the work of some famous painter or an original composition by the great Sarony."[2] The calculated indeterminacy of this statement suggested that compelling artwork was just as likely to come from either source. It also implied, however, that the inherent material value of fine art was less significant than the informational value represented in its compositional design—a quality that could be extracted and recirculated easily through reproduction. Conceiving artistic labor as an ephemeral "imprint of personality" rather than as a finely crafted object had been a persistent theme of Sarony's career. Yet at this pivot point in photographic history, at the turn of the twentieth century and just prior to the dawn of modernism, it also represented a significant gamble on a strategy for legitimizing the medium of photography that ultimately failed. That Sarony bet everything late in his career on a historical path not taken helps to explain, at least in part, why his artistic contributions to the field have not been better remembered.

The illustrations in *Sarony's Living Pictures* pushed the notion of form versus content to its extreme, by redoubling the hybrid media strategies he deployed for years as a creative supplement to his portrait business. The "reproductive art" described in advertisements did not involve directly photographing artworks in their original form. Instead, Sarony employed live models to reenact their compositions as *tableaux vivants* in his studio and then heavily retouched the resulting photographs before printing them in color. An illustration titled *Going to the Bath*, which appeared in the first issue of *Sarony's Living Pictures*, was modeled after the 1887 painting *Allant au bain* by French academician William-Adolphe Bouguereau (figs. 78 and 79). In Sarony's image, a barefoot young woman, dressed modestly in homespun, hefts a baby onto her hip. Her outstretched toes, the angle of her arm, and even the stray tufts of hair escaping from her upswept coiffure have all been carefully reproduced from Bouguereau's composition, along with the distant lake and mountain range in the painting's background.

At the same time, the immutable photographic basis for the image is made clear by the model's relatively unidealized face and the solid weight of the child, who straddles the mother's hip rather than being compacted into a picturesque but unrealistic bundle, as in Bouguereau's painting. An introductory text to the magazine written by the publisher A. E. Chasmar identified these minor alterations as fortifications of painterly realism—a technological improvement upon the traditional subjectivity of art. "The painter's dream is here made real, and with a fidelity to nature and a

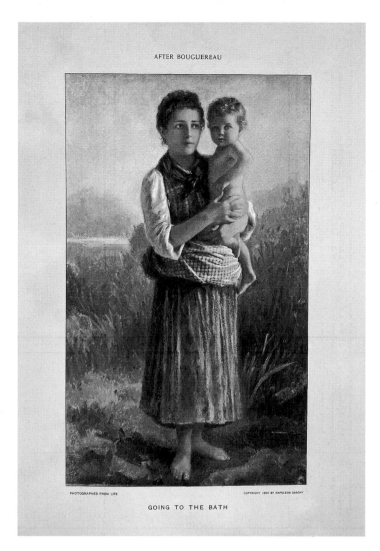

AFTER BOUGUEREAU

PHOTOGRAPHED FROM LIFE COPYRIGHT 1894 BY NAPOLEON SARONY

GOING TO THE BATH

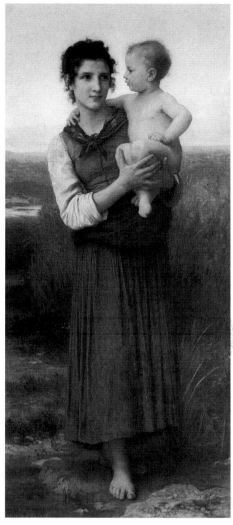

Fig. 78 | Napoleon Sarony, *Going to the Bath*. From *Sarony's Living Pictures* 1, no. 1 (October 1894). Collection of the author.

Fig. 79 | William-Adolphe Bouguereau (1825–1905), *Allant au bain*, 1887. Oil on canvas, 175.3 × 80.6 cm. Photo: Wikimedia Commons.

regard for the beauty of line and form such as must be both the despair and the high aim of every idealist in art."[3] Other plates similarly adapted contemporary academic works at recent salon exhibitions in Paris and London by such artists as Jacqueline Comerre-Paton and Pierre Dupuis, using their compositions as starting points for Sarony's complex multimedia translations, which he created from a blend of photography, paint, and print. Owing either to the photographer's sensitivity about crediting authorship or to his desire to showcase the creative translation his image-making process required, every plate included a caption that identified the original artist and noted that the composition had been "photographed from life" and copyrighted by Napoleon Sarony.

As mediations of fine art, the illustrations published in *Sarony's Living Pictures* were complicated, to say the least, as their content reflects the input of multiple authors and

an array of image-making technologies. For some later critics, the magazine also presented a challenge to good taste so egregious that it cast doubt on the seriousness of Sarony's entire career. Writing in the 1970s, Ben Bassham said that the only unifying theme of the photographer's living pictures was their utter lack of "truth to media," which placed Sarony at odds with his contemporaries. Bassham remarked that during the same period, when Timothy H. O'Sullivan captured the sublimity of the American West, Jacob Riis exposed the squalor of New York City's Lower East Side, and Eadweard Muybridge investigated motion, Sarony abandoned all pretense of using the camera to discover "the poetry and beauty of the real," and instead "remained in his Union Square loft studio, arranging folds of drapery, tilting light screens, adding still another vase to the background clutter of accessories" to ensure that "his subject, his 'reality,' was painstakingly arranged in advance." Sarony's photomechanical variation on Bouguereau's painting was the final damning offense, in Bassham's view, for it represented "a picture based on a painting that was itself inspired by the realism of photography—kitsch squared, so to speak," and a cheap ploy to win artistic recognition by forcing photography into "a novel, if questionable, form."[4]

These objections are worth noting at length because they help to articulate the challenges that exist in taking Sarony's magazine seriously as a contribution to the history of photography in the United States, as well as why I believe it is nonetheless productive to do so. Until recently, modernist anxieties surrounding kitsch have made artifacts of popular visual culture a third rail for serious art-historical scrutiny. In 1939, Clement Greenberg famously described the emergence of a modernist avant-garde as the necessary antidote to industrially produced kitsch, arguing that while the former "moves" or makes progress on behalf of "the values of genuine culture," kitsch merely mimics its form while making few if any interpretive demands on its consumers.[5] Recent scholarship, however, warns against such quick critical dismissal by examining how the constructed divide between art and kitsch sustains the fiction of a unified elite culture by disregarding images made by and for nonwhite, immigrant, or working-class popular audiences.[6] This is not to propose that *Sarony's Living Pictures* should be regarded as an avant-garde gesture, let alone a particularly successful one—it was neither—but it is revealing that none of the nineteenth-century photographers whom Bassham credited with capturing "the poetry and beauty of the real"—Muybridge, O'Sullivan, and Riis—aimed explicitly to position their work as fine art; this was a distinction bestowed upon them posthumously by the later twentieth-century art world. Sarony's gambit to claim the mantle of art for his photographic work, however unsuccessful, imbues his unrealized ambitions with significance as a source of important untapped insights about the changing hierarchies that reshaped photographic practice and its aesthetic goals just before the emergence of modernism in art.

Charges against Sarony of a lack of "truth to media" are particularly instructive in this regard—first, because they highlight how this modernist sensibility was applied

retroactively to form a "usable past" for twentieth-century photographic priorities, and, second, because the anachronistic insistence effectively disguises the distinctive media profile of *Sarony's Living Pictures*. Though the magazine's illustrations anticipate pictorialist strategies for elevating art photography by engaging traditional forms of making art, the results are not exactly photographs made to look like paintings, nor are they paintings reproduced through photography. Instead, they draw equally on both parent media to create a truly hybrid form. The publication, then, is better understood as an ambitious experiment in color photomechanical printing than as an attempt to make photographs that mimic paintings, or vice versa. Furthermore, Sarony's goal is consistent with the strategies of transmedial fortification that he explored throughout his career, whether in lithography or photography. In this sense, however kitschy it may appear to be, *Sarony's Living Pictures* represented the culmination of the artist's long-term aim to expand the circulation and public life of modern popular art.

In fact, there is evidence to suggest that Sarony thought of the magazine in just this way, and that he conceived it as a platform for shaping his lasting legacy as a creator of artistic reproducible imagery. A decade before the magazine's first issue appeared, the photographer had begun signaling a sincere desire for professional change. He confessed to an interviewer in 1881 that the repetitive demands of his business and the weight of his celebrity were becoming an unbearable burden: "Think what I must suffer . . . fancy my despair. All day long I must pose and arrange for those eternal photographs. They will have me. Nobody but me will do; while I burn, I ache, I die, for something that is truly art. All my art in the photograph I value as nothing. I want to make pictures out of myself, to group a thousand shapes that crowd my imagination. This relieves me, the other oppresses me."[7] The dramatic language and emotional intensity of the statement make it stand out among the chipper platitudes more characteristically attributed to Sarony in newspapers of the period. Perhaps for this reason, it was frequently reprinted as evidence of the photographer's genuine, if tempestuous, creative sensibilities. Paradoxically, the same quotation was used in foundational twentieth-century textbooks on photographic history to suggest that Sarony was never truly invested in making art from photography—that he valued this possibility "as nothing."[8] Weighing Sarony's ambitions against the limited professional pathways available to photographers in his lifetime makes it easy to imagine a reality somewhere between these two extremes. From this perspective, the statement simply registers his understandable frustration that the business of making portraits could not help him realize the shapes that crowded his imagination.

Whatever the case, Sarony gradually backed away from the demands of photographic portraiture in the years following the interview. Though he continued to participate in sessions for celebrities and other high-profile clients, he increasingly left management of the day-to-day business in the hands of his son, Otto, while devoting his own days to sketching in charcoal and pastel in a private studio on the third

floor of his Union Square building. By the 1890s, it was reported that Sarony rarely made portraits at all and was "spending his time principally in the preparation of the sketches which he [is] publishing in serial form."[9] The project referred to was, of course, the magazine *Sarony's Living Pictures*, which in the context of longer-term professional woes may have seemed a promising strategy for developing a new audience for fine artworks produced and distributed at industrial scale.

Moreover, there was good reason to believe that color printing was a legitimate path forward for artistic photography during the late nineteenth century. One detail that has gone overlooked in condemning *Sarony's Living Pictures* as kitsch is that the "reproductive art" it contained was produced by the Photochrome Engraving Company—a color-printing firm owned and operated by a young Alfred Stieglitz. Though Stieglitz later obscured his connection to the company when he reshaped the story of his artistic origins, he remained actively engaged in its operations until at least 1903 and certainly would have been aware of a title helmed by the most prominent photographer in the United States. Whatever the level of his direct involvement, Stieglitz's connection to *Sarony's Living Pictures* offers a tantalizing window onto the complex entanglements with nineteenth-century visual culture that shaped the emergent form of modernist photography and its more successful twentieth-century campaign for photographic legitimacy. This makes it productive to probe the visual culture surrounding the production of *Sarony's Living Pictures* to consider why this failed experiment might once have made sense as a commercial gambit and artistic swan song.

THE DAYS OF LIVING PICTURES

The term "living pictures" was not, of course, coined specifically for Sarony's magazine but was a commonly used phrase with broad cultural currency in the nineteenth century. In addition to referring to spectacular stage entertainments, living pictures could describe critical engagement with images that embraced the illusions of technological modernity. For this reason, the term supplies a useful conceptual framework for conceiving of the rich intermediality and modes of comparative interpretation that characterized "premodernist" viewing practices. The earliest use of the phrase "living pictures" dates to the late eighteenth century, when it was used interchangeably with *tableaux vivants* to describe a static scene in which live performers enacted well-known works of art. The origins of this practice are usually traced to private performances given by Lady Emma Hamilton in her home in Naples. In the 1760s, Lady Hamilton's husband, Sir William Hamilton, amassed a collection of antique sculpture and artifacts from the newly rediscovered sites at Pompeii and Herculaneum, and as an after-dinner amusement, Lady Hamilton would duplicate the poses of the figures for the benefit of a private audience. The pastime expanded in popularity by the early nineteenth century, becoming a voguish parlor game enjoyed by members

of the upper classes in Europe and the United States. It also was introduced to the realm of commercial theatrical entertainment, so that by the 1830s, the performance of living pictures, living statuary, or *poses plastiques* were common entr'acte performances or, occasionally, self-contained presentations in their own right.[10]

Central to the appeal of *tableaux vivants*, in both private and public iterations, was the generalized license they provided to push boundaries of normal social propriety and indulge in representational uncertainty. The practice's vaguely artistic associations created circumstances where it was acceptable to reveal bodies in states of undress that would otherwise have been socially unthinkable. The transgressions ranged from the relatively innocent baring of shoulders and ankles by society debutantes, posed as paintings in their parents' parlors, to the sexualized presentation of scantily clad women in gentlemen's clubs and taverns. In the latter venues, performers were usually not nude but were costumed in flesh-colored body stockings, as Adah Isaacs Menken had been onstage in *Mazeppa*. And just as Menken held mid-nineteenth-century audiences in thrall with the contradictory claims of her performance, the uncertain virtue of *tableaux vivants'* risqué display of flesh added to their appeal. That said, licentiousness was ultimately less inherent to the form than was the fundamental sense paradox a "living picture" took as its premise. The same willing suspension of disbelief that allowed living, breathing performers to be "read" as statues, and enabled audiences to see nudity where there was none, supported viewers' divergent visual impressions without contradiction. At the same time, because a performer's ability to hold still was essential to a successfully staged *tableau vivant*, the sport for audiences came in scrutinizing static figures for signs of life—for any telltale hint of motion that would spoil the illusion. Similar, then, to vexing questions of visual and dramatic realism, living pictures provided their audiences with satisfying opportunities to relish the coincident contradictions between high and low, fact and fiction, proper and indecent. Whether staged in tribute to great works of art or for the purposes of a sleazy peep show, living pictures suggested a visual framework for exploring and expanding the bounds of social acceptability by appropriating the trappings of high culture.

Indeed, by the close of the nineteenth century, the term "living pictures" had expanded far beyond its specific original meaning to convey an array of paradoxical visual experiences. From the death-defying attractions witnessed under the Barnum & Bailey big top to textual descriptions of the divine visions of the prophet Ezekiel, living pictures could describe anything perceived as persuasively vivid or uncommonly picturesque—any visual example of the artistic and imaginative infusing the mundane realities of everyday life. For example, a book reviewer for the *Times* of London wrote in 1893 that Rudyard Kipling's recently published collection of short stories, *Many Inventions*, "draws a living picture of the galling realities of a guerilla campaign against Afghan tribesmen."[11] A real estate promoter selling land on Peconic Bay wrote

beneath an engraved illustration of sailboats bobbing on the water, "You can see a hundred living pictures like this from any one of the choice sites in West Neck Park that yet remain unsold."[12] The term was also applied to society women promenading in the latest fashions, to theatrical stage sets, and to dancing figures at costume balls that made the world appear "a living picture book." During an unseasonable heat wave in 1894, a newspaper in York, Pennsylvania, reported, "These are the days of living pictures. Scanty attire and picturesque poses are noticed on every hand these hot evenings."[13] In all their iterations, living pictures represented the intermingling of the real and unreal, a sense that what was experienced was too beautiful and unusual to be understood except in terms of art.

The concept of living pictures penetrated the realm of fine art as well, where it was frequently used to describe portraits created from life or perceived to be especially lifelike. The *Brooklyn Daily Eagle* reported in 1893 that when the sculptor Frederick MacMonnies discovered that "there was no living picture" of Nathan Hale (that is, no portrait completed during his lifetime) upon which to base a commissioned monument, he decided that "the next best thing" would be to employ a model from New England with the same "puritan blood running in their veins" so that he might create a living picture of his own—in the studio and immortalized in the final sculpture.[14] Similarly, an art critic reviewing an exhibition at the New Gallery in London praised John Singer Sargent's portrait of Mrs. Hugh Hammersley as the exhibition's "most daring, original and living picture." Although Sargent's loose brushwork sharply divided reception of the work, the *Times* critic wrote that the vivacity of the portrait's subject could hardly be denied. "The very head literally vibrates with life, never has the spirit of conversation been more actually and vividly embodied."[15] What made these artworks living pictures, then, was a sense of accuracy that animated static visual reproduction. Most commonly, the quality was described in terms of contradiction— paintings that seemed to move, human statues that were uncannily still. Whether they were performed, written, or painted, their pleasurable effect was generated by an awareness of the contradiction between reality and perception, by having one's senses so thoroughly deceived that one could be forgiven for ignoring the truth. The quality that united sailboats on the water and Sargent's portrait was a vivid reciprocity between art and life. The first presented a vision of reality so picturesque that it seemed to subsume the viewer in a life-sized painting, and the second was an inanimate portrait image so well wrought that it improbably vibrated with a lively spirit of conversation.

In short, the term "living picture" might be used to describe any visual experience so persuasive that it appeared to defy the logical limits of material reality. This perhaps made it inevitable that during the 1890s the term would be applied to the earliest form of motion pictures. American newspapers announced in April 1893 that Thomas Edison's latest marvel, the "kinetograph," would be unveiled at the Columbian Exposition

Fig. 80 | Advertising poster for Thomas Edison's Vitascope, 1896. Library of Congress, Prints and Photographs Division, 2003689462.

in Chicago. Only the most recent in a series of revolutionary technological marvels, the kinetograph promised to be "to the eye what the phonograph is to the ear." Just as earlier inventions made it possible to record live musical performances so that they could be experienced in perpetuity, the kinetograph preserved the appearance of the world like "a mechanical retina, which stores away a living picture to be reproduced in all its action, every movement faithfully shown at any time and in any place."[16]

The promise of such a perfect recording device presented a tacit challenge to extant forms of visual media, and the announcement prompted a ripple of reaction among producers of theater, painting, and photography, as they suddenly reconsidered their engagement with motion. The *American Journal of Photography* announced anxiously in 1893 that, unlike a still photograph, which captured only "arrested action," the kinetograph image depicted "the living man, his every gesture, the play of expression on his face and the movements of his lips."[17] Suddenly, it appeared likely that the portrait style that Sarony and other Gilded Age commercial photographers had carefully cultivated could be upstaged by a new way of documenting likeness and seeing life in action through the modern magic of a mechanical retina. Edison officially associated his inventions with the legacy of living pictures two years later, when he titled his electrically powered projection system the Vitascope, a name that translates roughly to seeing or picturing life, and displayed moving kinetoscope images for theaters of spectators within large-scale golden frames (fig. 80).

In the world of theater, the advent of motion pictures prompted a new generation of technologically sophisticated *tableaux vivants* onstage. The most famous of these was *Kilanyi's Living Pictures*, a phenomenally successful production that took British and American theaters by storm between 1893 and 1895, the same period during which

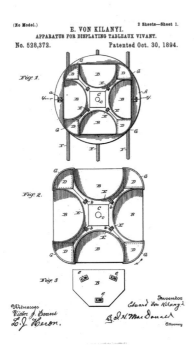

Fig. 81 | Edward von Kilanyi, *Apparatus for Displaying Tableaux Vivant*, US Patent Drawings for the Glyptorama, 30 October 1894. Photo: Google Patents.

Edison unveiled both the kinetograph and the Vitascope motion-picture projection system and Sarony began publishing his *Living Pictures* magazine. Unlike conventional staged tableaux, which relied primarily on costume and the audience's imagination for the persuasiveness of their effect, Edward von Kilanyi's *Living Pictures* employed artificial lighting and mechanical stagecraft to enhance the illusionistic realism of depicted artworks.[18] Whereas earlier tableaux were revealed to audiences by simply lifting a curtain, *Kilanyi's Living Pictures* were presented on a specially designed revolving platform. Patented in October 1894, this staging device, popularly known as the "glyptorama," was divided into four shallow sections that accommodated separate removable backgrounds, vastly reducing the preparation time required between scenes (fig. 81). As the audience admired one tableau, the next was posed in a neighboring chamber and then rotated into view. The result was that theatergoers took in living artistic reproductions one after the other through the portal of an oversized picture frame. Among the most celebrated of Kilanyi's tableaux was a living Venus de Milo, which featured a model in a white body stocking wearing long black gloves that made her arms appear truncated beneath the artificial lights in the theater. Contemporary observers simultaneously expressed amazement at the effect and a perfect understanding of how it was achieved, with one describing how the costume made the model's arms "merge into the background" so that she "brought into perfect relief the mutilated torso of the Louvre's priceless treasure."[19]

Though they evoked the classical past in their subject matter, *Kilanyi's Living Pictures,* and other rival productions that sprang up in their wake, were direct products of the media culture of their era. Lynda Nead has noted that the rhythmic rotation of the glyptorama onstage imbued formerly static *tableaux vivants* with the animation of contemporary technological spectacles such as magic lanterns, stereopticons, or the motion picture "mutoscope."[20] The theatricalization of visual effect and the resulting sensory thrills aligned these new, technologically sophisticated living picture shows with what Tom Gunning has described as the "cinema of attractions." Unlike films made after 1906 that relied on narrative dramatic structures, the short motion picture spectacles made by Georges Méliès, the Lumière brothers, and W. K. L. Dickson for the Edison companies were nonlinear visual spectacles. Many depicted simple, familiar sights from a fixed perspective—a view of a waterfall, a couple kissing, or genre subjects suggested by popular prints and narrative paintings. Spectators were not permitted to lose themselves in a fictional world or its absorptive drama but instead remained highly "aware of the act of looking."[21] Just as viewers were amazed by the illusionistic qualities of Kilanyi's Venus de Milo even as they recognized the trickery behind it, the cinema of attractions presented the persuasive illusions of synthesized motion that made trains appear to race out of tunnels or rockets blast off to the moon, even as these illusions were undercut by technological glitches and clunky jump cuts that left little doubt of their disjuncture with reality. For Gunning, such "exhibitionist confrontation rather than diegetic absorption" underscored the relation to the spectator that early cinema shared with later avant-garde practice.[22]

This strategy of attraction was not unique to early motion pictures but can also be seen in the provocative push and pull between seeing and knowing that characterizes an array of spectacular nineteenth-century entertainments, including dramatic realism, trompe l'oeil paintings, the operational aesthetic of Barnum's displays, and photographs of "impossible" subjects by Sarony, Notman, and Rejlander—all of which engaged critical attention by inviting viewers to "look askance" at their environment.[23] What is crucial to emphasize, however, is that these entertainments, and the mode of critical vision they nurtured, relied on suspending disbelief and exercising doubt simultaneously. *Kilanyi's Living Pictures* and Vitascope projections similarly deployed the theatrical device of an oversized picture frame to contextualize the technological marvels displayed within. The tension between old and new, real and fake, held viewers in a state of rapt awareness. This suggests that the usable past for avant-garde practices can be productively expanded to include processes of comparative discernment born in early mass visual culture, mechanical reproduction, and kitsch, as well as more radically innovative technologies.

In fact, one consequence of the introduction of motion pictures in the 1890s was the acceleration of processes of reproduction, circulation, and consumption of visual material that had characterized mass visual culture for decades. Charles Musser has argued

that part of the attraction of early cinema was the opportunity it offered nineteenth-century audiences to indulge in a mode of comparative, transmedial viewing with which they were already quite familiar. He points out that, with certain rare exceptions, early motion pictures offered little new subject matter, serving simply as the repositories for content reproduced elsewhere. Seeing familiar subjects reproduced onscreen constituted what Musser describes as a visual "source of play." Spectators who encountered reproductions of a famous painting in a book, magazine, or newspaper might see the same work reproduced again on the stage by live performers, or on the screen via cinematography.[24] The diversity of forms and the speed with which pictorial ideas were reproduced and consumed reduced the likelihood of direct comparison between original and copy, along with the importance of the relationship between them. Viewers who consumed pictorial ideas through these cascading chains of reproduction gained familiarity with artworks they had never experienced in their original form. The diverse attractions surrounding cinema transformed reproduction and consumption into a self-conscious form of entertainment and suggested a strategy through which contemporary viewers might process the complex proliferation of period media forms by exercising comparison and judgment across a range of representational possibilities.

Prompting comparative evaluation of modes of reproduction was the essential premise of *Kilanyi's Living Pictures* and the foundation for their popular success. Audiences assessed the quality of performed pictures against an imagined catalogue of "originals" that were probably only familiar through other forms of reproduction. While audiences recognized the Venus de Milo, only a few would have seen the original sculpture at the Louvre. Far more often, American viewers "knew" works of art in the form of mass reproductions—plaster casts, miniature replicas, and diverse forms of print. Indeed, contemporary reviews indicate that beyond iconic antique subjects, the best-received subjects in living pictures shows were those that enacted popular paintings, including Hermann von Kaulbach's *Fairy of the Moon*, Pierre-Auguste Cot's *Springtime*, Paul Delaroche's *Pharaoh's Daughter* (better known as *Miriam and Moses*), and Bouguereau's *Cupid and Psyche*.[25] Of these, only two were exhibited in the United States: Kaulbach's painting was shown at the 1893 Columbian Exposition and Cot's was a promised gift to the Metropolitan Museum of Art. All, however, were frequently reproduced in the illustrated press in the 1890s, and most theatergoers who applauded the enactment of the paintings onstage would have known them as reproductions in newspapers, books, and stereographs rather than in their original form. Thus, part of the engaging novelty of living pictures and early cinema alike was seeing the cascading chains of reproduction common to late nineteenth-century visual experience drawn to logical extreme and expanded to such immersive scale that these mechanically produced images could be reinhabited by human actors.

Within a media environment of mechanized complexity, the art of living pictures attempted a literal reinsertion of human presence into the static stuff that crowded mass visual culture. The confused intermingling of human presence and

mass reproduction was carried into venues where such popular entertainments were consumed at the turn of the twentieth century. In May 1895, vaudeville impresario Oscar Hammerstein invited Kilanyi to adapt his *Living Pictures* tableaux for display in the newly opened Olympia Theatre. Located on the corner of Broadway and 44th Street, Hammerstein's Olympia was one of a growing number of multipurpose entertainment spaces custom made to support the "cinema of attractions." For the fifty-cent price of admission, visitors could attend concerts and performances in the two main auditoriums, play billiards, go bowling, eat in the Oriental Café roof garden, or enjoy kinetoscope and Vitascope presentations.[26] The diverse range of amusements encapsulated the nimble skills of visual literacy required of fin-de-siècle audiences, as well as the sensory overload their simultaneous consumption must surely have produced. During a single evening, a viewer at the Olympia might see a stage show that combined living pictures, artificial lighting, dance troupes, and illusionistic set pieces that incorporated real working fountains and sawmills. One critic, after seeing the stage show at the Olympia, reflected that while the scenery was gorgeous, the costuming exquisite, and the mechanical effects wonderful, "the actors— well, they were lost, overshadowed by their surroundings; and anyway, they were only the links to connect a series of beautiful living pictures."[27] Subsumed within a dizzying proliferation of effects and attractions that vied for attention, human performers provided a tenuous point of connection across an unrelated sequence of theatrical stimuli, providing a relatable scale of perception within the expanse of mass visual culture. For nineteenth-century viewers confronted by this unprecedented proliferation of information, images, and consumable goods, living pictures represented a fantasy of visual culture that could be easily understood and reinhabited by individual presence. Within the oversized frame of the living picture, the mounting distinctions between painting, sculpture, print culture, and performance could be collapsed into a single, knowable form. Rather than preserve the boundaries between media as sacred and untouchable, living pictures deliberately dismantled and reassembled a profusion of visual content in order to edify and amuse, astonish and amaze. The result was a playful mode of engagement that transformed art from something sacrosanct into material that might be appropriated for everyday use, a set of templates to be explored, reproduced, and appreciated again and again.

Sarony's Living Pictures

It was in this context, during "the days of living pictures," that Sarony's periodical was launched. Though sales probably benefitted from the title's resonance with Kilanyi's popular stage show, the first advertisements for the magazine predated the troupe's theatrical premiere, suggesting that the print project was not a direct imitation of Kilanyi's specific iteration of living pictures but was motivated by the broader cultural phenomenon of media-bending visual images that abounded in the 1890s.

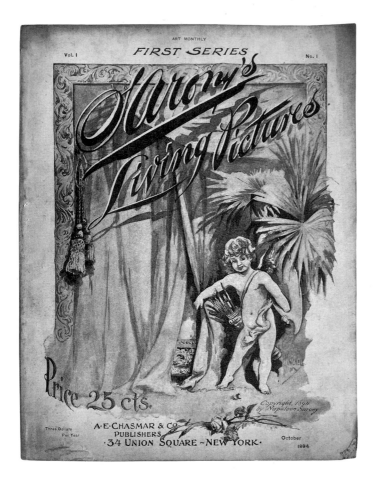

Fig. 82 | Winchell, New York, cover illustration for *Sarony's Living Pictures* 1, no. 1 (October 1894). Collection of the author.

The cover illustration for the inaugural issue evokes theatrical presentations of motion pictures and *tableaux vivants*, depicting the figure of Cupid drawing back the curtain on a stage bounded by a large picture frame (fig. 82). The magazine's title is rendered in flourishing calligraphy across the upper register of the image in script that resembles Sarony's famous signature. Along the lower margins, however, the hard edge of the frame dissolves, so that the scene is ambiguously located in a space somewhere between a picture frame and a theater stage—a fitting preamble to the hybrid processes of handwork, camerawork, and posed performance used to create the images inside. Reinforcing the theme of intermediality, Cupid is outfitted with a quiver of paintbrushes, pencils, and crayons instead of his usual arrows. In his left hand he holds a palette, and with his right he reveals that what lies behind the curtain is another frame set inside the first. The image within an image evokes the layered, indeterminate experience of reality and art, capturing the sensory uncertainty that characterized living pictures.

The introductory text in the magazine's first issue, written by the publisher A. E. Chasmar, confirmed that this slippage between imagined and actual appearances was

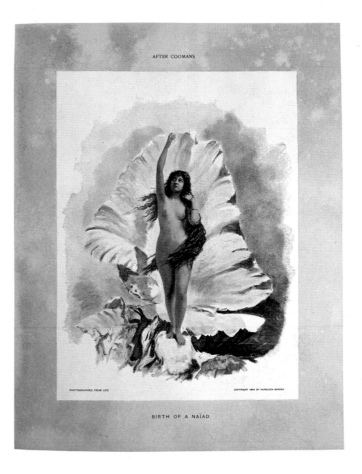

AFTER COOMANS

PHOTOGRAPHED FROM LIFE

COPYRIGHT 1894 BY NAPOLEON SARONY

BIRTH OF A NAÏAD

Fig. 83 | Napoleon
Sarony, *Birth of a Naïad*.
Sarony's Living Pictures
1, no. 1 (October
1894). Collection of the
author.

central to the project's mission: "Here is art, not only founded upon nature, but through
which nature herself is seen." Chasmar added that unlike artworks made either by hand
or by the camera, *Sarony's Living Pictures* filtered artistic imagination through the lens
of photographic realism, so that audiences could "compare with the ideal of the artist,
a realization of that ideal in the flesh." The first illustration appears to deliver upon
this fleshly promise. Sarony's *Birth of a Naïad* depicts a nude female figure standing
on the lip of an open oyster shell (fig. 83). One raised arm lingers on the upper edge,
as if she has just emerged to take a first, curious look at an unfamiliar world. Her ges-
ture of pushing back the hinged shell mirrors that of the magazine's reader, turning
the pages to take in a novel mode of image making. Chasmar's introduction informed
readers that illustrations like *Birth of a Naïad* were not simply photographs, prints, or
paintings but new forms of fortified hybrid images that combined the strongest ele-
ments of all three media into what was best described as "a reproductive art."

The captions on *Birth of a Naïad* underscored the necessity of understanding
Sarony's image through the lens of intermedial literacy required by theatrical spec-
tacle and the cinema of attractions. The fanciful mythological subject was labeled

"photographed from life" and identified as based on a painting by the Belgian artist Joseph Coomans (or, more probably, on a widely circulated photogravure of Coomans's painting *Birth of a Nereid* published in 1884 by the Philadelphia firm Gebbie & Co).[28] Alerted to the presence of these media components, viewers could search the image for noticeable junctures between photograph and painting and judge for themselves the reliability and virtue of the respective media forms—comparing, as Chasmar put it in his introduction, the ideal of the artist against its real manifestation. Adding to the attraction of the image is its risqué flirtation with presenting female nudity in a mainstream publication. The naïad's windblown hair strategically shields her genitalia from view, but her breasts are clearly visible, albeit rendered in soft detail. Nonetheless, while the seashell and atmospheric environment have clearly been rendered by hand, the model's face is recognizable as a photograph, leaving the viewer to wonder how much farther down her body the photorealism extends.

Although *Sarony's Living Pictures* is best remembered for provocative nude images that reproduced subject matter common to *tableaux vivants*, such images constituted only a fraction of the magazine's content. Especially in the early issues, nudes were a minor component within a larger spectrum of hybrid media translations. Most of the original content that Sarony created for the magazine consisted either of photographed tableaux reproducing recognizable paintings like the ones already described, or of original compositions in charcoal depicting similar sentimental subjects. More significant in understanding the goals of the publication was the inclusion of past photographs from the Sarony studio among these newly created images. Freshly colorized, enlarged, and printed on heavy paper stock by the Photochrome Engraving Company, the photographs were otherwise scarcely altered from their original appearance. To some extent, the inclusion of this older work rehearsed Sarony's familiar strategy of elevating photography by bringing it into proximity with traditionally accepted media. In this case, Sarony presented photographs as part of a spectrum of "reproductive art" with varying subject matter and styles. Yet, considering the frustrations of Sarony's late career and his burning desire to make "something that is truly art," his goal may also have been to reposition his legacy as a photographer by prompting readers to reconsider the artistic quality of portraits that originally circulated as collectible cabinet cards.

Sarony's *King Lear* shows how re-mediation was deployed to highlight the artistic content of his earlier photographic work. The portrait, which originally circulated as a cabinet card, depicts the American actor William E. Sheridan crowned with brambles as the mad King Lear of act 3, grief-stricken and alone in the wilderness (fig. 84). Sheridan was a member of Edwin Booth's theater company in the 1870s and '80s, and Sarony had photographed him around 1880 in a series of costumed character studies that included his depiction of Lear. Sarony's haunting photograph was taken at unusually close range, making it visually distinct from his more conventional studio portraits, which show full standing figures in staged studio environments. In its

reproduction in *Living Pictures*, Sheridan's bony shoulder is tinted peach, making it jut forward from the blue-gray of his robe and the surrounding atmospheric background. The image is also in soft focus, compared with Sarony's typical work, which enhances the emotional expressiveness of the actor's face and makes it resemble the austere, modern photographic style that was beginning to come into vogue with the growing pictorialist movement of the late 1890s. Sheridan had died in 1887, only a few years after Sarony made his portrait. Since he had never been a major celebrity, there had probably been little demand for the cabinet card, and by 1894, the actor may have been unfamiliar to most magazine readers.[29] This makes the portrait's inclusion in *Sarony's Living Pictures* particularly interesting, for it reveals that the photographer was not simply exploiting the popularity of recent work but going farther back in his oeuvre to reexamine and revive exceptional photographs made years before. Reprinting Sheridan as Lear introduced the portrait to a new audience of potentially appreciative viewers who, unfamiliar with its subject, may have been willing to consider the photograph's merits purely on its own terms as an artwork.

The Dying Gladiator recasts one of Sarony's photographs of the famous German bodybuilder Eugen Sandow as an artistic study in sculptural form (fig. 85). In this case, the composition was not altered or retouched for its appearance in the magazine but was simply tinted a deep teal blue to enhance the resemblance between Sandow's skin and marble statuary. Sarony's original portrait, in addition to circulating as a conventional cabinet card, had also appeared in Graeme Mercer Adam's book *Sandow on Physical Training* (1894) in an alternate version that showed Sandow as the dying gladiator viewed from the rear. Sarony's reproduction of his work as a fine art print reclaimed it from the conventional commercial functions for which it had been created and, through its title, reasserted its compositional connection to a longer tradition of art making. Sandow was a natural fit for Sarony's magazine, and indeed an ideal subject in an era that relished the appearance of single subjects portrayed in diverse media. The strongman's stage shows, which featured him performing a sequence of static postures inspired by classical statuary, were themselves variations on the tradition of *poses plastiques* performance. Sandow's professional experience prepared him for the rigors of holding poses in a nineteenth-century portrait studio, and the variety of new and old media in which he appeared demonstrates the changing pace of representation.

A significant point of aesthetic connection between late nineteenth-century photography and early film is Sandow's appearance in the 1894 Edison kinetoscope short *Eugen Sandow: The Modern Hercules* (fig. 86). The forty-second film shows Sandow striking poses and flexing his muscles while rotating his body 360 degrees to display front and back. The darkened interior of Edison's Black Maria movie studio casts Sandow's illuminated body in sculptural relief, much as Sarony's photographs do. This connection is strikingly displayed in *The Souvenir Strip of Edison Kinetoscope*, a card produced and sold alongside the film. The card-mounted composite image shows twelve

KING LEAR

W. E. SHERIDAN

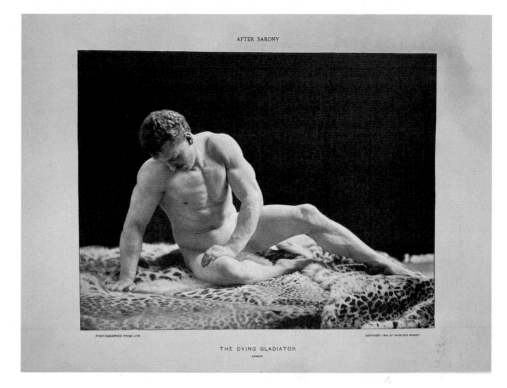

AFTER SARONY

PHOTOGRAPHED FROM LIFE

COPYRIGHT 1894 BY NAPOLEON SARONY

THE DYING GLADIATOR
SARONY

Fig. 84 | Napoleon Sarony, *King Lear. Sarony's Living Pictures* 1, no. 1 (October 1894). Collection of the author.

Fig. 85 | Napoleon Sarony, *The Dying Gladiator. Sarony's Living Pictures* 1, no. 1 (October 1894). Collection of the author.

photographic frames from *The Modern Hercules* arranged in two sequences of motion. The text printed alongside the image instructs viewers in how to read the images in relation to one another, observing "that each picture has a slight change of position as it passes the point of vision." What is represented, the text explains, is "rapid photographing" that creates an "illusionary spectacle of moveable figures," made visible by the reproduction of static forms. That Edison explained his invention by pointing to photography, while Sarony sought new ground for his photographic work, speaks to the shifting pace of visual representation and the unpredictable fortunes of shifting media hierarchies in the days of living pictures.

Unfortunately for Sarony, his magazine failed to deliver the lasting recognition and success he craved. Though the first two issues had a print run of more than fifty thousand copies, sales tapered off thereafter, as did the general production quality of the magazine. This decline was matched, and perhaps compounded, by Sarony's failing health. After the first issues appeared in 1894, the photographer suffered a series of minor strokes that limited his ability to work. The magazine continued to be produced sporadically under the title *Sarony's Sketchbook* until about 1897 (the year after Sarony's death), but it ceased to include new illustrations after 1895, and the photographer's active involvement probably ended around the same time.

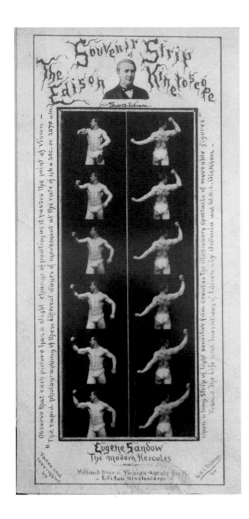

In the early decades of the twentieth century, the idea of living pictures evolved again. Monumental stage productions like Kilanyi's were displaced by a panoply of vaudeville entertainments, and the glyptorama displays staged at the Olympia Theatre were absorbed by the Ziegfeld Follies in 1907, when Florenz Ziegfeld Jr. took over management of the venue.[30] The illustrations created for *Sarony's Living Pictures* had a twentieth-century afterlife as well. Between 1900 and 1903, Edison's American Mutoscope and Biograph Company repurposed several illustrations from the magazine's early issues in a series of short motion pictures titled *Living Pictures*, for which Sarony was posthumously credited in the company's catalogue.[31] Each film lasts around one minute and presents a static shot of a theatrical stage. It begins with a view of a brocade curtain that is drawn open by two waiting attendants to reveal a *tableau vivant* within a painted frame. For "motion" pictures, the depicted action is subtle, more representative of the early spectacles that characterized the cinema of attractions than of later movies that deployed more sophisticated linear narratives.

In the 1903 film *The Birth of the Pearl*, for instance, which is based on Sarony's illustration *Birth of a Naïad*, the curtain opens on a giant clam shell (fig. 87). After a few seconds, the upper half of the shell opens to reveal a resting sea nymph who stands up sleepily and stretches, mimicking the pose of Sarony's illustration briefly, and gazes at the audience before the waiting attendants close the curtain and the film ends. The Edison films *By the Sea* and *The Tempest* also reproduce Sarony's compositions more or less directly, returning these living pictures to the chain of multimedia reproduction that initiated their publication in the magazine.

MASS MEDIA AS MODERN ART

Although Kilanyi's stage productions and the advent of motion pictures provided context for Sarony's magazine venture, a Tile Club story called "Around the Wood

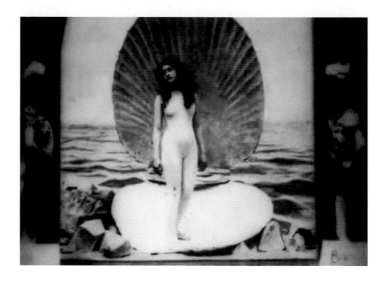

Fire" suggests that he considered printmaking an avenue to making modern, popularly accessible art long before the advent of *Sarony's Living Pictures* in the 1890s. Though published in 1902, the story, by Francis Hopkinson Smith, recalls the club's heyday in the 1870s and offers a romantic account of the ale-fueled jollity that animated the group's meetings. On the evening described in Smith's story, "Briareus," the club's alias for the painter William Merritt Chase, engaged his fellow Tilers in a spirited discussion of the oppressive conservatism of the National Academy of Design. At a recent gathering of academy members, "the aged fossils and young fungi who formed the geological and botanical collection which enriched that institution had advanced ideas so utterly at variance with the established code of the Tenth Street Munich School that Briareus had left in disgust." At a slight remove from the main group, composed mostly of painters, Sarony ("the Hawk") and Frederick Dielman ("the Terrapin") discussed the latest advances in color printing with passionate interest.[32] Sarony proclaimed that recent technological breakthroughs in lithography and photomechanical printing were the destiny and career salvation for all American artists—something new and modern that would revolutionize the form and circulation of art. The wood engravings published in *Harper's Weekly* and *Frank Leslie's Illustrated Newspaper* were "as dead as Julius Caesar and copperplate." According to Sarony, the future would be in color, and with newly emerging technologies, artworks would be produced more rapidly and reach wider audiences than ever before. He clarified that what he had in mind was not the type of chromolithography that Currier & Ives or Sarony & Major had created in the mid-nineteenth century. Instead, the key to modern reproductive art involved combining photographic reproduction with lithographic printing. Imagining himself positioning a camera before the easel in Dielman's studio, Sarony described his vision: "Before you can wink your eye you have the girl's head

which Terrapin finished yesterday photographed from the original canvas on a sheet of zinc, slapped on a Hoe press, and by sundown an edition of fifty thousand copies is in the hands of the newsboys. 'Here's your horiginal 'ead by the famous hartist, B. Terrapin, five cents.'" By exhibiting paintings through print media, an artist need not be subject to the whims of an academy or see his work languish in obscurity as a singular, unsold object in the studio. It could instead travel at the accelerated pace of modern news media, moving in a single day from the easel to the photographic plate, and then to a steam-powered rotary printing press, and from there into the hands of the public. Furthermore, Sarony noted, the appeal of any image when circulated in print could be enhanced by accompanying text describing the intention behind its creation, and an enticing note of promotion announcing that "at the present writing the paint is not dry on the Terrapin's canvas," so the public would be assured that the print before them represented the very latest advancement in US art. Before Dielman could react to Sarony's suggestions, Catgut, a violinist named Joseph Lewenberg who was among the Tile Club's honorary musical members, called upon the Tilers "to drop that art stuff," so he could play a Beethoven sonata that "will melt your soul into honey."[33]

Though the nostalgic reminiscences recorded in Smith's Tile Club stories should not be taken as solid facts, Chase's frustrations with the National Academy were real enough to suggest that other anecdotes also contained a significant element of truth. It seems reasonable, then, to imagine that on one evening or several, a Tile Club gathering was animated by Chase bristling over the future of American painting and Sarony waxing enthusiastic about the latest advances in color printing.

Sarony was hardly alone in regarding mass reproduction as a modern strategy for expanding fine art audiences in the United States. For many nineteenth-century observers, art publishing seemed an ideal solution to the problems of scale and authorship that accompanied the expansion of mass visual culture. It promised a means of cultivating a vast network of consumers while retaining creative and financial control of one's work. Between the 1860s and 1890s, innovative printers and publishers such as Louis Prang and Sylvester Rosa Koehler promoted art appreciation by circulating high-quality chromolithographs alongside essays outlining aesthetic principles. Prang cultivated relationships with contemporary US artists, and Tile Club members Frederick Dielman, J. Carroll Beckwith, J. Alden Weir, Elihu Vedder, and Winslow Homer all circulated reproductions of their paintings through Prang's publishing house.[34]

Sarony's dream of a fleet, sophisticated mode of reproduction would have resonated with fellow artists, then, regardless of their preferred medium, but there were some specific considerations. For painters, it would expand access and potential sales of a unique original that was already accepted as art. For photographers, it held the additional promise of elevating artistic consideration of their medium through enhanced public engagement and the development of an appreciative audience.[35]

Though photography had long counted reproducibility among its virtues, it was not until the widespread adoption of halftone processes in the late 1880s that photographic images could be directly reproduced alongside text in magazines and newspapers. Until then, it was necessary that photographs be translated into other media or tipped in to publications by hand. Most important, as Sarony described to Dielman, developing a high-quality method of reproduction would allow the latest products of the studio to be published alongside critical commentary that explained its aesthetic virtue. Strategies of photomechanical reproduction supplied photographers with a two-pronged tool for artistic legitimacy by lending visibility to creative work and helping define the critical discourse around it.

It is little wonder, then, that improving technologies for color printing and photomechanical reproduction was a major preoccupation of the international photographic community during the latter half of the nineteenth century. The race to develop the first commercially viable process resulted in numerous patents and many short-lived or unsuccessful experiments. Around 1870, Edward Bierstadt, brother of the painter Albert, invested in a printing process called the artotype, which became the most common mode of photographic reproduction used in the United States in the following decade. Akin to the collotype and albertype processes developed in Austria, the artotype used metal plates coated in a light-sensitive gum bichromate to reproduce a photograph's intermediate tones, though its weakness was that it could not be printed easily alongside text.[36] Frederick Ives and Max Levy of Philadelphia solved that problem in the 1880s when they developed the first cross-line screens, which allowed photographs to be reproduced as color halftones alongside print on a letterpress machine. Unfortunately, their elaborate process remained too expensive for widespread use until the 1890s. By that time, another partnership had already crossed the finish line. German-American photographer William Kurtz joined with Ernst Vogel (the son of pioneering photographic chemist Hermann Wilhelm Vogel) to develop the first commercially viable three-color halftones. Using their novel process, Kurtz made a still life image of a bowl of fruit that became the first photographic print to be mass-produced in color. It was published in *Photographische Mitteilungen* in Germany in January 1893 and in the US trade journal *Engraver and Printer* two months later.[37]

Another leader in photomechanical reproduction in the United States was a young Alfred Stieglitz. In October 1890, Stieglitz assumed directorship of a New York printing firm called the Heliochrome Company, which was dedicated to pursuing a process like Kurtz's. Though Stieglitz later implied that he accepted the position only to appease a friend of his father's, he took considerable interest in the race to improve and develop photographic reproduction technology. During his first year as director, he bankrupted the company by investing heavily in experimental printing processes without taking in a single order. This financial disaster would have seemed an

ideal exit point had Stieglitz really been uninterested in the endeavor, but rather than move on, he asked his father for an additional investment of $5,000 so he could resurrect the ruined business and try again.[38]

And although Kurtz and Vogel were the first to mass-produce color photographic images in 1893, Stieglitz was not far behind. In January 1894, he celebrated the accomplishment of his renamed Photochrome Engraving Company with a full-color frontispiece in the *American Amateur Photographer* of his photograph *The Last Load*. Stieglitz explained in accompanying text that his photograph of Tyrolean farmers in a hay cart had previously been exhibited in its "uncolored" form to great acclaim but now appeared improved through full colorization to demonstrate the vibrancy of his company's photochrome process. Developed in Switzerland in 1886, photochrome was the technological antecedent to offset lithography. Images were produced by transferring a conventional black-and-white dry-plate original to between two and twenty lithographic stones—each designated to a single color. So, like Kurtz's three-color halftones, Stieglitz's photochromes were the products of a color printing process rather than being true color photographs. Yet, whereas Kurtz's halftone process mechanized this separation by rephotographing the image multiple times through specially prepared screens, photochrome allowed individual color plates to be adjusted by hand according to the printer's discretion, so that the final mix of colors was both subjective and entirely imagined. This is apparent in *The Last Load* in undifferentiated areas of bright yellow that were applied to the hay cart and the field behind it. While symbolically suggestive of ripening hay, the sunny hue was more a register of the capabilities of the printing process than an accurate representation of natural appearances.

The garishly colored photograph represents a significant departure from the austere, modernist sensibility that Stieglitz would later champion (biographer Richard Whelan describes *The Last Load* as "perhaps the worst artistic lapse of his entire career"), but he nonetheless took considerable pride in the photograph at the time of its publication.[39] In a subtle dig at Kurtz and Vogel, Stieglitz wrote in his editorial comments, "Although we do not as a rule, favor colored photographs, as they are generally crude and inartistic, we think that this attempt will be appreciated by most of the readers of the *American Amateur Photographer*. The print is particularly interesting as a specimen of colored photography."[40] At the end of that year, in December, apparently still nursing the professional rivalry, Stieglitz followed up by publishing a colored image of a fruit basket remarkably similar to the one Kurtz and Vogel used to announce their initial technical triumph.[41]

Stieglitz made much of his desire to part ways with the Photochrome Engraving Company later in his career, but his dissatisfaction is not entirely backed up by his professional actions or published statements during the 1890s. He served as full-time director and leading artist of the company from 1891 to 1895, and the position was instrumental in establishing him within the US photographic community by providing

entry to the leading trade journals of the period. When Stieglitz became coeditor of the *American Amateur Photographer* in the spring of 1893, his Photochrome Engraving Company was already producing the reproductions for the magazine as well as for the *Photographic Times*, *Anthony's Photographic Bulletin*, and many other major US photographic journals. It was not until 1895 that Stieglitz finally distanced himself from the firm after a bout of ill health forced him to choose between managing its day-to-day operations and keeping up with mounting editorial responsibilities at the *American Amateur Photographer* (from which he also resigned the following year, in 1896). Even after giving up direct supervision of the firm's activities, he retained a voice in shaping policies regarding printing practices and maintained an office in the building until 1903.[42] According to an October 1895 article on color printing in *Anthony's Photographic Bulletin*, the work produced by the Photochrome Engraving Company was "equal to anything that has been done, and yet Mr. Alfred Stieglitz, the artist of the firm, is seeking effects still higher before permitting them to bear the imprint of his company."[43] Clearly, then, Stieglitz was still actively involved in overseeing creative and technical aspects of production for the firm for at least a year after the first issue of *Sarony's Living Pictures* was produced.

Perhaps the greatest evidence of Stieglitz's faith in the quality of his company's photomechanical printing was his decision to use the Photochrome Engraving Company to produce the high-quality reproductions for his own journals, *Camera Notes* and *Camera Work*. Although it has been suggested that his awareness of photomechanical printing was something "he took with him to *Camera Work*" from the Photochrome Engraving Company "for the explicit purpose of recreating the high-quality photographic prints seen in Europe," he actually produced his magazines from this office space and relied on the company for his illustrations.[44] Allan Sekula has argued that the photomechanical reproductions in Stieglitz's magazines were the most effective "ploy" enlisted in his campaign to elevate consideration of the art of photography. By printing images as separate plates on heavy-weight paper, as they appeared in *Camera Notes*, or on fragile tissue in *Camera Work*, Stieglitz presented photographic reproductions as precious objects of craftsmanship. According to Sekula, the photogravures that appeared in *Camera Work* toned in sepia, blues, violets, and greens "established a tradition of elegance in photographic reproductions" that was crucial in making Stieglitz's publication the "monumental framing device that stood behind every photograph aspiring to art status" in the twentieth century. In a profound sense, then, we might think of Stieglitz as "a magazine artist" as well as a photographer, and his two journals as his meaningful creative contributions to establishing an intellectual and material framework for modern photographic discourse.[45]

While *Sarony's Living Pictures* clearly did not match Stieglitz's later publications in terms of intellectual and aesthetic rigor or longevity, it nonetheless shared the foundational aspiration of using photomechanical reproduction to change public perceptions

about the art of photography. Perhaps that is why Sarony, a former printmaker himself, placed his trust in Stieglitz and the Photochrome Engraving Company when seeking a firm to produce his project. In his history of photomechanical reproduction, David A. Hanson remarked upon the first issue of *Sarony's Living Pictures*: "This wonderful piece of kitsch was probably in the shop of the Photo-chrome Company just as Stieglitz was contemplating his departure. It appears that there is more to his involvement in this company and the experiments in half-tone that took place during his tenure there than has yet been investigated."[46] The second half of this assertion is certainly true, even if later established time lines are somewhat misleading. The first issue of *Sarony's Living Pictures* appeared in October 1894, between the publication of Stieglitz's *Last Load* and the colorful fruit still life in the *American Amateur Photographer*, at a time when Stieglitz remained publicly invested in the products his firm was producing.

Stieglitz later explained his decision to distance himself from the firm by saying that although he "loved fine printing," he was disillusioned with the photoengraving business, as it demanded "speed and quantity" rather than "careful craftsmanship."[47] It is thus potentially significant that Stieglitz's departure from the Photochrome Engraving Company in 1895 coincided with the end of Sarony's active involvement with the *Living Pictures* magazine. When Sarony's studio was liquidated in March 1896, among the items sold at auction was a group of images described as his "Nature and Art Series," mixed-media sketches that seem to have been the originals from which the magazine's illustrations were produced. The auction catalogue's description noted of these drawings that "several years ago, Mr. Sarony began to form a collection of works in which photography and art were combined. He posed the human figure before the camera, and from a print from the negative built up a picture, altering and painting over the photograph. Some of these images were reproduced and published in a work called 'Sarony's Living Pictures,' but the manner of their reproduction was unsatisfactory to Mr. Sarony, and the issue was terminated abruptly."[48] If this information is accurate, it is possible that the collaborative experiment in photomechanical printing proved disappointing to both parties, and that responsibility for producing a "wonderful piece of kitsch" is not attributable to Sarony alone.

Whatever their relationship as printer and client, there are tantalizing suggestions that the two photographers had more significant professional contact than previously suspected. Despite his prodigious writing on the American photographic scene of the 1890s, Stieglitz never mentioned Sarony by name, but it is impossible that the prominent elder photographer's work would have been unknown to him—even if their relationship was a contentious one. This possibility is suggested in a fiery article that Stieglitz wrote for the *American Annual of Photography and Photographic Times Almanac* in 1896. The previous year, Stieglitz had spearheaded a campaign to increase exhibition possibilities for US photographers through the organization of a national photographic salon. There had been photographic trade conferences in the United States for some time, but few outside the industry attended. Stieglitz hoped that a grander

event could win broad public interest and promote organized discourse around fine art photography. His organizational efforts gained little support among local photographers, however, and Stieglitz used the article to vent his frustration. He wrote that almost a year had passed since he first proposed the idea for an American salon, and yet no one bothered to listen to reason regarding its utter necessity. Throughout Europe, photographic exhibitions were decreasing in number and increasing in quality. Medals were being abandoned as old-fashioned, and distinguished panels of judges were becoming more selective, ensuring that only the very best work would be shown. Stieglitz wrote that the dearth of qualified photographic artists was only "one of the great difficulties to be overcome in this country." Equally unfortunate was the stubborn refusal of Americans to settle on a single city as the country's cultural mecca. England had London, and France had Paris, but in the United States, Stieglitz complained, "petty jealousy" prevented Boston, Chicago, and Philadelphia from conceding that New York City was the obvious center of national artistic activity. Most troubling was the mercenary spirit Stieglitz claimed to encounter whenever he approached prominent members of the New York photographic community, even among those who professed to be artists. "The American's enthusiasm is rarely very great unless he sees a likelihood of turning his labors into dollars and cents." He had approached several of the country's "recognized leaders in pictorial photography" to ask what share of the work they would be willing to undertake in his proposed national salon, but none volunteered to work under his direction. The young photographer appeared to hold a particular grudge against one industry leader in particular. "The most prominent of all, a man of means, replied in a condescending manner that *'he was willing to show his pictures' (!!)* but that 'he did not think he could give the cause any time'; and still this very gentleman preaches about art photography in America and complains of the lack of interest taken in pictorial work on this side of the water!" Stieglitz concluded by promising that he would continue, despite these frustrations, in his attempts to fashion a silk purse from the sow's ear of American photography. His only goal was for the United States to "soon show the world the finest collection of pictorial photographic work ever seen, if only to make up for all its former deficiencies and backwardness."[49]

Though Stieglitz did not name the prominent man of means who had offended him, it is difficult to imagine another photographer in the United States at the time who could have fit the description as well as Sarony did. The insinuation was enhanced by the placement of Stieglitz's article immediately following a five-page feature interview with Sarony that described his style of portraiture as "the art of not posing." Written by Gilson Willets, the article outlined the studio methods that made Sarony "the father of artistic photography in America," including how to direct subjects, how to compose a portrait, and how to enhance the artistic character of a photographic image. "Sarony is both photographer and artist, but he is first of all an artist. His success qualifies him to lay down the law and gives authenticity to his views, which he

so courteously permits me to reproduce here."[50] For those who read the two articles in succession, it would not have required much imagination to identify Sarony as the unnamed gentleman who preached about art photography in America but refused to help Stieglitz in his campaign.

It is hardly necessary to expound upon the ultimate success of Stieglitz's efforts to construct a new artistic identity for photography in the United States, or to organize exhibition opportunities that would bring American photographers into dialogue with international practitioners. It was a project born of the fierce determination and persuasive powers that shine through the lines of his early impassioned writing. What does merit a closing note of emphasis, however, is that the American photographic scene he was determined to expose for its "deficiencies and backwardness" was not so bereft of ambition and talent as it was made to appear. It is more often that archival absences and the rehearsal of conventional narratives make the threads of continuity running through photographic history difficult to trace. In this regard, it is a pity that Stieglitz made a concerted effort later in his career to minimize evidence of his active investment and involvement in the debates that animated nineteenth-century American photography. As early as December 1897, it was reported that he had destroyed much of his back catalogue. Marmaduke Humphrey wrote that Stieglitz had made "twenty thousand negatives, and has smashed about eighteen thousand of these in his annual house-cleanings."[51] Later in his life, between the 1910s and 1940s, he repeatedly culled his papers and early photographs, burning prints, journals, and negatives that he described to Georgia O'Keeffe as being of "no earthly use." "So many should be torn up," he wrote, "but it is difficult to draw a line."[52] Sarah Greenough notes that in addition to wanting to pare down his archive, Stieglitz seemed to feel a deeper need to shed the past in order to make room "for the new," as he told Sherwood Anderson, and to create an ordered vision of that past for posterity.[53] Ultimately, his decisions about what aspects of the past should be "torn up" reshaped his artistic oeuvre into a statement of who he was as a modernist photographer—at the expense of preserving a full picture of the state of American photography as he had encountered and participated in it in the 1890s. The result, as Stieglitz apparently intended, is that the points of connection between modernist photography and what preceded it are difficult to trace in his work. Color photographs like *The Last Load*, which he had once displayed proudly, and examples of early studio work such as *The Card Players* survive only in reproduction and as rare album prints (fig. 88).

On the infrequent occasions when these photographs are discussed, they are presented as uncharacteristic lapses in judgment, an assertion that succeeds in part because there is not enough evidence of Stieglitz's other early efforts to create a balanced picture. *The Card Players*, for instance, appears particularly incongruous within the artist's larger body of work. Yet it must once have represented the photographer's artistic priorities, and contemporary tastes, because the photograph was exhibited in the Première exposition d'art photographique held by the Photo-Club de Paris in

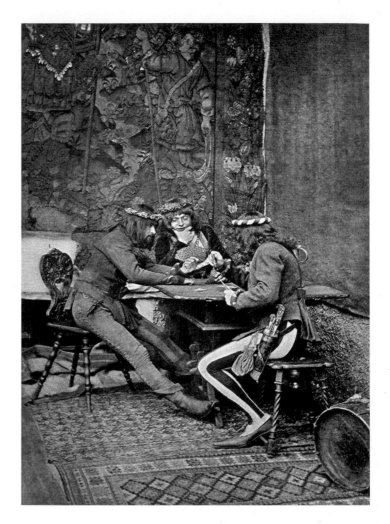

Fig. 88 | Alfred Stieglitz
(1864–1946), *The
Card Players*, 1894.
Heliogravure, 15.7 ×
11.5 cm (6 3/16 × 4
½ in.). Published by
T. Fillion / LeMercier
& Cie, Paris, in
*Première Exposition
d'Art Photographique*.
Courtesy of the J. Paul
Getty Museum.

1894, after being selected by its distinguished panel of judges.[54] The scene features three lanky young men dressed in medieval tights and posed before a hanging tapestry background. Replete with theatrical props, the tableau's staging and spatial construction bear close resemblance to contemporary popular photography. But to draw *The Card Players* into alignment with Stieglitz's more familiar body of work, scholars have suggested that the photograph was meant as satire, or as a reflection on European genre painting, rather than considering how it might be in dialogue either with European photography or with the contemporary work of American photographers such as James Landy, William Notman, Jeremiah Gurney, José María Mora, Benjamin Falk, or, of course, Napoleon Sarony.[55] Though it is understandable to wish for art history to be drawn in clean lines, and for artists to have clear and consistent creative points of view, the interconnections between modernism and the rich visual culture that preceded it are far messier and more beautifully entangled than the stories we tell about them conventionally allow.

CONCLUSION

NINETEENTH-CENTURY AFTERIMAGES

Sarony's death in November 1896 prompted an outpouring of remembrances from across the US art world. Most of them focused on his professional accomplishments, describing Sarony as a photographic giant, a true artist, a luminary talent. Thomas Nast was among the few who cautioned that exaggerating Sarony's accomplishments was a disservice to his legacy. It was better to remember him "for having done intelligent, clever work when other men were commonplace,"[1] and to value his foundational contribution to American photography rather than to misrepresent his lasting place as its pinnacle. One tribute to Sarony, written by the editor Edward L. Wilson in 1893, seems to capture this spirit by sharing a memory of the photographer that was unusually personal in tone. Wilson recalled that one evening, just after dusk, he was passing through Union Square Park when he spotted someone "moving about rather strangely" beneath a cluster of trees. Drawing nearer, he discovered his old friend Sarony, dancing in the twilight while scattering crumbs from a loaf of bread he held under his arm to a flock of chirping, hopping sparrows. Wilson realized that the photographer believed himself alone, and he watched for a moment in surprised amusement before announcing his presence, in part because he hated to interrupt the fun, noting that the dancing photographer "seemed highly delighted, and the sparrows appeared to be having a grand good time too." Wilson admitted that it was odd to share this kind of memory publicly; the anecdote had little to do with Sarony's photography, but he explained that he felt compelled to offer the "commonplace" encounter

as a character sketch of his indescribable friend, who was "always wonderful, always lively, always exciting, always supplying much to delight the thoughtful observer."[2]

There is much we can learn about people who are long dead. Most often, however, it comes from the fragments of their lived experience that survive in archival documents—collected letters and official records, or passing mention in newspapers. This information resembles the formal, posed history that is intentionally preserved in artifacts like portraits. It captures the public-facing pose that people meant to leave behind and offers either a posthumous encounter with what they considered their best face or an ignominious trace of appearances they might prefer to have been forgotten. What happens behind the scenes, when the performance ends or the camera lens is covered, can be harder to recover. Moments of transition between the bright successes and noteworthy failures are the twilight passages of cultural memory. They occur in every life and every history, but they usually rely on information that appears too commonplace (or too awkward) to be set down in writing. Wilson's peculiarly touching anecdote about an old man feeding sparrows in the dark offers a reminder that even details that appear disconnected from important official facts can communicate vividly what a person was like to those who knew him. Understanding how these twilight passages inform history's more visible successes and failures makes it worth pausing over crumbs of information or unfiled photographs that do not fit easily within standard categories.

The vicissitudes of cultural memory are a leitmotif in Sarony's story. His success as a photographer (and his frustration as a lithographer) came in part from a desire to have his name remembered in connection with his work. During his lifetime, he enjoyed good fortune and gained recognition for aligning a mechanical process with an artistic presence, but the circumstances that made the gesture significant faded quickly. This was in part because the name Sarony, which accrued monumental status during the artist's lifetime, continued its exponential expansion for years after his death (fig. 89). If anything, being freed from individual creative control accelerated the growth of the Sarony name into a global commercial brand.

The photographer's son, Otto, had been the immediate, and apparently reluctant, inheritor of the family name. Sarony's will gave Otto three months to decide whether he would accept control of the portrait business, with the binding condition that doing so would mean dividing profits with his stepmother, Louie, and his half sister, Belle, for a period of fifteen years. After that point, all the negatives and studio equipment—along with the family name—would be owned by Otto outright, but in the meantime he would receive a one-third share return on his full measure of work, plus his usual $75 weekly salary.[3]

It would have been understandable if Otto found this arrangement a bitter pill to swallow. A photographer himself, he had been directing portrait sessions under the Sarony signature since the late 1880s and probably presided over most of what the

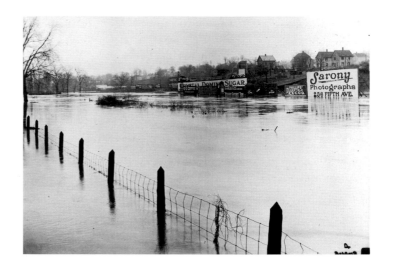

Fig. 89 | Elwin R. Sanborn (1869–1947), *Sarony Billboard in Flooded Conditions at East 222nd Street, Bronx, New York*, 1912. Courtesy of the Westchester County Archives.

studio produced between 1893 and his father's death in November 1896. He may also have found the studio name inescapably freighted with his father's larger-than-life presence. Nonetheless, Otto at first acceded to the conditions of the will and continued as sole proprietor of the Sarony studio, but only for a time. On 7 October 1898, he sold "all the fixtures, implements, cameras, lenses, specimens and materials used in and about the photographic establishment . . . together with the trade-mark 'Sarony'" to Jonathan F. Burrow, a former partner in the Burrow-Giles Lithographic Company that his father had sued all the way to Supreme Court. Seeking a larger income four years later, Otto separately sold the rights to his own name to the photographic entrepreneur Theodore C. Marceau and took a position managing Marceau's studio. After Otto died, in September 1903, the "Otto Sarony" label continued to be applied to portraits taken by other photographers. David Shields writes that the great irony of Otto Sarony's career is that while many of the portraits he produced at the Sarony studio were not individually credited, most photographs appearing under the brand Otto Sarony were "in all probability not his creations, but those of W. H. Babbitt and a host of nameless cameramen."[4] In 1906, when the Marceau Studio merged with the Otto Sarony Studio, the volume of portraits being issued under Otto's name multiplied. This at last became a problem for the original Sarony studio, which was still owned by the Burrow family. In 1907, the two competing Sarony firms, neither of which had any living Saronys in its employ, sued each other for control of the valuable brand name.[5] Little more than a decade after Napoleon Sarony's death, the name and signature that had been key to his assertions of artistic individuality became a diluted corporate moniker used to market photographic portraiture in studios from New York to New Zealand.

Other aspects of American photography were, of course, changing too during the early years of the twentieth century. Stieglitz succeeded in establishing a salon

for American photography in 1902 and coined the term "Photo-Secession" in connection with his planned exhibition at the National Arts Club. Stieglitz noted carefully at the time that this title should not be understood in terms of secession from the United States, a prospect with troubling associations only a few decades after the Civil War, but asserted that "Photo-Secession actually means a seceding from the accepted idea of what constitutes a photograph."[6] In its concept and organization, the Photo-Secession signaled a radical break with the conservatism and commercialism that had characterized prior photographic practice, a deliberate reinvention that separated a modern movement from its foundations. Compounded by the Kodak revolution and the growth of vernacular photography, the techniques and aesthetic priorities that guided American photographers in the nineteenth century were quickly growing unrecognizable, and there was a growing sense that the early history of photography in the United States was in danger of fading from memory.

The critic Sadakichi Hartmann, who was intermittently an ally and adversary of Stieglitz's, was among the few who felt moved to preserve this disappearing past. Between 1898 and 1916, Hartmann wrote fifty-five character sketches of photographers whom he called "the valiant Knights of Daguerre," in an attempt to preserve the memories of a rapidly changing artistic field.[7]

Hartmann's 1906 conversation with Benjamin J. Falk provides a fitting coda to Sarony's story, for it attests to the uneasy coexistence of two very different camps of photographic practice in the United States at the turn of the twentieth century and the uncertain borderlines that separated them. Born in 1853, Falk had worked steadily in the New York photographic industry since the 1870s. He began as an apprentice to George Gardner Rockwood, and shortly afterward came under the unofficial professional mentorship of Sarony. According to Hartmann, this pedigree made Falk a genuine representative of American photography's "old guard," and, admirably to Hartmann's mind, part of "the old guard that never surrendered."

For more than three decades, Falk remained persistently loyal not only to his profession but to practicing in the manner of studio portraiture he had originally been taught. This was a matter of philosophy rather than of technology, however, since Falk doggedly kept pace with every practical innovation in the field. Considering the rapid evolution of photography during the last three decades of the nineteenth century, this meant that by 1906 Falk had mastered an extensive list of technological forms. When his studio opened in 1877, Falk worked exclusively in the wet-plate collodion process used by Civil War photographers. A few years later, he became among the first in the US industry to shift his practice to gelatin dry plates. Immediately following the electrification of Manhattan in 1882, Falk had his studio wired so he could use carbon arc lamps to make portraits by artificial light. He made Broadway history in March 1883, using a mobile version of the same technology, when he became the first photographer to depict a cast of actors performing on a theatrical

stage.[8] Over the years, Falk also experimented with composite photography, artificial flash powders, and stop-motion action pictures. He told Hartmann that in the early 1900s he had briefly considered converting his entire portrait practice to color autochromes before he determined that the technology could not meet the demands of a busy studio (though he confided that his dearest wish was to see color photography "effective [and] in good working order before I make my departure from this earth"). After reviewing Falk's long and impressive list of career accomplishments, Hartmann reflected with bemusement, "Strange that I should never have run across this man before now. Only when my editor suggested his name did I recall that there was such a photographer in existence."[9] Despite a lifetime in photography, and despite never surrendering, Falk and the old guard he represented were, by 1906, rapidly fading from living memory.

The same was certainly true of Napoleon Sarony, but as Hartmann ventured deeper into Falk's photographic memories, he found that Sarony's name came up again and again. When Hartmann asked Falk about his early work with electricity, the photographer demurred, singing Sarony's praises instead. It was Sarony, Falk said, who set the standard for using natural lighting in the 1870s. "He merely had to pose a person there and was sure of a result."[10] When prompted to describe how he had gotten a start in theatrical portraiture, Falk recalled how much he had admired Sarony, how much he had learned from him, and that he "really owed 'an awful lot' to him." Indeed, Falk had done his best to keep Sarony's legacy alive in the ten years since his death. He took over the presidency of the Photographers' Copyright League of America, which he and Sarony helped found, and kept a large bronze bust of the photographer on display in his studio.[11]

With the studio tour complete, Hartmann and Falk retired to an adjacent "growlery," the Victorian-era term for a room intended for fellowship and drinking (Hartmann noted that the presence of this outmoded style of parlor in a modern business was an apt metaphor for the vanishing photographic world Falk still inhabited). Whether inspired by the space or by the drinks, the two men found themselves in a mood for reminiscing, and the conversation turned again to Sarony. "There we sat in the twilight and talked of conventions and exhibitions of color. . . . Noticing a few of the charming photographic crayons by Sarony on the wall, the latter became for a while the topic of our animated conversation. We both agreed he was a wonderful man, a true genius in his way." It was not the first time that Hartmann had expressed admiration for Sarony. Ten years earlier, he penned an obituary in the *Tatler*, writing that it was hard to conceive of New York City without the presence of its most delightfully eccentric artist. "Besides being one of the best photographers in the world, he was a crayon artist of merit; moreover he took pride in his photography and justly felt that he had raised it to the dignity of an art."[12] In his conversations with Falk, Hartmann extended the highest praise in his critical vocabulary, describing Sarony's

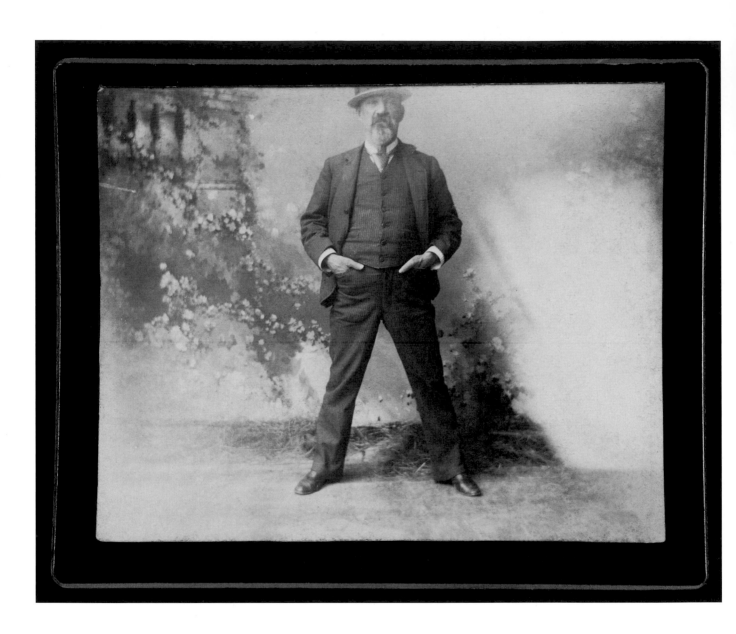

style of portraiture as "unphotographic." He typically reserved this term for work that demonstrated the highest level of aesthetic sophistication and surpassed the medium's capacity for facile mimesis. He reasserted this point at the close of the interview, saying that Sarony had been unphotographic in his "particular kind of work, even as Steichen is to-day." Anticipating that readers might be surprised to see the modern photographer compared with his Gilded Age predecessor, Hartmann explained, "Steichen and Sarony, an inadequate comparison? Not at all. Each man represents a different phase of art, and one as good as the other, I suppose, in the long run of time. Sarony will always occupy a little niche in the estimation of photographers. Let us be just and hope that Steichen will do the same."[13]

It is an important check on more entrenched histories of photography to recall that these two futures once seemed equally viable. In the longer run of photographic history, Sarony's dramatic artistic gestures, like his self-portrait dressed in fur and standing in artificial snow, played an important part in demonstrating how the medium could be unphotographic. His staged portraits surpassed prevailing expectations by using the pencil of the sun to represent illusion, imagination, and aspiration.

Another portrait of Sarony, which is preserved in the Special Collections of the Harvard Fine Arts Library, illustrates the modern phase of art that had begun by the close of his career (fig. 90). Taken by an unknown photographer, it comes from a series of card-mounted prints that depict the artist in his studio late in life, and perhaps was occasioned by the closing of his Union Square business in 1896.

It is not the form or setting that makes the portrait remarkable, however, so much as the fact that it represents Sarony in a guise that appears nowhere else in his artistic oeuvre. Gone are the costumes, wigs, and fezzes that defined the flamboyant character of his nineteenth-century self-portraits. Instead, Sarony looks like an ordinary modern man dressed in a sack suit and flat-brimmed hat. He has abandoned the courtly posture and typical dramatic profile to face the camera directly. It is as if he is announcing that the jig is up, the play ending, and that the time has come to draw the curtain on past illusions. So, this time, rather than orchestrate another beguiling portrait for our delight, Sarony the celebrity photographer simply gazes back at his longtime viewers with his hands in his pockets. Positioned behind him is a painted backdrop like the ones that had been his studio mainstays, but it is not allowed to define the scene. A shaft of bright sunlight from an unseen window erases the details of its decoration and reveals a hard line of demarcation where the wrinkled canvas edge meets a scuffed wooden floor. The horizontal framing of the portrait similarly turns the aesthetic conventions of the cabinet card portrait sideways, exposing a wide margin of empty foreground and abruptly cropping the subject across the crown of his hat. This detail is the clearest surviving relic of Sarony's nineteenth-century practice. Extending beyond the limits of his pictorial space, the diminutive photographer assumes monumental proportions even at the closing curtain.

Sarony's career as a photographer similarly stretched across the divided time line that is conventionally used to measure a formative period in the medium's history. His New York City portrait studio opened in 1866, one year after the Civil War ended, and closed three decades later, just before the turn of the century. At the start of that period, the medium of photography was new, and nebulous enough in its applications that early photographers remained reluctant to claim the title of artist. By the close, however, the field had shifted. Photographers did not hesitate to call themselves artists, and the status of their medium as a tool for making art was considerably more assured. Though the outcome was not Sarony's alone to claim, his contributions to a twilight passage in American photographic history merits a larger share of remembrance than posterity has allotted him.

NOTES

INTRODUCTION

1. Culver Pictures has since moved to a new location in Long Island City, and its extensively digitized materials are available at http://www .culverpictures.com.

2. See Boxer, "Century's Photo History"; McPhate, "With Corbis Sale."

3. Steedman, *Dust*, 8; see Derrida, *Archive Fever*.

4. Elkins, *What Photography Is*, 116; Benjamin, *Arcades Project*, N1a, 8, 460.

5. Bassham, *Theatrical Photographs of Napoleon Sarony*.

6. McCandless, "Portrait Studio and the Celebrity," 63.

7. Sarony provides an estimate of his total photographic output in Willets, "Photography's Most Famous Chair"; slightly different modern accounts are offered in Bassham, *Theatrical Photographs of Napoleon Sarony*, and McCandless, "Portrait Studio and the Celebrity."

8. McCandless, "Portrait Studio and the Celebrity," 63.

9. See Haltunnen, *Confidence Men and Painted Women*; Kasson, *Rudeness and Civility*; Sheehan, *Doctored*.

10. Burns, *Inventing the Modern Artist*, 247.

11. McCandless, "Portrait Studio and the Celebrity," 67.

12. Langill and Falk quoted in "Sarony: As Seen by His Contemporaries," *Wilson's Photographic Magazine*, February 1897, 69–75 (quotations on 69 and 70).

13. Nast quoted in ibid., 74.

14. See Bellion, *Citizen Spectator*; Harris, *Humbug*; Cook, *Art of Deception*; Leja, *Looking Askance*; Staiti, *Deceptions and Illusions*.

15. See Harris, *Humbug*.

16. Bellion, *Citizen Spectator*, 7, 14–15.

17. Leja, *Looking Askance*, 12.

18. See Derrida, *Right of Inspection*, unpaginated; Azoulay, *Civil Contract of Photography*, 105.

19. See Adorno, "Culture Industry Reconsidered"; Debord, *Society of the Spectacle*; Marshall, *Celebrity and Power*; Rojek, *Celebrity*; Dyer, *Stars*.

20. Boorstin, *Image*, 57, 61. See also Braudy, *Frenzy of Renown*, 452.

21. Adorno, "Culture Industry Reconsidered."

22. See Roach, *It*, and celebrity biographies such as McLean, *Being Rita Hayworth*; Stacey, *Star Gazing*.

23. Marcus, *Drama of Celebrity*, 4.

24. Whitman, "Visit to Plumbe's Gallery."

25. Trachtenberg, *Reading American Photographs*, 42.

26. Volpe, "Cartes de Visite Portrait Photographs," 160.

27. Murphy, *American Realism and American Drama*, xi.

28. See Knoper, *Acting Naturally*; Robinson, *American Play*; Levine, *Highbrow/Lowbrow*.

29. Murphy, *American Realism and American Drama*, 18; Senelick, *Theatre Arts on Acting*, 240; Wilson, *History of American Acting*, 140–54.

30. The letters were collected and published in 1926 as *The Art of Acting*.

31. Glenn, *Female Spectacle*, 23–26.

32. Bakhtin, *Rabelais and His World*, 16.

33. Lambert-Beatty, "Parafiction," 54.

34. See Sandage, *Born Losers*. I was also inspired by the College Art Association panel organized in 2014 by Jan Dirk Baetens, "Toward a Loser's Art History: Artistic Failure in the Long Nineteenth Century," and especially the paper delivered by Geoffrey Batchen titled "The Biggest Loser," which explored the possibility of rewriting the history of photography on the basis of pictures that survive only as textual

description in nineteenth-century trade literature.

35. Gilder, "Month in Literature, Art, and Life," 23–24.

36. Derrida, *Copy, Archive, Signature*, 24–25.

37. Glass, "Trademark Twain," in *Authors Inc.*, 57–82. See also "The Tramp in Melbourne: A Morning with Mark Twain," *Herald Standard* (Melbourne), 26 September 1895, 1, reprinted in Scharnhorst, *Mark Twain: The Complete Interviews*, 229–30.

38. Gaines, *Contested Culture*, 51–80.

39. See Leja, "Fortified Images for the Masses"; Bear, *Disillusioned*.

40. Seavey, "Backgrounds: A Review."

CHAPTER 1

1. Stieglitz, "Hand Camera," 216–17.

2. Naef, *In Focus*, 24.

3. Whelan, *Alfred Stieglitz*, 118.

4. Robertson, *Stephen Crane*, 189.

5. Bochner, *American Lens*, 1.

6. Sekula, "Invention of Photographic Meaning," 458.

7. Louis-Jacques-Mandé-Daguerre, "Daguerreotype" (1839), in Trachtenberg, *Classic Essays on Photography*, 13.

8. Talbot, "Art of Photogenic Drawing"; see also his *Pencil of Nature*.

9. Fineman, *Faking It*, 28. See also Batchen, *Burning with Desire*.

10. See Samuel F. B. Morse, "The Daguerrotipe," *New-York Observer*, 20 April 1839, 62.

11. Quoted in Newhall, *Daguerreotype in America*, 83 (Emerson), 82 (Brady).

12. Quoted in Root, *The Camera and the Pencil*, 427.

13. White, "Morning at Sarony's."

14. Root, *The Camera and the Pencil*, 32–33.

15. Robinson, *Pictorial Effect in Photography*, 13.

16. Fineman, *Faking It*, 28.

17. See Bear, *Disillusioned*.

18. Robinson, *Elements of a Pictorial Photograph*, 18–19.

19. Vogel, *Chemistry of Light and Photography*, 77–78, 155.

20. Robinson, *Pictorial Effect in Photography*, 161–62.

21. Stieglitz, "Hand Camera," 217.

22. Kennel, *Charles Marville*, 75.

23. Wilson, "Outdoor Photographs Taken Indoors," 131.

24. Ibid., 129, 131.

25. Cooper, "High Lights in Photography," 324.

26. "Sarony," *Wilson's Photographic Magazine*, February 1897, 65–68 (quotation on 67).

27. Roy, "Le merchand Adolphus Saroni"; "Sarony married to Lehouillier," 29 January 1818, Quebec Cathedral Anglicane, Quebec Vital and Church Records, Drouin Collection, 16211_44963628.

28. Leblanc de Marconnay, "Napoléon Sarony."

29. Thomas, "Late Napoleon Sarony," unpaginated, Harriet Endicott Waite Papers, Archives of American Art, Smithsonian Institution.

30. "Ellen Major Sarony," Green-Wood Cemetery Interment Records, Brooklyn, NY, 15 January 1858.

31. Saints Peter and Paul Catholic Church, Brooklyn, wedding records for 1858.

32. Thomas, "Late Napoleon Sarony," Harriet Endicott Waite Papers.

33. Peters, *America on Stone*, 356.

34. Westchester County Land Records, Westchester County Archives, Westchester, NY, 172-361, 220-155, 237-437; Panetta, *Westchester*, 146.

35. "Sarony's Photographic Portraits," *Birmingham Daily Post* (UK), 31 March 1862; Karel, "Silvestre Laroche."

36. Bradshaw, "Nude in Art."

37. For more on Disdéri, see McCauley's biography, *A. A. E. Disdéri*.

38. Burns, *Inventing the Modern Artist*, 221–22, 247 (quotation).

39. Van Wyck, *Recollections of an Old New Yorker*, 186.

40. James Edward Kelly, "Sarony, the Photographer," unpaginated manuscript, James Edward Kelly Papers, Archives of American Art, Smithsonian Institution.

41. Shelton, "Artist Life in New York," 35–36.

42. James Edward Kelly, "Sarony, the Photographer."

43. Shelton, *Salmagundi Club*, 42.

44. Bassham, *Theatrical Photographs of Napoleon Sarony*, 5.

45. Daniels, "Sarony and His Customers."

46. "Sarony: As Seen by His Contemporaries," *Wilson's Photographic Magazine*, February 1897, 69–75 (quotation on 74).

47. See Kaplan, *Strange Case of William Mumler*, 17; Leja, *Looking Askance*, 21–58; Tucker, *Nature Exposed*, 65–125.

48. See Harris, *Paper Promises*.

49. "National Photographic Association," *Philadelphia Inquirer*, 12 May 1870.

50. Tucker, *Nature Exposed*, 124.

51. Leja, *Looking Askance*, 46.

52. Fineman, *Faking It*, 28.

53. Leja, *Looking Askance*, 46.

54. "A Prestidigitateur in Trouble," *New York Times*, 11 June 1876, 5.

55. "Sarony," *Frank Leslie's Illustrated Newspaper*, 8 August 1868, 322.

CHAPTER 2

1. Bassham, *Theatrical Photographs of Napoleon Sarony*, 14.

2. Nadar, *When I Was a Photographer*, 191–92, 226–27.

3. Taft, *Photography and the American Scene*, 345.

4. *Philadelphia Photographer* 5 (1878): 275, quoted in ibid., 347.

5. See Volpe, "Cartes de Visite Portrait Photographs"; Trachtenberg, *Reading American Photographs*; McCandless, "Portrait Studio and the Celebrity."

6. See Halttunen, *Confidence Men and Painted Women*; Kasson, *Rudeness and Civility*.

7. Lears, *No Place of Grace*, 35–38. See also Burns, *Inventing the Modern Artist*, 232–35; Susman, *Culture as History*, 271–85.

8. James, *Principles of Psychology*, 291.

9. Ibid., 294.

10. Jaffee, "'One of the Primitive Sort,'" 104, 130.

11. Volpe, "Cartes de Visite Portrait Photographs," 159, 158.

12. Ibid., 168. See also Sheehan, *Doctored*.

13. Trachtenberg, *Reading American Photographs*, 40.

14. "A Broadway Valhalla—The Opening of Brady's New Gallery," *New York Times*, 6 October 1860, 4.

15. Root, *The Camera and the Pencil*, 253.

16. "A Few Words on Portraiture," *American Journal of Photography*, 1 August 1863, 50.

17. See Disdéri, "Aesthetics of Photography"; "Troubles of a Photographer," *Humphrey's Journal*, 1 January 1865, 265.

18. Cooper, "High Lights in Photography," 324.

19. "Mrs. Napoleon Sarony to Marry Again," *Kansas City Journal*, 9 December 1897, 6.

20. Raymer, *Photo Lighting*, 31.

21. "High Art, as a Transcript of Nature—With a Sketch of the Celebrated Establishment of Napoleon Sarony, 680 Broadway," Napoleon Sarony scrapbook, Harvard Theatre Collection, Houghton Library, Harvard University.

22. Wilmeth and Bigsby, *Cambridge History of American Theatre*, 1:448.

23. Mullenix, *Wearing the Breeches*, 62. See also Sentilles, *Performing Menken*.

24. Brooks, *Bodies in Dissent*, 167.

25. Sentilles, *Performing Menken*, 96.

26. Shteir, *Striptease*, 26.

27. Sentilles, *Performing Menken*, 95.

28. Quoted in Brooks, *Bodies in Dissent*, 169.

29. Twain, "Menken," 6.

30. "At Prince of Wales Theatre," *Birmingham Daily Gazette* (UK), 23 January 1866.

31. See Cooper, "High Lights in Photography"; "Napoleon Sarony," *Opera Glass*, January 1898, 14–15.

32. Garbutt and Middleton, "History of Photography in Birmingham," 166.

33. "Photography in Birmingham," *Art Journal* 5 (1 May 1866): 158–59.

34. Pemberton, *Birmingham Theatres*, 29–30.

35. "One Woman's Grave: Where Was Adah Menken Buried," *Chicago Daily Inter-Ocean*, 8 December 1879, 6.

36. "Suggestions for Posing," *Anthony's Photographic Bulletin*, June 1870, 1.

37. Seymour, "Posing and Grouping."

38. "Pencil Jottings," *Illustrated Photographer*, 17 July 1868, 289–90, and 31 July 1868, 313.

39. See "Comfort for Photographic Sitters," *North Wales Chronicle*, 20 January 1866; "Talk in the Studio: Sarony's Posing Apparatus," *Photographic News* (London), 4 May 1866, 216; Towler, *Negative and Print*, 176–77.

40. Volpe, "Cartes de Visite Portrait Photographs," 161.

41. Quoted in "Comfort for Photographic Sitters."

42. "Appareil de pose de M. Sarony," *Bulletin de la Société française de photographie* 12 (November 1866): 288–91.

43. Sheehan, *Doctored*, 48–80 (quotations on 75, 76).

44. Wilson, "Hour with Mr. Sarony," 83.

45. Towler, *Negative and Print*, 176–77.

46. See Pauwels, "Resetting the Camera's Clock."

47. Taft, *Photography and the American Scene*, 345.

48. Wilson, "Hour with Mr. Sarony," 83.

49. Scharf, *Art and Photography*, 358.

50. See *Photographic Notes*, 1 August 1860, 207–8, quoted in Newhall, *History of Photography*, 64.

51. Willems, "Between Panoramic and Sequential." On photosculpture, see Sorel, "Photosculpture."

52. "Sarony's Walking Lady," *Albion*, 12 April 1873, 234.

53. Gunthert, "Conquête de l'instantané," 54; see also Prodger, *Time Stands Still*, 41.

54. "Sarony's Walking Lady," 234.

55. "The New Size," *Philadelphia Photographer* 3 (October 1866): 311–13. See also Rohrbach, *Acting Out*, 15.

56. Quoted in Taft, *Photography and the American Scene*, 323.

57. Ibid., 334–35.

58. Fisher, *Historical Beginnings of the American Theater*, 11–20.

59. McCandless, "Portrait Studio and the Celebrity," 68.

60. See Murphy, *American Realism and American Drama*; Demastes, *Realism and the American Dramatic Tradition*.

61. McArthur, *Actors and American Culture*, 183–89; Wilson, *History of American Acting*, 140–45. See also Coquelin, Irving, and Boucicault,

Art of Acting; Knoper, Acting Naturally.

62. Glenn, Female Spectacle, 24.

63. "Sarah Bernhardt's Art," Washington Post, 7 November 1880, 2; Glenn, Female Spectacle, 23–26.

64. Quoted in "Women Before the Camera," Omaha Daily Bee, 10 December 1893, 10.

65. See Coleman's 1981 essay, "Directorial Mode."

66. Quoted in "Sarony's Cameraman," Image: Journal of Photography of the George Eastman House 1 (September 1952): 3–4.

67. Bradshaw, "Nude in Art," 92.

68. Cooper, "High Lights in Photography," 324.

69. "Women Before the Camera," Omaha Daily Bee, 10 December 1893, 10.

70. Quoted in McCauley, A. A. E. Disdéri, 89.

71. Ibid.

72. Willets, "Art of Not Posing," 188.

73. Ibid.

74. Wilkie Collins to Napoleon Sarony, 19 March 1887, Folger Shakespeare Library.

CHAPTER 3

1. "Sketches of Prominent Photographers: Napoleon Sarony," Photographer's Friend, January 1871, 7–8.

2. For more on the history of intellectual property in the United States, see Bacha, Owning Ideas.

3. Tatham, "Lithographic Workshop," 45–47 (quotation on 46).

4. Sarony's Bazaar catalogue, ca. 1830, Bibliothèque et Archives nationales du Québec.

5. "To Exonerate from Prison," New York Evening Post, 5 July 1835. See also Leblanc de Marconnay, "Napoléon Sarony"; "Imports at

Philadelphia," Philadelphia Inquirer, 4 June 1833, 2.

6. "Sketches of Prominent Photographers: Napoleon Sarony," Photographer's Friend, January 1871, 7.

7. Ibid. On Sarony's early life, see also Peters, Currier and Ives, 334–35; and Thomas, "Late Napoleon Sarony," Harriet Endicott Waite Papers, Archives of American Art, Smithsonian Institution.

8. Brown, Beyond the Lines, 35–38.

9. See Piola, Philadelphia on Stone; Barnhill, With a French Accent; Last, Color Explosion; Peters, Currier and Ives; Peters, America on Stone.

10. "Sarony: As Seen by His Contemporaries," Wilson's Photographic Magazine, February 1897, 74.

11. See Barnhill, "French Technology and Skills"; Hewes, "French Lithographic Prints."

12. Wilson, Memorial History, 360; Grimes, Appetite City, 11; Gayler, "Half a Century Since."

13. Carr, "Dream Painter," 372.

14. See Lepler, Many Panics of 1837, 123–42.

15. See Roberts, "Veins of Pennsylvania."

16. Reilly, American Political Prints, 102–4.

17. Peters, America on Stone, 120. For more on Sarony's career in lithography, see ibid., 350–57; and Peters, Currier and Ives, 120–29.

18. Leblanc de Marconnay, "Napoléon Sarony," 3–4.

19. Erffa and Staley, Paintings of Benjamin West, 206.

20. Leja, "Issues in Early Mass Visual Culture," 521.

21. Erffa and Staley, Paintings of Benjamin West, 207.

22. Mainardi, "Copies, Variation, Replicas."

23. Latour, "Visualization and Cognition," 21.

24. Cordell, "Reprinting, Circulation, and the Network Author," 418.

25. Love, "Close But Not Deep," 371.

26. Marzio, "Illustrated News in Early American Prints"; Leja, "News Pictures in the Early Years."

27. Peters, Currier and Ives, 40.

28. LeBeau, Currier and Ives, 12.

29. Peters, Currier and Ives, 119.

30. Brust and Shadwell, "Many Versions and States," 3.

31. Peters, Currier and Ives, 120.

32. The Sarony & Major print was registered on 1 October 1846, but the Currier print is dated only 1846. See the dated records of the Library of Congress Prints and Photographs division at https://www.loc.gov/pictures/item/2003664100 and https://www.loc.gov/pictures/item/91795889/.

33. Peters, America on Stone, 357, 352.

34. Peters, Currier and Ives, 120.

35. Superior Court of the City of New York, Napoleon Sarony, Naturalization Record Number 239a, National Archives at New York City, 20 December 1856.

36. Peters, Currier and Ives, 120.

37. Thomas, "Late Napoleon Sarony," Harriet Endicott Waite Papers.

38. "Fine-Art Gossip," Bulletin of the American Art-Union 2 (June 1849): 24–27. Sarony created lithographic reproductions of Thomas Cole's Good Shepherd (1849, Museum of Fine Arts, Boston), John Trumbull's Death of General Warren (ca. 1850, American Antiquarian Society, Worcester, MA), and Rembrandt Peale's Court of Death (1859, Library of Congress, Prints and Photographs Division).

39. Burns and Davis, American Art to 1900, 222–24.

40. "Fine Arts: Susannah and the Elders," Literary World 5 (15 December 1849): 519–20.

41. See the advertising sections in the *Historical Magazine, and Notes and Queries Concerning the Antiquities, History, and Biography of America* (New York: Charles B. Richardson, 1859), vol. 3; and "A Superb Picture: Rosa Bonheur's Great Painting," *Harper's Weekly*, 14 April 1860, 240.

42. Leja, "Fortified Images for the Masses," 61–62.

43. Bayliss and Bayliss, *Photographers in Mid-Nineteenth-Century Scarborough*, 20.

44. See Averill, "Close Harmony Singing."

45. Francis Lister Hawks, "Introduction," in Perry, Jones, and Hawks, *Narrative of the Expedition*, iv.

46. Thomas, "Late Napoleon Sarony," Harriet Endicott Waite Papers.

47. Rinhart and Rinhart, *American Daguerreian Art*, 270–71; Bassham, *Theatrical Photographs of Napoleon Sarony*, 8.

CHAPTER 4

1. Daniels, "Sarony and His Customers."

2. Gilder, "Month in Literature, Art, and Life," 23–24.

3. Derrida, *Copy, Archive, Signature*, 29.

4. Plunkett, "Mayall, John Jabez Edwin."

5. Quoted in Ronan Deazley, "Commentary on Fine Arts Copyright Act 1862," in Bently and Kretschmer, *Primary Sources on Copyright*, https://pure.qub.ac.uk/en /publications/commentary-on-fine -arts-copyright-act-1862.

6. Trachtenberg, *Reading American Photographs*, 72.

7. Cohen et al., *Copyright in a Global Information Economy*, 55. On the history of art and intellectual property, see Delamaire and Slauter, *Circulation and Control*.

8. Copyright Act Amendment, Washington, DC (1865), in Bently and Kretschmer, *Primary Sources on Copyright*, unpaginated.

9. McCauley, "'Merely Mechanical,'" 58.

10. See ibid.; Lerner, "Nadar's Signatures."

11. French Literary and Artistic Property Act, Paris (1793), in Bently and Kretschmer, *Primary Sources on Copyright*, unpaginated.

12. Latournerie, "Petite histoire des batailles," 43.

13. See Goldstein, *Censorship of Political Caricature*, 143.

14. Court of Cassation on Photography (1862), and Fréderic Rideau, "Commentary on the Court of Cassation on Photography (1862)," both in Bently and Kretschmer, *Primary Sources on Copyright*, unpaginated.

15. Gaines, *Contested Culture*, 47. See also Edelman, *Ownership of the Image*.

16. Clemens's personal copy of the birthday volume, published by Harper and Brothers in 1902, is in the private collection of Kevin MacDonnell.

17. "Famous Snap Shots: Sarony, the New York Photographer Writes of His Art," *Philadelphia North American*, 23 March 1894, 6a.

18. "S. L. Clemens to Mr. Row, November 14, 1905," in Paine, *Mark Twain's Letters*, 2:785–86.

19. Glass, *Authors Inc.*, 57–82. See also Scharnhorst, *Mark Twain: The Complete Interviews*, 229–30.

20. Rasmussen, *Dear Mark Twain*, 3.

21. Wilkie Collins to Napoleon Sarony, 19 March 1887, Folger Shakespeare Library.

22. Paine, *Mark Twain*, 768–70 (quotation on 769).

23. Thornton, *Handwriting in America*, 85–87.

24. Poe, "Chapter on Autography," 50.

25. Thornton, *Handwriting in America*, 87.

26. Ibid., 88.

27. Derrida, "Signature, Event, Context," in *Limited, Inc.*, 19–21.

28. Barthes, *Camera Lucida*, 4.

29. Derrida, *Copy, Archive, Signature*, 29.

30. A limitation statement signed by Mark Twain was reproduced on the back of the flyleaf in each volume of the 1901 Riverdale Edition of *The Writings of Mark Twain*, 22 vols. (Hartford: American Publishing Co.; New York: R. G. Newbegin Co., 1901).

31. Daniels, "Sarony and His Customers."

32. Cooper, "Sarony Photographs of Oscar Wilde."

33. Mendelssohn, *Making Oscar Wilde*, 81.

34. See, all in the *Birmingham Daily Post* (UK), "Sarony's Photographic Portraits," 31 March 1862; "Notice: Mr. Sarony Takes Photographs," 4 June 1862; and "Photography, Birmingham" (on Thrupp's takeover of the business), 14 May 1866.

35. Bradshaw, "Nude in Art."

36. "Did Sarony Invent Oscar Wilde?," *New York Times*, 14 December 1883, 4.

37. "Oscar Wilde Once More," *St. Louis Globe-Democrat*, 23 December 1883.

38. *Burrow-Giles Lithographic Company v. Sarony*, 111 U.S. 53 (1884), https://supreme.justia.com/cases /federal/us/111/53/.

39. Ibid.

CHAPTER 5

1. Cohen, *Luxurious Citizens*, 8–9. See also Hoganson, *Consumer's*

Imperium; Burns, *Inventing the Modern Artist*.

2. Taft, *Photography and the American Scene*, 334–36.

3. Weston, "Daybooks, 1923–1930," 311.

4. Brooks, "On Creating a Usable Past"; Mumford, *Brown Decades*.

5. Orvell, *Real Thing*. See also Lears, *No Place of Grace*; Levine, *Highbrow/Lowbrow*.

6. Latour, *Reassembling the Social*, 7–8.

7. Leja, "Fortified Images for the Masses," 82.

8. Orcutt, *Power and Posterity*, 5.

9. Ibid., 141–47; Giberti, *Designing the Centennial*, 173.

10. Quoted in Post, *1876: A Centennial Exhibition*, 15 (commas added for clarity).

11. Whaples, "United States: Modern Period"; see also Scranton, *Endless Novelty*.

12. Whaples, "United States: Modern Period," 168–69.

13. James Mohr and John Nichols, eds., "World Industrial Production, 1870–1930," Mapping History, University of Oregon, Department of History, https://mappinghistory.uoregon.edu/english/US/US26-02.html.

14. US Centennial Commission, *International Exhibition, 1876*, 8.

15. Ibid., 38.

16. Ibid., 8.

17. Marsh, *Memoir of the Centennial Exhibition*, 22, Joseph Downs Collection, Winterthur Museum, Garden & Library.

18. Brown, *Making Culture Visible*, 61.

19. Napoleon Sarony, Photographic Hall application no. 7182, 17 November 1875, RG 230, United States Centennial Commission, series 230.22, Bureau of Fine Arts, Applications for Spaces, box A-127, City of Philadelphia, Department of Records, City Archives.

20. "Making the Banner," *New York Times*, 2 July 1876, 7; "Centennial Tableaux," *Boston Daily Advertiser*, 7 July 1876, col. D; "Sarony's Centennial Tableaux," *Boston Daily Globe*, 28 July 1876, 4.

21. "Sarony's Centennial Tableaux," *Boston Daily Globe*, 28 July 1876, 4.

22. Bonner, *Star-Spangled Sentiment*, unpaginated.

23. Marling, *George Washington Slept Here*, 120.

24. Most of the artifacts pictured in *Sarony's Centennial Tableaux* are now in the collection of the New-York Historical Society. They include Washington's inaugural chair, 1785–89 (object no. 1916.7); Cornelius Kierstede, tankard owned by Abraham De Peyster, ca. 1700 (object no. 1911.39); and a case clock made by Asa Whitney, ca. 1798–1812 (object no. 1948.38).

25. Primary source descriptions of the De Peyster tankard include "A Glimpse of an Old Dutch Town," *Harper's New Monthly Magazine*, March 1881, 524–39, esp. 533; Earle, *Colonial Days in Old New York*, 111.

26. Schwartz, *Spectacular Realities*, 119.

27. Barthes, *Camera Lucida*, 5.

28. Cooper, "High Lights in Photography," 324.

29. Bassham, *Theatrical Photographs of Napoleon Sarony*, 13.

30. S. F. E., "At Sarony's."

31. Correspondence between Sarony and John Sartain suggests that the photographer bought this sculpture after d'Amore was unable to afford return shipping following the Centennial Exhibition. See Sarony to Sartain, n.d. (probably 1876–77), Bryn Mawr College Library, Special Collections, Rare Books and Manuscripts. This temple bell may be the one described in "The Tile Club Afloat," *Scribner's Monthly*, March 1880, 647.

32. Simmons, *Museums*, 84; Larwood, *History of Signboards*, 158.

33. See *Catalogue of Oil Paintings, Original Drawings* in the Archives of American Art at the Smithsonian Institution.

34. See Burns, *Inventing the Modern Artist*; Cikovsky, "William Merritt Chase's Tenth Street Studio"; Blaugrund, *Tenth Street Studio Building*; and John Davis, "William Merritt Chase's International Style," in Smithgall et al., *William Merritt Chase*, 47–60.

35. Blaugrund, *Tenth Street Studio Building*, 109.

36. Shelton, "Artist Life in New York," 34.

37. "Bob Ingersoll's Corner in Gods—What Is He Going to Do with Them?," *Los Angeles Herald*, 13 November 1878.

38. Burns, *Inventing the Modern Artist*, 67, 125–26.

39. Ibid., 68.

40. Miscellaneous unidentified and undated clippings related to the studio's move and opening can be found in Sarony's scrapbook, ca. 1871–77, Harvard Theatre Collection, Houghton Library, Harvard University.

41. "An Artistic Resort," unidentified clipping, n.d. [1877], ibid.

42. "The Tile Club at Work," *Scribner's Monthly*, January 1879, 72–73.

43. See Pisano, *Tile Club*.

44. Shelton, *Salmagundi Club*, 41–42.

45. Quoted in Burns, *Inventing the Modern Artist*, 127; see also John Davis's essay in Smithgall et al., *William Merritt Chase*, 58.

46. Becker, "Cabinet Cards"; Plunkett, "Carte-de-Visite."

47. "Retouching Frames," *Anthony's Photographic Bulletin*, March 1870, 12; see also "Patent Claims,"

Scientific American, 23 February 1867, 126–32, esp. 128.

48. White, "Morning at Sarony's."

49. Furniss, *Confessions of a Caricaturist*, 60.

50. "Our Picture: Some Interviews with Mr. Sarony," *Wilson's Photographic Magazine*, January 1893, 5–15 (quotation on 10).

51. David S. Shields, "Seeing the Stage," Broadway Photographs, https://broadway.library.sc.edu/content/seeing-stage.html.

52. Frohman, "Actress Aided by Camera."

53. Larson, *Scene Design in the American Theatre*, 12. For twentieth-century reactions to Daly's stage design, see Matthews, "Simplification of Stage Scenery," 361.

54. Huber, "Memories East."

55. Towler, "L. W. Seavey's Scenic Studio," in *Silver Sunbeam*, 602; "Trade Catalogs from La Fayette W. Seavey," 1800s, Smithsonian Libraries Trade Literature Collections, SILNMAHTL_18245, unpaginated. See also Pauwels, "José María Mora and the Migrant Surround."

56. Hartnoll and Found, "Joseph Jefferson." Online version (2003) available at https://doi.org/10.1093/acref/9780192825742.001.0001.

57. Benjamin Falk acquired the city street backdrop after Sarony's death in 1896 and used it in many of his studio's photographs, with his name painted in the place of his former mentor's.

58. Adams, *Dictionary of the Drama*, 471.

CHAPTER 6

1. Tennant, "Photographic Days," 131.

2. "Sarony's Living Pictures," *Chicago Journal of Commerce*, 21 March 1895, 28.

3. A. E. Chasmar, introduction to Sarony, *Sarony's Living Pictures: Photographed from Life*, 1.

4. Bassham, *Theatrical Photographs of Napoleon Sarony*, 20.

5. Greenberg, "Avant-Garde and Kitsch," in *Art and Culture*, 6.

6. Boylan, "Stop Using Kitsch as a Weapon," 42–55.

7. Daniels, "Sarony and His Customers."

8. See Newhall, *History of Photography*, 71; Gernsheim, *History of Photography*, 464.

9. "Napoleon Sarony," *New York Sun*, 13 November 1896, 7. See also Sarony, "Private Character of Artist's Models," 106–8; Bradshaw, "Nude in Art"; Germaine, "Trilby Demand"; "Models in Rebellion," *Washington Post*, 27 January 1895, 13.

10. On the history of *tableaux vivants*, see Nead, *Haunted Gallery*, 70–78.

11. "Many Inventions," *Times* (London), 7 July 1893, 3.

12. "On Peconic Bay," *New-York Tribune*, 25 June 1893, 8.

13. "Hot Wavelets," *York (PA) Daily*, 9 February 1894, 1.

14. "Nathan Hale—MacMonnies," *Brooklyn Daily Eagle*, 31 December 1893, 5.

15. "New Gallery," *Times* (London), 1 May 1893, 7.

16. "The Kinetograph," *American Journal of Photography*, July 1893, 333.

17. Ibid.

18. Faulk, *Music Hall and Modernity*, 157–59.

19. "Startling Tableaux These," *New York World*, 22 March 1894, 2.

20. Nead, *Haunted Gallery*, 73–74.

21. Gunning, "Cinema of Attractions"; see also Charney and Schwartz, *Cinema*.

22. Gunning, "Cinema of Attractions," 41.

23. See Bear, *Disillusioned*; Cook, *Art of Deception*; Harris, *Humbug*; Leja, *Looking Askance*.

24. Musser, "Cornucopia of Images," 34. See also McDonnell, *Edge of Your Seat*.

25. "Startling Tableaux These.

26. Musser, "Cornucopia of Images," 5.

27. Clarke, "How a Spectacular Is Produced," 290.

28. Reed, *Masterpieces of German Art*, 171.

29. "William E. Sheridan Dead," *New York Times*, 12 June 1887, 2.

30. Adams, Keene, and Koela, *Seeing the American Woman*, 74–75. See also Allen, *Horrible Prettiness*; Kibler, *Rank Ladies*.

31. In addition to *The Birth of the Pearl*, the American Mutoscope and Biograph Company catalogue includes four short films titled *Living Pictures*, which include subjects closely resembling illustrations from *Sarony's Living Pictures* magazine. These are *Living Pictures: By the Sea, and The Tempest* (1900) (Biograph production no. 1596); *Living Pictures: Faith, and The Morning Star* (1900) (Biograph production no. 1597). Niver, *Early Motion Pictures*, 30, 186. See also American Mutoscope and Biograph Company, *Biograph Photo Catalog*, vol. 4, production nos. 1503, 1596, 1597, 1599, and 1601.

32. See Millet, *Julian Alden Weir*.

33. Smith, "Around the Wood Fire," 160–62.

34. Mancini, *Pre-Modernism*, 62–97.

35. See also Bann, *Parallel Lines*; Batchen, "Double Displacement"; Snyder, "Making Photographs Public."

36. Taft, *Photography and the American Scene*, chap. 21.

37. See McFarland, "William Kurtz"; Hoffman, *Stieglitz*.

38. Whelan, *Alfred Stieglitz*, 103–6.

39. Ibid., 105.

40. Stieglitz, "Editorial Comment."

41. Photochrome Engraving Company, "Photographic Reproduction from Nature."

42. Norman, *Alfred Stieglitz: An American Seer*, 35–42; Thompson, "Stieglitz's Portfolios."

43. "Three-Color Process Business," *Anthony's Photographic Bulletin*, October 1895, 334.

44. Brooker and Hacker, *Oxford Critical and Cultural History*, 273.

45. Sekula, "Invention of Photographic Meaning," 458–59.

46. David A. Hanson Collection of the History of Photomechanical Reproduction, catalogue, p. 6, Special Collections, Sterling and Francine Clark Art Institute.

47. Norman, *Alfred Stieglitz: An American Seer*, 35.

48. *Catalogue of Oil Paintings, Original Drawings* (unpaginated), in the Archives of American Art, Smithsonian Institution.

49. Stieglitz, "American Photographic Salon," 194–95.

50. Willets, "Art of Not Posing," 188.

51. Humphrey, "Triumphs in Amateur Photography."

52. Stieglitz to O'Keeffe, 19 May 1932 and 17 May 1932, Alfred Stieglitz / Georgia O'Keeffe Archive, Yale Collection of American Literature, Beinecke Rare Book and Manuscript Library, Yale University.

53. Stieglitz to Anderson, 30 November 1925, in Greenough, *Alfred Stieglitz: The Key Set*, 1:xii.

54. Naef, *Collection of Alfred Stieglitz*, 30–32.

55. For reproductions of Stieglitz photographs that show the influence of popular American and European paintings and photography, see *Untitled*, in the *American Amateur Photographer* 6 (January 1894): 18; *Die Würfelspieler*, in *Der Amateur Photograph* 1 (March 1887), unpaginated; *Meditation*, in the *American Amateur Photographer* 4 (February 1892): 73; and *Peace*, in the *Photographic Times* 23 (21 July 1893), 391.

CONCLUSION

1. "Sarony: As Seen by His Contemporaries," *Wilson's Photographic Magazine*, February 1897, 69–75 (quotation on 74).

2. Wilson, "Our Picture," 14.

3. "Will of Sarony," *New York Sun*, 18 November 1896, 8.

4. David S. Shields, "Otto Sarony," Broadway Photographs, https://broadway.library.sc.edu/content/otto-sarony.html, and "Sarony, Studio," https://broadway.library.sc.edu/content/studio-sarony.html.

5. Jonathan Burrow transferred the business to his son Ernest Burrow in 1906. See "Ernest M. Burrow vs Theodore Marceau."

6. Stieglitz, "Origin of the Photo-Secession," 120.

7. Hartmann, *Valiant Knights of Daguerre*, 4–5.

8. David S. Shields, "Benjamin Falk," Broadway Photographs, https://broadway.library.sc.edu/content/benjamin-j-falk.html.

9. Hartmann, *Valiant Knights of Daguerre*, 227–33 (quotation on 228).

10. Ibid., 232.

11. "Manual of the Photographer's Association of America," *Anthony's Photographic Bulletin*, May 1895, 166.

12. Hartmann, "Death of Napoleon Sarony."

13. Hartmann, *Valiant Knights of Daguerre*, 233.

BIBLIOGRAPHY

ARCHIVAL SOURCES

Sarony's surviving correspondence and
other papers are not collected in any
one repository; instead, they are scat-
tered among several archives, including
the Bibliothèque et Archives natio-
nales in Quebec, the Folger Shake-
speare Library, the Bryn Mawr College
Library, the Houghton Library at Har-
vard University, the Library of Con-
gress, the Morgan Library and Museum
in New York, the Mark Twain Papers
at UC–Berkeley, and the University of
Pennsylvania Special Collections. The
negatives from Sarony's studio appear
to have been lost, but what remains of
his studio's collection of printed pho-
tographs was donated to Harvard Uni-
versity by Evert Jansen Wendell in 1918
and is held between the Harvard Fine
Arts Library and the Harvard Theatre
Collection in Houghton Library.

American Antiquarian Society, Worces-
 ter, MA, Graphic Arts Collections
Archives of American Art, Smithsonian
 Institution, Washington, DC
 *Catalogue of Oil Paintings, Origi-
 nal Drawings, Arms and Armor,
 Antiquities, Indian Relics, Curios,
 Etc. Etc., Property of Napoleon
 Sarony* (New York: Thomas

E. Kirby, Auctioneer / American
 Art Association, 1896). Ameri-
 can Art Auction Catalog Collec-
 tion, 1785–1962.
Kelly, James Edward. "Sarony, the
 Photographer." James Edward
 Kelly Papers.
Thomas, Henry Atwell. "The Late
 Napoleon Sarony: Sketch of His
 Life by a Relative and Former
 Pupil." 1896. Harriet Endicott
 Waite Papers.
Bibliothèque et Archives nationales du
 Québec
 Sarony's Bazaar catalogue,
 ca. 1830.
Bryn Mawr College Library, Special
 Collections, Rare Books and Man-
 uscripts, Bryn Mawr, PA
 Sarony, Napoleon, to John Sartain,
 n.d. (ca. 1876–77).
Folger Shakespeare Library, Washing-
 ton, DC
 Collins, Wilkie. Autograph letters,
 signed and initialed, to various
 people. London, 1877–89.
 Langtry, Lillie. Autograph let-
 ters, signed, to various people.
 1887–90.
 Sarony, Napoleon. Autograph let-
 ters, signed, to Augustin Daly.
 New York City, 1872–95.

Harvard Theatre Collection, Houghton
 Library, Harvard University, Cam-
 bridge, MA
 Napoleon Sarony scrapbook, ca.
 1871–77.
Library of Congress, Manuscript Divi-
 sion, Washington, DC
 Sarony, Napoleon, to Cora Linn
 Daniels, 1883. Napoleon Sarony
 Correspondence, Miscellaneous
 Manuscript Collection.
 Sarony, Napoleon, to Fran-
 ces Benjamin Johnston, 4 Feb-
 ruary 1893. Box 4, microfilm
 reels 3–4, Frances Benjamin
 Johnston Papers—General
 Correspondence.
Morgan Library and Museum, New
 York, NY
 Sarony, Napoleon, to Harper
 Brothers Publishing, 4 April
 1890.
National Portrait Gallery, London,
 Camille Silvy Collection
 Album Daybooks, vols. 1–12, 1860.
Quebec Cathedral Anglicane, Quebec
 Vital and Church Records, Drouin
 Collection
Saints Peter and Paul Catholic Church,
 Brooklyn, NY, Wedding Records
Sterling and Francine Clark Art Insti-
 tute, Williamstown, MA, David A.

Hanson Collection of the History of Photomechanical Reproduction

Mark Twain Papers, Bancroft Library, University of California, Berkeley
 Sarony, Napoleon. Letters to Samuel Clemens.

Westchester County Archives, Elmsford, NY, Westchester County Land Records

Winterthur Museum, Garden & Library, Winterthur, DE
 Marsh, E. S. *Memoir of the Centennial Exhibition of 1876*, 1876–77. Centennial Exhibition Collection, 1874–1878, Joseph Downs Collection of Manuscripts and Printed Ephemera.

University of Pennsylvania, Special Collections, Philadelphia, PA
 Sarony, Napoleon, to Ada Rehan, n.d. (1890s).

Yale University, Beinecke Rare Book and Manuscript Library, New Haven, CT, Yale Collection of American Literature

PUBLISHED SOURCES

Adams, Katherine H., Michael L. Keene, and Jennifer Koela. *Seeing the American Woman, 1880–1920: The Social Impact of the Visual Media Explosion*. London: McFarland, 2012.

Adams, William Davenport. *A Dictionary of the Drama*. Vol. 1. London: Chatto & Windus, 1904.

Adorno, Theodor W. "Culture Industry Reconsidered." In *The Culture Industry: Selected Essays on Mass Culture*, edited by J. M. Bernstein, 98–106. London: Routledge, 2001.

Allen, Robert C. *Horrible Prettiness: Burlesque and American Culture*. Chapel Hill: University of North Carolina Press, 1991.

American Mutoscope and Biograph Company. *Biograph Photo Catalog*.

Vol. 4, nos. 1503–2002. https://doi.org/doi:10.7282/T37M088C.

"An Artist Photographer." *Home Journal*, 7 October 1871, 4.

Averill, Gage. "Close Harmony Singing." In *Continuum Encyclopedia of Popular Music of the World, Part One: Performance and Production*, edited by David Horn, John Shepherd, Michael Seed, and Dave Laing, 2:122–25. New York: Bloomsbury Academic, 2003.

Azoulay, Ariella. *The Civil Contract of Photography*. Translated by Rela Mazali and Ruvik Danieli. New York: Zone Books, 2008.

Bacha, Oren. *Owning Ideas: The Intellectual Origins of American Intellectual Property, 1790–1909*. Cambridge: Cambridge University Press, 2016.

Baker, William, Andrew Gasson, Graham Law, and Paul Lewis, eds. *The Public Face of Wilkie Collins: The Collected Letters*. 4 vols. London: Pickering & Chatto, 2005.

Bakhtin, Mikhail. *Rabelais and His World*. Translated by Helene Iswolsky. Bloomington: Indiana University Press, 1984.

Bann, Stephen. *Parallel Lines: Printmakers, Painters, and Photographers in Nineteenth-Century France*. New Haven: Yale University Press, 2001.

Barnhill, Georgia B. "French Technology and Skills in the United States." In Barnhill, *With a French Accent*, 15–32.

———, ed. *With a French Accent: American Lithography to 1860*. Worcester, MA: American Antiquarian Society, 2012. Exhibition catalogue.

Barnhill, Georgia B., Diana Korzenik, and Caroline Sloat, eds. *The Cultivation of Artists in Nineteenth-Century America*. Worcester, MA: American Antiquarian Society, 1997.

Barthes, Roland. *Camera Lucida: Reflections on Photography*. New York: Hill and Wang, 1980.

Bassham, Ben L. *The Theatrical Photographs of Napoleon Sarony*. Kent: Kent State University Press, 1978.

Batchen, Geoffrey. *Burning with Desire: The Conception of Photography*. Cambridge: MIT Press, 1997.

———. "Double Displacement: Photography and Dissemination." In Gervais, *"Public" Life of Photographs*, 39–73.

Bayliss, Anne, and Paul Bayliss. *Photographers in Mid-Nineteenth-Century Scarborough: The Sarony Years—A History and Dictionary*. Scarborough, UK: A. M. Bayliss, 1998.

Bear, Jordan. *Disillusioned: Victorian Portraiture and the Discerning Subject*. University Park: Penn State University Press, 2015.

Becker, William B. "Cabinet Cards." In Hannavy, *Encyclopedia of Nineteenth-Century Photography*, 233–34.

Begley, Adam. *The Great Nadar: The Man Behind the Camera*. New York: Tim Duggan Books, 2017.

Bellion, Wendy. *Citizen Spectator: Art, Illusion, and Visual Perception in Early National America*. Chapel Hill: University of North Carolina Press, 2011.

Benjamin, Walter. *The Arcades Project*. Edited by Rolf Tiedemann. Translated by Howard Eiland and Kevin McLaughlin. Cambridge: Harvard University Press, 1999.

———. "Little History of Photography." 1931. Reprinted in *Walter Benjamin: Selected Writings*, vol. 2, part 2, *1931–1934*, 507–30. Cambridge: Harvard University Press, 2005.

Bennett, Tony. "The Exhibitionary Complex." *New Formations* 4 (Spring 1988): 73–102.

Bently, Lionel, and Martin Kretschmer, eds. *Primary Sources on Copyright*

(1450–1900). Cambridge: University of Cambridge Faculty of Law, and CREATe, University of Glasgow School of Law, 2008. http://www.copyrighthistory.org.

Blaugrund, Annette. *The Tenth Street Studio Building*. Seattle: University of Washington Press, 1997. Exhibition catalogue.

Bochner, Jay. *An American Lens: Scenes from Alfred Stieglitz's New York Secession*. Cambridge: MIT Press, 2005.

Bolger Burke, Doreen. *In Pursuit of Beauty: Americans and the Aesthetic Movement*. New York: Metropolitan Museum of Art/Rizzoli, 1986. Exhibition catalogue.

Bonner, Robert E. "Star-Spangled Sentiment." *Common-Place* 3, no. 2 (2003). http://web.archive.org/web/20030627093241/www.historycooperative.org/journals/cp/vol-03/no-02/bonner/.

Boorstin, Daniel. *The Image: A Guide to Pseudo-Events in America*. 1961. New York: Knopf, 2012.

Bowersox, A. L. "Photographers at Home and Abroad." *Photographic Times and American Photographer* 25 (August 1894): 148–49.

Boxer, Sarah. "A Century's Photo History Destined for Life in a Mine." *New York Times*, 15 April 2001.

Boylan, Alexis L. "Stop Using Kitsch as a Weapon: Kitsch and Racism." *Rethinking Marxism: A Journal of Economics, Culture, and Society* 22, no. 1 (2012): 42–55.

Bradshaw, William R. "The Nude in Art: An Interview with Napoleon Sarony." *Decorator and Furnisher*, June 1895, 91–93.

Braudy, Leo. *The Frenzy of Renown: Fame and Its History*. New York: Vintage Books, 1997.

Brilliant, Richard. *Portraiture*. London: Reaktion Books, 1991.

Brooker, Peter, and David Hacker, eds. *The Oxford Critical and Cultural History of Modernist Magazines*. Vol. 2. Oxford: Oxford University Press, 2009.

Brooks, Daphne. *Bodies in Dissent: Spectacular Performances of Race and Freedom, 1850–1910*. Durham: Duke University Press, 2006.

Brooks, Van Wyck. "On Creating a Usable Past." *Dial*, 11 April 1918, 337–41.

Brown, Joshua. *Beyond the Lines: Pictorial Reporting, Everyday Life, and the Crisis of Gilded Age America*. Berkeley: University of California Press, 2006.

Brown, Julie K. *Making Culture Visible: The Public Display of Photography at Fairs, Expositions, and Exhibitions in the United States, 1847–1900*. New York: Routledge, 2018.

Brownell, William C. "The Younger Painters of America." *Scribner's Monthly*, May 1880, 2.

Brust, James, and Wendy Shadwell. "The Many Versions and States of *The Awful Conflagration of the Steam Boat Lexington*." *Imprint* 15, no. 2 (1990): 2–13.

Bunnell, Peter C., ed. *A Photographic Vision: Pictorial Photography, 1889–1923*. Salt Lake City: Peregrine Smith, 1980.

Burgess, N. G. "Taking Portraits After Death." *Photographic and Fine-Art Journal* 8, no. 3 (1855): 80.

Burns, Sarah. *Inventing the Modern Artist: Art and Culture in Gilded Age America*. Berkeley: University of California Press, 1996.

Burns, Sarah, and John Davis. *American Art to 1900: A Documentary History*. Berkeley: University of California Press, 2009.

Buszek, Maria Elena. *Pin-Up Grrrls: Feminism, Sexuality, Popular Culture*. Durham: Duke University Press, 2006.

Carr, Lyell. "A Dream Painter." *Quarterly Illustrator* 2, no. 8 (1894): 372–76.

Charney, Leo, and Vanessa R. Schwartz, eds. *Cinema and the Invention of Modern Life*. Berkeley: University of California Press, 1995.

Cikovsky, Nicolai, Jr. "William Merritt Chase's Tenth Street Studio." *Archives of American Art Journal* 16, no. 2 (1976): 2–14.

Clark, Ronald. *Edison: The Man Who Made the Future*. New York: Putnam, 1977.

Clarke, Redfield. "How a Spectacular Is Produced." *Godey's Magazine*, March 1895, 280–90.

Cohen, Joanna. *Luxurious Citizens: The Politics of Consumption in Nineteenth-Century America*. Philadelphia: University of Pennsylvania Press, 2017.

Cohen, Julie E., Lydia Pallas Loren, Ruth L. Okediji, and Maureen A. O'Rourke. *Copyright in a Global Information Economy*. 5th ed. Philadelphia: Wolters Kluwer, 2019.

Coleman, A. D. "The Directorial Mode: Notes Toward a Definition." In Goldberg, *Photography in Print*, 480–91.

Cook, James W. *The Art of Deception: Playing with Fraud in the Age of Barnum*. Cambridge: Harvard University Press, 2001.

Cooper, John. "The Sarony Photographs of Oscar Wilde." Oscar Wilde in America: A Selected Resource of Oscar Wilde's Visits to America. https://www.oscarwildeinamerica.org/sarony/sarony-photographs-of-oscar-wilde-1882.html.

Cooper, W. A. "A Few Words About Sarony." *Wilson's Photographic Magazine*, February 1897, 68–69.

———. "High Lights in Photography, No. 4: Napoleon Sarony."

Photo-American 5 (September 1894): 323–27.

———. "Sarony." *Wilson's Photographic Magazine*, February 1897, 64–68.

Coquelin, Constant, Henry Irving, and Dion Boucicault. *The Art of Acting*. New York: Dramatic Museum of Columbia University, 1926.

Cordell, Ryan. "Reprinting, Circulation, and the Network Author in Antebellum Newspapers." *American Literary History* 27, no. 3 (2015): 417–45.

Crackle, Nym. "Round About the Kit Kat." *Quarterly Illustrator* 2, no. 8 (1894): 361–71.

Daniels, Cora Linn. "Sarony and His Customers—Photographing Famous Persons." *New York Times*, 19 May 1881.

Day, F. Holland. "Art and the Camera." *Camera Notes* 1, no. 2 (1897): 27–28.

Debord, Guy. *Society of the Spectacle*. Translated by Fredy Perlman. Detroit: Black & Red, 1967.

Delamaire, Marie-Stéphanie, and Will Slauter, eds. *Circulation and Control: Artistic Culture and Intellectual Property in the Nineteenth Century*. Cambridge: Open Book, 2021.

Deleuze, Gilles, and Félix Guattari. *A Thousand Plateaus: Capitalism and Schizophrenia*. Translated by Brian Massumi. London: Continuum 2004.

Demastes, William W., ed. *Realism and the American Dramatic Tradition*. Tuscaloosa: University of Alabama Press, 1996.

Derrida, Jacques. *Archive Fever: A Freudian Impression*. Translated by Eric Prenowitz. Chicago: University of Chicago Press, 1996.

———. *Copy, Archive, Signature: A Conversation on Photography*. Translated by Jeff Fort. Stanford: Stanford University Press, 2010.

———. *Limited, Inc*. Edited by Gerald Graff. Translated by Jeffrey Mehlman and Samuel Weber. Evanston: Northwestern University Press, 1988.

———. *Right of Inspection*. Translated by David Wills. New York: Monacelli Press, 1998.

Disdéri, A. A. E. "The Aesthetics of Photography, Continued." *Humphrey's Journal*, 15 September 1863, 155.

Dodge, Mary B. "In Sarony's Studio." *House Journal*, 1 May 1872, 11.

Dyer, Richard. *Stars*. London: British Film Institute, 1979.

Earle, Alice Morse. *Colonial Days in Old New York*. New York: Scribner, 1896.

Edelman, Bernard. *Ownership of the Image: Elements for a Marxist Theory of Law*. New York: Routledge & Kegan Paul, 1979.

Edwards, Steve. *The Making of English Photography: Allegories*. University Park: Penn State University Press, 2005.

Elkins, James. "Art History and Images That Are Not Art." *Art Bulletin* 77, no. 4 (1995): 553–71.

———. *What Photography Is*. New York: Routledge, 2011.

Erffa, Helmut von, and Allen Staley. *The Paintings of Benjamin West*. New Haven: Yale University Press, 1986.

"Ernest M. Burrow vs Theodore Marceau and Otto Sarony Company." In New York Bar Association, *Supreme Court of the State of New York, Appellate Division-First Department*, 1–20. New York: Martin B. Brown, 1907.

Faulk, Barry J. *Music Hall and Modernity: The Late-Victorian Discovery of Popular Culture*. Athens: Ohio University Press, 2004.

Fineman, Mia. *Faking It: Manipulated Photography Before Photoshop*. New

Haven: Yale University Press, 2012. Exhibition catalogue.

Fisher, James. *Historical Beginnings of the American Theater*. Lanham, MD: Rowman and Littlefield, 2015.

Frohman, Daniel. "Actress Aided by Camera." *Cosmopolitan*, February 1897, 413.

Furniss, Harry. *The Confessions of a Caricaturist*. Vol. 2. New York: Harper & Brothers, 1902.

Gaines, Jane. *Contested Culture: The Image, the Voice, and the Law*. Chapel Hill: University of North Carolina Press, 1991.

Garbutt, W. H., and E. C. Middleton. "The History of Photography in Birmingham." *Photogram*, May 1900, 164–68.

Gayler, Charles. "Half a Century Since." *Frank Leslie's Popular Monthly*, November 1892, 533–44.

Germaine, Harry. "The Trilby Demand." *Chicago Daily Inter-Ocean*, 2 June 1895.

Gernsheim, Helmut. *A Concise History of Photography*. Toronto: General Publishing, 1986.

Gernsheim, Helmut, and Alison Gernsheim. *The History of Photography*. London: McGraw-Hill, 1969.

Gervais, Thierry, ed. *The "Public" Life of Photographs*. Cambridge: MIT Press, 2016.

Giberti, Bruno. *Designing the Centennial: A History of the 1876 International Exhibition in Philadelphia*. Lexington: University Press of Kentucky, 2002.

Gilder, Joseph Benson. "The Month in Literature, Art, and Life." *Critic* 1, no. 1 (1897): 23–24.

Glass, Loren. *Authors Inc.: Literary Celebrity in the Modern United States, 1880–1980*. New York: New York University Press, 2004.

Glenn, Susan. *Female Spectacle: The Theatrical Roots of Modern Feminism*.

Cambridge: Harvard University Press, 2000.

Gold, Susanna W. *The Unfinished Exhibition: Visualizing Myth, Memory, and the Shadow of the Civil War in Centennial America.* New York: Routledge, 2017.

Goldberg, Vicki, ed. *Photography in Print.* Albuquerque: University of New Mexico Press, 1981.

Goldstein, Robert Justin. *Censorship of Political Caricature in Nineteenth-Century France.* Kent: Kent State University Press, 1989.

Greenberg, Clement. *Art and Culture: Critical Essays.* Boston: Beacon Press, 1989.

Green-Lewis, Jennifer. *Framing the Victorians: Photography and the Culture of Realism.* Ithaca: Cornell University Press, 1996.

Greenough, Sarah, ed. *Alfred Stieglitz: The Key Set.* 2 vols. New York: Harry N. Abrams, 2002.

Grimes, William. *Appetite City: A Culinary History of New York.* New York: Macmillan, 2009.

Gruber-Garvey, Ellen. *Writing with Scissors: American Scrapbooks from the Civil War to the Harlem Renaissance.* Oxford: Oxford University Press, 2012.

Gunning, Tom. "The Cinema of Attractions: Early Film, Its Spectator, and the Avant-Garde." In *Theatre and Film: A Comparative Anthology,* edited by Robert Knopf, 37–45. New Haven: Yale University Press, 2008.

Gunthert, André. "La conquête de l'instantané: Archéologie de l'imaginaire photographie en France (1841–1895)." PhD diss., École des hautes études en sciences sociales, Paris, 1999.

Haltunnen, Karen. *Confidence Men and Painted Women: A Study of Middle-Class Culture in America,* 1830–1870. New Haven: Yale University Press, 1986.

Hannavy, John, ed. *Encyclopedia of Nineteenth-Century Photography.* New York: Taylor & Francis, 2008.

Harris, Mazie M. *Paper Promises: Early American Photography.* Los Angeles: J. Paul Getty Museum, 2018.

Harris, Neil. *Humbug: The Art of P. T. Barnum.* Chicago: University of Chicago Press, 1973.

Hartmann, Sadakichi. "The Death of Napoleon Sarony." *Tatler,* 10 November 1896, 4.

———. *The Valiant Knights of Daguerre: Selected Critical Essays on Photography and Profiles of Photographic Pioneers.* Edited by Harry W. Lawton and George Knox. Berkeley: University of California Press, 1978.

Hartnoll, Phyllis, and Peter Found. "Joseph Jefferson." In *The Concise Oxford Companion to the Theatre,* edited by Phyllis Hartnoll and Peter Found. 2nd ed. Oxford: Oxford University Press, 1996.

Hewes, Lauren B. "French Lithographic Prints: Very Beautiful." In Barnhill, *With a French Accent,* 33–47.

Hoffman, Katherine. *Stieglitz: A Beginning Light.* New Haven: Yale University Press, 2004.

Hoganson, Kristin. *Consumer's Imperium: The Global Production of American Domesticity, 1865–1920.* Chapel Hill: University of North Carolina Press, 2007.

Huber, Babette. "Memories East: Victor's Old Wagon Shop." *Rochester Democrat and Chronicle,* 27 January 2012.

Humphrey, Marmaduke. "Triumphs in Amateur Photography, I—Alfred Stieglitz." *Godey's Magazine,* December 1897, 584.

Huntington, David C. *The Quest for Unity: American Art Between the World's Fairs, 1876–1893.* Detroit: Detroit Institute of Arts, 1983. Exhibition catalogue.

"In the Studio." *Harper's Monthly Magazine,* May 1872, 892–94.

Jaffee, David. "'One of the Primitive Sort': Portrait Makers of the Rural North, 1790–1860." In *The Countryside in the Age of Capitalist Transformation,* edited by Steven Hahn and Jonathan Prude, 103–40. Chapel Hill: University of North Carolina Press, 1985.

James, William. *The Principles of Psychology.* Vol. 1. New York: Henry Holt, 1890.

Kaplan, Louis. *The Strange Case of William Mumler, Spirit Photographer.* Minneapolis: University of Minnesota Press, 2008.

Kaplan, Wendy, ed. *The Arts and Crafts Movement in Europe and America: Design for the Modern World.* Los Angeles: LACMA, 2004. Exhibition catalogue.

Karel, David. "Silvestre Laroche." In *Dictionnaire des artistes de langue française en Amérique du Nord,* 465. Quebec City: Musée du Québec Presses de l'Université Laval, 1992.

Kasson, John. *Rudeness and Civility: Manners in Nineteenth-Century Urban America.* New York: Hill and Wang, 1990.

Kennel, Sarah. *Charles Marville: Photographer of Paris.* Washington, DC: National Gallery of Art, 2013. Exhibition catalogue.

Kibler, M. Alison. *Rank Ladies: Gender and Cultural Hierarchy in American Vaudeville.* Chapel Hill: University of North Carolina Press, 2005.

Knoper, Randall. *Acting Naturally: Mark Twain in the Culture of Performance.* Berkeley: University of California Press, 1995.

Krauss, Rosalind. *The Originality of the Avant-Garde and Other Modernist*

Myths. Cambridge: MIT Press, 1985.

Lambert-Beatty, Carrie. "Parafiction: Make-Believe and Plausibility." *October* 29 (Summer 2009): 51–84.

Larson, Orville K. *Scene Design in the American Theatre from 1915 to 1960*. Fayetteville: University of Arkansas Press, 1985.

Larwood, Jacob. *The History of Signboards: From the Earliest Times to the Present Day*. London: John Camden Hotten, 1867.

Last, Jay T. *The Color Explosion: Nineteenth-Century American Lithography*. Santa Ana: Hillcrest Press, 2005.

Latour, Bruno. *Reassembling the Social: An Introduction to Actor-Network Theory*. Oxford: Oxford University Press, 2005.

———. "Visualization and Cognition: Drawing Things Together." *Knowledge and Society* 6 (1986): 1–40.

Latournerie, Anne. "Petite histoire des batailles du droit d'auteur." *Multitudes* 2, no. 2 (2001): 37–62.

Lears, T. J. Jackson. *No Place of Grace: Antimodernism and the Transformation of American Culture, 1880–1920*. Chicago: University of Chicago Press, 1981.

LeBeau, Bryan F. *Currier and Ives: America Imagined*. Washington, DC: Smithsonian Books, 2002.

Leblanc de Marconnay, Hyacinthe-Poirier. "Napoléon Sarony." *Le populaire: Journal des intérêts canadiens* 74 (27 September 1837): 3–4.

Leja, Michael. "Fortified Images for the Masses." *Art Journal* 70, no. 4 (2011): 60–83.

———. "Issues in Early Mass Visual Culture." In *A Companion to American Art*, edited by John Davis, Jennifer A. Greenhill, and Jason D. LaFountain, 505–24. West Sussex: Wiley-Blackwell, 2015.

———. *Looking Askance: Skepticism and American Art from Eakins to Duchamp*. Berkeley: University of California Press, 2004.

———. "News Pictures in the Early Years of Mass Visual Culture in New York: Lithographs and the Penny Press." In *Getting the Picture: The Visual Culture of the News*, edited by Jason E. Hill and Vanessa Schwartz, 146–53. London: Bloomsbury Press, 2015.

Leonardi, Nicoletta, and Simone Natale. *Photography and Other Media in the Nineteenth Century*. University Park: Penn State University Press, 2018.

Lepler, Jessica. *The Many Panics of 1837*. Cambridge: Cambridge University Press, 2013.

Lerner, Jillian. "Nadar's Signatures: Caricature, Self-Portrait, Publicity." *History of Photography* 41, no. 2 (2017): 108–25.

Levine, Lawrence. *Highbrow/Lowbrow: The Emergence of Cultural Hierarchy in America*. Cambridge: Harvard University Press, 1990.

Love, Heather. "Close But Not Deep: Literary Ethics and the Descriptive Turn." *New Literary History* 41, no. 2 (2010): 371–91.

Mainardi, Patricia. "Copies, Variation, Replicas: Nineteenth-Century Studio Practice." *Visual Resources* 15, no. 2 (1999): 123–47.

Mancini, J. M. *Pre-Modernism: Art-World Change and American Culture from the Civil War to the Armory Show*. Princeton: Princeton University Press, 2005.

Marcus, Sharon. *The Drama of Celebrity*. Princeton: Princeton University Press, 2019.

Marling, Karal Ann. *George Washington Slept Here: Colonial Revivals and American Culture, 1876–1986*. Cambridge: Harvard University Press, 2013.

Marshall, P. David. *Celebrity and Power: Fame in Contemporary Culture*. Minneapolis: University of Minnesota Press, 1997.

Marzio, Peter. "Illustrated News in Early American Prints." In *American Printmaking Before 1876: Fact, Fiction, and Fantasy*, 53–60. Washington, DC: Library of Congress, 1975.

Mathews, Nancy Mowll, ed. *Moving Pictures: American Art and Early Film, 1890–1910*. Manchester, VT: Hudson Hills Press, 2005. Exhibition catalogue.

Matthews, Brander. "The Simplification of Stage Scenery." *Unpopular Review* 11, no. 22 (1919): 350–63.

McArthur, Benjamin. *Actors and American Culture, 1880–1920*. Iowa City: University of Iowa Press, 2000.

McCandless, Barbara. "The Portrait Studio and the Celebrity: Promoting the Art." In *Photography in Nineteenth-Century America*, edited by Martha Sandweiss, 48–75. Fort Worth: Amon Carter Museum, 1991. Exhibition catalogue.

McCauley, Elizabeth Anne. *A. A. E. Disdéri and the Carte de Visite Portrait Photograph*. New Haven: Yale University Press, 1985.

———. *Industrial Madness: Commercial Photography in Paris, 1848–1871*. New Haven: Yale University Press, 1994.

———. "'Merely Mechanical': On the Origins of Photographic Copyright in France and Great Britain." *Art History* 31, no. 1 (2008): 57–78.

McDonnell, Patricia. *On the Edge of Your Seat: Popular Theater and Film in Early Twentieth-Century American Art*. New Haven: Yale University Press, 2002.

McFarland, J. Horace. "William Kurtz: Artist, Illustrator, Investigator." *Inland Printer* 15, no. 3 (1895): 265–67.

McLean, Adrienne. *Being Rita Hayworth: Labor, Identity, and Hollywood Stardom*. New Brunswick: Rutgers University Press, 2004.

McLuhan, Marshall. *Understanding Media*. London: Routledge, 2001.

McPhate, Mike. "With Corbis Sale, Tiananmen Protest Images Go to Chinese Media Company." *New York Times*, 27 January 2016.

Mendelssohn, Michèle. *Making Oscar Wilde*. Oxford: Oxford University Press, 2018.

Millet, Josiah B. *Julian Alden Weir: An Appreciation of His Life and Works*. New York: Century Association, 1921.

Mullenix, Elizabeth Reitz. *Wearing the Breeches: Gender on the Antebellum Stage*. New York: St. Martin's Press, 2000.

Mumford, Lewis. *The Brown Decades: A Study of the Arts in America, 1865–1895*. New York: Harcourt, Brace, 1931.

Murphy, Brenda. *American Realism and American Drama, 1880–1940*. Cambridge: Cambridge University Press, 1987.

Musser, Charles. "A Cornucopia of Images: Comparison and Judgment Across Theater, Film, and the Visual Arts During the Late Nineteenth Century." In Mathews, *Moving Pictures*, 5–37.

Myers, Robin, Michael Harris, and Giles Mandelbrote, eds. *Owners, Annotators, and the Signs of Reading*. London: British Library, 2005.

Nadar [Gaspard-Félix Tournachon]. *When I Was a Photographer*. 1900. Translated by Eduardo Cadava and Liana Theodoratou. Cambridge: MIT Press, 2015.

Naef, Weston. *The Collection of Alfred Stieglitz: Fifty Pioneers of Modern Photography*. New York: Viking Press, 1978.

———. *In Focus: Alfred Stieglitz*. Los Angeles: J. Paul Getty Museum, 1995.

Nead, Lynda. *The Haunted Gallery: Painting, Photography, and Film Around 1900*. New Haven: Yale University Press, 2008.

Newhall, Beaumont. *The Daguerreotype in America*. New York: Dover, 1976.

———. *The History of Photography*. New York: Museum of Modern Art, 1949.

Niver, Kemp R. *Early Motion Pictures: The Paper Print Collection in the Library of Congress*. Washington, DC: Library of Congress, 1985.

Norman, Dorothy. *Alfred Stieglitz: An American Seer*. New York: Aperture, 1973.

Orcutt, Kimberly. *Power and Posterity: American Art at Philadelphia's 1876 Centennial Exhibition*. University Park: Penn State University Press, 2017.

Orvell, Miles. *The History of Photography: From 1839 to the Present*. New York: Museum of Modern Art, 1982.

———. *The Real Thing: Imitation and Authenticity in American Culture, 1880–1940*. Chapel Hill: University of North Carolina Press, 1989.

Paine, Alfred Bigelow. *Mark Twain: A Biography*. Vol. 2. New York: Harper, 1912.

———, ed. *Mark Twain's Letters*. Vol. 2. New York: Harper & Brothers, 1917.

Panetta, Roger G. *Westchester: The American Suburb*. New York: Fordham University Press, 2006.

Pauli, Lori. *Acting the Part: Photography as Theatre*. New York: Merrell, 2006.

———, ed. *Oscar G. Rejlander: Artist Photographer*. New Haven: Yale University Press, 2018.

Pauwels, Erin. "José María Mora and the Migrant Surround in American Portrait Photography." *Panorama: The Journal of the Association of American Art Historians* 6, no. 2 (2020). https://doi.org/10.24926/24716839.10613.

———. "'Let Me Take Your Head': Photographic Portraiture and the Gilded Age Celebrity Image." In *Beyond the Face: New Perspectives on Portraiture*, edited by Wendy Wick Reaves, 136–55. Washington, DC: National Portrait Gallery, Smithsonian Institution, 2018.

———. "Resetting the Camera's Clock: Sarony, Muybridge, and the Aesthetics of Wet-Plate Photography." *History and Technology* 31, no. 4 (2015): 482–91.

Pemberton, T. Edgar. *The Birmingham Theatres: A Local Retrospect*. Birmingham, UK: Cornish Brothers, 1890.

Perry, Matthew Calbraith, George Jones, and Francis L. Hawks. *Narrative of the Expedition of an American Squadron to the China Seas and Japan. . . .* Vol. 1. Washington, DC: A. O. P. Nicholson, 1856.

Peters, Harry T. *America on Stone: The Other Printmakers to the American People*. New York: Arno Press, 1976.

———. *Currier and Ives: Printmakers to the American People*. Garden City: Doubleday, Doran, 1929.

Photochrome Engraving Company. "Photographic Reproduction from Nature." *American Amateur Photographer* 6 (December 1894): 536.

"Photography as a Hindrance and a Help to Art." *British Journal of Photography* 38 (8 May 1891): 294–96.

"Photography in the Great Exhibition." *Philadelphia Photographer* 8 (June 1876): 182–86.

Piola, Erika. *Philadelphia on Stone: Commercial Lithography in Philadelphia,*

1828–1878. University Park: Penn State University Press, 2012.

Pisano, Ronald G. *The Tile Club and the Aesthetic Movement in America*. New York: Harry N. Abrams, 1999.

Plunkett, John. "Carte-de-Visite." In Hannavy, *Encyclopedia of Nineteenth-Century Photography*, 276–77.

———. "Mayall, John Jabez Edwin." In Hannavy, *Encyclopedia of Nineteenth-Century Photography*, 907.

Poe, Edgar Allan. "A Chapter on Autography." In *Complete Works of Edgar Allan Poe*, edited by Nathan Haskell Dole, 10:46–129. New York: Williams-Barker, 1908.

Post, Robert C., ed. *1876: A Centennial Exhibition*. Washington, DC: National Museum of History and Technology, 1976.

Prodger, Philip. *Time Stands Still: Muybridge and the Instantaneous Photography Movement*. New York: Oxford University Press, 2003. Exhibition catalogue.

R. A. S. "About Some Photographic Ghost Stories." *British Journal of Photography* 10 (1 January 1863): 14–16.

Rasmussen, R. Kent, ed. *Dear Mark Twain: Letters from His Readers*. Berkeley: University of California Press, 2013.

Raymer, Felix. *Photo Lighting: A Treatise on Light and Its Effect Under the Skylight*. St. Louis: H. A. Hyatt, 1902.

Reed, J. Eugene. *The Masterpieces of German Art Illustrated: Being a Biographical History of Art in Germany and the Netherlands, from the Earliest Period to the Present Time*. Philadelphia: Gebbie & Co., 1884.

Reilly, Bernard. *American Political Prints, 1766–1876: A Catalog of the Collections in the Library of Congress*. Boston: G. K. Hall, 1991.

Rinhart, Floyd, and Marion Rinhart. *American Daguerreian Art*. New York: Crown, 1967.

Roach, Joseph. *It*. Ann Arbor: University of Michigan Press, 2007.

Roberts, Jennifer L. "The Veins of Pennsylvania: Benjamin Franklin's Nature-Print Currency." *Grey Room* 69 (Fall 2017): 50–79.

Robertson, Michael. *Stephen Crane, Journalism, and the Making of Modern American Literature*. New York: Columbia University Press, 1997.

Robinson, Henry Peach. *The Elements of a Pictorial Photograph*. London: Lund, 1896.

———. *Pictorial Effect in Photography, Being Hints on Composition and Chiaroscuro for Photographers*. London: Piper and Carter, 1869.

Robinson, Marc. *The American Play: 1787–2000*. New Haven: Yale University Press, 2009.

Rohrbach, John, ed. *Acting Out: Cabinet Cards and the Making of Modern Photography*. Berkeley: University of California Press, 2020. Exhibition catalogue.

Rojek, Chris. *Celebrity*. London: Reaktion Books, 2001.

Root, Marcus Aurelius. *The Camera and the Pencil; or, The Heliographic Art*. Philadelphia: J. B. Lippincott, 1864.

Roy, Pierre-Georges. "Le merchand Adolphus Saroni." In *Toutes petites choses du régime anglais*, 222–23. Quebec City: Éditions Garneau, 1946.

Sandage, Scott A. *Born Losers: A History of Failure in America*. Cambridge: Harvard University Press, 2006.

Sarony, Napoleon. "Private Character of Artists' Models." *American Annual of Photography and Photographic Times Almanac* 9 (1895): 106–9.

———. *Sarony's Living Pictures: Photographed from Life*. New York: A. E. Chasmar, 1894–95.

Scharf, Aaron. *Art and Photography*. New York: Penguin, 1983.

Scharnhorst, Gary, ed. *Mark Twain: The Complete Interviews*. Tuscaloosa: University of Alabama Press, 2006.

Schwartz, Vanessa R. *Spectacular Realities: Early Mass Culture in Fin-de-Siècle Paris*. Berkeley: University of California Press, 1999.

Scranton, Philip. *Endless Novelty: Specialty Production and American Industrialization, 1865–1925*. Princeton: Princeton University Press, 2018.

Seavey, Lafayette W. "Backgrounds: A Review." In *Photographic Mosaics: An Annual Record of Photographic Progress*, edited by Edward L. Wilson, 106–7. Philadelphia: Edward L. Wilson, 1878.

———. "How to Use Photographic Backgrounds." *Scientific American*, 2 December 1876, 782.

Sekula, Allan. "On the Invention of Photographic Meaning." In Goldberg, *Photography in Print*, 452–73.

———. *Photography Against the Grain: Essays and Photo Works, 1973–1983*. Halifax: Press of the Nova Scotia College of Art and Design, 1984.

Senelick, Laurence. *Theatre Arts on Acting*. New York: Routledge, 2013.

Sentilles, Renée. *Performing Menken: Adah Isaacs Menken and the Birth of American Celebrity*. Cambridge: Cambridge University Press, 2003.

Seymour, R. A. "Posing and Grouping." *Illustrated Photographer*, 7 February 1868, 10.

S. F. E. "At Sarony's." *Boston Evening Transcript*, 1 March 1872.

Sheehan, Tanya. *Doctored: The Medicine of Photography in Nineteenth-Century America*. University Park: Penn State University Press, 2011.

Shelton, William Henry. "Artist Life in New York in the Days of Oliver Horn." *Critic* 1, no. 43 (1903): 31–40.

———. *The History of the Salmagundi Club as It Appeared in New York Herald Tribune Magazine on Sunday, December Eighteenth, Nineteen Twenty-Seven.* New York: Salmagundi Club, 1927.

———. *The Salmagundi Club.* New York: Houghton Mifflin, 1918.

Shields, David S. *Still: American Silent Motion Picture Photography.* Chicago: University of Chicago Press, 2013.

Shteir, Rachel. *Striptease: The Untold History of the Girlie Show.* Oxford: Oxford University Press, 2004.

Simmons, John E. *Museums: A History.* Lanham, MD: Rowman and Littlefield, 2016.

Smith, Francis Hopkinson. "Around the Wood Fire." In *The Novels: The Other Fellow and Tile Club Stories,* 159–71. New York: Charles Scribner's Sons, 1908.

———. *A Book of the Tile Club.* New York: Houghton Mifflin, 1886.

Smithgall, Elsa, Erica Hirshler, Katherine M. Bourguignon, Giovanna Cinnex, and John Davis. *William Merritt Chase: A Modern Master.* New Haven: Yale University Press, 2016. Exhibition catalogue.

Snyder, Joel. "Making Photographs Public." In Gervais, *"Public" Life of Photographs,* 17–37.

Sontag, Susan. *On Photography.* New York: Farrar, Straus and Giroux, 1977.

Sorel, Philippe. "Photosculpture—The Fortunes of a Sculptural Process Based on Photography." In *Paris in 3D,* edited by Françoise Reynaud, Catherine Tambrun, and Tim Timby, 80–89. Paris: Carnavalet, 2000. Exhibition catalogue.

Stacey, Jackie. *Star Gazing: Hollywood Cinema and Female Spectatorship.* London: Routledge, 1994.

Staiti, Paul. *Deceptions and Illusions: Five Centuries of Trompe l'Oeil Painting.*

Washington, DC: National Gallery of Art, 2002. Exhibition catalogue.

Steedman, Carolyn. *Dust: The Archive and Cultural History.* Manchester: Manchester University Press, 2001.

Stieglitz, Alfred. "The American Photographic Salon." *American Annual of Photography and Photographic Times Almanac* 10 (1896): 194–96.

———. "Editorial Comment." *American Amateur Photographer* 6 (January 1894): 1.

———. "The Hand Camera—Its Present Importance." Reprinted in Goldberg, *Photography in Print,* 214–17.

———. "The Origin of the Photo-Secession and How It Became 291." In *Stieglitz on Photography: His Selected Essays and Notes,* edited by Sarah Greenough and Richard Whelan, 118–23. New York: Aperture, 2000.

Sturgis, Alexander. *Telling Time.* London: National Gallery Company, 2000. Exhibition catalogue.

"Superiority of American Photographs." *Frank Leslie's Illustrated Newspaper,* 18 November 1876, 179C.

Susman, Warren I. *Culture as History: The Transformation of American Society in the Twentieth Century.* New York: Pantheon, 1985.

Taft, Robert. *Photography and the American Scene: A Social History, 1839–1939.* New York: Dover, 1938.

Talbot, William Henry Fox. *The Pencil of Nature.* London: Longman, Brown, Green, and Longmans, 1844.

———. "Some Account of the Art of Photogenic Drawing." *Philosophical Magazine,* March 1839, 196–211.

"Talks About Sarony." *Chicago Daily Inter-Ocean,* 22 November 1896, 31.

Tatham, David. "Lithographic Workshop, 1825–50." In Barnhill,

Korzenik, and Sloat, *Cultivation of Artists,* 45–52.

Tennant, John A. "Photographic Days." *Photographic Journal of America* 31 (March 1894): 130–33.

Thompson, Julia. "Stieglitz's Portfolios and Other Published Photographs." In Greenough, *Alfred Stieglitz: The Key Set,* 2:934–42.

Thornton, Tamara Plakins. *Handwriting in America: A Cultural History.* New Haven: Yale University Press, 1996.

Towler, John. *The Negative and Print; or, The Photographer's Guide in the Gallery and in the Field, Being a Text-Book for the Operator and Amateur. . . .* New York: Joseph H. Ladd, 1866.

———. *The Silver Sunbeam: A Practical and Theoretical Text-Book on Sun Drawing and Photographic Printing.* New York: E. & H. T. Anthony, 1873.

Trachtenberg, Alan, ed. *Classic Essays on Photography.* Sedgwick, ME: Leete's Island Books, 1980.

———. *Reading American Photographs: Mathew Brady to Walker Evans.* New York: Hill and Wang, 1989.

Tucker, Jennifer. *Nature Exposed: Photography as Eyewitness in Victorian Science.* Baltimore: Johns Hopkins University Press, 2013.

Tuckerman, Henry Theodore. *Book of the Artists: American Artist Life. . . .* New York: G. P. Putnam's Sons, 1867.

Twain, Mark. "The Menken—Written Especially for Gentlemen." 1863. In *Mark Twain's San Francisco,* edited by Bernard Taper, 6–8. New York: Heyday, 1963.

United States Centennial Commission. *International Exhibition, 1876: Official Catalogue.* Part 2. Philadelphia: John R. Nagle, 1876.

Van Wyck, Frederick. *Recollections of an Old New Yorker.* New York: Liveright, 1932.

"A Veteran Photographer." *Photographic Times and American Photographer* 25 (August 1894): 134.

Vogel, Hermann Wilhelm. *The Chemistry of Light and Photography*. New York: D. Appleton, 1875.

Volpe, Andrea. "Cartes de Visite Portrait Photographs and the Culture of Class Formation." In *The Middling Sorts: Explorations in the History of the American Middle Class*, edited by Burton J. Bledstein and Robert D. Johnston, 157–69. New York: Routledge, 2001.

Weston, Edward. "Daybooks, 1923–1930." In Goldberg, *Photography in Print*, 303–14.

Wexler, Laura. *Tender Violence: Domestic Visions in an Age of US Imperialism*. Chapel Hill: University of North Carolina Press, 2000.

Whaples, Robert. "United States: Modern Period." In *Oxford Encyclopedia of Economic History*, 5:167–74. Oxford: Oxford University Press, 2003.

Whelan, Richard. *Alfred Stieglitz: A Biography*. New York: Little, Brown, 1995.

White, Richard Grant. "A Morning at Sarony's." *Galaxy: A Magazine of Entertaining Reading*, March 1870, 3.

Whitman, Walt. "Visit to Plumbe's Gallery." *Brooklyn Eagle*, 2 July 1846.

Willems, Philippe. "Between Panoramic and Sequential: Nadar and the Serial Image." *Nineteenth-Century Art Worldwide* 11 (Autumn 2012). https://www.19thc-artworldwide .org/autumn12/willems-nadar-and -the-serial-image#_ftn61.

Willets, Gilson. "The Art of Not Posing—An Interview with Napoleon Sarony." *American Annual of Photography and Photographic Times Almanac* 10 (1896): 188–94.

———. "Photography's Most Famous Chair." *American Annual of Photography and Photographic Times Almanac* 13 (1899): 56–62.

Wilmeth, Don B., and Christopher Bigsby, eds. *The Cambridge History of American Theatre*. Vol. 1. Cambridge: Cambridge University Press, 1998.

Wilson, Edward L. "An Hour with Mr. Sarony—Our Picture." *Philadelphia Photographer* 4 (March 1867): 82–84.

———. "Our Picture: Some Interviews with Mr. Sarony." *Wilson's Photographic Magazine*, January 1893, 5–15.

———. "Outdoor Photographs Taken Indoors." *Philadelphia Photographer* 3 (May 1866): 129–31.

———. "Sarony." *Wilson's Photographic Magazine*, February 1897, 65–68.

Wilson, Garff B. *A History of American Acting*. Westport, CT: Greenwood Press, 1980.

Wilson, James Grant. *The Memorial History of the City of New-York*. New York: New-York History Co., 1893.

INDEX